FRANKENTHALER

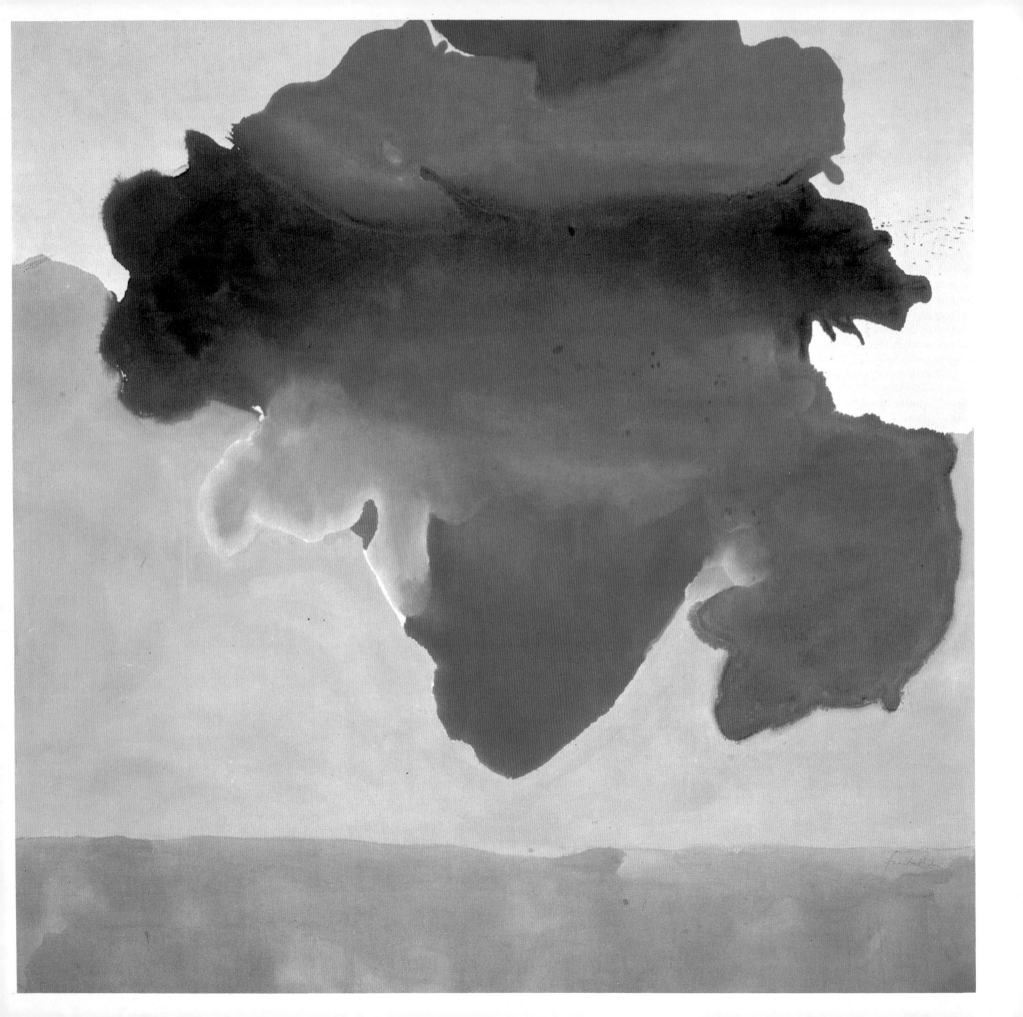

TEXT BY BARBARA ROSE

HARRY N. ABRAMS, INC., PUBLISHERS, NEW YORK

Title page plate

1. THE BAY. *1963. Acrylic on canvas, 80¾ × 81¾"*
The Detroit Institute of Arts, Gift of Dr. and Mrs. Hilbert H. de-Lawter

Book design:

ROBERT MOTHERWELL

Standard Book Number: 8109–0126–9

Library of Congress Catalogue Card Number: 70–141762

HARRY N. ABRAMS, INCORPORATED, NEW YORK

Printed and bound in Japan

CONTENTS

LIST OF PLATES

Colorplates are marked with an asterisk.
Unless otherwise specified in the captions,
works are in the collection of the artist

FRANKENTHALER

Among the radiant stained canvases of Helen Frankenthaler are some of the most beautiful as well as some of the most historically significant works of the nineteen fifties and sixties. Frankenthaler changed painting; but her development took place within a context stressing continuity. Given her background, it was natural that she should become a painter within a tradition.

The youngest of three daughters of Alfred Frankenthaler and his German-born wife, Martha (Lowenstein) Frankenthaler, she received all the cultural advantages her family could provide. Unlike many avant-garde artists from provincial backgrounds or culturally deprived circumstances, she absorbed the history of art gradually and naturally; culture was not exotic or foreign, but part of her life. Despite her familiarity with the traditional forms, however, her independence and restlessness would force her to reject the known, the expected, and the comfortable and to experiment with techniques and forms that consistently contradicted the prevailing taste.

Going against the grain often meant going it alone. In a later moment of reflection, she acknowledged the difficulty of her position. "To sustain conviction is often a struggle," she admitted. "No one enjoys being alone." Although socially and personally she maintained many contacts, Frankenthaler, as much as any major artist of the last two decades, worked outside the dominant values of the art of the sixties. As a human being of enormous wit, charm, and élan she was always accepted; as an artist she worked and waited for her success. But it

may have been precisely this isolation that permitted the deepening and maturing of her style.

This is not to say that Frankenthaler did not have her public. But until her 1969 retrospective at the Whitney Museum, which gained her applause from the *New York Times,* the mass media, and a new generation of young painters, that public was not large. Because of its originality and spirit of contradiction, Frankenthaler's art was misunderstood by fellow artists and sometimes reviled by critics for the very qualities for which it is esteemed today. Judged by the norms of academic Cubism and the prevailing de Kooning style that Frankenthaler rejected, her art was seen as "reckless," "thin," uncontrolled, uncomposed, lacking in impact, and too sweet in color.

Unlike the majority of modernists who were frustrated and misunderstood by their parents and teachers, Frankenthaler was supported and encouraged in her urge toward self-expression. This has to be taken into account when one tries to understand the kind of artist she became. Her sense of personal security and her natural talent gave her the conviction to allow her "mark" to stand—boldly, nakedly, and without apologies—while others were deadening their works with successive layers of muddy revisions. That she was capable of both assimilating tradition and challenging the accepted depended largely on two factors: her sense of continuity with the modern tradition and the strength she could summon to sustain herself alone in crisis.

To mention crisis at this time seems perhaps exaggerated, the rhetoric of crisis having been so overworked as to become meaningless. Yet if one compares Frankenthaler's paintings at any given moment

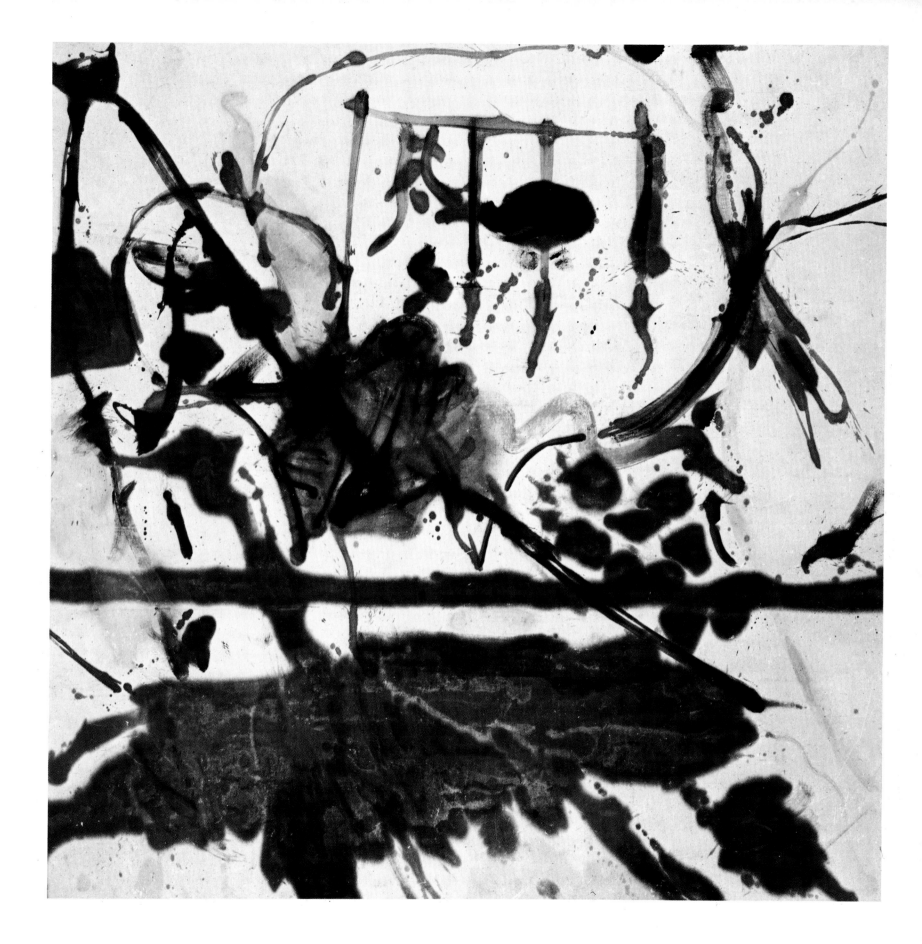

with what is going on around her, one realizes that she is consistently running against the pack, challenging the given, and, especially in recent works, challenging herself. One might even say that she falters only in those instances where she gives in to the prevailing mode, as, for example, when she attempted to accommodate herself to the athletic excesses of "action" painting in the late fifties or to the puritanical reductiveness of the minimal sensibility in the late sixties.

The current reevaluation of Frankenthaler's contribution is the result of a change in taste created by the recognition of Morris Louis and Kenneth Noland, who have publicly acknowledged their debt to her. The new appreciation of her work is also related to a return to painterliness on the part of many younger artists able to see Frankenthaler's atmospheric illusionism with fresh eyes unclouded by the fog of art world polemics. After a decade of hard-edged rigor, both artists and the general public are eager to accept Frankenthaler's counterstatement: the freedom, spontaneity, openness, and complexity of an image, not exclusively of the studio or the mind, but explicitly and intimately tied to nature and human emotions.

It is possible that Helen Frankenthaler's education was the most consistent and thorough of any painter of the New York School. Her artistic formation progressed step by step, from the formal academicism of Brearley, an exclusive New York girls' school, to the more permissive atmosphere of the progressive Dalton School. At Dalton she was the favorite pupil of the celebrated Mexican muralist Rufino Tamayo, mainly, she claims, because she painted such good Tamayos. "I used his medium literally: a third turpentine, a third linseed oil,

a third varnish," she recalls. Tamayo was the "first real artist" she had known; she was impressed above all with his seriousness and his attitude toward his work. He taught her "practical methods and materials; how to stretch a canvas with neat corners, how to apply the brush." Tamayo's awareness of Cubism and Picasso, which did not register at the time, carried over, she feels, to the "conscious attention and actual dissection of Cubism" she later undertook.

While studying with Tamayo she visited the old Guggenheim Museum on Seventy-second Street, which was near her family's apartment, and Tamayo's gallery, Valentine, where advanced European art was shown. As a teen-ager she often went to exhibitions at the Museum of Modern Art with her sister Marjorie. She remembers specifically a visit on which her sister took her to see Dali's *Persistence of Memory*, his famous Surrealist painting of a melted watch. She was struck by the capacity of the human imagination to transform the images of the natural world into something strange and amazing. "For the first time I really looked and I was astonished," she remembers. Perhaps the image of a form flowing and melting, changing into a fluid state, had special meaning for her even at an early age; eventually she would employ such fluid images, although in an abstract form, in her own paintings.

Staying on in New York for a semester after her high school graduation because she was only sixteen, she continued to study with Tamayo informally. In the Spring of 1946 she left to attend Bennington College. Paul Feeley, just returned from the Marines, had become head of the art department. Away from Tamayo she dropped the " 'Mexicanness'

of his blues and oranges and ochers and reds, watermelons, hands and arms reaching against the night-starry skies," although she retained a fondness for Tamayo as her first real art teacher and the first important artist she had known.

With Feeley her training began in earnest. An artist of great foresight and analytic ability, Feeley became a lifelong friend and supporter, and his impact on Frankenthaler's art was decisive. At Bennington, Feeley conducted seminars in which he dissected and meticulously analyzed the work of the major modern masters. Tacked to a permanent Celotex rolling easel were reproductions (usually cut out of *Art News*) of works by Mondrian, Kandinsky, Picasso, and Braque, as well as Old Master prints. Frankenthaler remembers in particular two works which were analyzed in detail: Cézanne's *Card Players* and Matisse's *Blue Window*. From the former, she began to learn how the illusion of depth, of three-dimensional space behind the frame, could be checked and balanced by an equal emphasis on the two-dimensional surface design. The latter supplied perhaps her first indication of how an open format of large areas of transparent color could give a sensation of light and atmosphere, and how reserved areas of uncolored canvas acted as a foil for color, allowing the picture to "breathe" and expand spatially. Later both Cézanne and Matisse would be recalled in her own work.

Frankenthaler has described the analysis of a painting in Feeley's seminar: "We would really sift every inch of what it was that worked; or if it didn't, why. And cover up either half of it or a millimeter of it and wonder what was effective in it . . . in terms of the paint, the subject matter, the size, the drawing. . . . Would it matter if you put

it upside down?" Although he had a rare understanding of the mechanics of the various modern styles, the emphasis of Feeley's teaching was on Cubism, especially on the formative Analytic Cubist works of Picasso and Braque. "He would never teach or give out with dogmatic perceptions, but just in dwelling on something would . . . pull the feeling out of you," Frankenthaler reminisced later. Feeley's own work during that period was closely tied to American Cubism, especially to the work of Max Weber. Through Feeley, Frankenthaler became acquainted with the Expressionist landscapes of Dove, Hartley, and Marin. She discounts, however, the similarities critics have seen between her work and the nature abstractions of Dove and Marin. She has never spoken of a debt to Dove, but she admits: "I looked hard at Marin, but I didn't have any of the feeling for him I had for Kandinsky." Despite her disavowal of any links, analogies between her work and the native American tradition undeniably exist. Frankenthaler would probably insist that such similarities are the result of having been influenced by the same sources as Dove and Marin, that is, Kandinsky's early abstract landscapes in Dove's case, and Cézanne's watercolors in Marin's.

The most important thing Frankenthaler learned from Feeley's meticulous analysis of Cubism was a clear conception of the function of pictorial illusionism since Cézanne. "How a picture works best for me involves how much working false space it has in depth," she has said. "The memory of this goes back to classes in Cubism. The color and light in a picture work in terms of this pseudo-perspective; whether it be a Cubist Picasso or Braque or a Noland stripe painting—it's a play of ambiguities. Titian is involved with ambiguity, too."

At Bennington, Frankenthaler continued to draw and paint from the model. Among her realistic paintings were several graveyard land-scapes, studio still lifes, and figure studies of fellow students. The graveyard appealed to her as a subject not for reasons of any morbid romanticism, but because it was both "landscape and man-made." Sometimes she set her easel up out of doors to paint the green hills and mountains of Vermont. She had by this time rejected academic painting and considered herself a follower of Cézanne and, eventually, a disciple of Picasso. "By the time I graduated," she recalls, "I really understood how to paint a Cubist picture. By that I don't mean I could paint something that had split up planes, but I understood how ambiguously a color can appear to be up close or miles away even if it covers the same area and has the same density." This perception, made while she studied with Feeley, would continue to be of immense impor-tance to her.

By cultivating an intense consciousness of the mechanics of Cubist space and composition, Frankenthaler was able to see the space-creating as well as the form-creating functions of line. Despite its emphasis on color, her style, probably because of its Cubist roots, has always been primarily concerned with creation of a certain kind of pictorial space, rather than with an exclusively hedonistic color ex-perience. Drawing and, subsequently, color function in the first place as agents of illusionism: that they have many other functions does not change this. Thus her primary concern with space saves Frankenthaler from ever falling into mere decorative or sensuous display. She has been quite clear about this in her statements. Shape, color, and scale

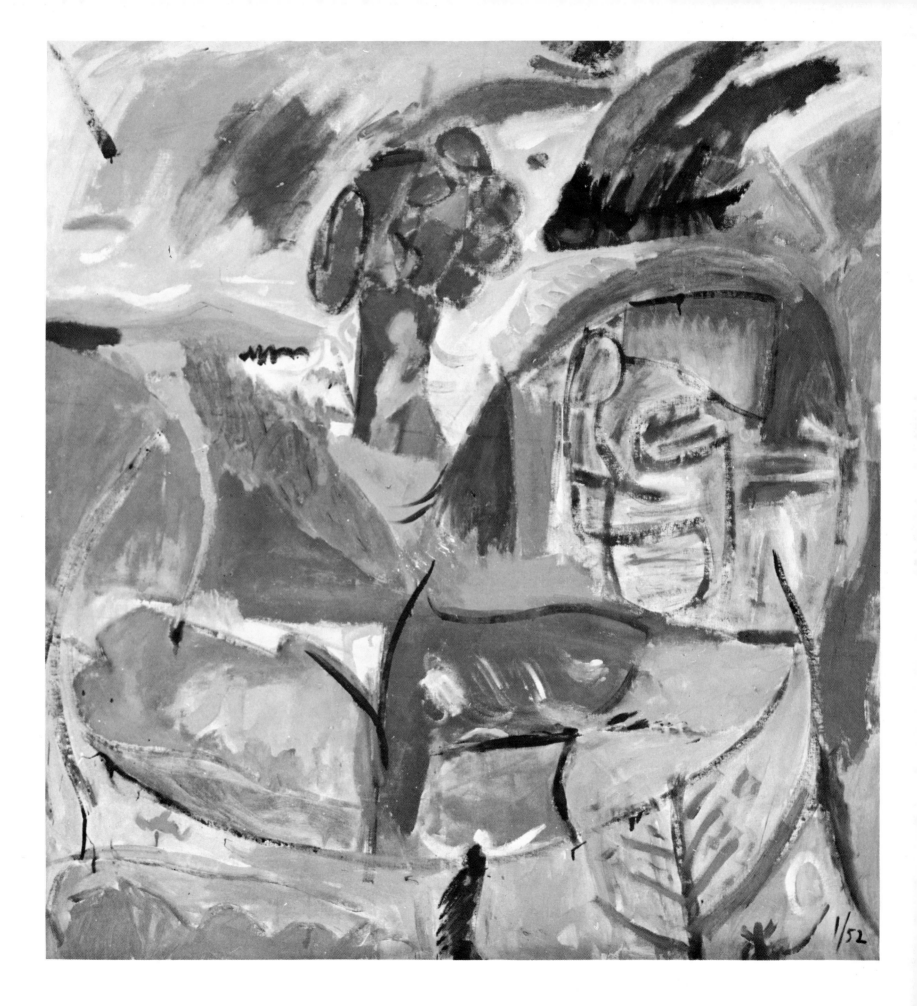

as well as drawing are important insofar as they create a certain kind of illusionistic space, the nature of which we shall examine at greater length.

Frankenthaler's relationship to Cubism, initiated by her contact with Feeley, remains a complex affair. She wished, she said later, "to push the development of Cubism so that line per se disappeared, but the need, the use, the memory, or function of it remained." Having mastered the shallow, delimited space and tight, internally balanced composition of Analytic Cubism, she became critical of precisely these aspects of the style. One of her initial criticisms, which she resolved in several different ways, was of the neglect of the corners in Analytic Cubism. Eventually she worked out several alternatives for dealing with the corners of paintings "using them or ignoring them or pretending they're not corners . . . or painting as if the corners were miles beyond my reach or vision." At other times, however, as in the 1964 squared-off series of "interior landscapes," she encloses a form to limit and define space in a specific way, so that it is felt as finite and measurable, as opposed to infinitely ambiguous.

Feeley's commitment to Cubism at the time—although his style changed later as he himself was influenced by his former student—was total. Frankenthaler recalls Feeley's cool reception of a reproduction of a painting by William Baziotes that she brought to class because she was impressed with the freshness of the shapes and the imagery. Feeley's Cubist orientation was reinforced by her study with Wallace Harrison (the Australian painter, not the architect), who ran a school on Seventh Avenue and Fourteenth Street where she studied during

one of the Bennington nonresident work terms. Feeley's students were customarily given a choice between studying at Hans Hofmann's school on Eighth Street or studying with the lesser-known Harrison. Frankenthaler chose the more intimate atmosphere of Harrison's studio, where there was no "scene," but only a few very serious painters like James Brooks and his wife, Charlotte, who were committed to an intense study of art rather than a life style. Typically, the crowd went one way, and Frankenthaler went the other. Harrison, she remembers, was "a mad Francophile and crazy about Picasso and Lipchitz." With Harrison and the Brookses, she visited many New York galleries and studied Lipchitz's abstract figure drawings. She herself labored to do such Cubist drawings with a greasy pencil on typewriter paper, carefully shading in chiaroscuro passages to model forms in depth.

After a trip to Europe, where she saw for the first time the paintings of Titian, Rubens, and Velázquez, the Old Masters who meant most to her, although she did not yet fully understand them, Frankenthaler returned to finish her senior year at Bennington. Early in 1949, she made her first sale of a Cubist still life in the style of Braque, to the critic Stanley Edgar Hyman, a member of the Bennington faculty. In the fall of 1949 she moved to New York, using a cold-water-flat studio she had originally shared with her classmate, art critic Sonya Rudikoff. To please her family and show that she was doing something legitimate, she enrolled as a graduate student in art history at Columbia, where she studied briefly with Meyer Schapiro. By the middle of the semester, however, she had stopped going to classes and was devoting herself entirely to painting.

Her interest in Kandinsky became a central focus. At Bennington, Feeley had tacked up reproductions of both Kandinsky's late Cubist works of the Bauhaus period and his early improvisations, but Frankenthaler was more attracted to the Expressionist landscapes which were often on view at the Guggenheim Museum. Given her predilection for landscape and for drawing, her interest in Kandinsky's improvisations was altogether natural. Kandinsky's freely expressive line, looping around or cutting jagged paths through patches of transparent color, and his tendency to float motifs on an open white ground are constantly referred to in Frankenthaler's early abstract landscapes. It appears, moreover, that she was acquainted with Kandinsky's theory that the artist improvises form out of his own feelings, memories, and associations. Of course, only the artist has the key to these memories and associations, and to understand them literally we must have the artist's own interpretation. Both Kandinsky and Gorky created allusive abstract landscapes, full of hidden meanings and hermetic symbolism which in several instances they took the trouble to decode verbally in statements explaining their imagery. Frankenthaler meant to be more general, perhaps; in any event she has never explicitly commented on the content of the specific allusions contained in her images. Certain of her paintings, however, seem to contain fairly obvious references to childhood memories. (In *Mother Goose Melody*, for example, the three central figural shapes might refer to Frankenthaler and her two sisters.)

Early in 1950, Frankenthaler was asked to organize an exhibition of Feeley's former students as a Bennington benefit at a Fifty-seventh Street gallery. As part of the publicity for the exhibition, she invited

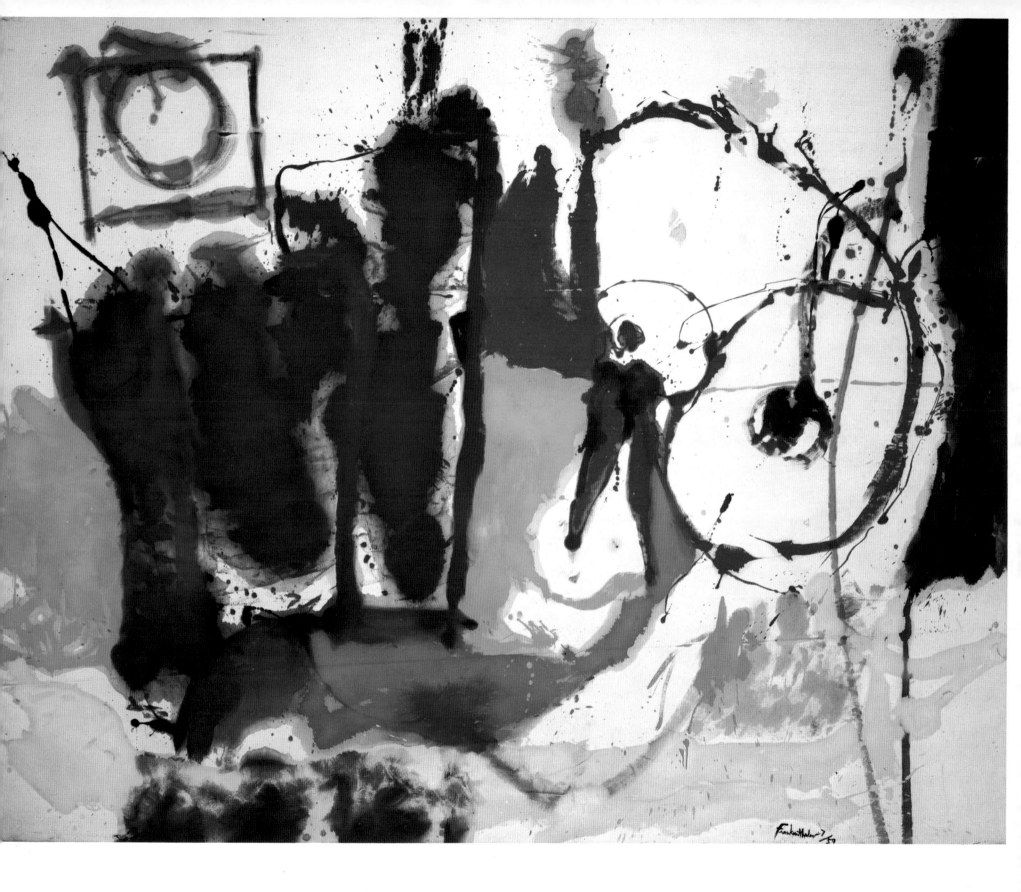

many art and literary figures to the opening; among them was the art critic Clement Greenberg, whom she had never met. In the show was her own nearly life-size painting—"large for the time but still an easel picture" she remembers—*Woman on a Horse,* which she had painted the preceding year while studying with Wallace Harrison. The style was Picassoid Cubist, combining full and profile views and attempting to integrate flatness with an illusion of depth. Drawing continued to take primacy over color, to which she did not pay any special attention. The painting, as she describes it, was an overambitious student work, executed in Grumbacher tube oils and gleaming with Demar varnish and retouching varnish. When she escorted Greenberg around the exhibition, he singled out *Woman on a Horse* as a painting he did not like.

For the following five years, she and Greenberg attended exhibitions, analyzed paintings, went to galleries, museums, the Cedar Street Bar, and the regular Friday night meetings of the Artists' Club. Often, they took trips to the country to paint from nature. One of the few representational works Frankenthaler keeps, in fact, is an expressionist portrait of Greenberg at his easel painting a *plein-air* landscape, which she did in the Bennington studio during the summer of 1951.

In the summer of 1950 Greenberg suggested that Frankenthaler go to Provincetown to study with Hans Hofmann. Although she came to have great affection for both Hofmann and Provincetown, where she continues to spend most of her summers, she felt that Feeley had provided her with so thorough an understanding of Cubism that she could learn little more from Hofmann. "Push-pull," Hofmann's celebrated method for

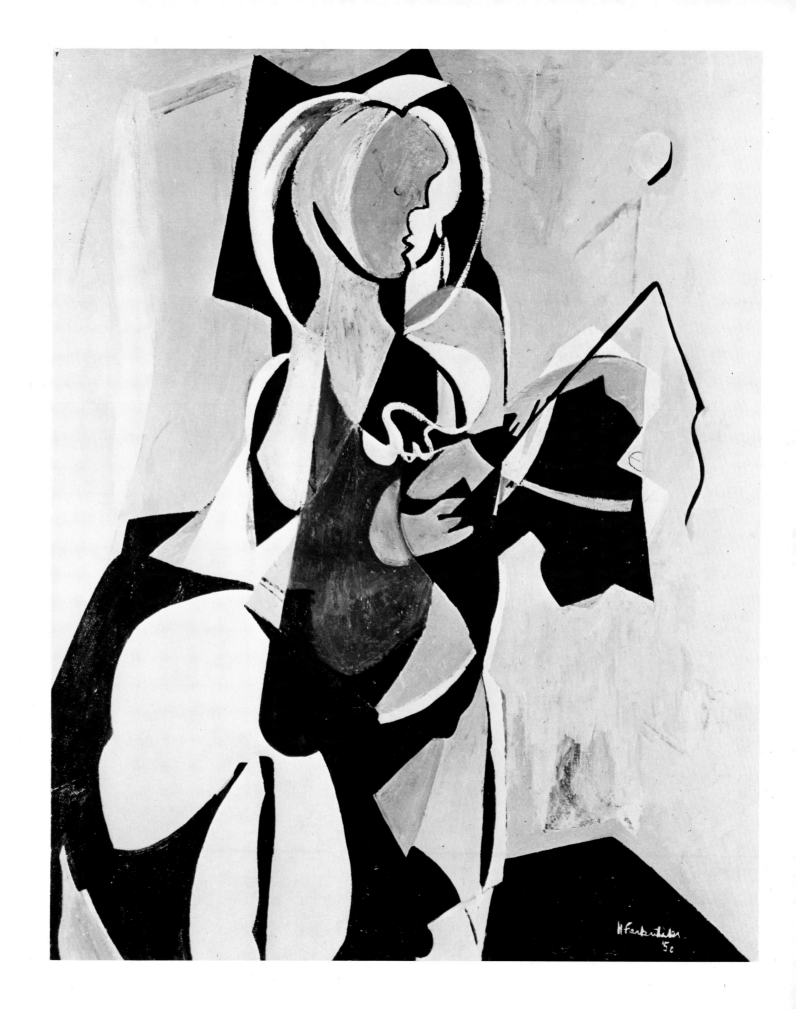

6. PROVINCETOWN BAY. *1950. Oil on sized, primed canvas, 16½×20". Collection Mr. and Mrs. Clement Greenberg, New York City*

balancing out the sensations of flatness and depth so that the latter did not contradict the former, was already familiar to Frankenthaler—although not by that name—from her study with Feeley and Wallace Harrison.

At that point, Frankenthaler was painting abstractions from nature. She often painted Provincetown Bay from her back porch, flattening and simplifying its shape by tilting the bay on its side, shifting it to a position more parallel with the picture plane, as Cézanne had done with his table tops. She recalls that one day the landscape painter Kaldis criticized her for not making the piles of the wharf look as if they were really in the water. "He couldn't understand that I didn't want the Bay that much in perspective. I wanted it to be a little flat, parallel in relation to the canvas itself." In addition to landscapes Frankenthaler also painted abstractions—in Hofmann's style, as she freely admits—which Hofmann often praised in class. Although Hofmann's emphasis was on color, Frankenthaler had not yet focused on color as central to her art and was still mainly interested in drawing.

Later that summer, she spent a few days visiting Greenberg at Black Mountain College, where he was teaching, but the snakes, the dismal barracks, and the bad food depressed her, and she returned to New York to find an apartment with her friend Gaby Rodgers, the actress. She was by that time part of a milieu of painters and poets, including Frank O'Hara, Kenneth Koch, John Ashbery, and Barbara Guest, who were also associated with the short-lived Artists' Theater. Among her friends were the younger "second generation" Abstract Expressionists Alfred Leslie, Grace Hartigan, Harry Jackson, Larry

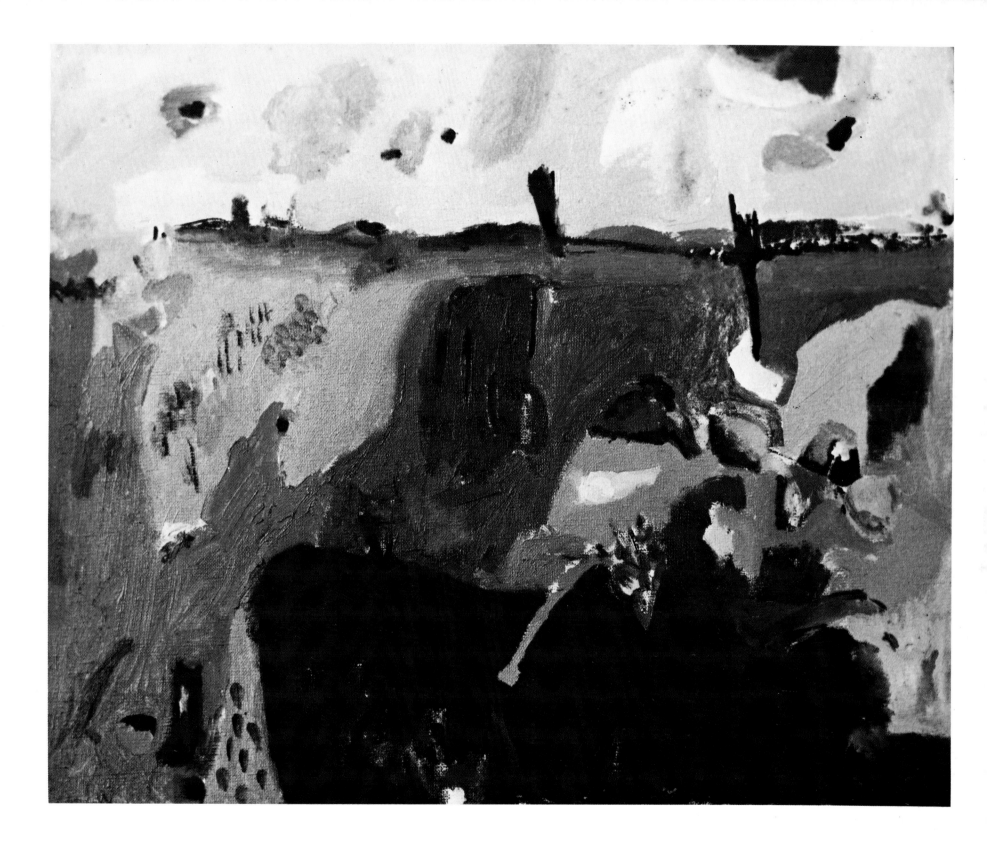

28

Rivers, and Joan Mitchell, whose heroes were de Kooning and Pollock. Later there would be a terrible split between partisans of the two, but for the time being the art world was so small and stakes so minimal that artists could band together in mutual support against their common enemy, the philistine public and the uptown museums.

Toward the end of 1950, Adolph Gottlieb saw one of Frankenthaler's paintings at Greenberg's apartment and chose the unknown twenty-two-year-old painter as his selection in a group exhibition picked by gallery artists at the Kootz gallery. An eccentric work with a heavy crust of paint thickened with plaster of Paris, it was the first painting she exhibited as a professional artist in New York. For Frankenthaler, 1950 had been busy and exciting, but the following year was crucial. "I was off on my own. I had a history. I was developing, but I was also developing in the context of the New York avant-garde of 1951." This context included, to begin with, the Gorky retrospective at the old Whitney on Eighth Street. Greenberg took her to the exhibition, her first full exposure to Gorky's work. She was very moved and excited. Gorky, though he had taken much from Kandinsky, offered a broader, more fluid way of working, as well as a more decidedly flat and frontal image. This was the direction Frankenthaler was already beginning to take in her own work, a direction that was surely reinforced by the exposure to Gorky.

That same year, Frankenthaler was the youngest painter to exhibit in the historic Ninth Street Show, an exhibition organized by members of the New York School in a storefront gallery on East Ninth Street to show their accomplishments to uptown dealers, collectors, curators,

and critics, whose reception was not yet enthusiastic. Frankenthaler remembers the shock of older artists at the large size of the paintings of the younger generation. In that year she also had her first one-man show of small landscapes and large abstractions still indebted to Cubism and to Gorky's and de Kooning's biomorphic drawing at the new Tibor de Nagy gallery, where John B. Myers courageously showed the work of relatively unknown younger painters.

In terms of Frankenthaler's future development, however, the great event of 1951 was Jackson Pollock's exhibition at the Betty Parsons gallery. She felt that she had learned a great deal from Gorky, but Pollock overwhelmed her.

Her first exposure to paintings like *Number One* and *Autumn Rhythm* was blinding; she recalls feeling as if she were "in the center ring of Madison Square Garden." She sensed the extraordinary physical impact of these paintings, the manner in which they appeared to surround the viewer, establishing a more intimate and direct contact between image and spectator than previous paintings. She knew at once that this was where one had to begin: "It was as if I suddenly went to a foreign country but didn't know the language, but had read enough and had a passionate interest, and was eager to live there. I wanted to live in this land; I *had to* live there, and master the language."

To help her learn the language, Greenberg took her the following spring to visit Pollock and his wife at their East Hampton home where they lived except during brief trips to New York. "Having looked at Cubism, been in New York in 1950, knowing de Kooning," Frankenthaler felt that Pollock's work was "a clinching point of departure." By that

time she knew that she did not want to be involved in "the cuisine of Cubism.... I also didn't want to put figures in my paintings," she recalls, "or to make de Kooning's kidney shapes." Despite her great admiration for de Kooning, a friend whose studio she sometimes visited, she felt that "with de Kooning, you could assimilate and copy; and that Pollock instead opened up what one's own inventiveness could take off from. Given one's own talent and curiosity, one could explore, originate, discover from Pollock as one might, say, from Picasso or Gorky or Kandinsky."

So Pollock became Frankenthaler's mentor, displacing Picasso, Gorky, and Kandinsky. In his Springs, Long Island, studio she saw his paintings rolled up or spread out on the floor and began to understand how he worked. Gradually, it became clear to her how his revolutionary new *technique*—taking the canvas off the easel and painting straight down from all sides, abandoning the traditional brushes and oils for enamel and a variety of dripping instruments—made possible a radical approach to form.

She has described the importance of weekends spent at Springs with Greenberg and the Pollocks. Although she never actually saw Pollock at work, she and Greenberg, together with Pollock and his wife, Lee Krasner, would go out to Pollock's studio, which was in a barn behind the house, several times during the weekend to look at the paintings he was making at various stages. She had felt de Kooning's influence, but she was far more drawn to Pollock's involvement with nature and to the originality of his technique. "I thought that Pollock was really the one living in nature, much more than Bill," she later wrote to her

friend, the poet and critic Gene Baro. For her, the difference was that "de Kooning made enclosed linear shapes and 'applied' the brush. Pollock used his shoulder and ignored edges and corners." Shortly, she would emulate Pollock, working not only with her hand and wrist but with her arms and shoulder, and, eventually, in large works, with her whole body. The overt physicality of Pollock's method, the sense of the painting having been, as Frankenthaler puts it, "choreographed," made possible a large scale, a boldness and an openness that appealed to her.

By her own admission, Frankenthaler's debt to Pollock was enormous; and she was not prepared to assimilate his influence all at once. To begin with, however, Pollock's work showed her a way of integrating surface and image which freed her from the restrictions of Cubist design and technique. Pollock's work together with Greenberg's analysis of it gave her, above all, "a sense of being as open and free and surprised as possible." From them she learned to develop her "own sense of knowing when to stop, when to labor, when to be puzzled, when to be satisfied, when to recognize beautiful or strange or ugly or clumsy forms and to be free with what you are making that comes out of you." These were the things she understood intuitively.

She also understood—again it would appear on a purely intuitive level—that to imitate Pollock's drip was to become a mere epigone, and she was far too ambitious and original an artist to be anyone's follower. (One story she relates that reveals her independence regards her resentment of Tamayo's corrections on her paintings: "I didn't want him to touch the painting itself but to show me on a separate piece of

paper or on something he was doing, but not to paint on my painting.")
Moreover, she generally disliked the quality of the drip. She began
to work on the floor rather than at an easel because "it became a
physical necessity to get the pictures off the wall," to work "from above
down into the field." She liked to work on the floor precisely because
"you could work quickly *without* getting a drip," which she found "a
kind of boring accident." For her the drip always had the same charac-
ter, and she was more interested in cultivating a variety of images,
rather than in elaborating gestural virtuosity.

Because she did not adopt the dripping technique that, as Michael
Fried has pointed out, allowed Pollock to marry painting and drawing,
she was unable to achieve a full integration of the two until much
later. In the first paintings Frankenthaler made after her exposure to
Pollock, painting and drawing remain the separable elements that they
are in Kandinsky and Gorky, despite her adoption of Pollock's working
methods. Like Pollock, she was working on the floor now, pouring and
spilling paint directly into unsized and unprimed raw canvas, which
allowed an unprecedented unity of image with surface.

Undoubtedly, Frankenthaler had a natural sympathy for Pollock's
work because of their mutual interest in drawing. She was able to as-
similate Pollock's advances partly because she had the advantage of
knowing Greenberg and Pollock personally; but others had that advan-
tage and were not able to make the leap she did. The crucial factor
seems to be that she was *prepared,* both artistically and psychologically,
to understand and accept Pollock's message. Even before she saw
Pollock's paintings unrolled on the floor of his studio, Frankenthaler

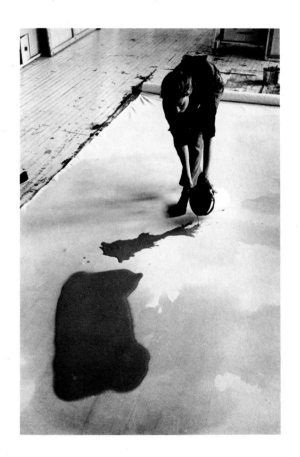

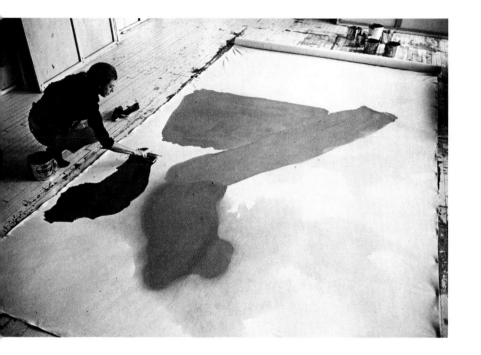
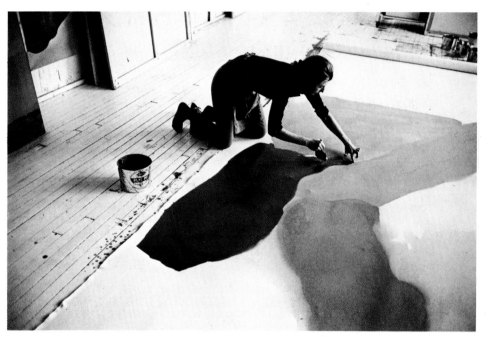

7–9. Helen Frankenthaler Working at Her 83rd Street Studio. 1969

34

had been experimenting with working on the floor. Using a medium made of plaster of Paris, enamel, house paint, oil, sand, and kerosene, she was creating a hard surface that was explicitly and self-evidently flat. (It was one of these paintings that Gottlieb had selected for the Kootz exhibition.) As a student, she had been interested in Dubuffet—she recalls having brought Feeley a Dubuffet catalogue from Paris—and his hard, encrusted surface may have been in the back of her mind. In Europe, Dubuffet and other "matter" painters like Tapiès had sought to go beyond Cubism by creating an obviously flat painting-object, in which the image did not exist behind the surface, as in Cubism, but literally on top of it. This was one way of making flatness explicit. Pollock's dripping directly into raw canvas suggested another way of making flatness explicit—by emphasizing the canvas weave and the physical character of the support as a piece of cloth, known to be flat by its identification as cloth. But this flatness, insured by identification and not by depiction, had the added advantage that it did not demand sacrificing illusionism for literalness, which both Dubuffet and Tapiès were forced to do.

Frankenthaler, and, it appears in retrospect, no one else at that moment, immediately seized on Pollock's discovery and understood its radical implications. Extending Pollock's method by thinning down her medium so that paint not only sank into but soaked right through canvas, she created a stained image that was not literally on top of or illusionistically behind the picture plane but literally in and of the ground. The obvious identity of image with ground freed her to create an illusion of depth that did not oppose or contradict flatness, because

the eye perceived that the image imbedded in the support was contiguous with the surface. The identification of image with support achieved through staining allowed her even to modulate a form from light to dark and to vary intensity and saturation *without* creating any illusion of real space behind the surface plane. Essential to this achievement was the thinness and transparency of her medium; occasionally in later paintings when she is using a thicker, more opaque medium, this extraordinary unity of surface is destroyed and a succession of receding planes reminiscent of Cubism results. (Sometimes this tendency is counteracted by a reversal of figure-ground relationships, but generally the thicker, opaque medium used in the sixties created a new set of problems in terms of reconciling illusionism and flatness.)

In addition to a new approach to technique, Frankenthaler learned from Pollock how to compose without recourse to the Cubist "grid," the pictorial infrastructure of horizontals and verticals which acted as a scaffolding for analogous shapes hung on such a grid. The existence of this grid, frontal to the viewer and parallel to the picture plane, arose from the fact that Cubist pictures were easel pictures. Standing before an easel, the artist faced the canvas frontally. He was forced to compose with regard to a fixed top and bottom, left and right. Composition was based on the internal relationships between similar forms echoing one another and on the relationship between those forms and the frame. Pollock challenged such easel painting conventions as fixed focus, and part-to-part as well as image-to-frame relationships. He did this largely by working on the floor. Walking around his canvas, he was able to create an "all-over" image, a composition

that, because it was worked equally from all four sides, was balanced in terms of the single, indissoluble image rather than discrete part-to-part relationships. Frankenthaler feels that she learned from Pollock's way of working a new attitude toward composition: "When one made a move toward the canvas surface, there was a dialectic and the surface gave an answer back, and you gave it an answer back." In other words, she interpreted Pollock's rhythmic loops and arcs as a freer, more explicitly physical reformulation of Cubist surface-and-depth correlations—those to which Hofmann had referred as "push-pull."

She appreciated also that Pollock's freely improvised attack permitted certain random and accidental elements to find their way into his all-over design, since dripping or pouring was not as totally controllable as applying pigment with a brush or palette knife. His incorporation of such random elements added to the appearance that the resultant image was spontaneously generated rather than manipulated and contrived as in Cubism. The random element in Pollock's design had its origins in the Surrealist technique of *automatism*. Originally a method of free association, either of images or forms, automatism for Pollock became a way of achieving a more spontaneous and freer way of creating form.

Frankenthaler assimilated through Pollock an understanding of automatism, although because she is hardly a theoretician, she may not have called it that. While she is articulate and informed and has written both literary and art criticism, Frankenthaler is essentially an intuitive and a natural painter, and not an intellectual one.

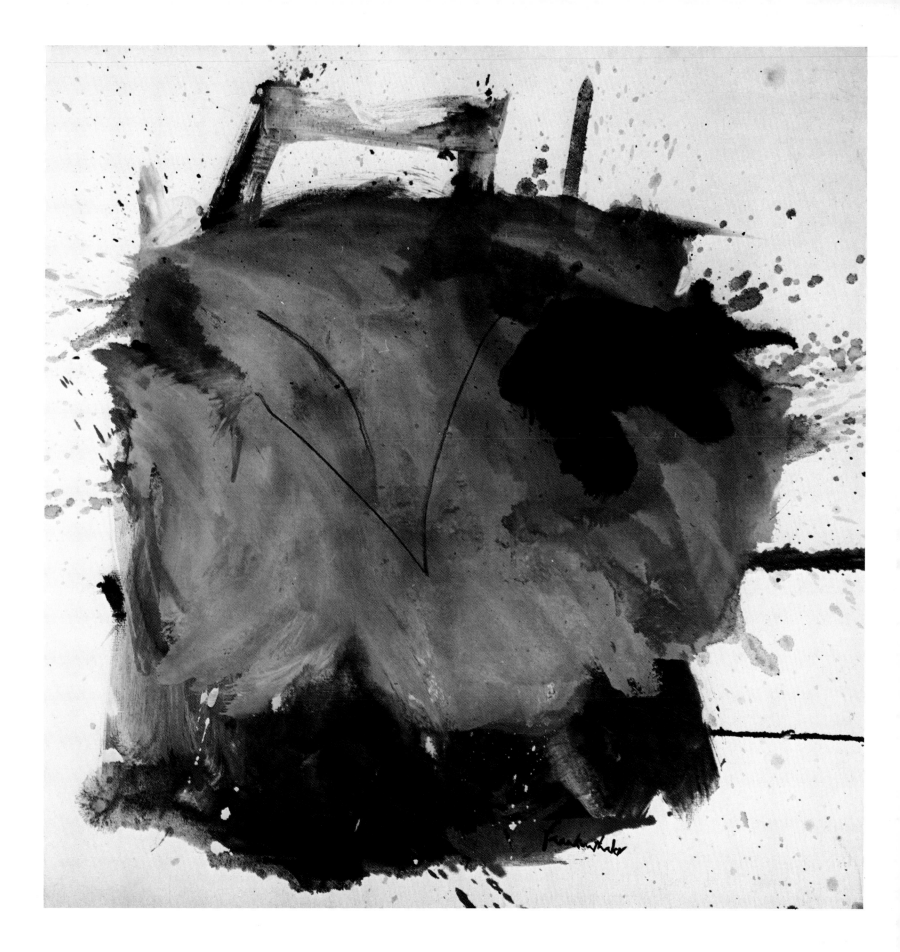

It is doubtful, for example, that she was acquainted with the technical jargon about automatism circulating during the forties while she was a student, when she had a passing interest in Surrealism (she knew Surrealist poetry and read the Surrealist art magazines). Nevertheless, she could not have made the paintings she did in the fifties had she not intuitively grasped the principle of automatism from seeing Pollock's paintings and understanding how he made them. From a later vantage point, it becomes increasingly clear that neither Pollock nor Frankenthaler could have relaxed the tight discipline of Cubist composition to create a more spontaneous and less deliberately contrived kind of order without the precedent of Surrealist automatism.

From Cubism Frankenthaler had learned a rigorous system of structuring and relating forms and a regard for pictorial unity that she has never lost. But Cubism stressed the mastery and domination of materials and forms; its approach was fundamentally a priori and intellectual. Through Surrealism (via Pollock) Frankenthaler learned how to reinforce her ties to nature, already inherent in her landscape image, by imitating the *processes* of nature—by allowing an image to spontaneously grow and evolve from the materials and process of its creation. Although the organic shapes of Baziotes, Gorky, and de Kooning may have appealed to her on one level, she rejected them ultimately for a way of working that did not imitate the shapes but the processes of nature and organic growth. Frankenthaler, in other words, does not depict a shape that looks *as if* it is growing and blossoming or flooding; she creates form by allowing paint literally to flow, spread, and unfold to create an image. This is also true of Louis.

Although it is not obvious, Frankenthaler took over another Sur-realist element from Pollock—the emphasis on psychological content. When she met Pollock, she was not yet a completely abstract painter, although she became increasingly so as time went on. She was as fascinated by the allusive quality of his imagery as by his radical new technique. Here she differed absolutely from Louis, Noland, and later Olitski, who were interested exclusively in Pollock's technique, opti-cality, and all-overness. Pollock had been deeply influenced by Jung's theories of the universal mythic archetypes buried in the collective unconscious. At Bennington, Frankenthaler was exposed to the literature of ritual, myth, and symbol through her teachers, the critic Kenneth Burke and the psychoanalyst Erich Fromm. In the first Pollock show she saw, she was particularly impressed by the painting *Number 14*. For her, it held "more than just the drawing, webbing,weav-ing, dripping of a stick, more than just the rhythm. It seemed to have much more complication and order of a kind that at that time I re-sponded to. . . . It is a totally abstract picture. But it had that addition-al quality in it for me."

This additional element—psychological content—was extremely im-portant because she came into contact with it at precisely the moment she began to part with recognizable subject matter. The allusive ele-ment in Pollock's art was therefore very appealing to her as a replace-ment for subject matter, an intermediate step between representation and full abstraction. Thus she found that in addition to purely formal elements in Pollock's work, she responded "to a certain Surreal element —the understated image that was really present: animals, thoughts,

jungles, expressions." In *Number 14,* she recalls seeing a drawing of something like an animal or fox in a wood in the center, which stuck in her mind. She associated this way of alluding to an image in an ostensibly abstract context with a game, which she used to play as a child, of finding images of animals hidden in rocks and trees. This well-known child's game is of course a simplification of Gestalt experiments in the perception of figure-ground relationships, about which E. H. Gombrich, among others, has written extensively in *Art and Illusion.*

Pollock's method of imbedding ambiguous forms in his abstractions was not consciously related to such Gestalt experiments, although it unavoidably recalls them. His source was more probably certain Surrealist concepts of free association, ultimately Freudian in origin, such as Ernst's *frottages* and Dali's psychologically charged forms. Both these methods in turn were related to the interpretation of Rorschach blots, amorphous abstract shapes used in psychological testing because of their allusive and suggestive character. Both Pollock's black-and-white paintings of 1951–52 and Frankenthaler's 1961 series recall the amorphous, psychologically charged forms of Rorschach blots, although not necessarily intentionally. It should be pointed out, however, that the images used in Rorschach tests are not pictorial and are deliberately calculated to evoke specific associations. The psychological allusions in Frankenthaler's images, on the other hand, are a possible effect, but not an end, of her range of forms.

That her paintings have psychological associations and allusions to natural forms has never been denied by Frankenthaler. There are, for

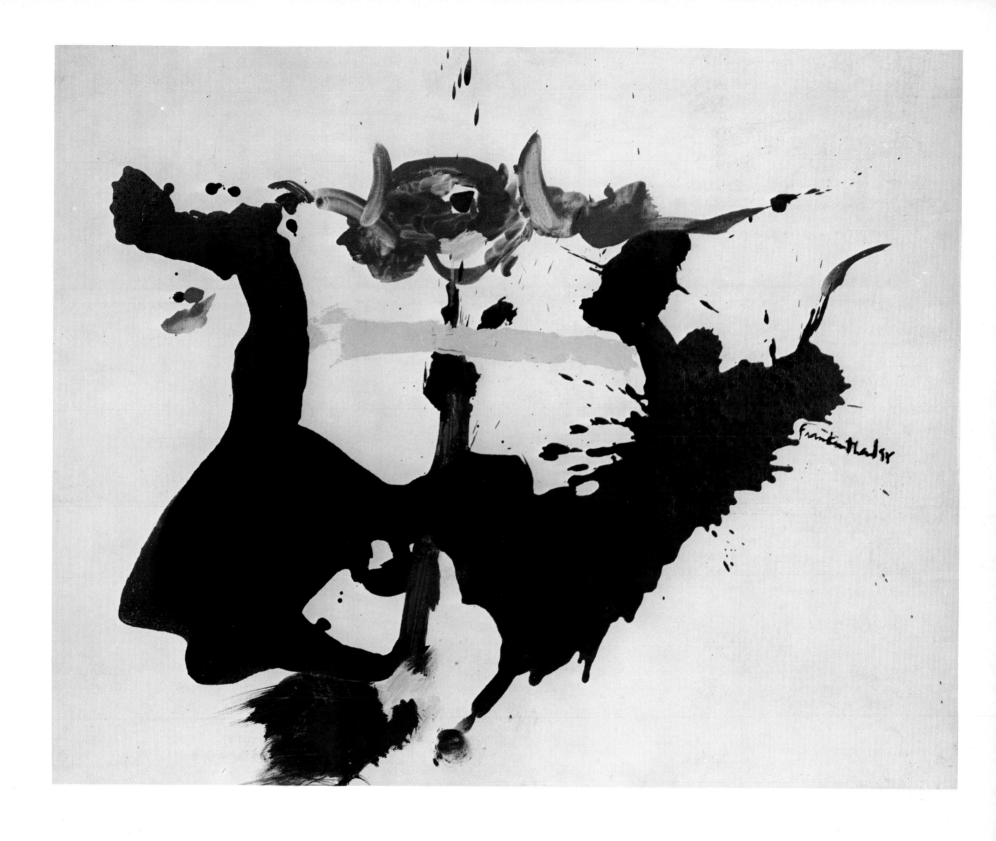

example, swans to be seen hidden as negative reserved shapes that the eye can reverse to read as positive in the "lake" in *Swan Lake II*. There are moons, as well, in *Three Moons*. Frankenthaler has explained that she titles her works not only because it is easier to remember them by name than by number, but also because when they are finished they remind her of something—a place, a scene, an emotion, a mood, a person—which is reflected in the title. (This has become less the case; as the paintings of the sixties grew more abstract, so did the titles.)

Of her titles, Frankenthaler explains: "I usually name them for an image that seems to come out of the pictures, like *Blue Territory*, or I look and see *Scattered Shapes*, or *Red Burden*. I don't like sentimental titles. A picture like *Small's Paradise* had an image in it reminiscent of Persian miniatures of paradise; also I'd been to that nightclub recently."

Frankenthaler's debt to Surrealism, like Pollock's, must be understood as having more than merely formal implications: to acknowledge and deliberately to give expression to the forces and the strivings of the unconscious is to take a particular stand, not only about art, but about life. Those artists who exchanged the rationalized geometric basis of Cubism for the greater liberation of automatic creation implicitly viewed the containment and rigid contours of Cubism as a metaphor for repression. Automatism and the spontaneous expression of the unconscious viewed in this light are valued for their capacity to free man from the repression and alienation from nature and the instincts imposed by a mechanistic civilization. Many Abstract Expressionists acknowledged the creative force of the unconscious. Unfortunately, those who had not subjected themselves first to the rigorous training of

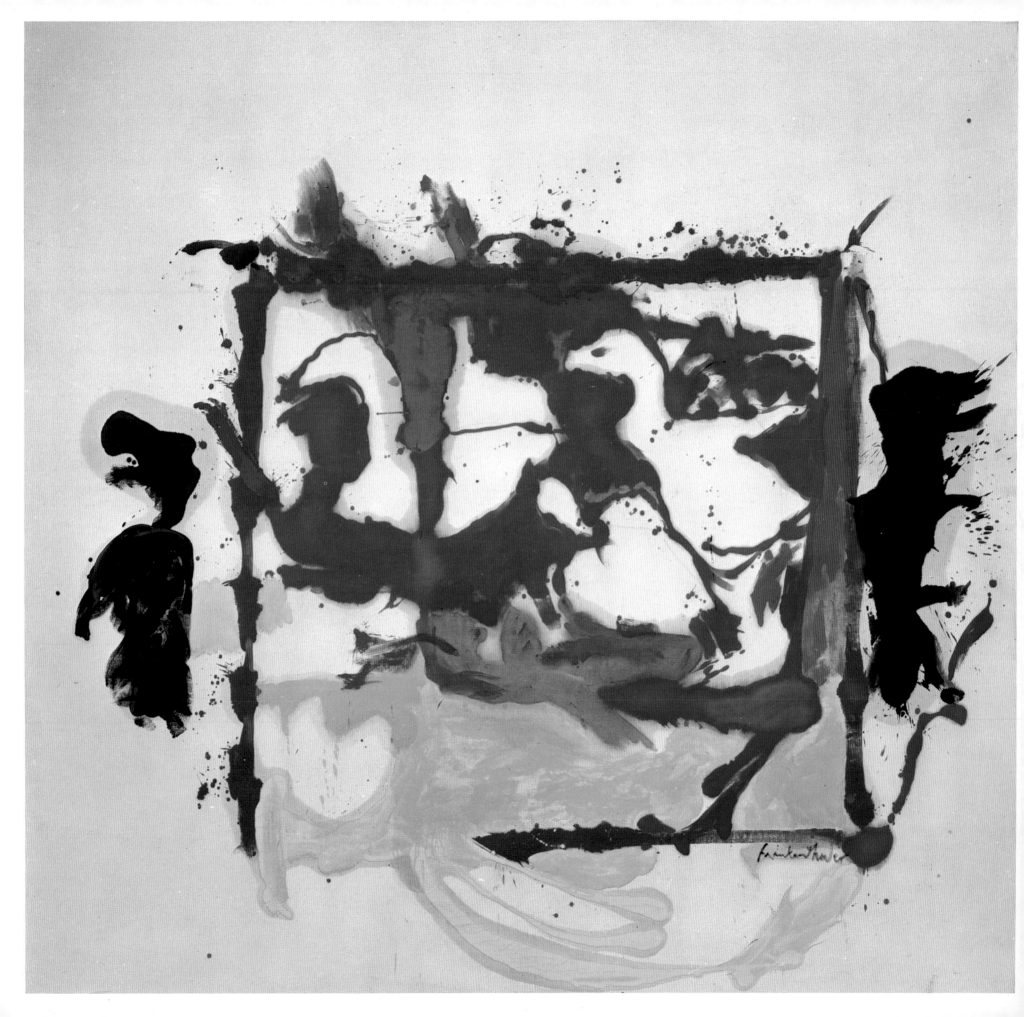

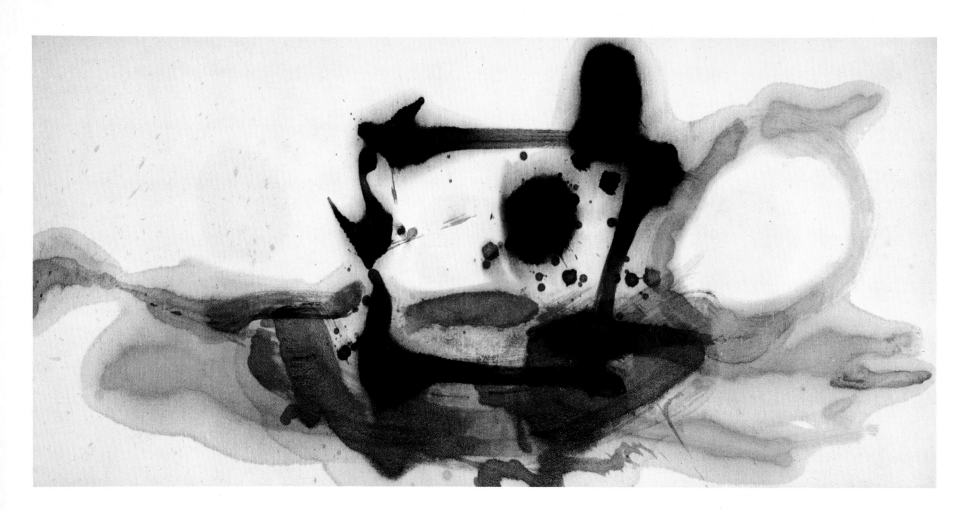

13. THREE MOONS. *1961. Oil on canvas, 19$\frac{1}{2}$×39$\frac{1}{2}$″. Collection Arthur and Molly Stern, Rochester*

14. SMALL'S PARADISE. *1964. Acrylic on canvas, 8′ 4″×7′ 9$\frac{3}{4}$″. The National Collection of Fine Arts, Smithsonian Institution, Washington, D.C.*

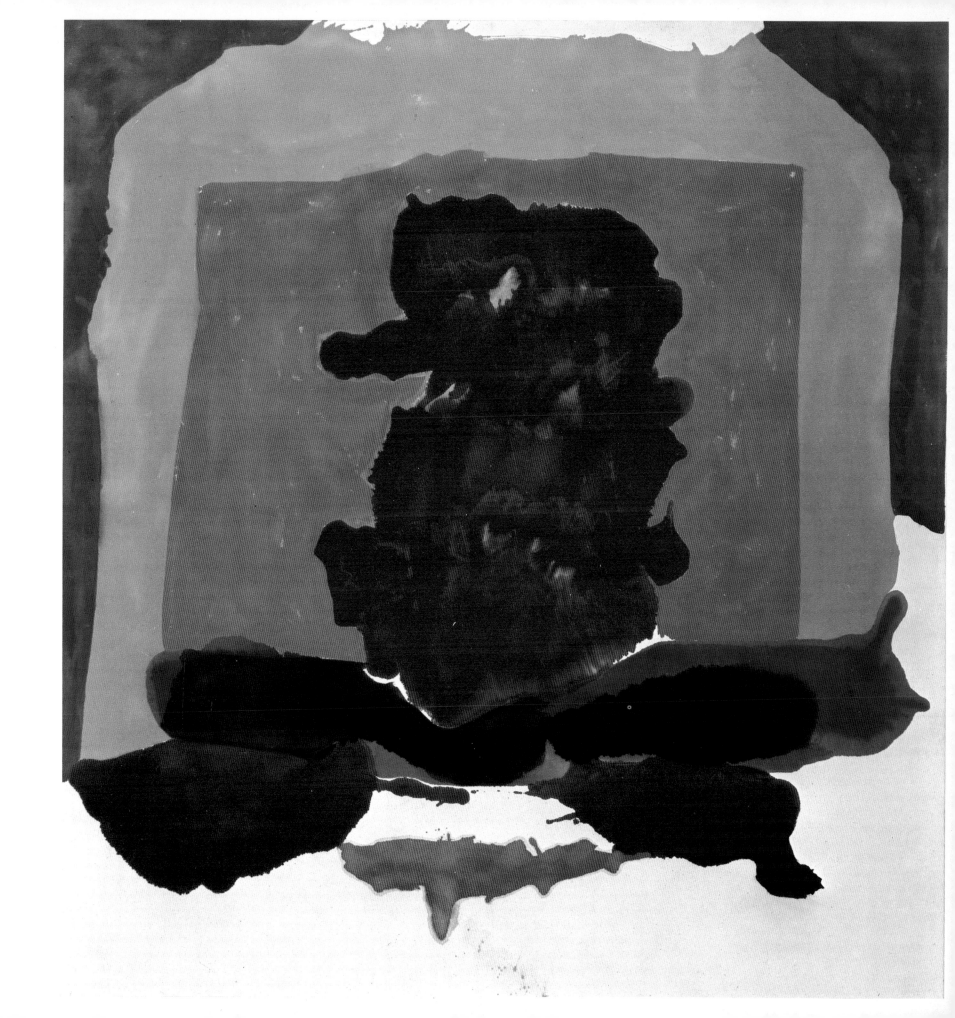

Cubism which both Pollock (with great difficulty) and Frankenthaler (more easily, as the recipient of a privileged education) had absorbed did not have the discipline to control the impulses of the unconscious. Many minor Abstract Expressionists used automatism not as a principle of form creation, but as an excuse for formlessness. Coincidentally, one of those who best understood the liberating possibilities of automatism was Frankenthaler's future husband, Robert Motherwell, who had popularized its use in New York in the early forties.

Although she assimilated a great deal of Surrealism instinctively through Pollock, of the actual Surrealists only Miró held any interest for Frankenthaler. She remarked in his work, as in Pollock's, the "associative" quality she wished to lend to her images, not at the expense of form, but as an additional element of meaning. "It's what comes through in association after your eye has experienced the surface of a great picture; it is incidental but can be enriching." She found Gorky's imagery too explicitly and overtly sexual, but Miró's more ambiguous biomorphism seemed to issue from a deeper, more generalized level of the unconscious and was more congenial to her.

In Miró's imagery, she found some of the same qualities that she responded to in Pollock; these she has described as "the role that the image plays; in a sense totally irrelevant to the aesthetics of a work of art, but in another sense adding a profound dimension, as certain webs of Pollock's became decipherable characters." Miró seems also to have influenced Frankenthaler's concept of landscape as well as her repertoire of organic shapes. His experiments emphasizing surface and the actual texture of the support in paintings on sandpaper, cardboard,

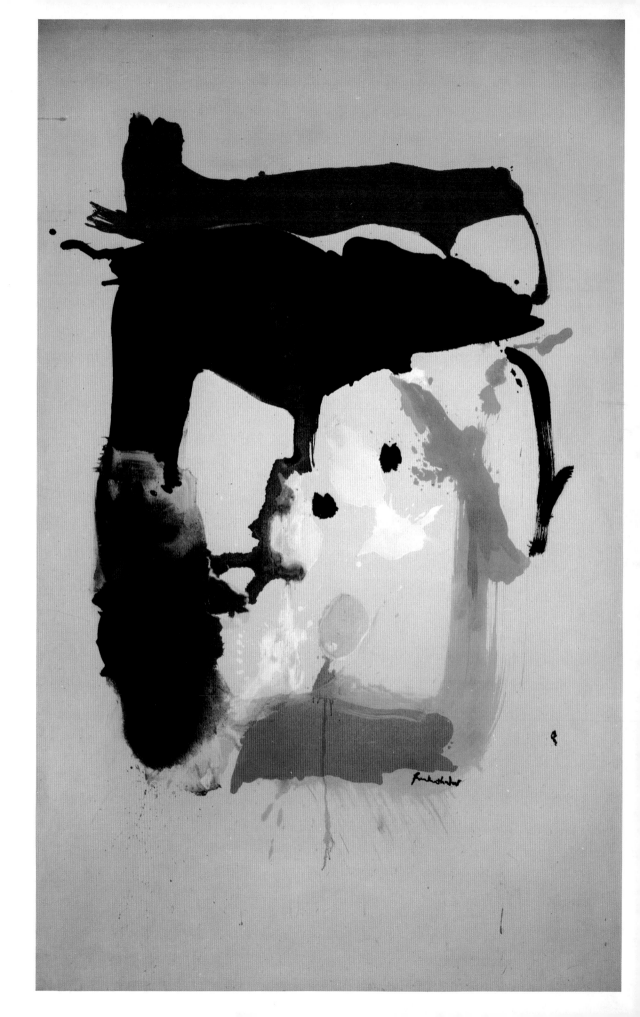

Masonite, and Celotex must also have been known to her. Known to her as well was the manner in which Miró modulated forms without creating a full sculptural illusionism.

Possibly, Frankenthaler came to have a deeper understanding of Miró through Greenberg, who had completed a study of Miró shortly before Frankenthaler met him. In any event, there are undeniable similarities between the kind of space she creates, with its explicit flatness constantly working against a complex spatial ambiguity, and the kind of fluid space created by Miró in the twenties. In Frankenthaler's work of the late fifties and the early sixties, analogies with Miró in the form of undulating patterns, multiple scale variations, and a pulsating biomorphism may also be found. In a painting like *Eden*, for example, one has the paradox of small elements appearing closer than larger elements by virtue of their placement or color. Earlier, Miró had created such paradoxical illusions in paintings like *Harlequin's Carnival*.

Similarly, the big red "hand"—of God, it has been suggested—in *Eden* may have as an antecedent Miró's Surrealistic personage *The Potato*. Frankenthaler's horizontal blotlike landscapes of the early sixties, such as *Landscape with Dunes*, have connections with such prophetic paintings by Miró as *Catalan Landscape*, with its reworkings of conventional landscape distinctions of foreground, middle ground, and background and its vestiges of perspective consistently blocked from creating a full illusionism. Frankenthaler's later works, however, in their combinations of aerial and frontal views, go beyond Miró's strict Cubist frontality in their free-roving point of view and in their call for bodily or physical, as well as purely retinal, response.

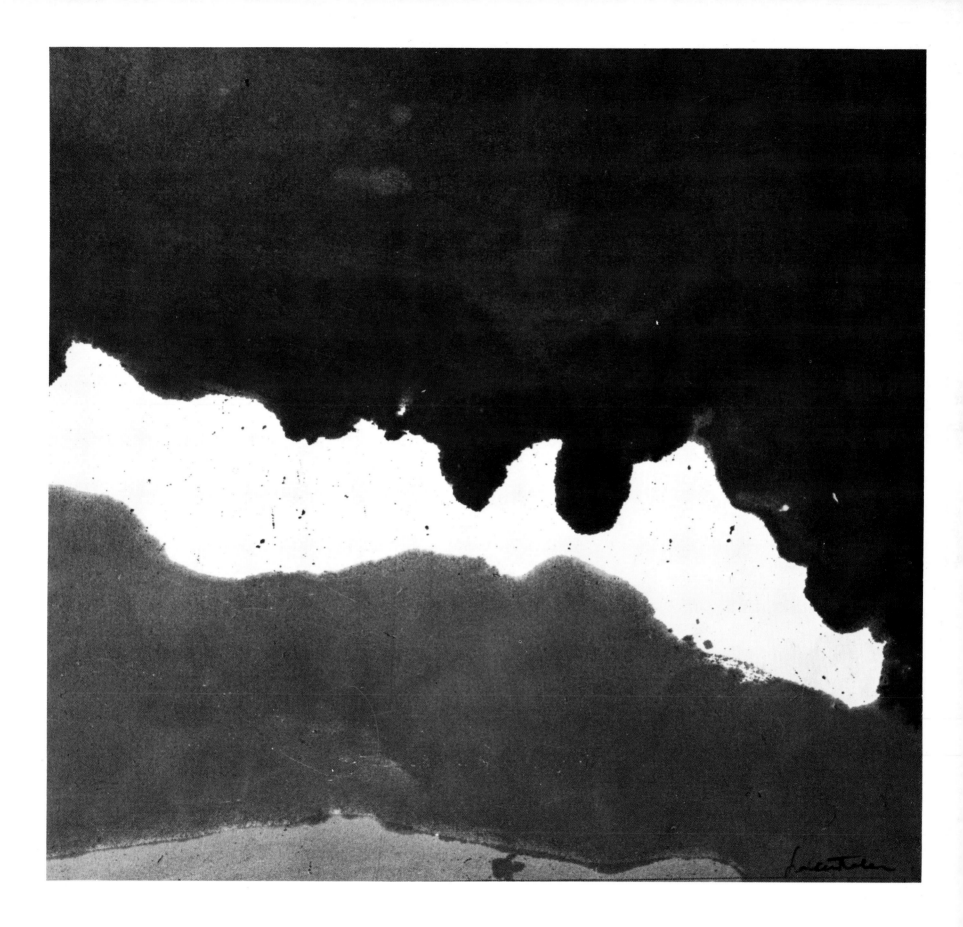

We have remarked that one of the constants of Frankenthaler's art is its inescapable landscape connotations. We may perhaps go further and relate her luminous colors, brilliant light, and sensuous facture to a specific landscape tradition—that of the *fête champêtre,* or lovers' picnic, with its erotic overtones and allusions to a paradise of youth, beauty, joy, and sensual delectation. When looking at some of Frankenthaler's landscapes, particularly those of the fifties and early sixties, with such suggestive titles as *Eden* and *Arcadia,* one may be struck by associations with the tradition of the lovers' picnic, or the innocence of the paradise lost or garden of love theme. Frankenthaler's feeling for nature and for the outdoor setting is so pervasive, apparently, that even the artificial, exotic glamour of the modern urban lovers' rendezvous, the nightclub, becomes for her an occasion of exuberant celebration. Although Small's Paradise, the Harlem nightclub that inspired one of her titles, may have only a passing relationship with the island of Cythera, there is no doubt that Frankenthaler's painting belongs to the same general category, in terms of feeling and mood, as Watteau's *fêtes galantes,* with their fragile transparent tints. Even the ephemeralness and the fugitiveness of many of Frankenthaler's images relate her to earlier painters who delighted in picturing life's pleasures while acknowledging their transitoriness.

In this context one may remark that a crucial work in Frankenthaler's early development is just such a nightclub scene or modern *fête galante. Ed Winston's Tropical Gardens,* one of a series of mural paintings on brown paper done in 1951–52, reveals the young painter equally drawn to both de Kooning and Pollock. The eighteen-foot-long work was ap-

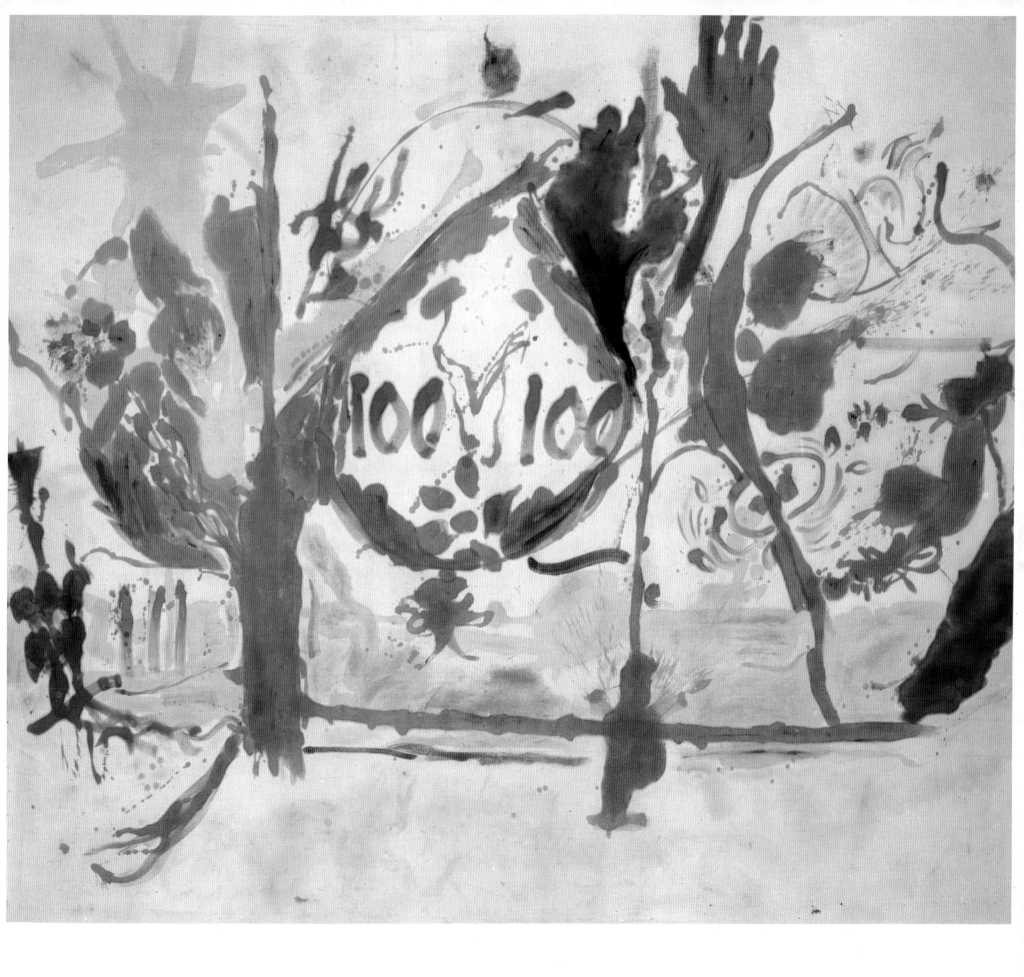

parently inspired by Pollock's continuous friezes, its rollicking cursive swirls of palm trees recalling Pollock's gestural "handwriting" in their rhythmic movement; but many allusions to de Kooning, such as the brushed passages and biomorphic shapes, are also present.

This work is enormously ambitious for a young painter. Frankenthaler's attempts to integrate subject, content, and form are not yet totally successful; nor has she yet decided between de Kooning's atomized Cubism and biomorphism and Pollock's all-overness and rejection of the brushstroke. Despite its unresolvedness, the painting charms us with its youthful gaiety and élan. Representational elements are still evident, although there is a curious transposition of an indoor scene into an outdoor setting—indicative perhaps of Frankenthaler's consistent need to translate man-made images into their equivalents in nature. She recalls that the subject of this painting was a "juke box bar on Eighth Street, filled with celluloid palm trees and five-and-ten-cent-store Hawaiian decor.... I had the memory of the place and did a sunny green and yellow landscape." Even in such a precocious work as *Ed Winston's,* the characteristics of Frankenthaler's style are already evident: the freedom of execution, the witty panache, the bold un-hesitant mark full of confidence.

Using as a point of departure a scene Pop artists would have delighted in caricaturing, she transforms its tawdry glamour into a tropical paradise. Thus we see her early in her career taking a positive stand in terms of the controversy provoked by industrialism regarding the relative importance of the urban versus the natural environment. As always, she opts for nature, recasting even the urban scene in a natural setting.

Going beyond her general affinities with the tradition of the *fête galante,* one finds Frankenthaler relating herself to the tradition of modern landscape within the lines set down by Monet and modified by Pollock. In his *Water Lilies,* Monet created for the first time an image which engulfed the viewer, because there was no horizon line within the painting allowing the viewer to orient himself. Pollock extended Monet's concept by creating a tangle of meshed webs larger than the field of vision, which appeared to envelop the spectator—for some viewers literally becoming an environment. More than a picture of nature, Pollock's paintings seemed to provide an experience of nature, which was something Frankenthaler grasped and elaborated on in her own work.

There is another important point of contact between Frankenthaler and late Impressionism. In Frankenthaler's paintings, the emphasis on the real identity of the canvas as a piece of cloth underlines the provisional nature of the illusion she creates; at the same time it exposes the fragility of her means for creating this illusion. Because of this, she communicates an essential modernity, since it is precisely the elusiveness of such fragile metaphors that modernism demands. Her insistence on the dual identity of the art object—on its qualities as a real object in the world weighed against those of an illusion created by the imagination—relates Frankenthaler quite specifically to Impressionism, for the Impressionists were the first to strike such a balance between the material qualities of pigment as a patch of color on a flat surface and the illusion of recognizable form built up out of these patches of color. Like the Impressionists' colored spots, Frankenthaler's

dreamy, floating washes are poised precariously between creating an illusion of imagined space and giving themselves away as merely pieces of dyed fabric. Thus the equilibrium struck first by the Impressionists, between literalism and illusionism, is forcefully reiterated by Frankenthaler.

One of the most significant steps Frankenthaler took in creating a style compatible with both modernism and certain traditional values of landscape painting occurred during a trip to Nova Scotia and Cape Breton in the summer of 1952. During this trip, she executed on a portable easel oil sketches from nature as well as a number of watercolors. Memories of the dramatic contrasts between the great wooded peaks and the transparent water below inspired her on her return to New York. "I came back and did *Mountains and Sea* and I know the landscapes were in my arms as I did it," she recalled later in an interview. Painted in October of that year in a new studio she was sharing with Friedel Dzubas, *Mountains and Sea* was one of the first paintings Frankenthaler executed on the floor, directly staining diluted pigment into raw duck. Cotton duck—untreated canvas used for sailcloth bought at Boyle's, a commercial sailcloth maker—was preferred by many painters because of its cheapness and its availability in widths greater than the imported linen traditionally used by artists.

The rough texture of the duck called attention to the canvas weave and to its identity as a piece of cloth, whereas the fluidity of Frankenthaler's medium, which she was then thinning down to a watery consistency—often causing turpentine halos to appear around forms— permitted the image to soak into the unprimed canvas. The result was

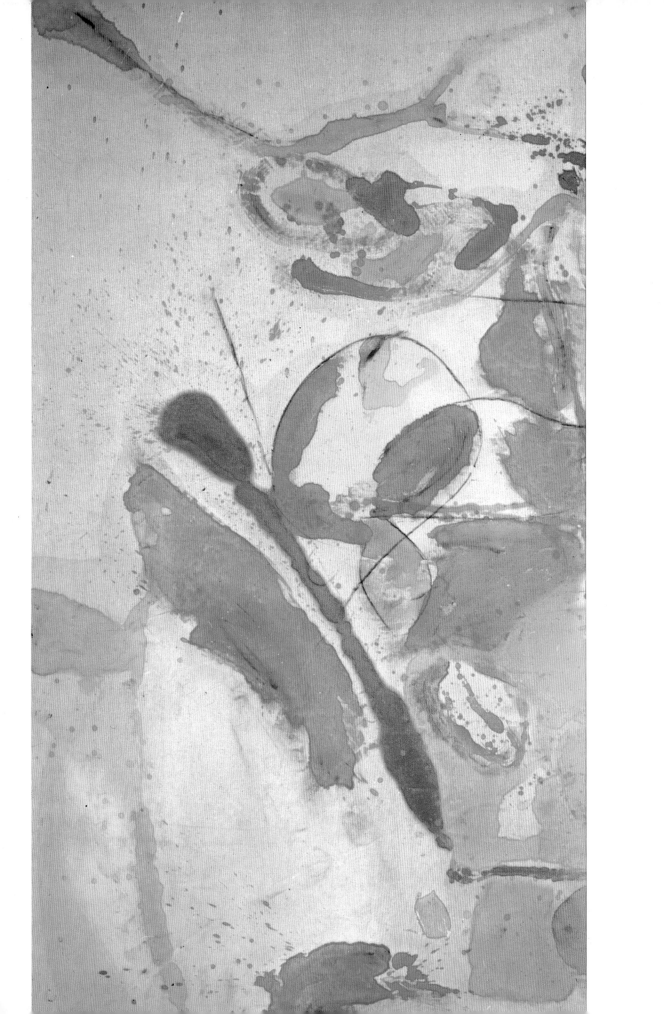

56

a binding of paint to canvas unprecedented in earlier art with its layered ground between pigment and support. Frankenthaler's staining, developed for the first time in *Mountains and Sea*, can in many respects be seen as the inevitable conclusion of many centuries of the development of *alla prima* painting. This development began over four hundred years ago, when Hieronymus Bosch first dispensed with laborious preliminary drawing and worked directly on the canvas. In the sense that he did not work with a graphic underpinning, Bosch was the first artist to draw in paint. The Venetians seized upon this way of working and in the sixteenth century created a richly sensuous "painterly" style, in which the weave of the canvas was frequently visible beneath a layer of paint. The evolution of the painterly style—from Titian and Tintoretto to the great painterly masters of the Baroque, Rubens, Rembrandt, Hals, and Velázquez, through Watteau, Tiepolo, and Goya to Manet and the Impressionists—must be seen as part of a long tradition, to which Frankenthaler surely belongs. In the twentieth century, the painterly received fresh formulation in Fauvism and the various freely executed expressionist styles stressing the loaded brush and culminating in Abstract Expressionism. Indeed, a more accurate description of New York School painting than Abstract Expressionism, a term generally disliked by its practitioners, is the "painterly abstraction" invented by Clement Greenberg to illustrate the relationship of the New York School to a historical tradition.

We have seen how much Frankenthaler's conception of painterliness owed to Pollock. Yet *Mountains and Sea*, in many respects her first fully realized work, is astonishingly original despite its large and obvious

debt to Pollock. This is so not only in terms of structure and image, but also in terms of facture, surface, and color. The major innovation in *Mountains and Sea* consists in Frankenthaler's managing to change the facture and surface of painterly painting by *dissociating for the first time the painterly from the loaded brush.*

In his black-and-white paintings of 1951, in which Duco enamel was sunk into raw canvas, Pollock had predicated the possible separation of the painterly from the loaded brush. But his medium was thicker and shinier than the extremely thinned-down medium Frankenthaler used in her first essays in staining. Her surface consequently was more uniform, more matte and less reflective. Significantly, too, she reintroduced color, the traditional focus for any painterly style, which was notably absent from Pollock's black-and-white paintings.

Probably one of Frankenthaler's objections to Pollock's dripping was —although she was not necessarily conscious of it—that dripping was still tied to the tradition of the loaded brush. To an extent even in Pollock's calligraphic 1951 paintings, which are the basis for the technique used in *Mountains and Sea,* one is aware of paint thickness. Frankenthaler's rejection of Pollock's dripping involved her personal interpretation of the painterly tradition—which was somewhat at odds with Pollock's. Her restlessness and need to change, if only to see how something else would feel or look, came from her own immediate experience and formation. For example, she mentions that she had always been attracted to Cézanne's late works, especially to his watercolors, "the ones that were not all filled in," to Matisse's luminous, flat planes of color, and to Kandinsky's and Gorky's transparent wash-

es. We have seen how she rejected Pollock's dripping and looked more directly to Cézanne, Matisse, Kandinsky, and Gorky. Ultimately, her image of a relaxed marine vision of transparent planes avoiding overlapping was defined in direct contrast to Pollock's muscular, densely interwoven and superimposed skeins and arching loops. In some respects, in fact, her aqueous image had more in common with early Rothko than with Pollock.

It was a considerable insight on Frankenthaler's part to understand that Pollock's radicality lay not in his image but in his technique. Earlier, John Graham had prophesied that a change in form could only be achieved through a change in technique. Both Pollock and Frankenthaler understood this. The importance of *Mountains and Sea* is that Frankenthaler added light and color to Pollock's technical breakthrough. In a sense, it means little to credit her with the invention of a revolutionary new technique already largely posited in Pollock's 1951 Duco enamel works. The quality of *Mountains and Sea* does not depend mainly on innovation, since in certain respects it is less advanced than Pollock's merger of the linear and the painterly. Despite its debt to Pollock, *Mountains and Sea* continues to exhibit a discontinuity amounting to an opposition between the two still reminiscent of Gorky. In most practical respects, then, Pollock's black-and-white paintings remain the first "stain" paintings. At any rate, they were the first pictures to enlist the viewer's awareness of the actual physical character of the surface to identify flatness.

Comparing *Mountains and Sea* with other works of the early fifties one is immediately struck by how its physical appearance differs from

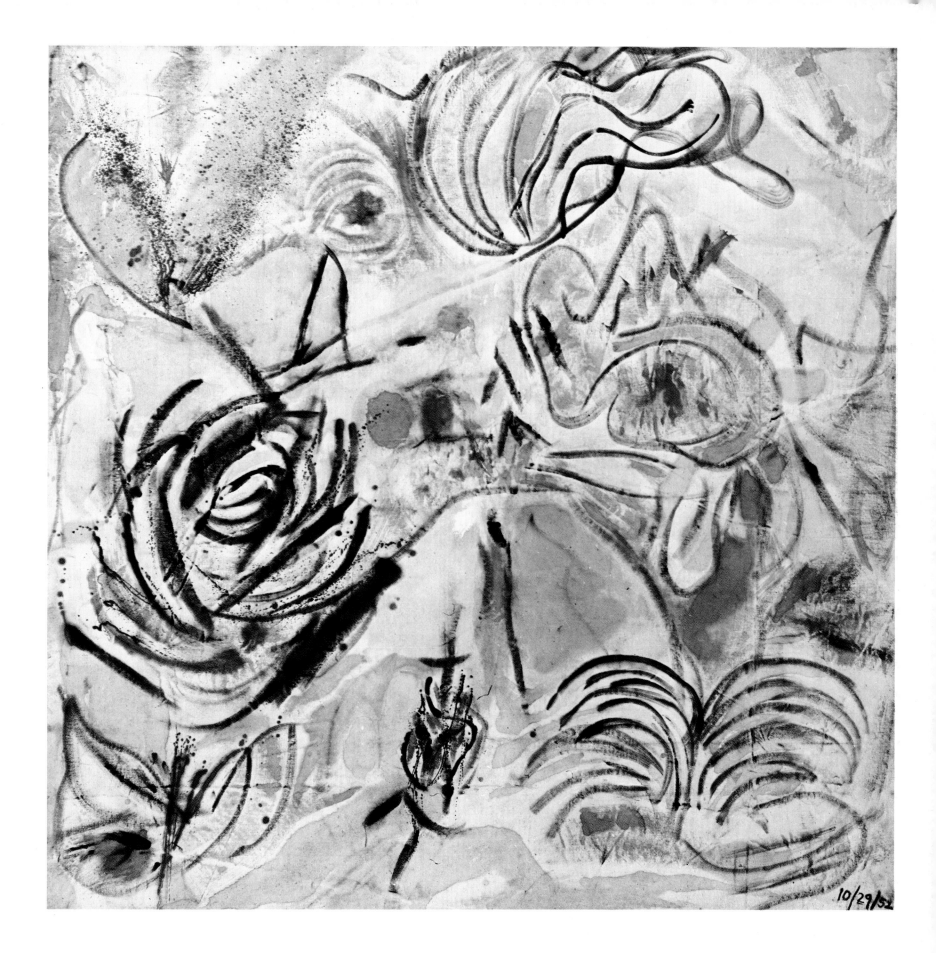

10/29/52

that of other paintings made at the time. Because pigment is thinned down to watercolor consistency, the whiteness of the canvas ground is fully utilized for its light-reflecting potential; the canvas ground, in other words, acts as the page beneath the transparency of watercolor wash to reflect light from behind.

If one reconstructs the basis for her decision to thin down her medium and soak or stain it into raw-canvas, one understands a lot about how Frankenthaler developed. The technique of soaking and staining used for the first time in *Mountains and Sea* is the exact opposite of the thick impasto she had just been using. It represents in a sense the translation of the watercolor technique into oil painting. Indeed, Frankenthaler had been painting watercolors in Nova Scotia; the first formulation of the atmospheric image in *Mountains and Sea* derived at least somewhat from a watercolor experience. In terms of a watercolor orientation, one can also see certain links between Frankenthaler and the earlier Anglo-American landscape tradition. Although she discounts the influence of this tradition on her work, the parallels between her image and technique and that of the watercolors of Dove, Marin, and O'Keeffe are too striking to ignore entirely.

Frankenthaler did not deliberately set out to revive an interest in color, a notably minor element in most American art of the forties and fifties. It is, however, no accident that she began to be interested in color at precisely the moment that the leading New York painters—Pollock, de Kooning, Kline, Motherwell—were painting in black and white. Her delight in opposition led her to think about color in such a context. And once again, characteristically, the color range she

sought to explore was not the conventional color of the spectrum that Hofmann or for that matter any of the Americans who derived from Fauvism were using, but an entirely unexpected and bizarre palette of beiges, mauves, and greens that hovered between the delicate and the faded, as well as novel juxtapositions of rusty browns and reds, dirty ochers, and grayed and muted pinks and blues.

When she first began to think about color—mainly in opposition, it would appear, to the prevailing taste—she considered it primarily a way of tinting drawing, of helping drawing to create a more complex and ambiguous space. She used colors to begin with "not because I was in love with the idea of putting color down, but because they made the drawing in my pictures move." Despite the new emphasis on color, drawing was, and continued to be for some time, the basis of Frankenthaler's style. In this she was close to the "action" painters; but she differed from them in her more complete understanding of Pollock's radicality, which had more to it than merely the dislocation of painterly gesture from the wrist to the shoulder and body. She recalls that when she first started to think about color, it was more or less out of perversity. "It occurred to me that something ugly or muddy could be a color as well as something clear and bright and a namable, beautiful known color."

Few, if any, of Frankenthaler's colors are pure hues. Her tendency is always to personalize color, to create an unexpected mixture, often from studio leftovers. She describes her way of working: "I will buy a quantity of paint but I hate it when it dries up and I haven't used it. If I have a pot of leftover green and a pot of leftover pink I will very often mix

it just because I want to use it up. If it doesn't work—well, that's a loss." As a result of this empirical trial-and-error method, Frankenthaler destroys many paintings each year: "For every one that I show there are many, many in shreds in garbage cans."

Because she used an extremely diluted medium, Frankenthaler was free to vary values, to introduce a kind of modulation within a given area which did not, however, evoke an illusion of sculptural modeling as in traditional painting. Her use of value contrasts did not create a sculptured illusion of the third dimension because staining limited illusionism and because such contrasts were not consistent, but arbitrarily applied to create an all-over rhythmic spotting (as in Pollock's drip paintings). Since line in her paintings was independent of any shape-creating function, these value contrasts could only imply a partial illusion of depth. And even that partial illusion was contradicted by the nakedness of the rough-textured canvas which proclaimed the character, location, and flatness of its surface more strongly than any illusion depicted on it evoked real space. In other words, the eye warned in advance cannot be fooled.

Of her working method, Frankenthaler has said: "I don't start with a color order, but find the color as I go." Without a priori attitudes toward either color or form, she began in the late fifties to draw directly in color: in works like *Nude*, a line bleeds and spreads into irregular blots. In the fifties, blank canvas was always enlisted to give relief to color, to isolate areas so that color would be intensified by contrast with its surroundings. In the palest, most transparent paintings, like *Seven Types of Ambiguity*, the bleached canvas color shines through

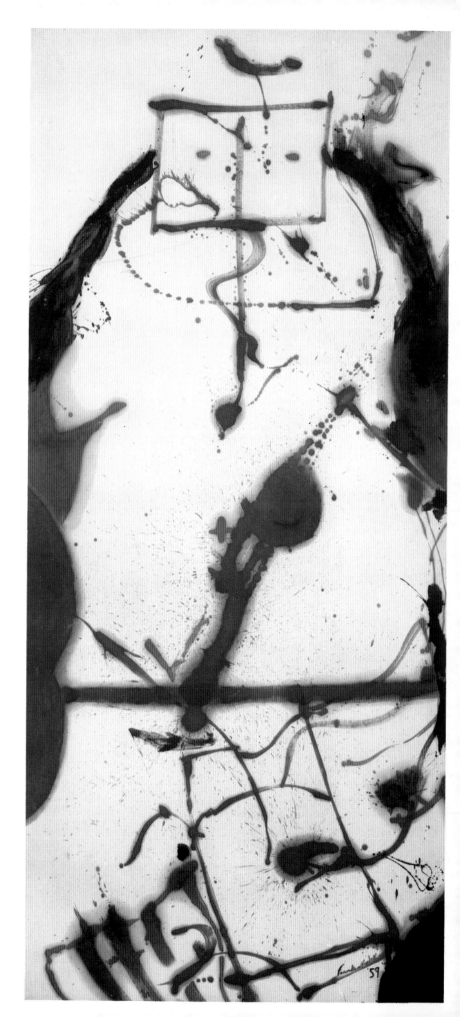

behind transparent washes, appearing to pour forth light from a distance, as the sun in a Lorrain or a Turner shines directly out at the viewer from within the painting.

Like color, form in Frankenthaler's art is associative and allusive. Mainly these allusions, like those of the colors, are to nature—the various formations that earth, sea, sky, and clouds can have, depending on the landscape and the weather. The kind of movement Frankenthaler creates—billowing, flooding, churning, or flowing—is also weather-related and can refer to varying states of wind and water.

Form in Frankenthaler's painting is created organically; it is the configuration color assumes when more or less controlled. A color is chosen, and somehow it is put down, either with the hand, the sponge, the mop, the rag, the brush, or any combination of these tools; or it is simply poured and blotted. The artist controls her image through a highly developed sense of hand and body coordination and a knowledge of her medium, both of its possibilities and its limitations. Frankenthaler has spoken of the "difference between image and gesture." Precisely the main differences between Frankenthaler and the "action painters" is her need to create not just the record of a gesture, but a distinct and decipherable image. She differs from them also in creating a soft, vulnerable, unified surface in comparison with the brushy, encrusted surfaces of action painting.

Even when one first encounters Frankenthaler as a young painter, there is no doubt that the bursting, seeping, expanding, and unfolding image she creates is distinctly her own. In Frankenthaler's case, then, quality depends not on innovation alone, but in large measure on the

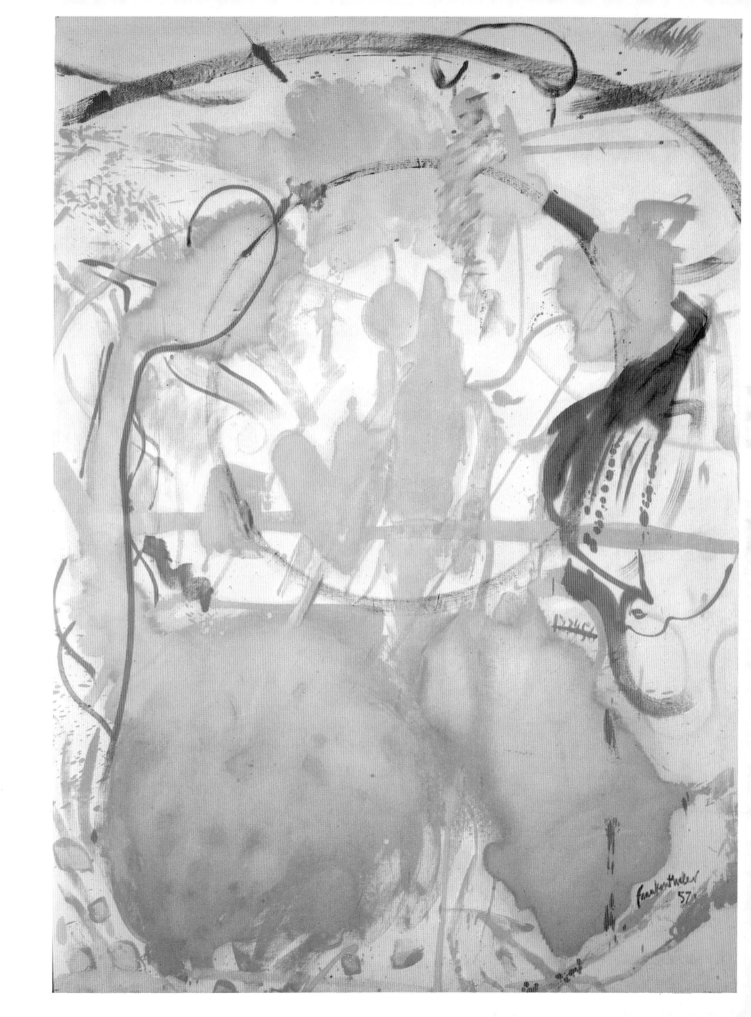

uniqueness of a sensibility and her success in communicating that uniqueness. *Mountains and Sea* is a great work not because of its historic interest as the painting that introduced Louis and Noland to staining, but because of its openness, scale, freshness of color, and originality of image.

Apparently, the important message Frankenthaler had for Louis and Noland was her ability to create a unified surface that communicated a Gestalt image immediately and directly: a "one-shot" image, as Noland has called it. Such immediate images were created by soaking and staining paint directly into the canvas fabric. Combined with her method of working on the floor from all sides—as opposed to in one direction against the wall or easel—staining had many immediate formal repercussions. The effacement of hand movements postulated by Pollock led to the creation of an automatic, mechanical, and impersonal technique, eventually carried to its logical limits by Louis, Noland, and Olitski. This automatic "brushless" technique removed a degree of contrivance which had prevented traditional painting from achieving a desired immediacy and unity of impact—an immediacy and unity not obtainable through the motion of the brush recording the manipulation of the hand and wrist.

By marrying the freedom of automatism with the impulse toward color expression, Frankenthaler was able to eliminate much of the airlessness and artificiality of color painting derived from Fauvist sources. She was able to redeem loose painterliness without compromising the principles of modernism. This achievement was by no means minimal; it was the ambition of the "action painters," but it was Frankenthaler's to attain.

For the painters who adopted it as a creative process, automatism allowed the incorporation of many chance elements that lent a look of spontaneity unknown to the geometric styles. In Frankenthaler's work accidents are permitted, but they are controlled by the painter's intelligence. In an interview, Frankenthaler stated: "I think most of my accidents are predetermined accidents; in other words, I might want a blob of blue that is two feet square. When I throw a blue on the canvas it might turn out to be an S-shape that is not two feet square, and I have something else, and I proceed from that, or I feel, no I can't work with that. And I stop. Or I leave it and then come back to it in a few weeks or months."

The degree to which Frankenthaler's patterns approximate to or deviate from each other and from familiar patterns or configurations introduces a kind of allusive ambiguity she obviously cultivates. Often there is a good deal of wit in these associations. She describes the creation of formal analogies as follows: "You might look, for example, at a roomful of chairs, or a tabletop of apples, or a hillside of trees, and without ever graphically referring to those chairs, apples, or trees, you might do a play on the color, shape, and positioning of these objects. You might put a green A-shape here, and below it a green A-shape there, which while they are very much the same are also totally different, just as each tree in a stand of trees is different from each other tree and different in its relation to the whole image."

Staining allowed Frankenthaler to maximize spatial ambiguity, so that the same shape might appear distant or near, depending on its placement. But its most important advantage was the resolution—or

at least the staving off—of the double-edged crisis which ultimately comprised the works of so many lesser artists unable to achieve a similar resolution.

The nature of this crisis was so deep and pervasive that Pollock himself was unable to create an entirely satisfactory new synthesis once he abandoned the drip technique. This dual crisis involved (1) the rejection of the tactile, sculptural space of painting from the Renaissance until Cubism in favor of the creation of a purely optical space that did not so much as hint at the illusion of a third dimension and (2) the avoidance, if not ideally the banishment, of figure-ground or positive shape against negative background silhouetted arrangements. The drip technique allowed Pollock to reconcile flatness with a purely optical illusionism by freeing line from its traditional role as shape-creating contour. In later works, Pollock further questioned the nature of figure-ground relationships by actually cutting holes out of his webs. In the paintings on glass, he attempted to render the background neutral by literally suspending the image against a transparent ground.

This is something that the stain technique, as Frankenthaler developed it, was able to do. Essentially, the great advantage of staining lay in its ability to render the background neutral by sinking the image directly into it. We have seen how Frankenthaler's early appreciation of Pollock's art gave her an enormous edge in overcoming the dual obstacles—sculptural illusionism and figure-ground opposition—impeding the development of post-Cubist style—based not on delimited shallowness and figure-ground exchanges but on opticality and openness. Obviously, the seeds of such a style existed in Impressionism and

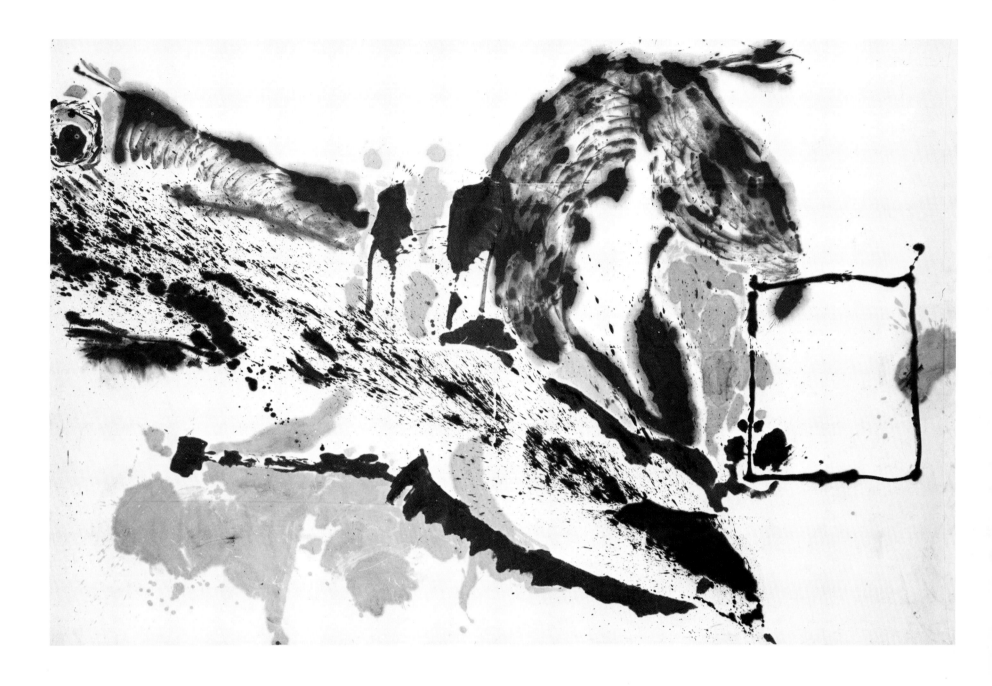

the various post-Impressionist movements indebted to Impressionism, especially in Matisse's art, to which Frankenthaler has drawn closer in her later works. The invention of staining permitted Frankenthaler to overcome the obstacles just mentioned because it identified figure with ground, thus eliminating any duality between them. At the same time it allowed her eventually to identify drawing with form creation by marrying the two in a manner that caused the painterly to encroach upon and ultimately to subsume the graphic entirely. This was a difficult and complex process, and it did not happen all at once.

For this reason, Frankenthaler's work of the fifties looked both backward, in the direction of Cubism and action painting, and forward, in the direction of the fully liberated color expression of the sixties, which would be free of Cubist composition and representational elements. As early as 1953, in the remarkable and prophetic *Open Wall*, she had grasped the means of eliminating any vestiges of academic painting remaining in her style. *Open Wall* is significantly different from *Mountains and Sea*, although painted only a year later. To the extent that the image in *Mountains and Sea* is denser in the center and fades out toward the edges, its composition recalls the structure of Analytic Cubism. In *Open Wall*, on the other hand, all four corners are painted out; the frame is imposed after the fact upon open forms that break the frame. The image is cut by the frame rather than contained by it as in Analytic Cubist painting. *Open Wall* also has a more concentrated and self-consciously formal character than *Mountains and Sea*. It is arranged in loosely painted but severely constructed bannerlike rectangles. (Because of this overt structure, *Open Wall* seems far more a painting of

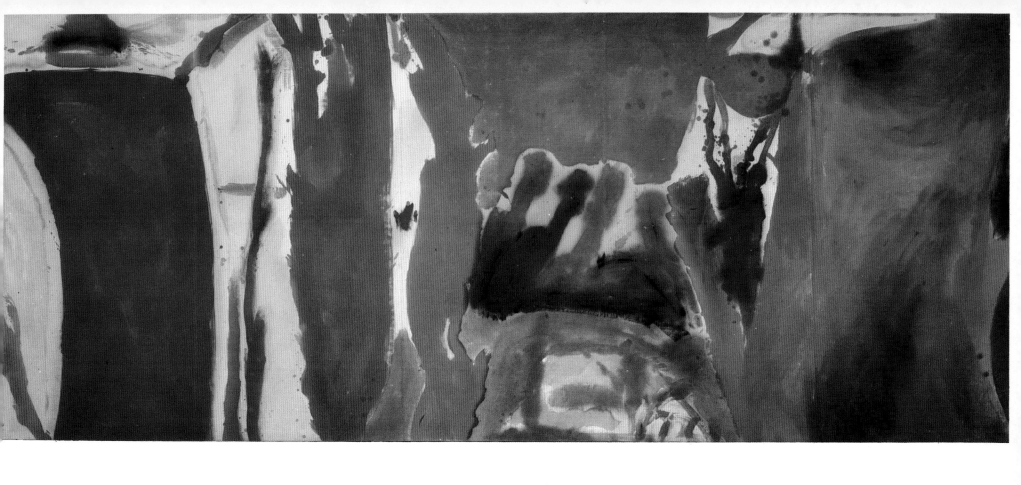

the sixties than of the early fifties.) Fluid color is manipulated in several ways: in the large rectangle at the right, paint is allowed to puddle and deepen in value from ocher to brown; in a corresponding framing element on the left, blue is modulated through several darker shades. The use of such framing elements relates *Open Wall* to traditional landscape painting, in which repoussoir elements in the foreground frame openings or clearings in the distance. The stain technique, however, deliberately inhibits any reading of Frankenthaler's framing elements as literally in relief or in any way disengaged from the surface. Nevertheless, it is undeniable that the overall structure of *Open Wall* bears a close relationship to traditional landscape composition.

The title *Open Wall* reveals Frankenthaler's intention. Through staining, she has achieved a way of both opening up and holding the surface —a distinct advantage over the strictly delimited shallowness of Cubist space in terms of creating a spacious visual field. In many respects, *Open Wall* resolves problems posed in *Mountains and Sea*. It represents, for example, an advance over Frankenthaler's early attempts at integrating line with form. There is no further discontinuity between the two in *Open Wall;* the bursting, streaming motifs elaborated from line that bleeds and spreads serve no graphic function. Drawing, in other words, no longer depicts shapes or models forms. Line may link pools of color or evoke a reminiscence of perspective that is never realized consistently or completely enough to convince. Or else it runs, gathers, and flows, thickening into pools or tapering off into spontaneous bursts which evanesce into invisibility. Indeed, Frankenthaler

cultivates this evanescent quality. She allows form to fade out by varying not only value but also intensity of saturation within a color area, emphasizing the tension between infinite and finite space.

The cultivation of every conceivable ambiguity is at the heart of Frankenthaler's style. The title of one of her paintings, *Seven Types of Ambiguity*, may be said to announce her aesthetic philosophy. Frankenthaler's title refers to William Empson's book on the categories of multivalent meaning open to poetry. In referring to Empson's book, Frankenthaler acknowledges her desire to maximize the kinds of ambiguity open to painting; toward this end, she uses as many kinds of illusion and allusion as possible. Form and color are themselves, create different kinds of pictorial space, and allude to nature, objects, feelings, and the human body. Thus Frankenthaler's is an extraordinarily complex statement, resonant with meaning on many levels.

The kind of space, image, and structure Frankenthaler creates largely depends on the way she works. Since 1952, as we have remarked, she has worked almost exclusively on the floor. This means that she is looking down at an image when she paints it. When this image is placed on the wall, vestiges of the aerial view that the artist has in creating it necessarily remain. Often the illusion is of an oblique tilting away of a flattened mass that may resemble an island on its side (as, for example, in *Cape* or *Tone Shapes*). The result is far more ambiguous than the tilted perspective of a Cézanne, which creates a more easily grasped and understood space because of its closed forms, legible contours, and figure-ground opposition. Frankenthaler's loose, open forms, irregular, amorphous contours, and images stained directly into the ground evoke

25. FLOOD. *1967. Acrylic on canvas, 10' 4" × 11' 8". Whitney Museum of American Art, New York City. Gift of the Friends of the Whitney Museum and Charles Simon*

by and immersed in water. Similarly, in a recent painting like the great swirling tide of *Flood*, one does not look *at* the sky in its changing aspects; one has the sensation of being *in* the sky, of being exposed bodily to the warmth of sunlight and the churning motion of a gathering storm.

Frankenthaler uses a number of devices for narrowing the distance between visual and bodily experience. One's awareness of how much her own body has participated in making the work is crucial. This depends on more than simply the slashing stroke of expressionist painting being enlarged by the action painter facing his enlarged easel picture. It depends on a kind of dazzling display of physical agility determining the degree to which the whole painting is alive and in balance, which is like juggling, tightrope walking, acrobatics. The soft, absorbent surface seems to yield to vision, to allow one to enter in, not as one perceived the space of traditional illusionistic painting, as if one *could* enter at will but, with a more direct bodily—as opposed to mental—experience, as if one *were* surrounded or immersed. That the landscape allusion is ubiquitous is also important; if this is a landscape and we cannot locate the point from which we are looking at it, we must be *in* it, as the artist was when she made it.

Another aspect of Frankenthaler's work that bears remarking on in this respect is her tendency to compose after the fact by cropping her paintings. Cropping serves multiple purposes. It allows her greater freedom to improvise—a form that doesn't "work" can just be cut off; but, most important, it neutralizes the edge. By neutralizing the framing edge, cropping aids the sensation of bodily involvement. Conversely, her centered frontal motifs have less ability to involve the body in an

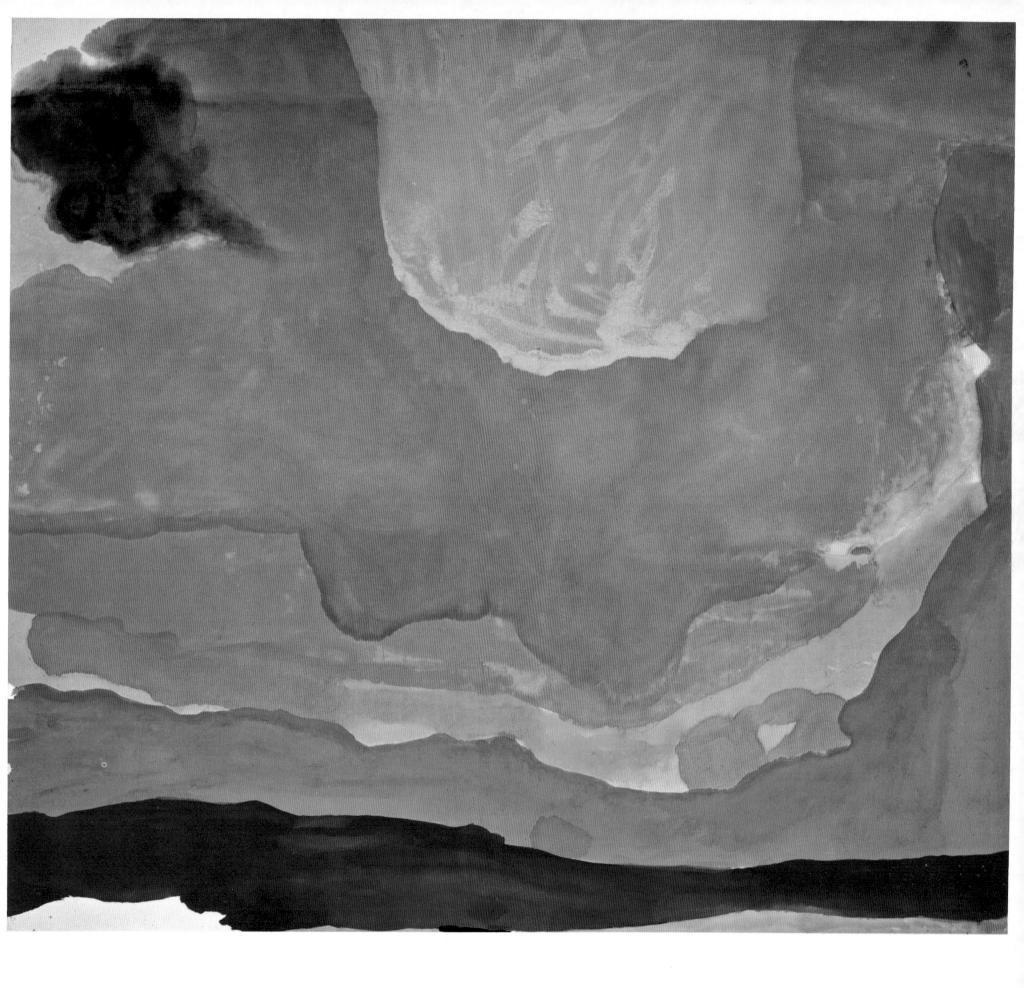

empathic reaction than cropped paintings like *Sea Goddess, Rainbow Arch,* or *Flood,* in which the framing edge is virtually denied. When the framing edge is not stressed or echoed within the composition, we are less able to look *at* the image as a depiction of a landscape. Rather, we seem called upon to feel actually a part of that landscape. In other words, when the framing edge is not reinforced by reiteration within the painting, it loses importance as a boundary dividing the painting space from the spectator's space. This is the opposite of what happens in paintings that implicitly or explicitly accept the scaffolding of the Cubist grid, with its stressed horizontals and verticals echoing and reinforcing the framing edge, which functions as a boundary between space within the painting and space without. The structure of Cubist and Cubist-derived paintings irrevocably differentiates pictorial space from the viewer's space by calling attention to the boundary between them. By cropping after the fact without regard to an a priori frame, Frankenthaler minimizes the importance of such a boundary, permitting easier "bodily" access to the space within the frame. Without the justification of logic insured by orienting the image to an a priori element such as the framing edge, however, these works must be accepted as complete or satisfactory strictly on the basis of right scale and placement of the image within the created space.

Because of cropping, in the majority of Frankenthaler's mature paintings the visual field is not contained; the image flows well beyond its confines like the expansive images of Baroque paintings whichs well beyond their boundaries. Nor does the frame assert itself sufficiently in her work to be felt as edge or any kind of external drawing element.

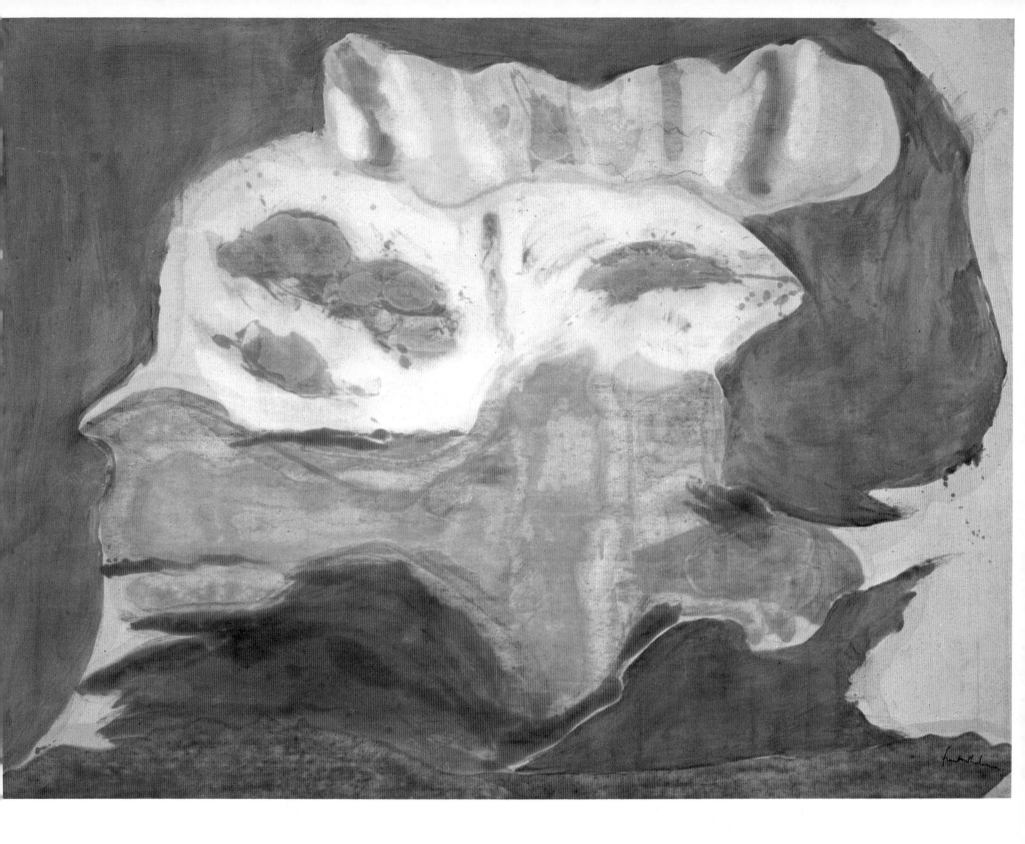

We get some sense of the physical as opposed to merely retinal involvement created by Frankenthaler from E. C. Goossen's description of her at work: "With the canvas thrown upon the floor, walked around and even into when necessary, the arms, legs and bodily efforts over at least sixty or seventy square feet of terrain preclude any mere projection of an a priori concept." This sense of physical involvement is something the spectator senses without having to see the artist at work. Sensed as well are the agility and sureness of muscular reflex and bodily coordination of the artist. Of the overt physicality of Pollock's paintings, Frankenthaler has said: "Jackson's 'spread' appealed to me enormously . . . the dancelike use of arms and legs in painting, being in the center, relating to the floor." In a sense the physicality of Pollock's paintings may be seen as a compensation for an absent figurative element. After Pollock, the figure can no longer be depicted; it is rather the spectator's own body that empathically assumes the role of the absent figure in the landscape. Frankenthaler first appears to understand this in a painting like *Nude*. In this inspired work, figure and landscape are telescoped to create an image of great originality and power. Here the identification of the human body *as* nature is not metaphorical but explicit. One of the few explicit allusions to the human figure in *Nude* was created by the reserved areas of white canvas which displace the figure into a landscape context, or perhaps more accurately a marine context, since the crisscrossing canals, streams, and lakes of paint as well as the blueness of the color suggest water rather than land. Such a telescoping of figure and landscape had been accomplished earlier by Gorky, de Kooning, and Pollock, undoubtedly under the influence

of Surrealism, which sought to create form so generalized that familiar categorical boundaries would no longer obtain. *Nude* itself is a kind of astonishing tour de force, the dramatic impact of the empty center prophecying in certain respects Louis's Unfurleds, in which paint spreads away from an open center. Ambiguity is maximized in every conceivable way. Given a purely landscape reading, the image appears to be tilting away from the viewer like a vast system of waterways seen from above. Seen as a nude nearly ten feet tall, the figure is obviously frontal, and snaps back to stretch up and tower over the viewer. The effect is related to the ambiguity of certain Gestalt experiments in which a given shape can be interpreted as either figure or ground.

Because Frankenthaler's expression is not merely conceptual, but requires a total mental, physical, and emotional involvement, she often has fertile spurts of activity alternated with less-successful periods. She works like a prospector; instinct, not logic, guides her. Probing until she hits a vein she can profitably exploit, she mines that particular territory until all of its potential yield is extracted. The changes in her work are organic; she does not move for the sake of moving, but because she has exhausted a certain direction. Within her own oeuvre, she constantly shuttles back and forth, painting small, painting large, switching formats, color ranges, formal motifs, often reworking themes from the past. Thus the central image of paintings of the early sixties may recall formats she explored in the early fifties, like *Shatter;* or the monumental bannerlike forms of the late sixties may bring to mind *Open Wall*. These motifs and formats, however, are revived in an altogether new context which changes their meaning considerably.

Frankenthaler does not view art in terms of formal problems and their solutions, but, as she puts it, as different ways of knowing herself. She does not seek to dominate or control a world or an image, but to present a world sensed, apprehended, and imaginatively re-created through visual metaphor.

The rhythm of her activity often means that the best paintings emerge in groups done within a relatively short time. In this regard 1953 was a particularly fruitful period. In that year, she produced not only *Open Wall* and several smaller, related works, but also *Shatter*, a masterpiece of spontaneity, grace, and elegance. To see how far she had come in freeing herself of Cubist elements in two brief years, it is instructive to compare *Shatter* with *Abstract Landscape* of 1951, to which it is related in terms of format and structure. Such a comparison makes it clear what she preserves and what she rejects in Cubism. She rejects, to begin with, the fragmentary character of Cubist drawing and composition. The linear arabesques of *Abstract Landscape*, still reminiscent of Gorky's fine line, have disappeared in *Shatter*. The visual rhyming of the leafy "palmetto" motif in *Abstract Landscape* (a continuation, perhaps, of the palm-tree motif of *Ed Winston's Tropical Gardens*) is relinquished in *Shatter* for an all-over spotting and dappling.

In *Abstract Landscape*, space is created through a series of planes parallel to the picture plane receding one behind another in the manner of orthodox Cubist composition. Individual shapes are sharply silhouetted like the shapes in Synthetic Cubist works, and composition is carefully integrated through the repetition of analogous forms (in this case the round "coconut" shapes, the vertical tree trunks, and the

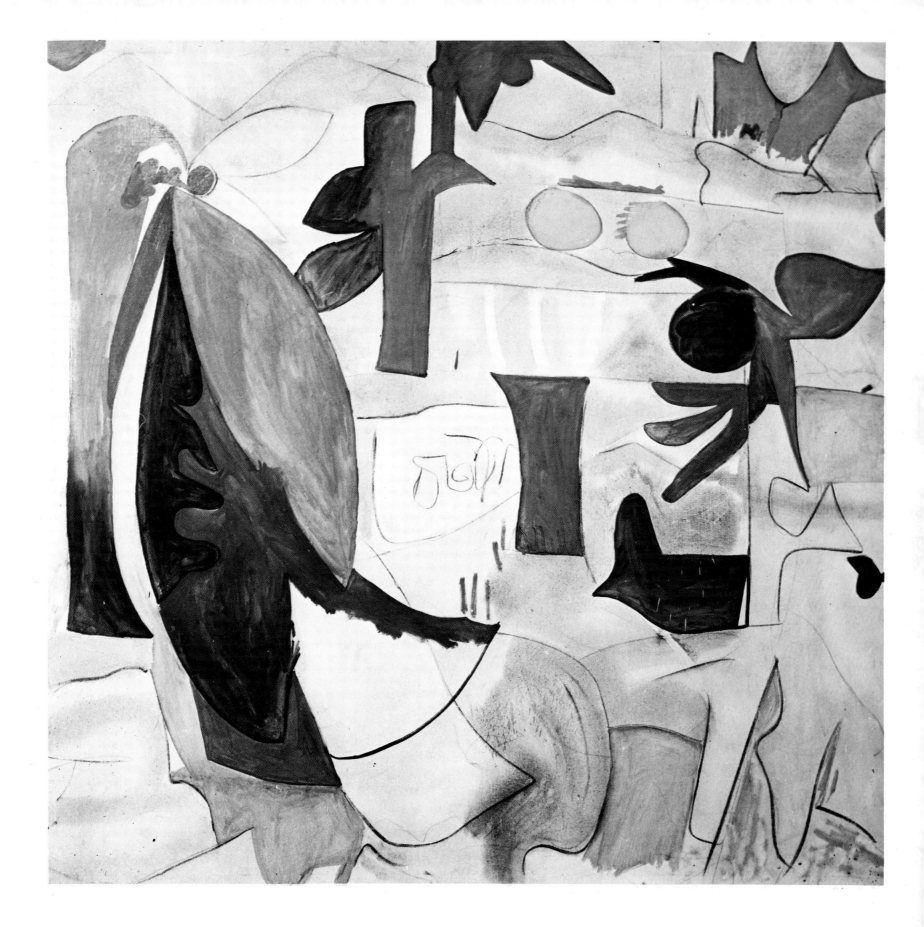

palm leaves). The eye "reads" the painting by perceiving such analogies and understanding the nature of these internal relationships. In this type of reading, details take precedence over the whole; in fact, the whole is understood only as a sum of its parts and of the relationships between those parts.

By the time she is painting works like *Shatter,* Frankenthaler has at least revised and in many cases rejected these Cubist attitudes toward space and form. She no longer creates a series of receding planes, but places her emphasis on unity of surface—achieved, as we have seen, largely through the use of the stain technique. Line as a graphic element has been banished, and shape no longer stands out as a positive figure against a negative background but is sunk into the surface, where it floats away from view into an amorphous atmospheric continuum. The hard edges and clear silhouetting of shape in *Abstract Landscape* give way to a lambent bleeding stain haloed by turpentine. This halo, an accidental factor caused by the nature of her medium, creates a transition between form and raw canvas. Thus the halo has a specific function: it softens contour and prevents figure-ground discontinuities.

As opposed to the laborious visual "rhyming" of *Abstract Landscape,* Frankenthaler substitutes a kind of light-hearted visual punning, by means of which relationships between roughly circular or elliptical or rectangular blots obtain. These relationships, however, are far looser and less calculated than the deliberate repetitions of Cubism. The most striking difference between *Abstract Landscape* and *Shatter* is the wholeness and unity of the latter, as opposed to the relative fragmentation of the former. Certainly Pollock's all-over method of balancing

out spatial and compositional tensions with regard to the whole of the image as a single Gestalt played a large part in Frankenthaler's new way of working, as did the example of Pollock's working from all four sides at once. Another distinction between the two works under discussion is that *Abstract Landscape* is rigidly oriented from top to bottom and yields only one reading, whereas *Shatter* has been created by working in from all four sides. This fact also gives to *Shatter* an utterly novel sense of centripetal movement—of an image whirling away from an imaginary center—opposed to the inert static quality of Cubism.

An image constructed this way had great significance not only for Frankenthaler, who took the notion directly from Pollock, but for other artists, like Noland. Frankenthaler has commented on the kind of unity she attempts to achieve in a painting like *Shatter:*

> A really good picture looks as if it's happened at once. It's an immediate image. For my own work, when a picture looks labored and overworked, and you can read in it—well, she did this and then she did that, and then she did that—there is something in it that has not got to do with beautiful art to me. And I usually throw those out, though I think very often it takes ten of those over-labored efforts to produce one really beautiful wrist motion that is synchronized with your head and heart, and you have it, and therefore it looks as if it were born in a minute.

During the middle fifties, Frankenthaler made several trips to Europe that undoubtedly reinforced her ties to traditional painting. Typical

of the more opaque gestural works of this period is *Venus and the Mirror* of 1956, painted shortly after she returned from a trip during which she discovered the greatness of Rubens. From him she learned to value still more highly the freshness of the sketch as opposed to the labored finished oeuvre, the "work" of art. The overall conception of this painting, with its diagonal "figure" of the missing nude, is apparently indebted to the great Rubens portrait of his wife, Helena Fourment, as Venus, which Frankenthaler had seen in Munich. The more resolved and complex painting of the following year, *Nude,* a harmony of blues shading off toward green on one end of the color scale and toward red on the other, also recalls the heroic proportions of Rubens nudes.

Nude was one of a series of paintings executed in 1957, including also *Eden, Seven Types of Ambiguity, Jacob's Ladder,* and *Round Trip,* which are among Frankenthaler's finest works. They were done during a particularly difficult period in her own life, a period during which she lived and worked alone. Paradoxically, they are pictures of an intense originality and an apparently joyous abandon. This creative period seems to have been inaugurated by the painting *Toward a New Climate,* in which Frankenthaler took off in a fresh direction involving a much freer gesture, larger scale, and a total mastery of the technique she had developed and which allowed her a greater fluency of gesture and speed of execution. *Toward a New Climate* is a very reduced picture. Its imagery is spare; most of the painting is blank canvas—it is virtually monochrome, and is executed in a pale and diluted medium. In its transparency and reductiveness, it is entirely opposed to the dense

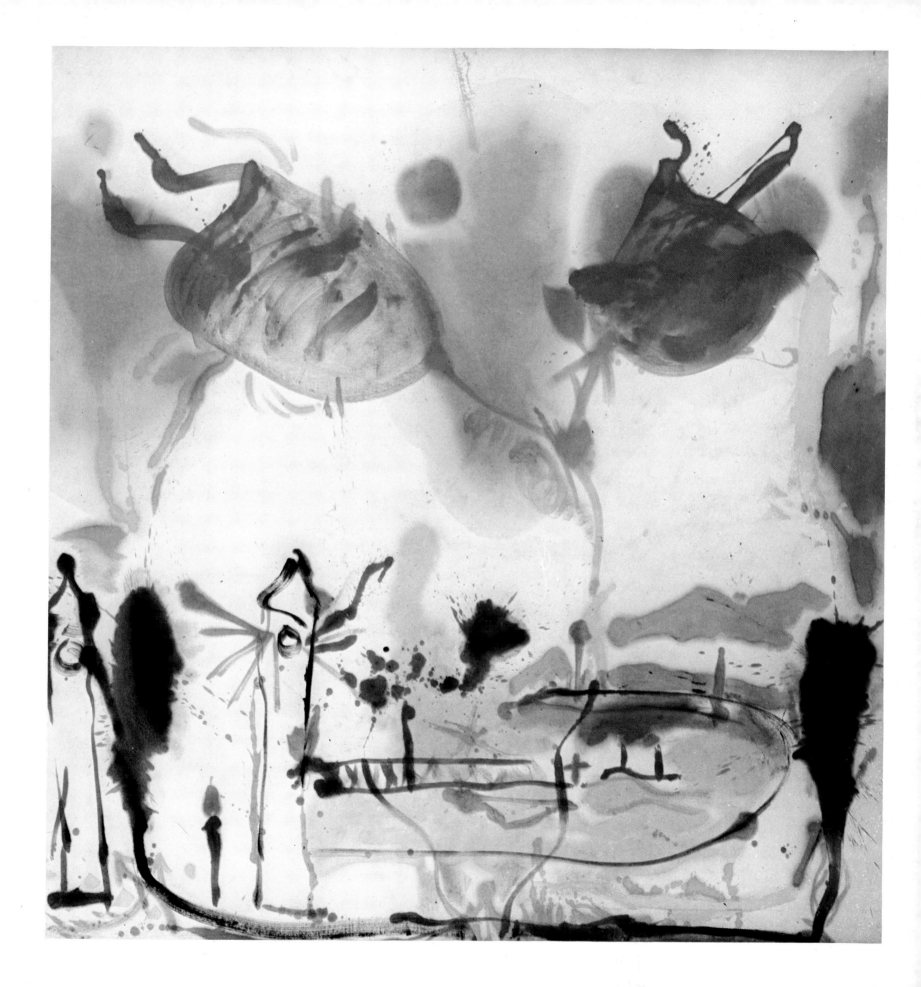

expressionist landscapes Frankenthaler herself had been painting in 1955 and 1956, as well as to the historical context in which it was made. A certain playfulness is introduced in the bursting sun motif, and space is created as economically as possible through the deft placement of a few diagonal marks. Despite its playfulness, however, Frankenthaler's friend the poet Frank O'Hara wrote that it was conceived in a moment of despair.

One must look beyond the immediate context for the source of the extraordinary series of works Frankenthaler produced in 1957. The kind of reductiveness through economy of means employed in these paintings, as well as certain of the playful motifs—like the bursting suns—can be found in Miró's paintings of the late twenties, in which a maximum sense of space and form is created through the use of the most minimal means. Frankenthaler's paintings of 1957 are remarkable not only for their technical mastery, but also for their clarity of organization. The "punning" spoken of earlier is used to great advantage to organize a surface in terms of design. Although Frankenthaler never uses so rigid a system as absolute symmetry, the paintings of 1957 are more symmetrical than most she has done. *Eden,* for example, is bisected by a rounded red form alluding perhaps to the legendary apple or to a metaphorical target with 100 (bull's-eye) inscribed on each side. Several critics have commented on the wit of the allusions in *Eden*—the presence of the snake as well as the big red hand of God at the top right, which balances the pronged form of the yellow sun at the upper left. Allusions to geometry are frequent in 1957. *Seven Types of Ambiguity* is organized around a series of circular motifs;

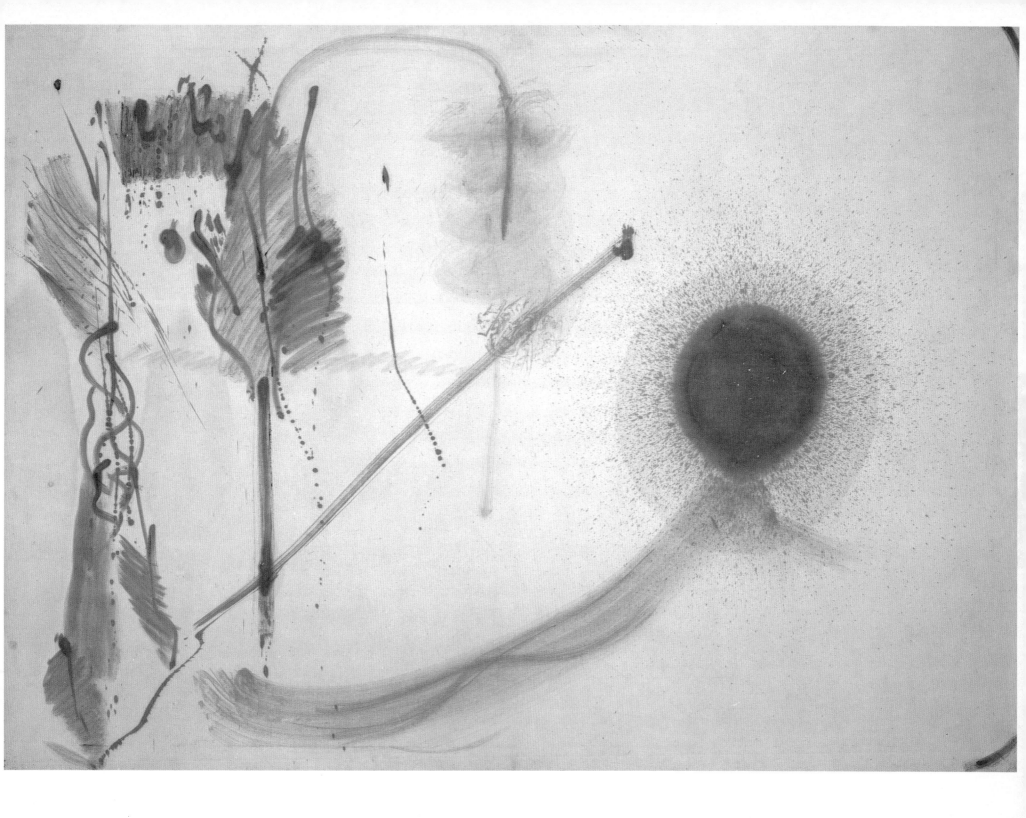

30. BEFORE THE CAVES. *1958. Oil on canvas, 8' 6" × 8' 8 7/8". University Art Museum, University of California, Berkeley. Anonymous gift*

Jacob's Ladder, on the other hand, is a checkerboard of patched rectangles.

Both the lucidity of form and clarity of organization of these paintings is lost in the more agitated and overtly gestural works of 1958, of which the large oil *Before the Caves*, with its looping paths and ambiguous cavities, is typical. The summer before this painting was executed, Frankenthaler had traveled to Altamira to see the cave paintings, to which the title of this painting apparently refers. In the upper right are the numerals 173—the address of the house of the painter Robert Motherwell, whom she married in April, 1958.

During the next two years, Frankenthaler rethought her premises and changed her technique somewhat. Because in her work form is married to technique in the most intimate way possible, changing technique allowed the expression of a new form. In 1960, in order to harden her edges and to create denser and more compact, and hence more brilliant areas, she began priming her canvases. She began deliberately then to center the image and leave the corners bare as well. But this centered image, which first appears in a fully realized form in 1961, is tighter, more deliberate, and more oriented with regard to the framing edge than even a central image like *Shatter*.

The period from 1961 to 1964 is one of intense creativity and realization for Frankenthaler. At first, there are the series of paintings with Rorschach-like blots, such as the forceful, emblematic *Swan Lake* and *Vessel*, and the brilliant horizontal *Sea Scape with Dunes* and *Arcadia*. Then, beginning in 1963, she changes directions, pins her image securely to the corners, and begins immersing form within form in paintings

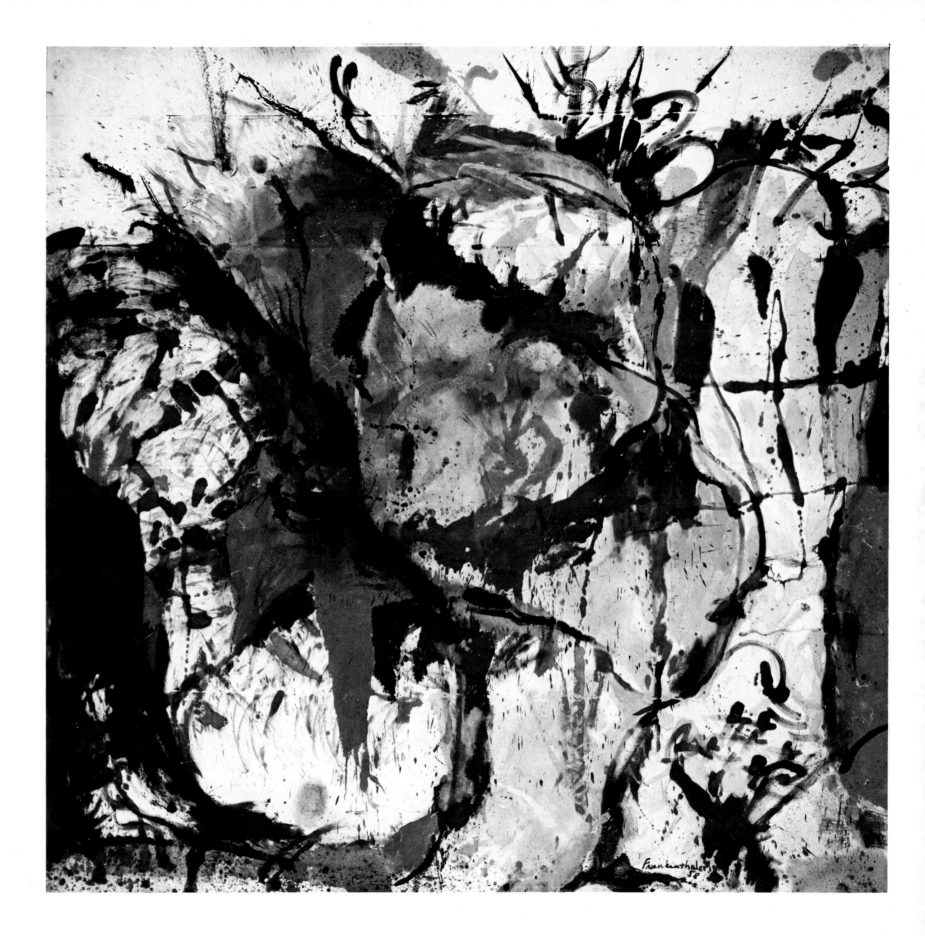

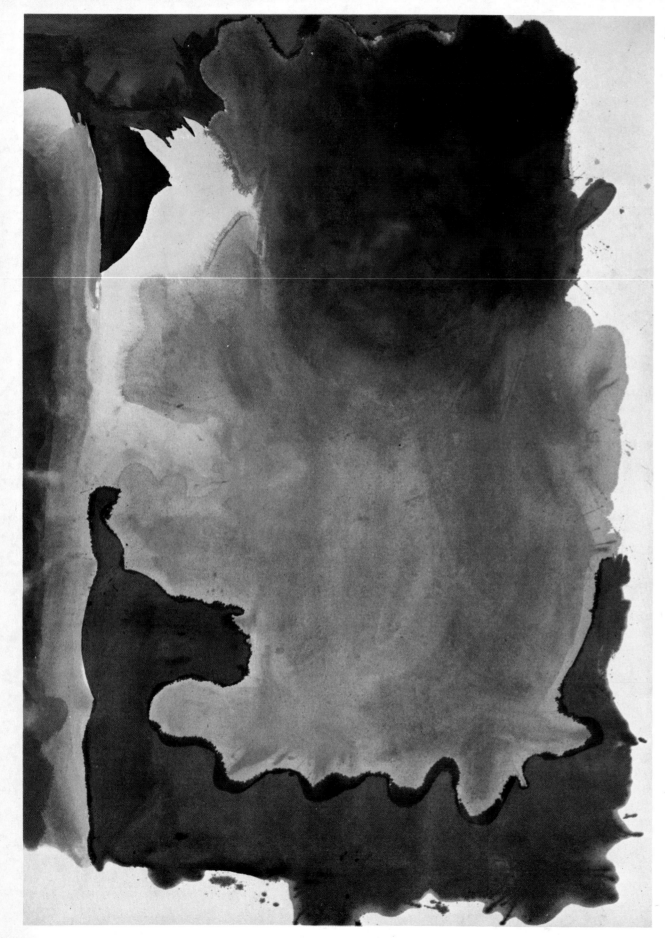

32. CANAL. *1963. Acrylic on canvas, 81 × 57½″*
Collection Mr. and Mrs. Clement Greenberg,
New York City

33. ISLAND WEATHER II. *1963*
Acrylic on canvas, 93⅛ × 58″
Collection Mr. and Mrs. Howard Sloan,
New York City

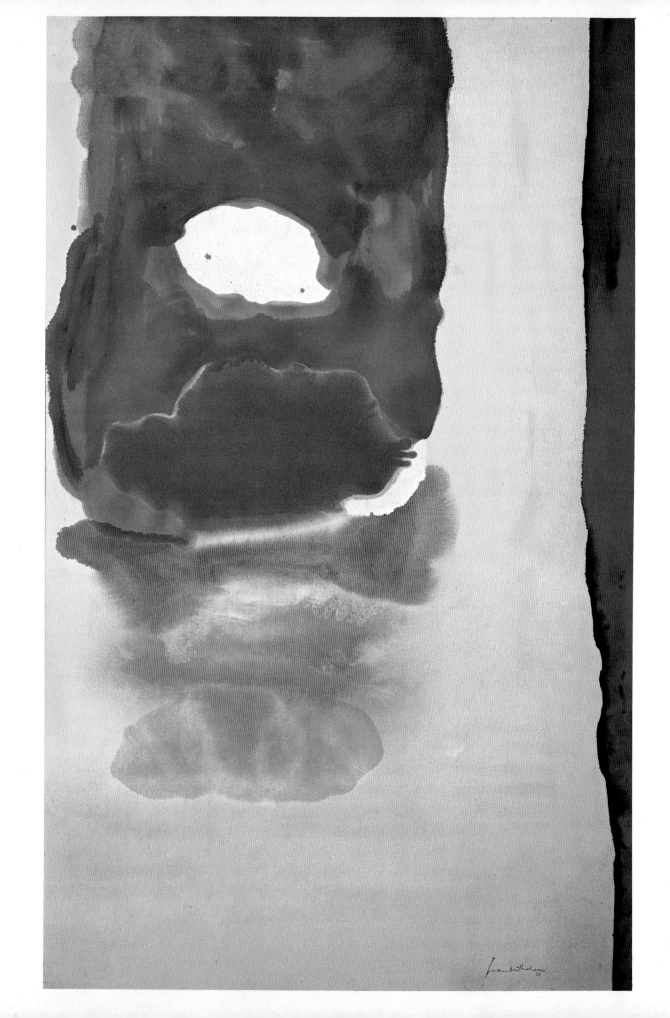

34. BUDDHA'S COURT. *1964. Acrylic on canvas, 96¾×93". Collection Mrs. Donald Straus, New York City*

To counteract the tendency of acrylics to produce a sharp edge, she began to immerse form within form, so that a Cubist succession of receding planes would not be created. Although edge against raw canvas may be sharply silhouetted, this silhouetting will be contradicted where color meets color, and transitions are accomplished through flooding and immersion, as, for example, in *The Bay,* one of the earliest paintings done in acrylics.

With the use of acrylics came a new palette of darker, more closely valued and resonant colors on the one hand and brilliant, light-saturated, hot colors on the other. The more violent aspects of gesture and the clearly calligraphic "handwriting" of the fifties is expunged in favor of a more compact image and broader, denser color areas. Once again, she turns to a more symmetrical image, this time to a series of enclosed rectangles echoing the framing edge. The paintings of 1964 with a square format, including *Buddha's Court, Small's Paradise,* and *Interior Landscape,* demonstrate an awareness of the serial paintings of Noland and Stella, although Frankenthaler's spontaneity and looseness remain at odds with the formal attitudes of serial painting.

Generally, one recognizes in Frankenthaler's development in the sixties a tendency toward more abstract form, the elimination of random blots and splatters, and other such vestiges of expressionism. Until the mid-sixties she was in the habit of going back to drawing landscapes or portraits. In a 1965 interview, however, she makes it clear how totally her ties to representational painting have been cut: "Lately I tend to sit in the crisis rather than go back to drawing." Her last landscape from nature, apparently, was a scene of Provincetown

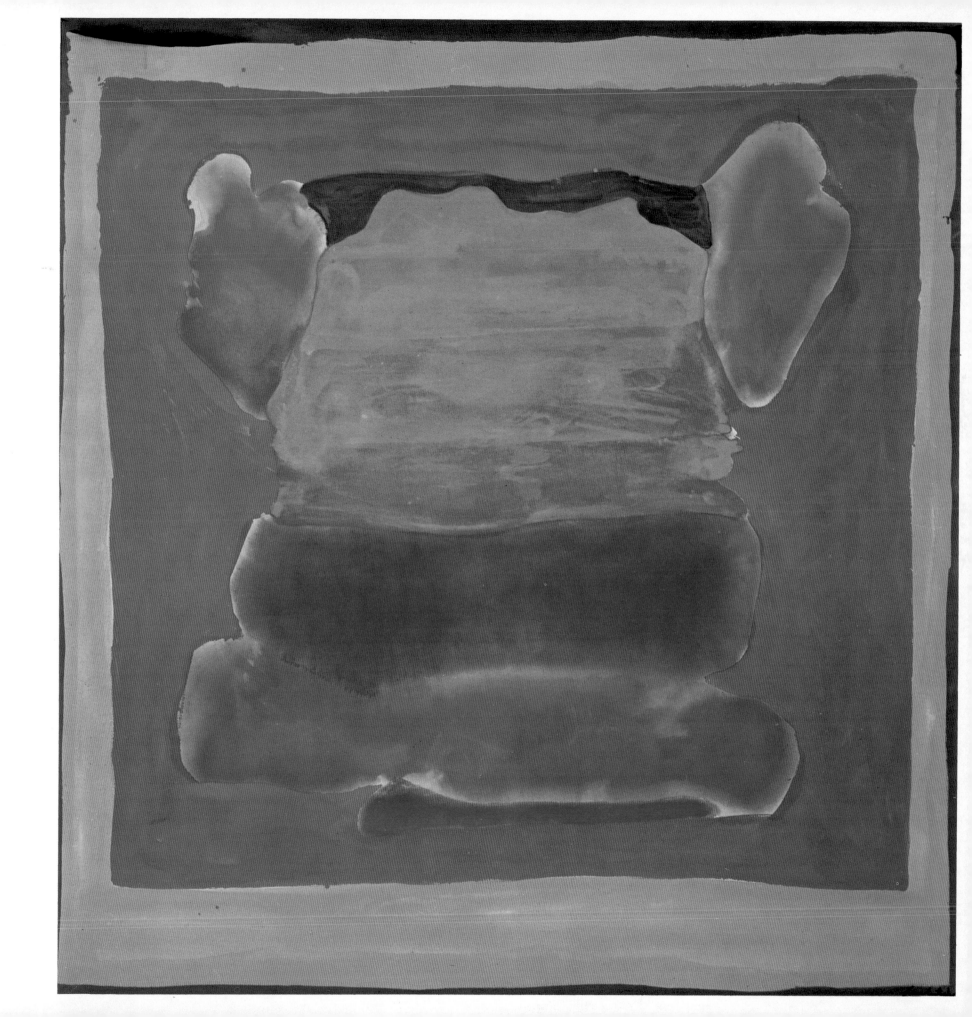

Bay done in 1964. In this interview (with Henry Geldzahler), she characterized the change in her attitude toward the external world: "I used to try to work from a given, made shape. But I'm less involved now with shape as such. I'm much more apt to be surprised that pink and green within these shapes are doing something." Because of her de-emphasis on shaping at this point, paintings of the mid-sixties tend to have more drifting, languid images suggestive of floating lateral movements and organic expansion rather than specific shapes.

Paintings done in 1966 continue to evoke analogies with the chromatic rather than the gestural aspect of Abstract Expressionism. Her more hieratic and emblematic images of the early sixties seem part of the general tendency away from the athletics of action painting. Once again, certain analogies with Rothko's rectangles come to mind, although Frankenthaler's color sense seems entirely in opposition to Rothko. The canvas is now seen more as a field to be divided. Bare canvas is often utilized as a reserved shape where channels between areas are left open. There are larger expanses of a single color, calling to mind Newman's dictum that "more blue is bluer than less blue." Frankenthaler's work of the late sixties follows her pattern of dialectical opposition: paintings like *Blue Head-On,* in which superimposed colors wash over the entire surface are followed by spare arrangements of more or less flat planes of color arranged around a bare center. Generally, one may characterize the works of the late sixties as being subject to a relentless paring down to the essential elements of painting. The coltish whimsy of the early works is gone, and in its place is a grave monumentality. Movement is slower; forms are larger and simpler.

Fewer decisions are made, but greater deliberation goes into each decision. Awkwardness is not avoided; harsh and somber tones like the green-gray range of *Tone Shapes* alternate with the lavish, orchestrated color of *Flood*. The general simplification that takes place in the late sixties lends an ascetic quality to many of Frankenthaler's recent works.

Frankenthaler's newest paintings fall into two categories. The first is directly related to Matisse, in terms of a decorative deployment of a few clear-cut shapes, such as *Tone Shapes* and *The Human Edge* (an ironic comment on Frankenthaler's relationship to "hard-edge" painting fashionable in the sixties). The other direction relates back to earlier works like *Open Wall*, in which tonal modulation and variation in saturation and intensity play a large role. Such works include *Adriatic, Cape,* and *Flood*. In the last, Frankenthaler began to reintroduce a complex illusionism offering a seemingly limitless expansion. Because this illusionism is coupled with a thinning down of her medium and a looser technique, its opticality is insured. The sumptuous color of *Flood* is based on a fresh palette Frankenthaler has recently developed: a high-key, brilliant range of hot oranges and ochers, pinks, and magentas is contrasted with an equally intense range of greens and purples that are only nominally cool. The generosity as well as the potency of the image in *Flood* and related works like *Coalition* insure their place among the finest paintings produced anywhere in the late sixties. These paintings are all that the art of the sixties has not been: free, spontaneous, romantic—full of light, air, and uninhibited *joie de vivre*. We are back again with Veronese's feasts and Tiepolo's skies.

But the direction of *Flood* is only one aspect of Frankenthaler's latest work. A painting like *Tone Shapes,* with its solemn, grave monumentality, is representative of the other direction Frankenthaler's recent paintings have taken. Although there is relatively little variation within a form in *Tone Shapes,* the large, simple shapes do not participate in the planar flatness that causes Matisse's late works to be so purely and exclusively decorative. This is so because in *Tone Shapes,* painted in the summer of 1968, forms are oriented directionally, suggesting elusive and complex spatial relationships. The placement of forms evokes the conventional landscape divisions of foreground, middleground, and background, even as these divisions are denied by the absence of horizon or ground lines. The original low-key palette of *Tone Shapes,* contrasting dark gray, purplish gray, and black, establishes its priority among Frankenthaler's paintings of 1966–67.

In a painting like *Cloud Slant,* done in 1968, Frankenthaler shows herself the master of the minimal format that had formerly caused her difficulty. By tilting the internal frame off to the right, she no longer makes the mistake of tying it down statically to the actual margin, but allows this open frame to float buoyantly, as if bounced off the edge. Perhaps her success with a minimal format demands such asymmetry; at any rate, *Cloud Slant* is a more spacious and lively painting than earlier attempts at a reduction of elements. As in a number of other paintings of the late sixties, white is used in *Cloud Slant* as a color. In other recent works, black assumes a color role—another Matissean device Frankenthaler shares with Noland and Stella.

It has been the fashion to characterize Frankenthaler as a "lyric"

painter. This is misleading: landscape painting, in which she obviously participates, is not necessarily identical with lyricism, nor for that matter is color painting per se. Many of Frankenthaler's late works especially seem to move away from any melodic, rhapsodic quality toward a gravity and solemnity, an almost ascetic restraint and directness. Sometimes this means that Frankenthaler will strain against her own innate grace to produce an awkward form that may be less familiar; or she will seek out the grating color chord, rejecting the sweet, the charming, or the ingratiating.

Since the fifties, Frankenthaler's work has consistently evolved away from the playful and engaging forms of her youthful works—even deliberately away from technical brilliance for its own sake—toward clear, simple forms whose irregular boundaries avoid any geometric analogue. Color, extended from the muted pastels of *Mountains and Sea* to the rusty palette of the late fifties, by the mid-sixties consists of a full range of intense hues usually separated by areas of raw canvas in order to accentuate their brilliance. Recently, however, dark tones have begun to predominate, and often little or no raw canvas is permitted to show. It is as if color, having been light and air for Frankenthaler, is translated now into gravity. Indeed, one of the most striking qualities about much of her new work is the translation of color values into weight. The balance in *Tone Shapes*, for example, is not achieved through harmony, but through one's sense that the small black area, the large gray mass, and the purplish boulderlike shape at the top are calibrated in terms of density and value to balance out appropriately. The relative opacity of these colors also tends to em-

phasize weight, mass, density, and gravity. And it is here, in her preoccupation with literal and metaphoric gravity, that Frankenthaler leaves off with the lyric. She is now a painter who builds as often as she sings.

Working as simply and as bluntly as she has recently brings Frankenthaler to another step in her development. She is prepared now to go not only against accepted taste but also against the self, to suppress her own virtuosity if need be in search of a deeper statement. She poses herself a special type of existential dilemma, that of attacking her own facility, forcing herself into a new direction as soon as she feels comfortable. Habit is the enemy. The self is constantly challenged; premises are held up to evaluation and fundamental assumptions are never held final. "I'd rather risk an ugly surprise than rely on things I know I can do," she has said. In many respects, her career parallels that of an artist like Degas. Although there are of course many intervening styles between Degas and Frankenthaler, there are certain striking analogies, particularly with regard to the kind of career each pursued. Possessed of great talent, a fortunate background, and a thorough academic training, both painters felt more closely tied to tradition than others of their generations. Moreover, in Frankenthaler's cultivation of the difficult, in her opposition to her own innate facility, one is reminded of Degas's similar rejection of all that came easily to him, of his late contorted nudes, whose broken contours show little trace of the elegant, fluent line of his youth.

In her life as in her art, Frankenthaler has said that she is interested primarily in growth and development. Throughout her career, she has been faithful to these principles. As one traces the course of her work,

one sees a steady maturation and an unwillingness to rest with any solution—no matter how successful. Coupled with this resistance to the facile is an iron-willed determination to face and confront the issues of the moment. Courage and staying power are rare in any age. In our own, Frankenthaler's combination of these qualities is an incalculable asset not only to American art but also to the future of painting in general. Her paintings are not merely beautiful. They are statements of great intensity and significance about what it is to stay alive, to face crisis and survive, to accept maturity with grace and even with joy.

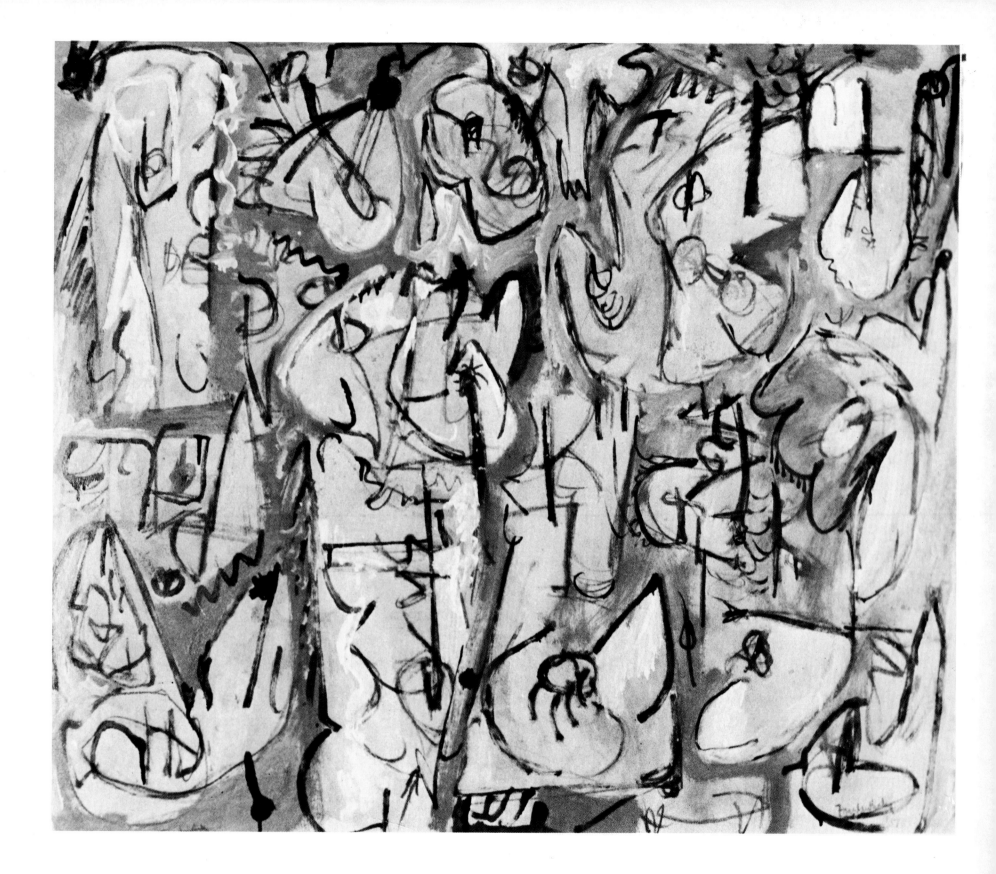

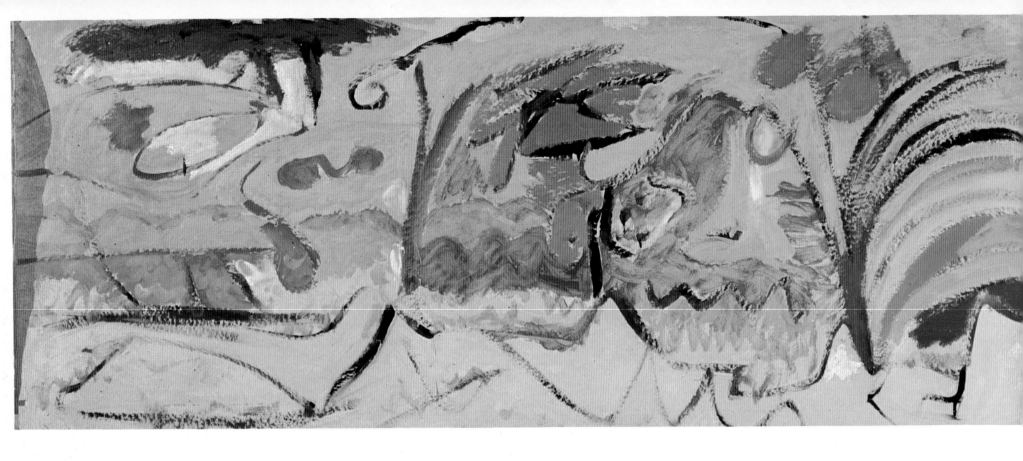

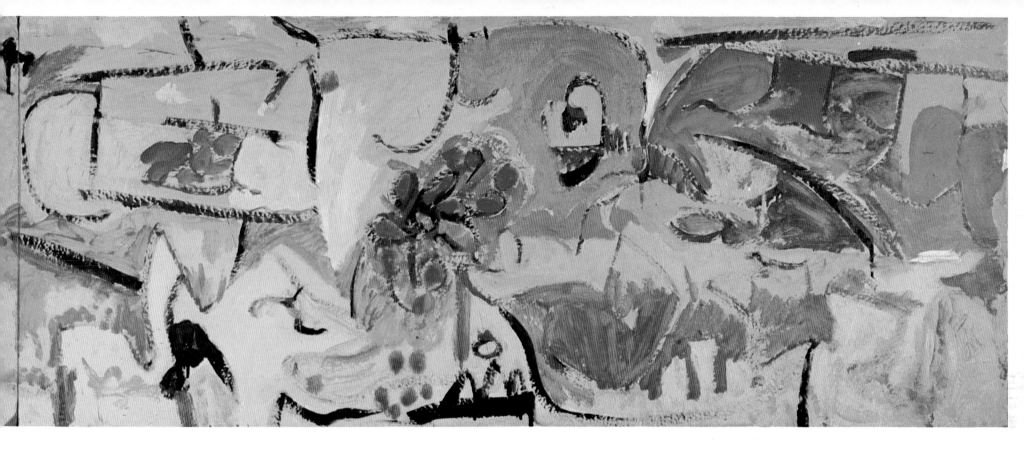

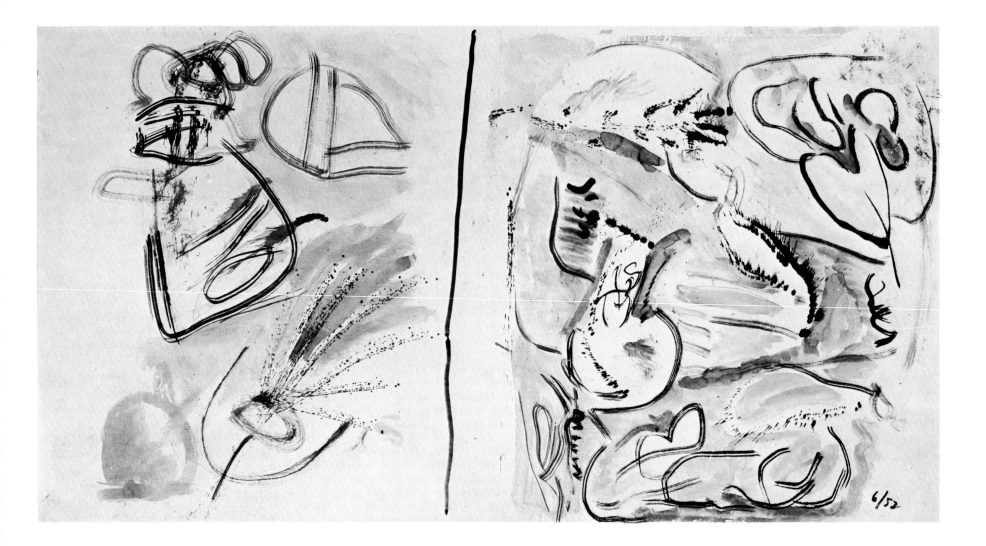

40. UNTITLED. *1952. Oil on mounted window shade, 36 × 66″*

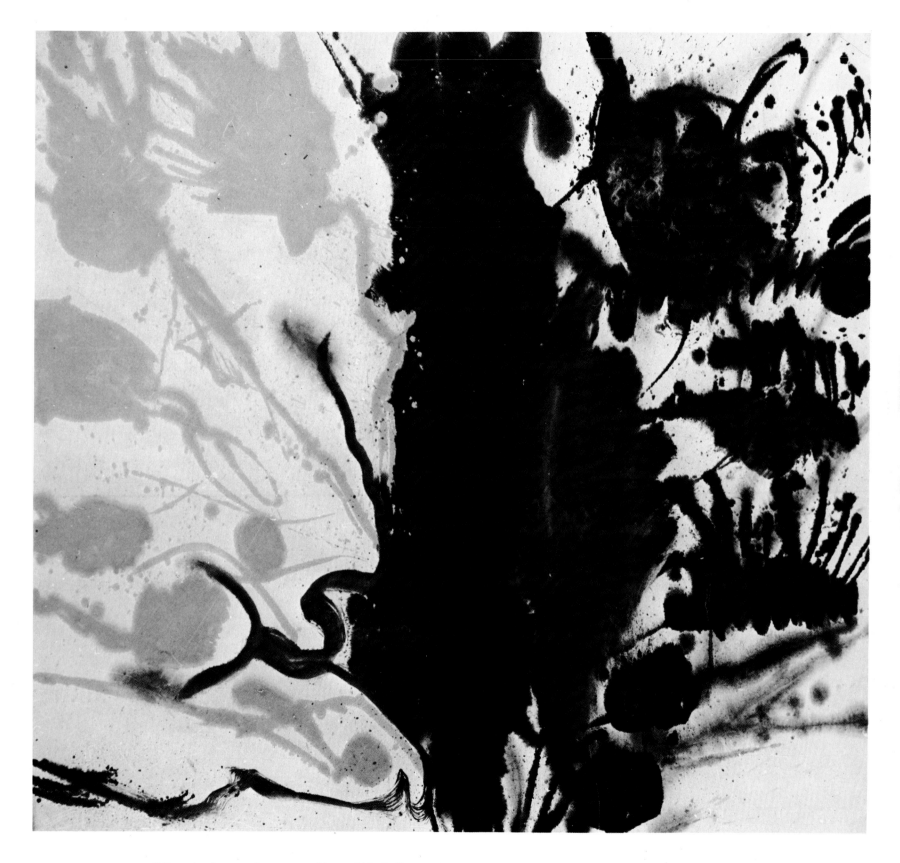

41. PASSPORT. *1953. Oil on sized, primed canvas, 49¾×53¾″. Collection Jacques Benador, Geneva*

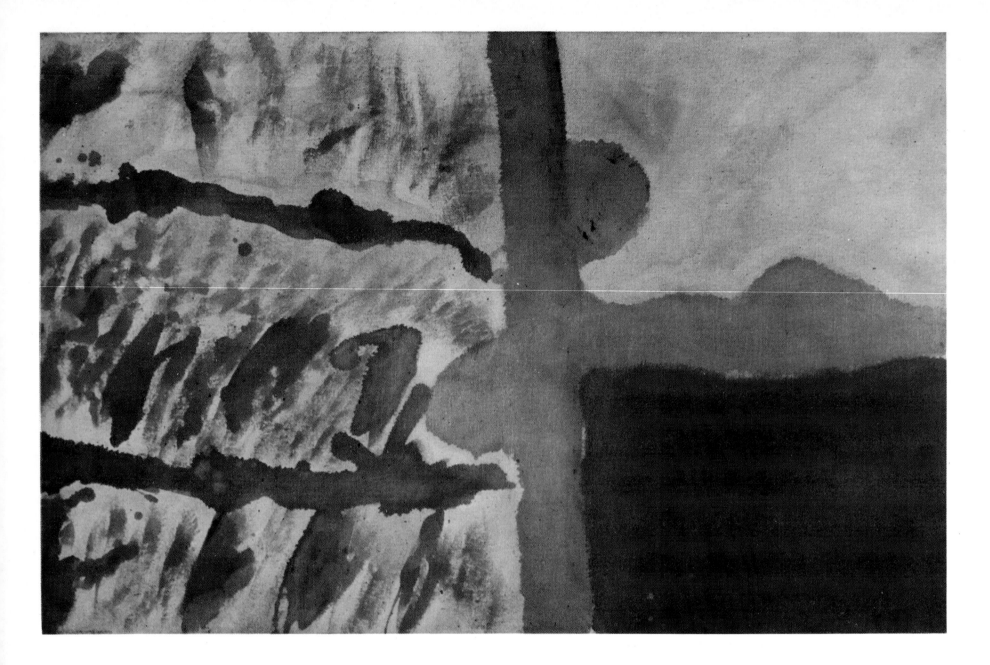

42. THE RIVER. *1953. Oil on canvas, 27×17″*

43. SHATTER. *1953. Oil on canvas, 48⅝×54⅛″*

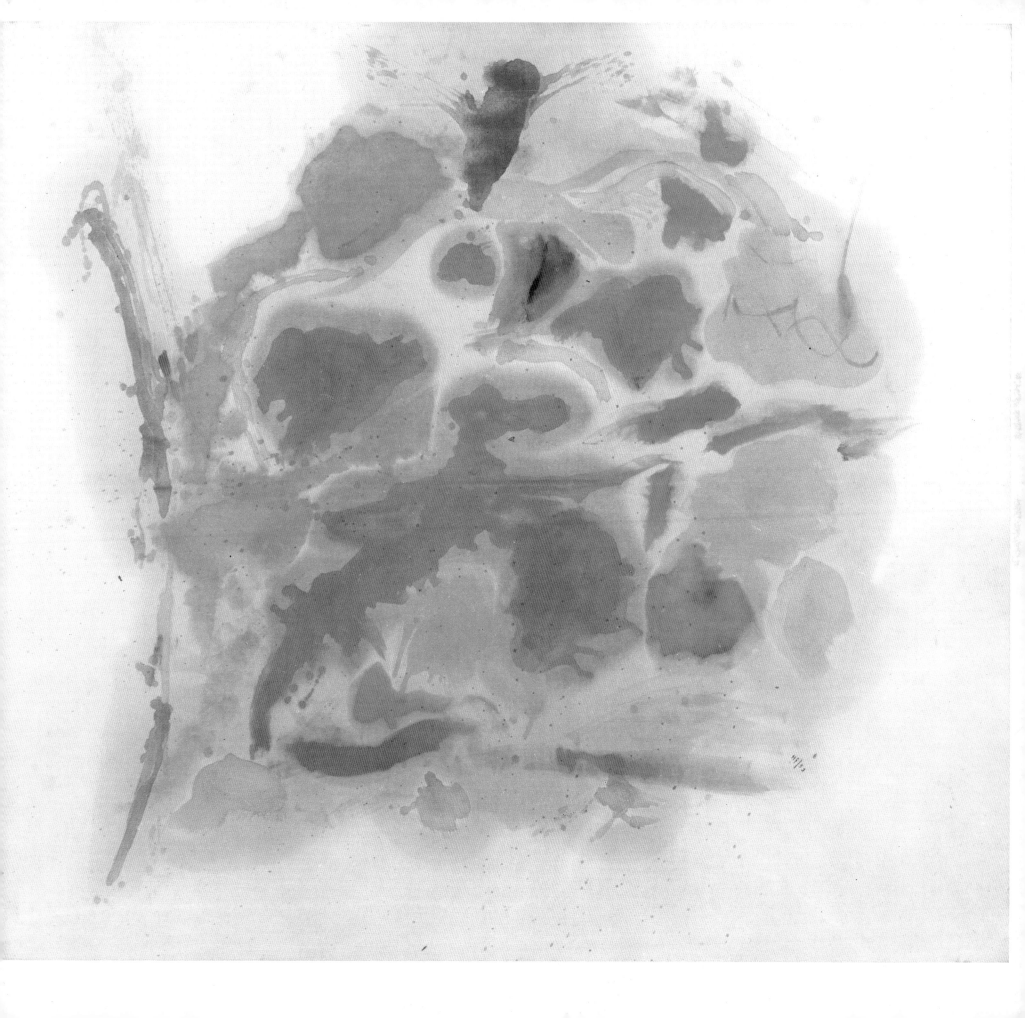

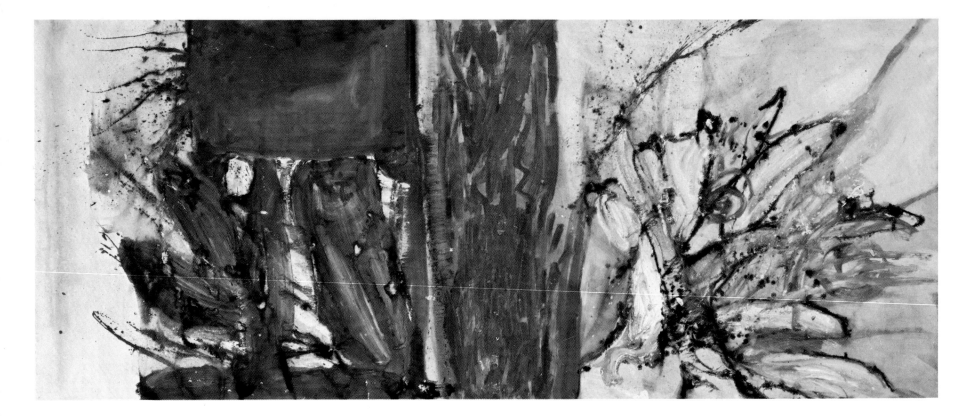

44. THE FACADE. *1954. Oil on sized, primed canvas, 40½ × 98". Museum of Art, Carnegie Institute, Pittsburgh*

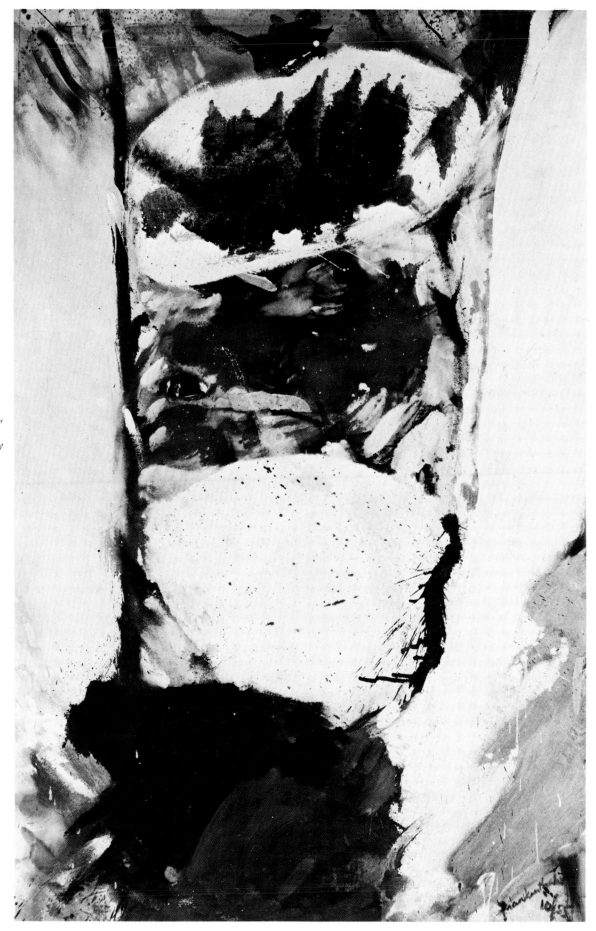

45. MIRAGE. *1955. Oil on canvas, 62 × 40″*
Collection Hyman N. Glickstein, New York City

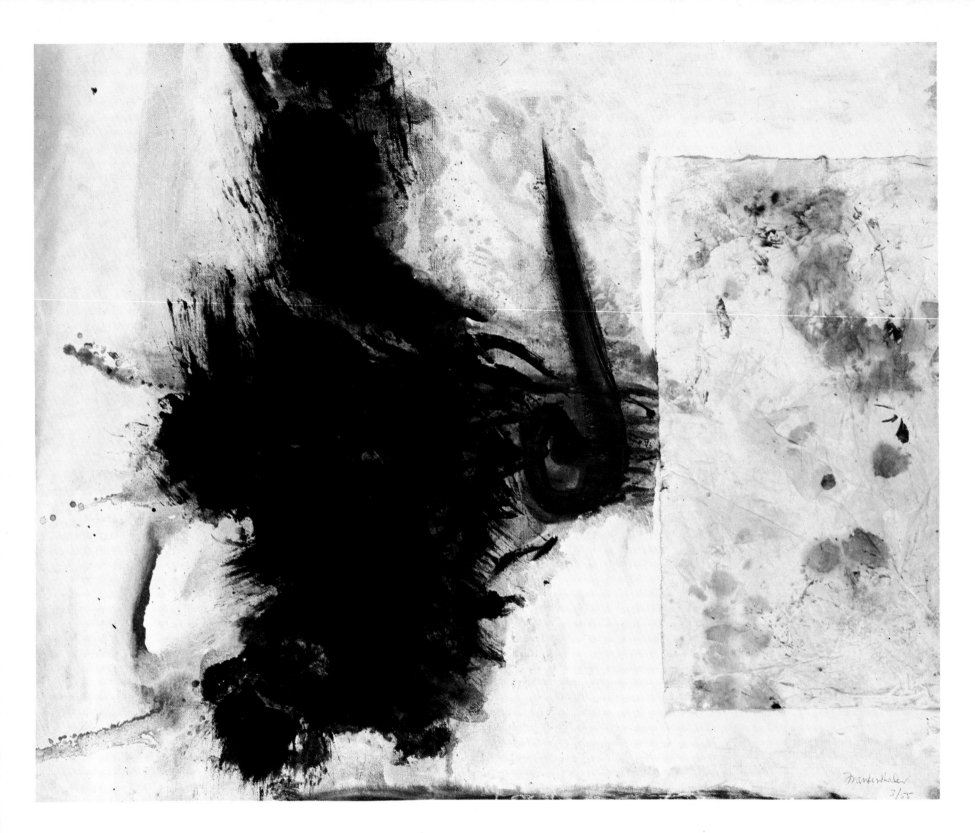

46. STILL LIFE WITH COLLAGE. *1955. Oil and collage on sized, primed canvas, 24×30″*

47. MOUNT SINAI. *1956. Oil on canvas, 30¼×30⅛″. Collection Roy R. Neuberger, New York City*

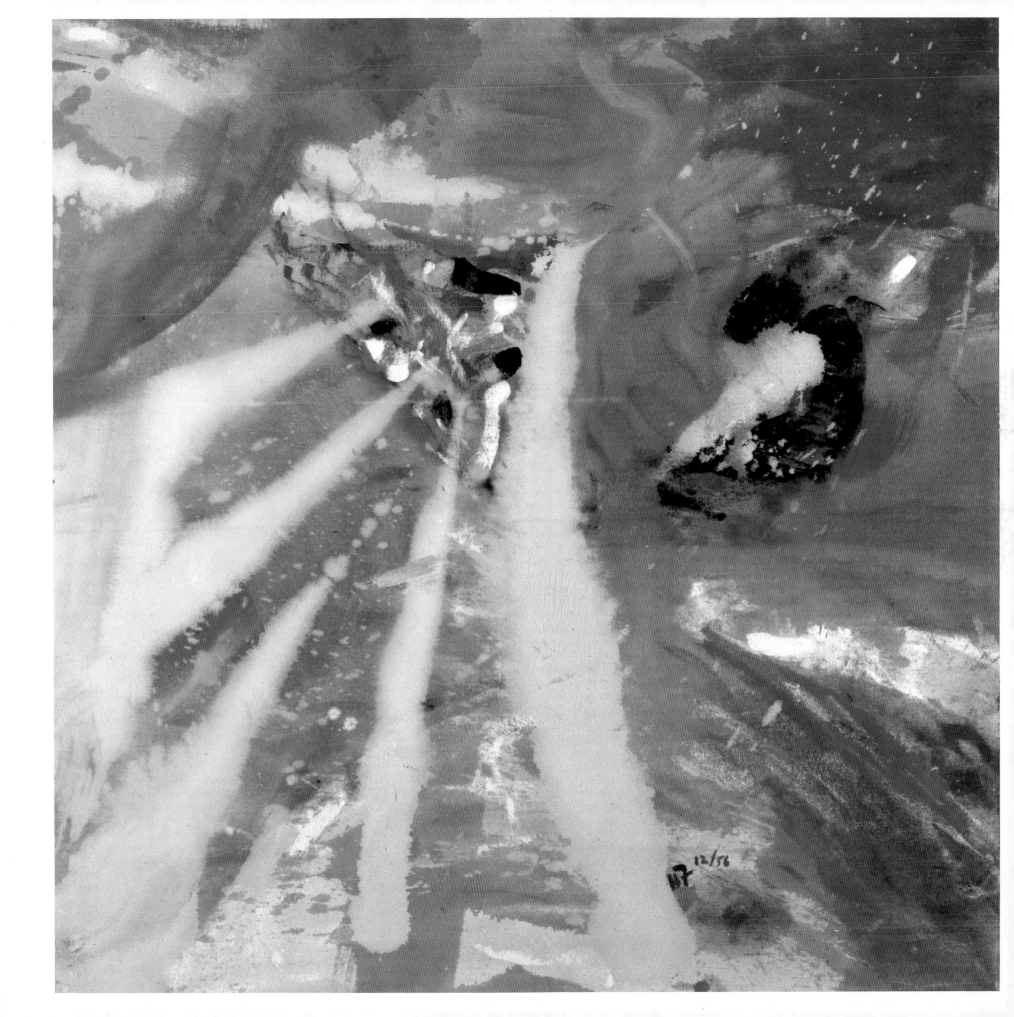

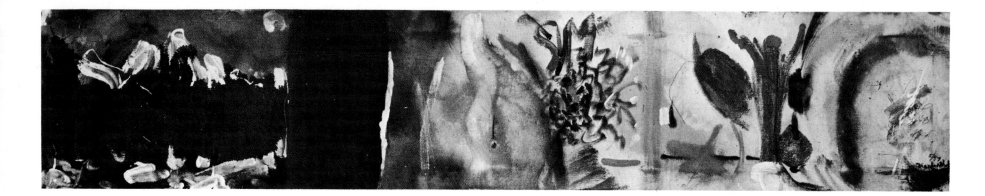

48. CINERAMA. *1957. Oil on canvas, 12 × 62". The America-Israel Cultural Foundation, New York City*
Gift of the artist. On loan to Helena Rubinstein Pavilion, Tel Aviv Museum

49. DAWN AFTER THE STORM. *1957. Oil on canvas, 67 × 70½"*

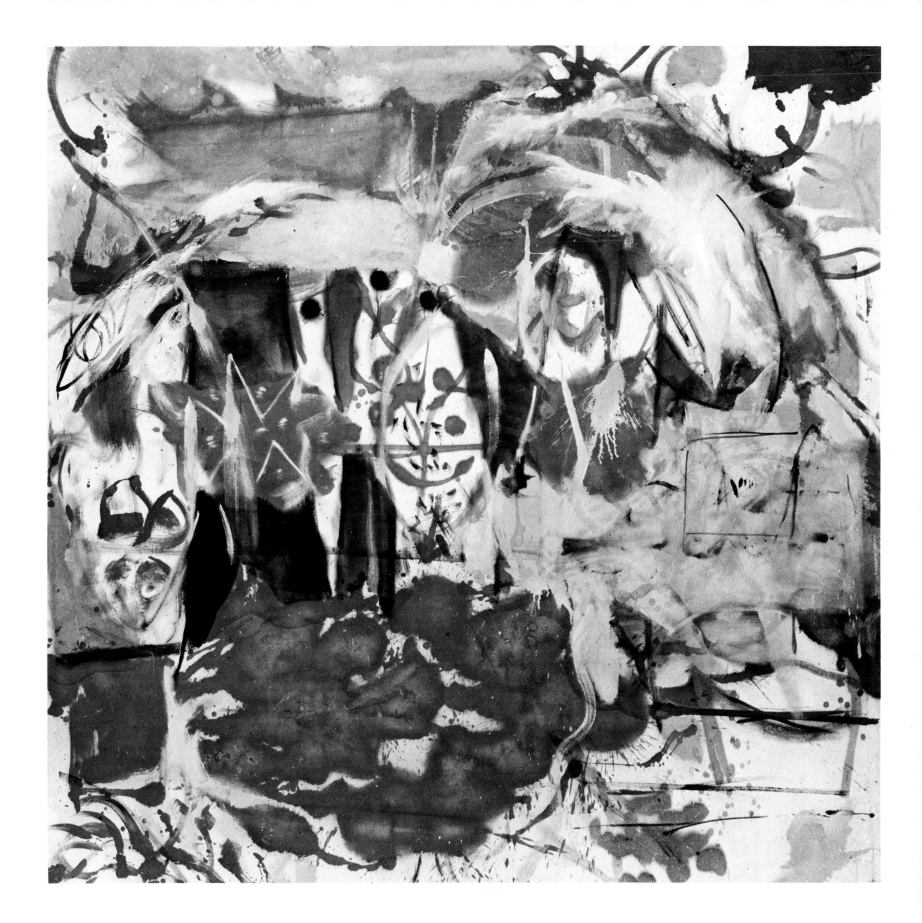

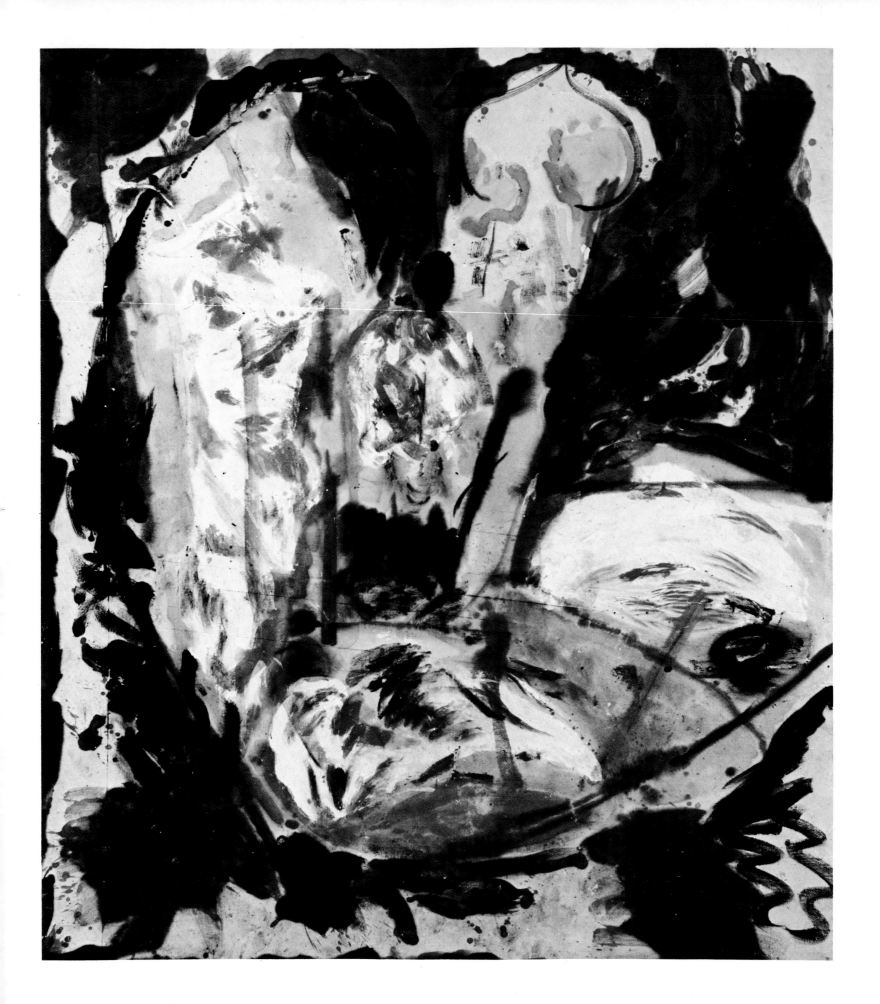

50. GIRALDA. *1957. Oil on canvas, 94×84″*

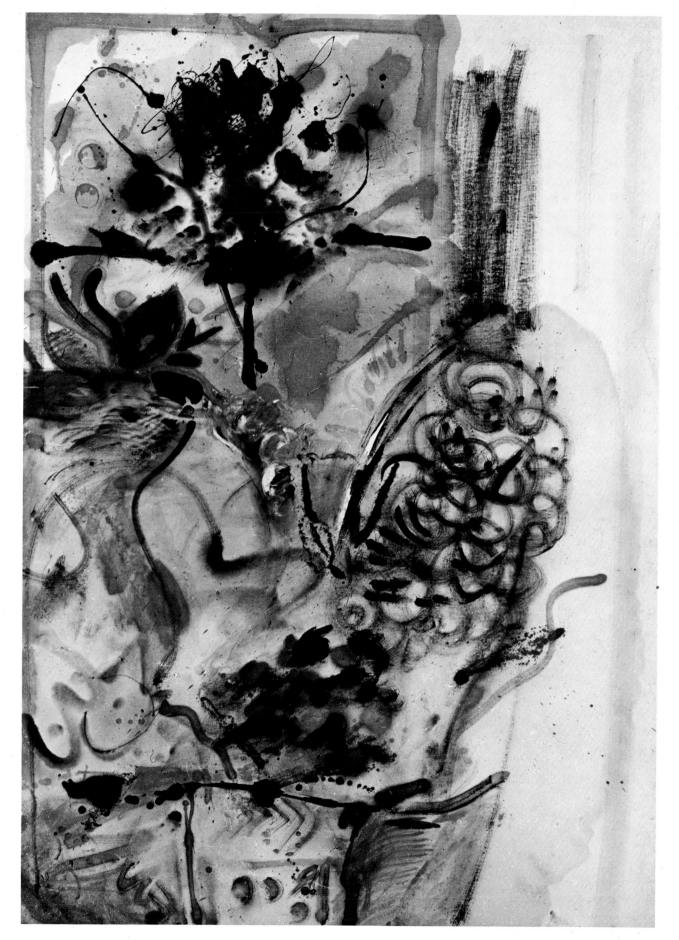

51. L'AMOUR TOUJOURS L'AMOUR. *1957*
Oil on canvas, 70×50″

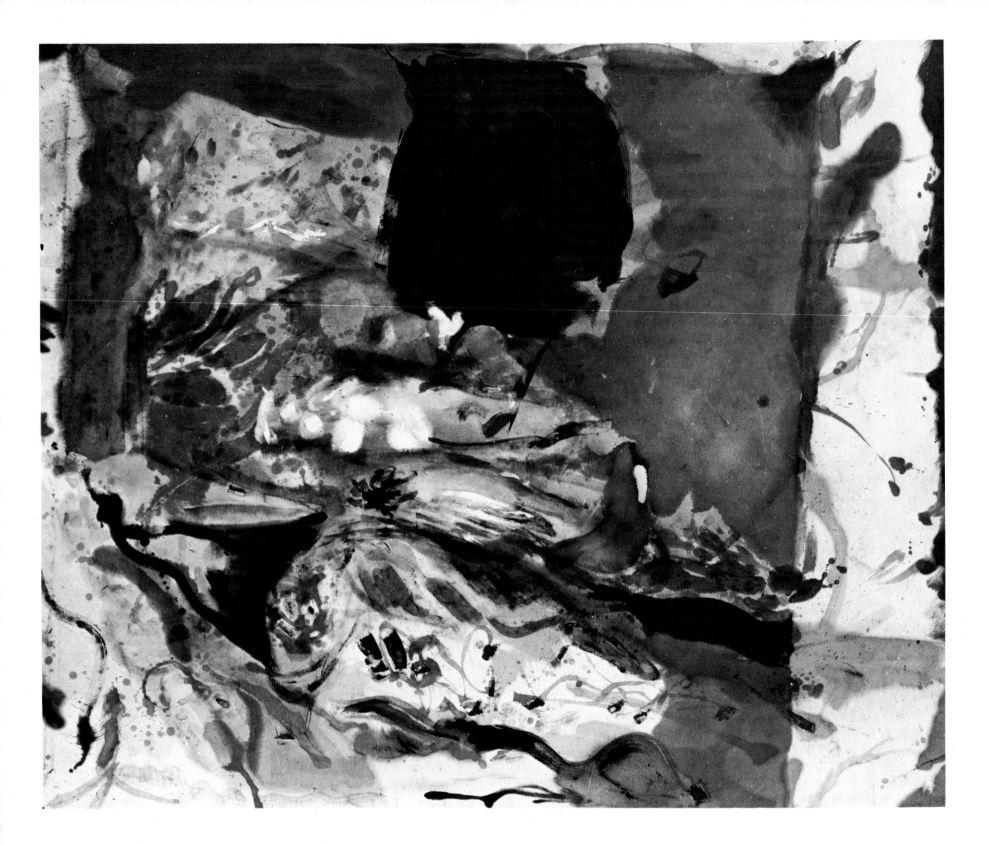

52. LORELEI. *1957. Oil on canvas, 70½×86½". The Brooklyn Museum. Gift of Allan D. Emil, 1958*

53. EUROPA. *1957. Oil on canvas, 70½×54¼"*

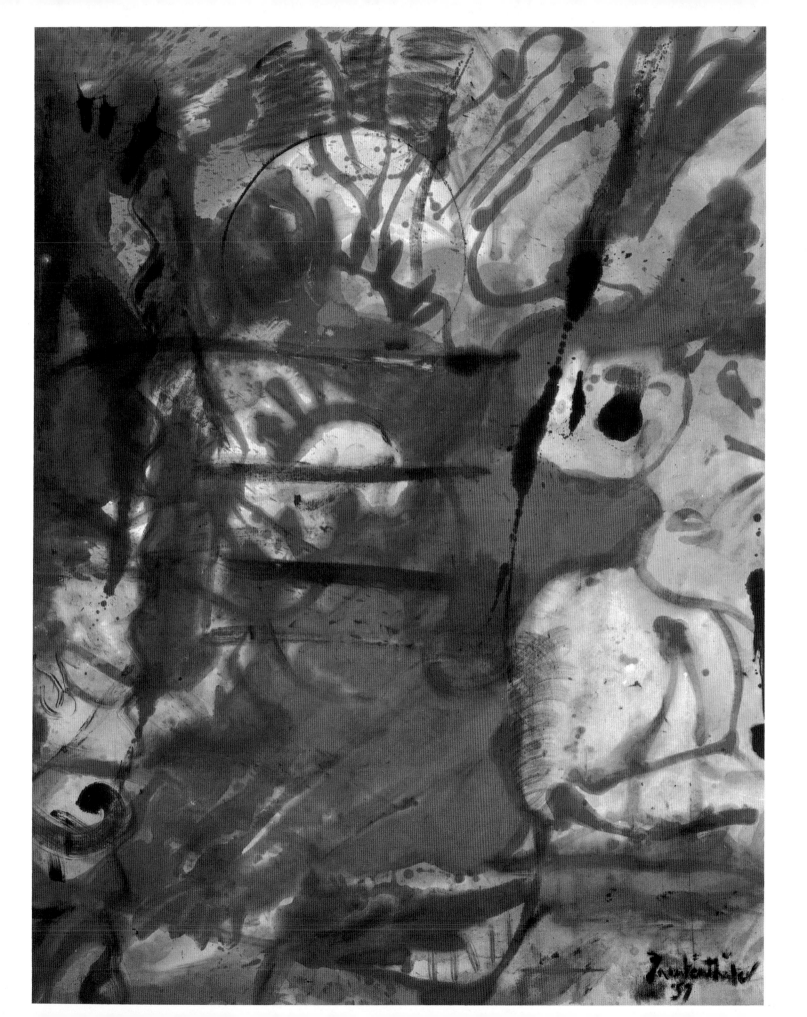

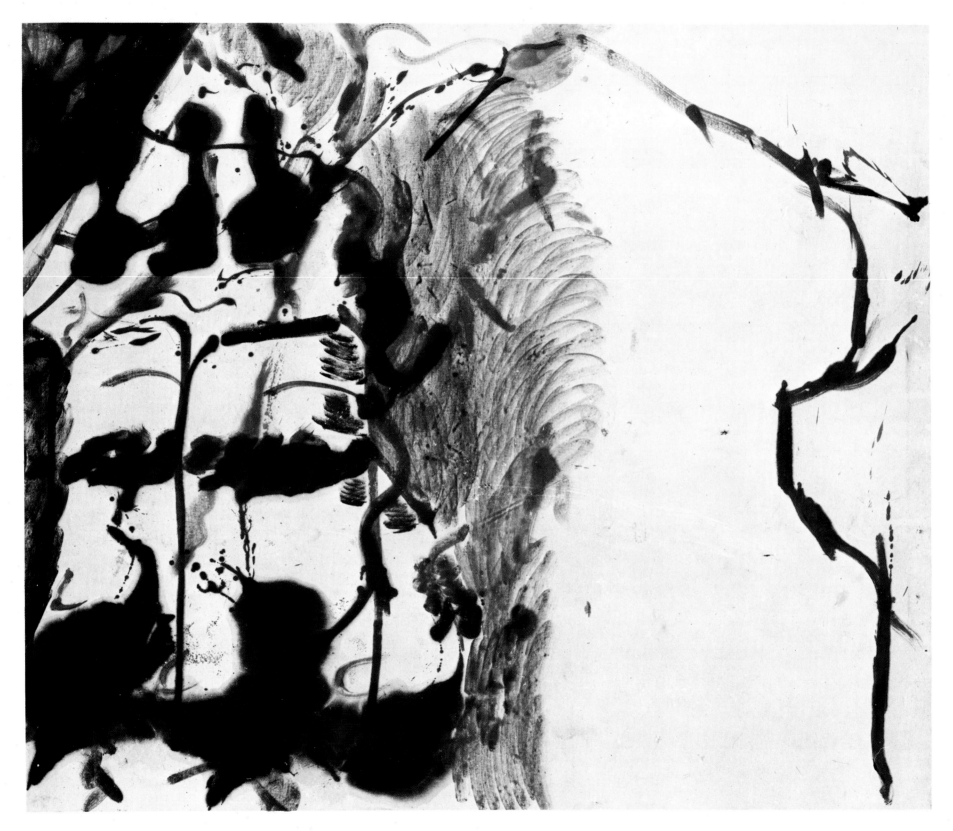

54. NEW YORK BAMBOO. *1957. Oil on canvas, 70×84″*

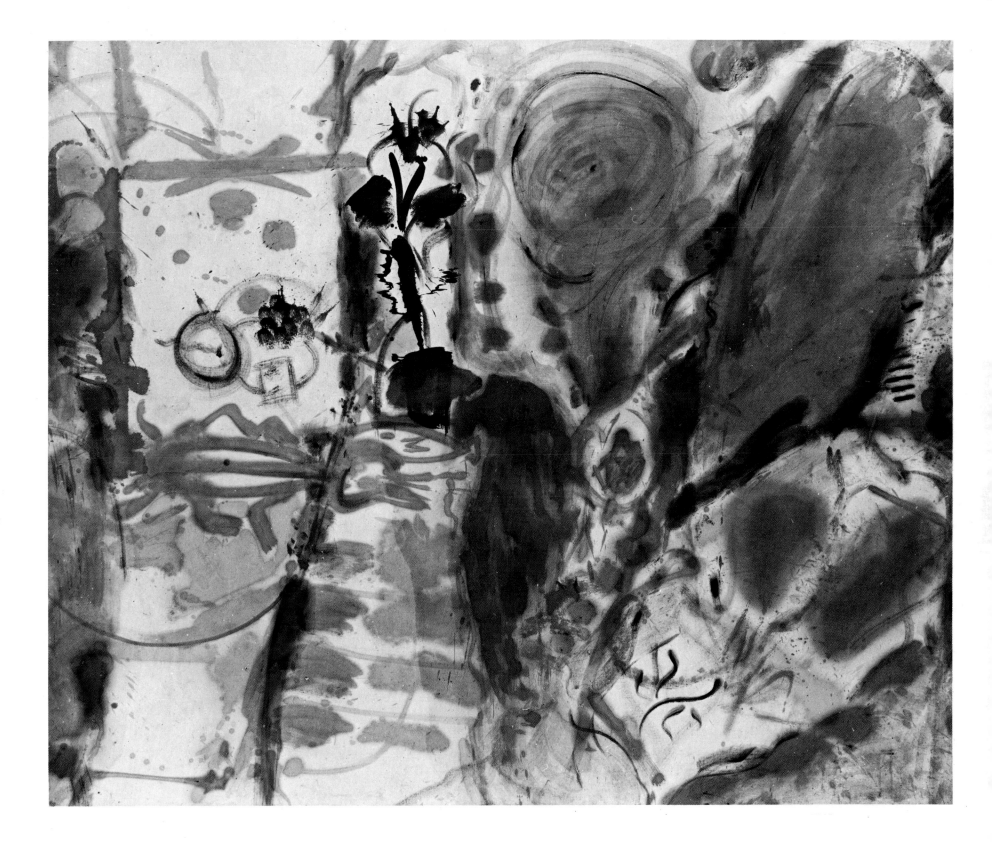

55. WESTERN DREAM. *1957. Oil on canvas, 70 × 86⅛"*

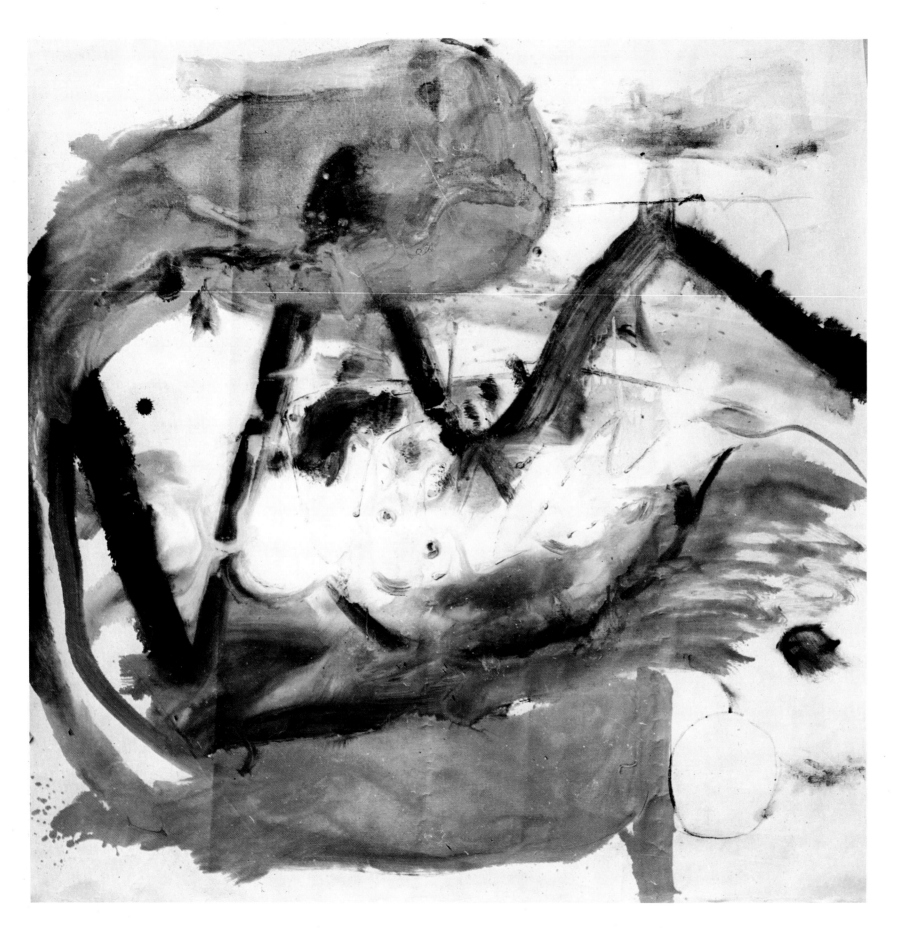

56. SOUL OF THE ALBINO. *1958. Oil on canvas, primed with gesso, 42×41". Collection Mrs. Milton Sperling, Los Angeles*

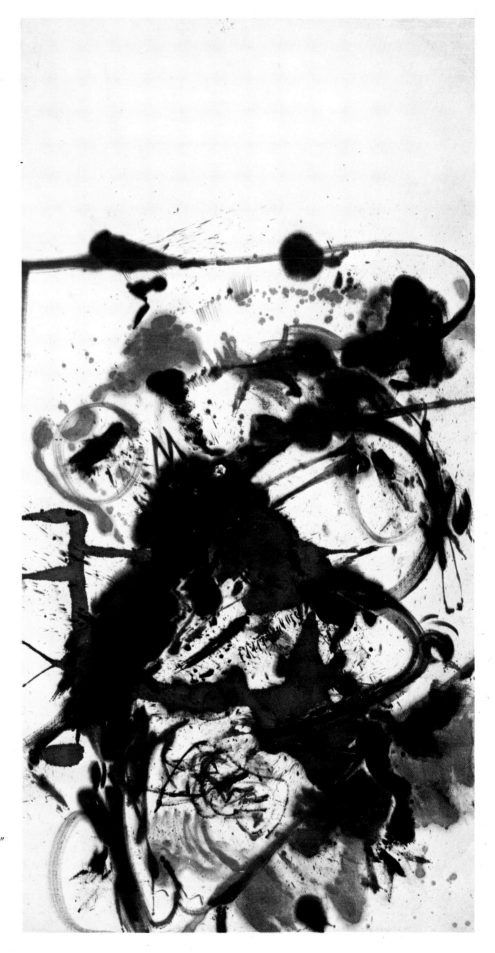

57. WINTER HUNT. *1958. Oil on canvas, 91×46½"*

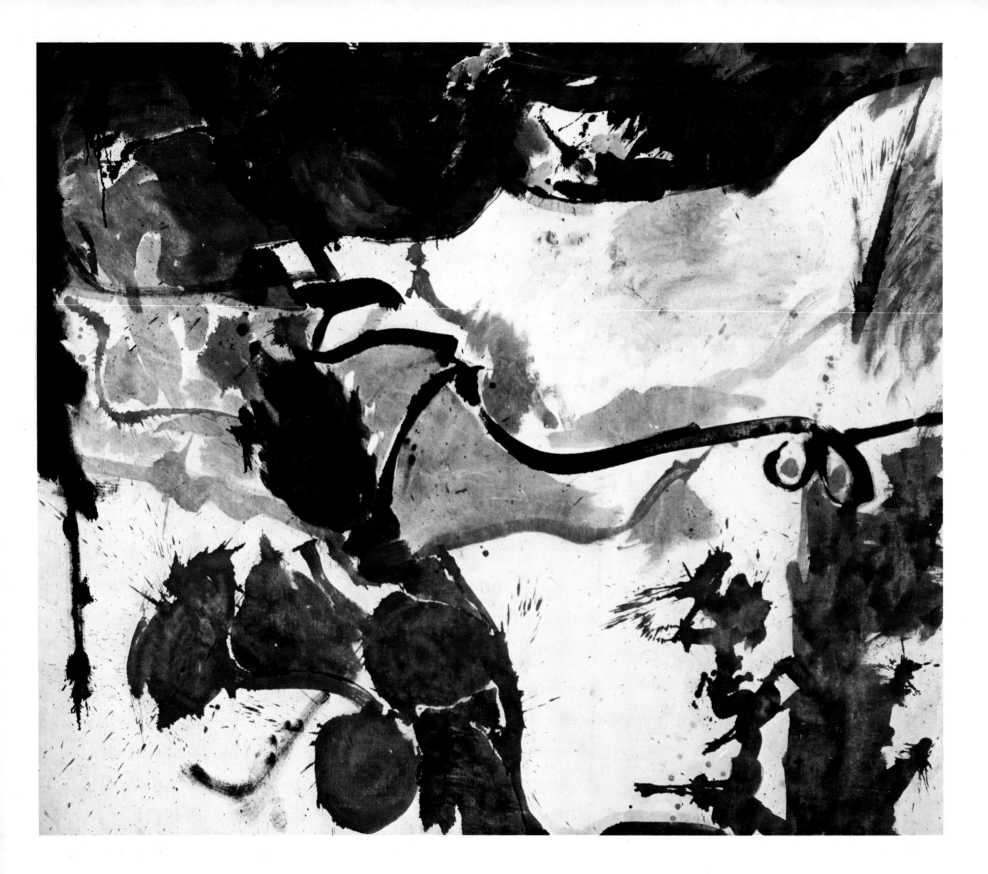

58. HOTEL CRO-MAGNON. *1958. Oil on canvas, primed with gesso, 67¾×80¾". Milwaukee Art Center. Gift of Mrs. Harry Lynde Bradley*

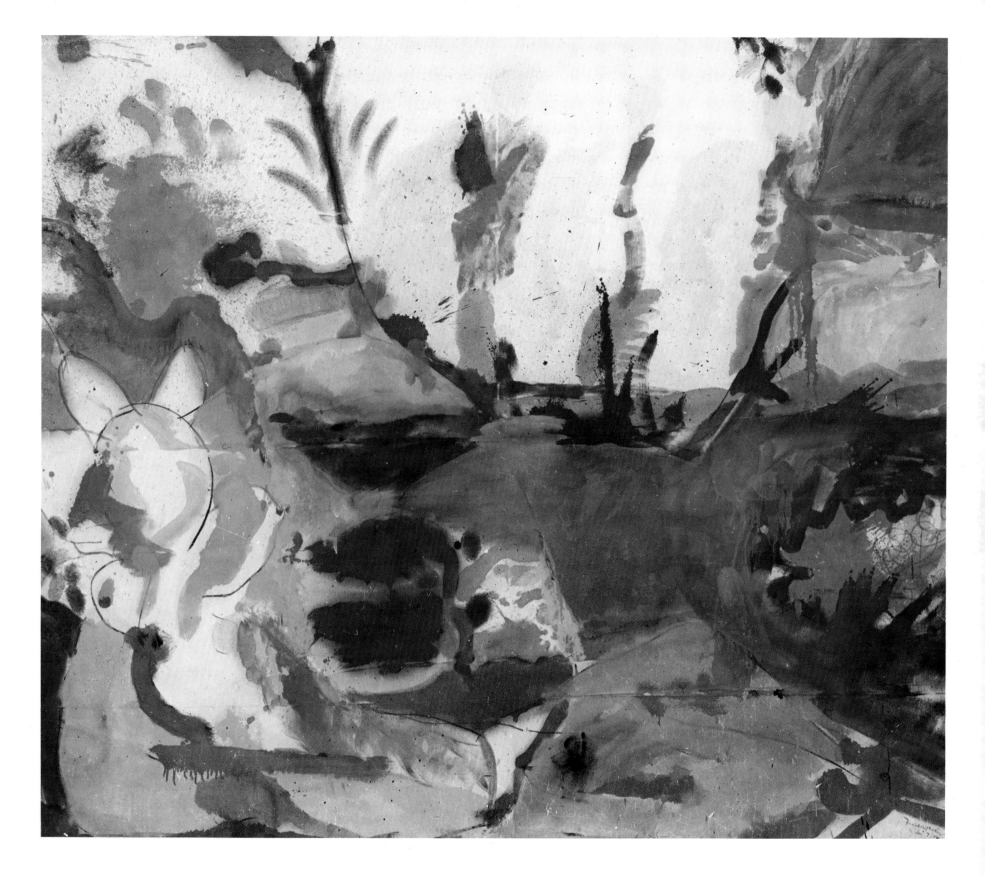

59. BASQUE BEACH. *1958. Oil on canvas, 58½×69½". Joseph H. Hirshhorn Collection*

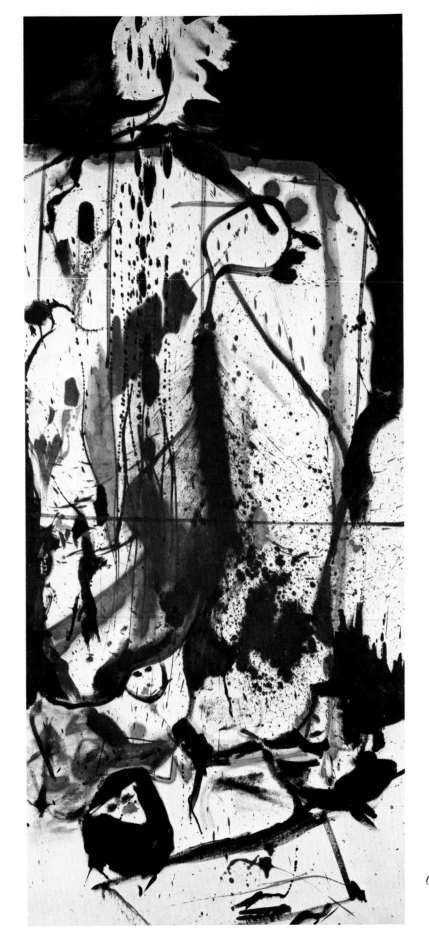

60. LAS MAYAS. *1958. Oil on canvas, 8′ 4¼″ × 3′ 7″. Collection Luciano Pistoi, Turin*

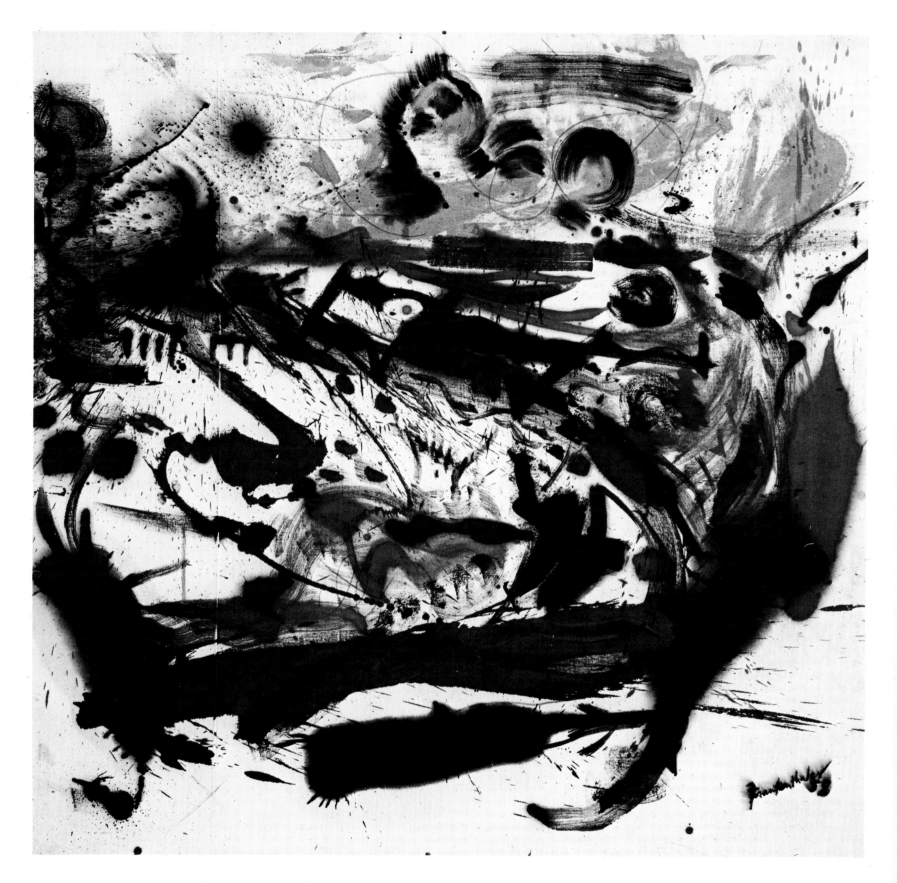

61. HUDSON VALLEY. *1958. Oil on canvas, 46×50″*

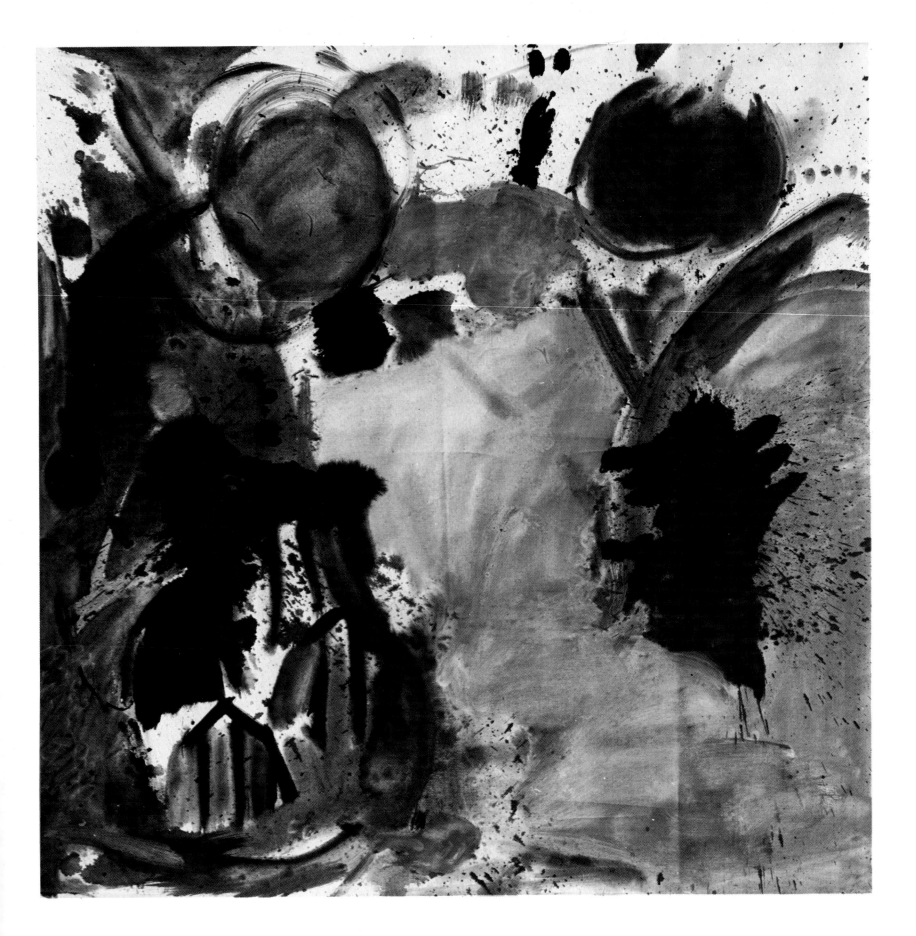

62. SILVER COAST. *1958. Oil on canvas, primed with gesso, 39×41". Collection Mrs. Jack Kramon, New York City*

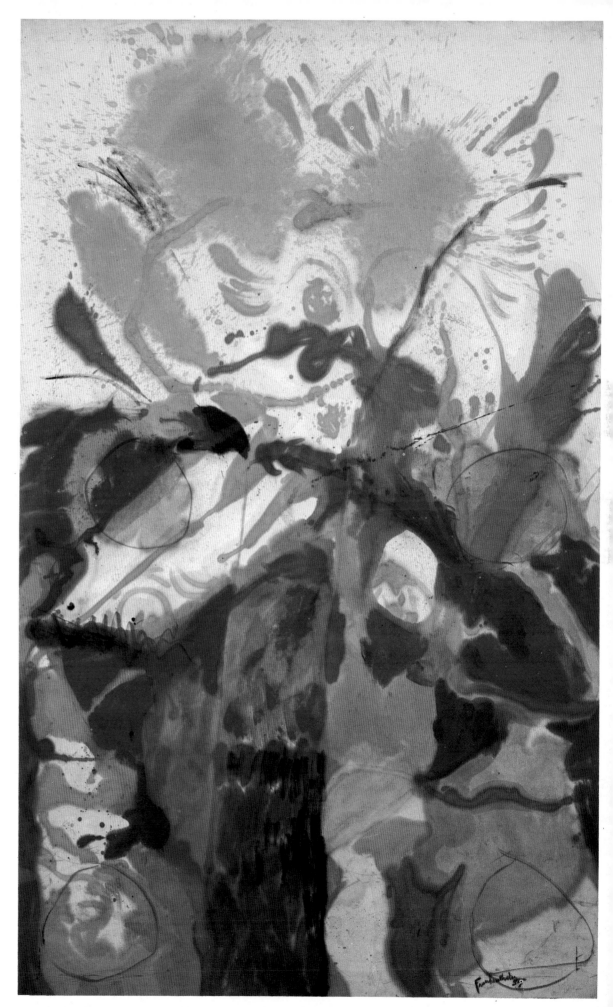

63. JACOB'S LADDER
1957. Oil on canvas, 9' 5⅜" ×5' 9⅞"
The Museum of Modern Art, New York City
Gift of Hyman N. Glickstein, 1960

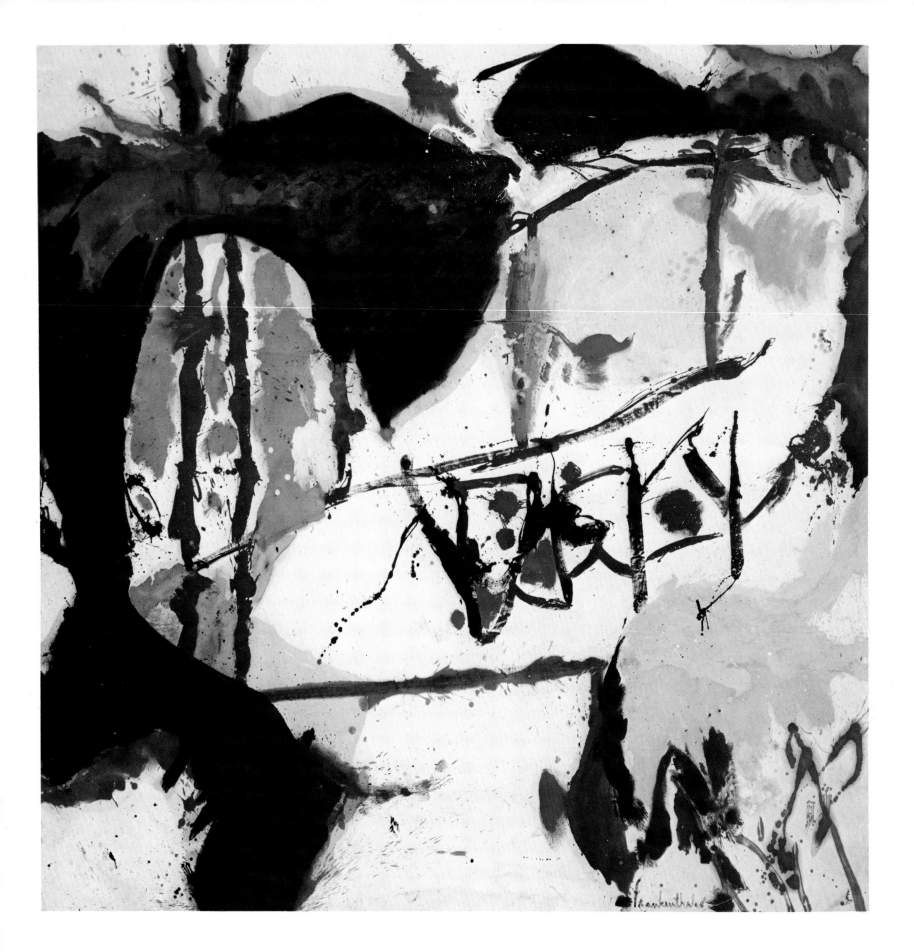

64. ACRES. *1959. Oil on canvas, 95×93"*

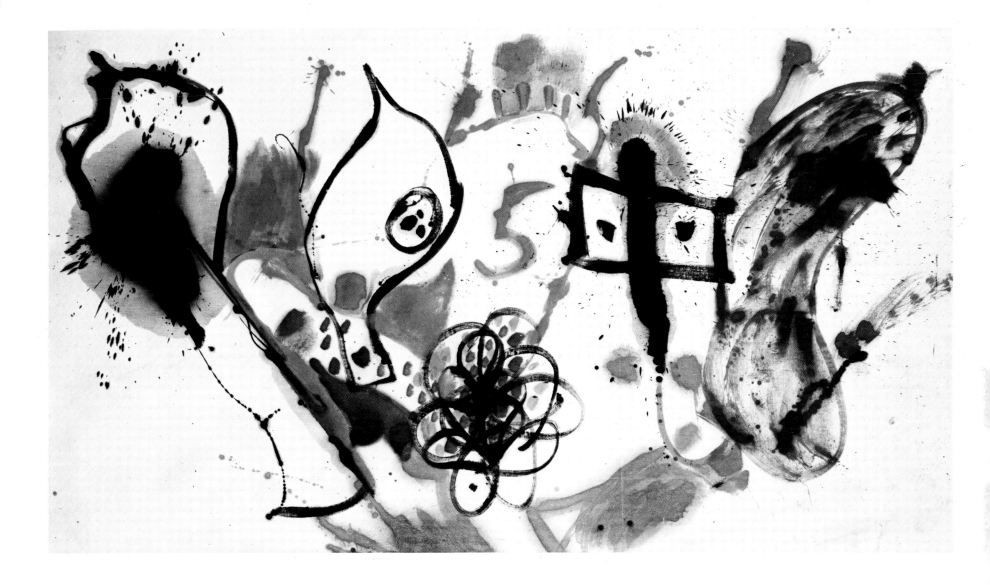

65. FIVE. *1959. Oil on canvas, 47×84". Collection Mr. and Mrs. Willard Gidwitz, Highland Park, Ill.*

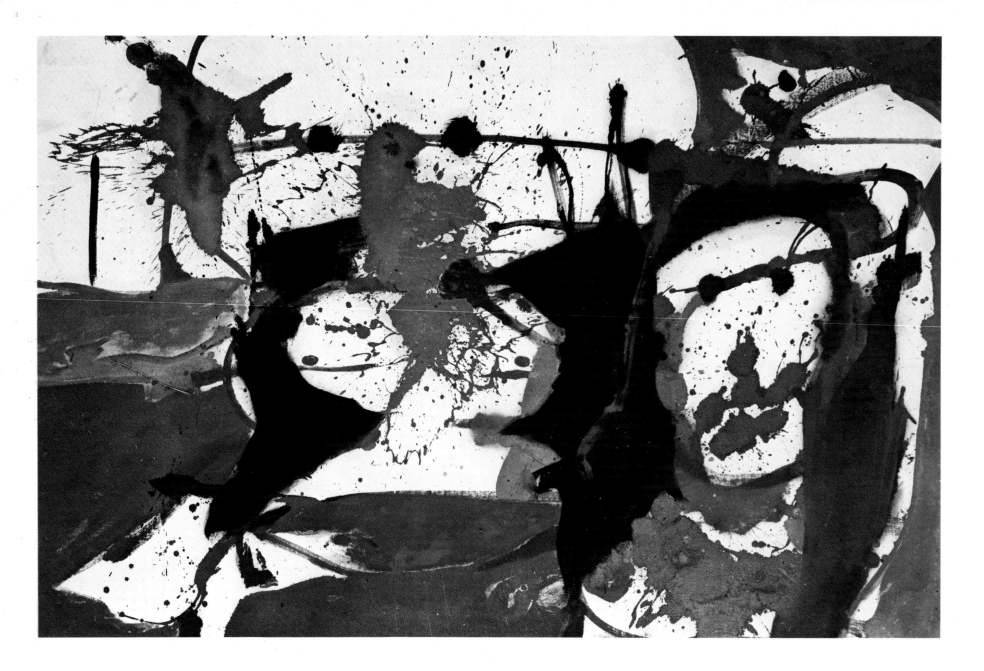

66. AUTUMN FARM. *1959. Oil on canvas, 43³⁄₄×67″*

67. ANCIENT MUSICAL INSTRUMENTS. *1959. Oil on sized, primed canvas, 50×42″. Collection Paul, Weiss, Goldberg, Rifkind, Wharton, and Garrison, New York City*

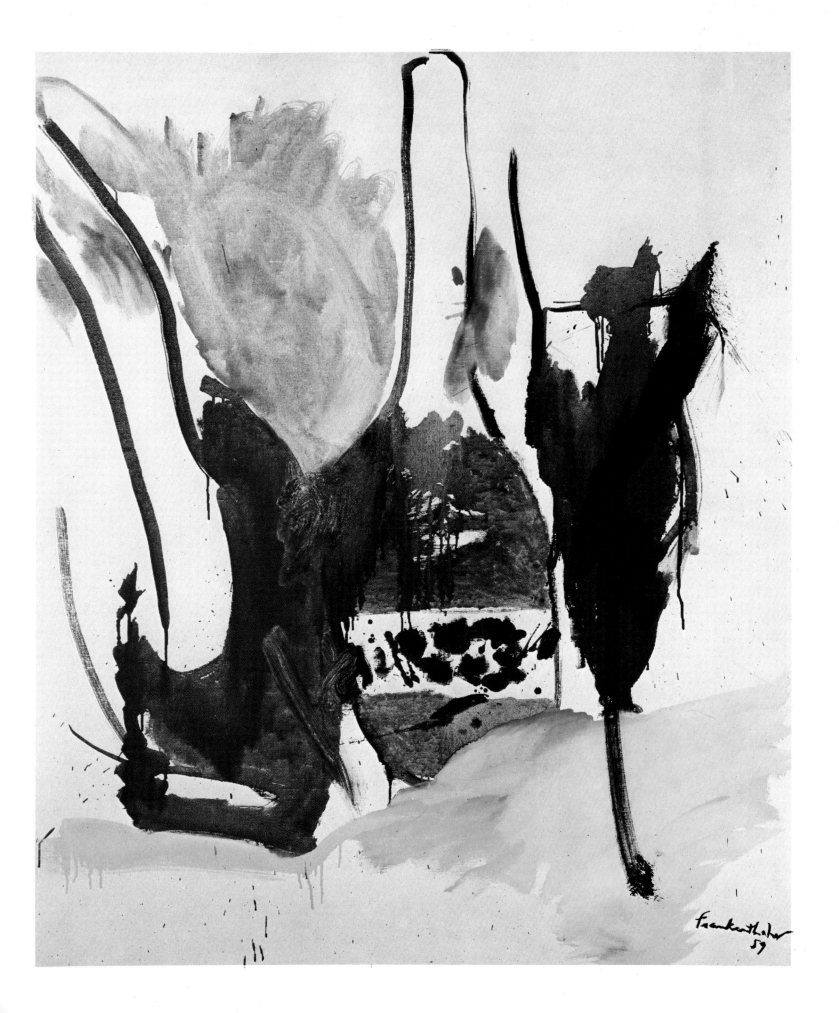

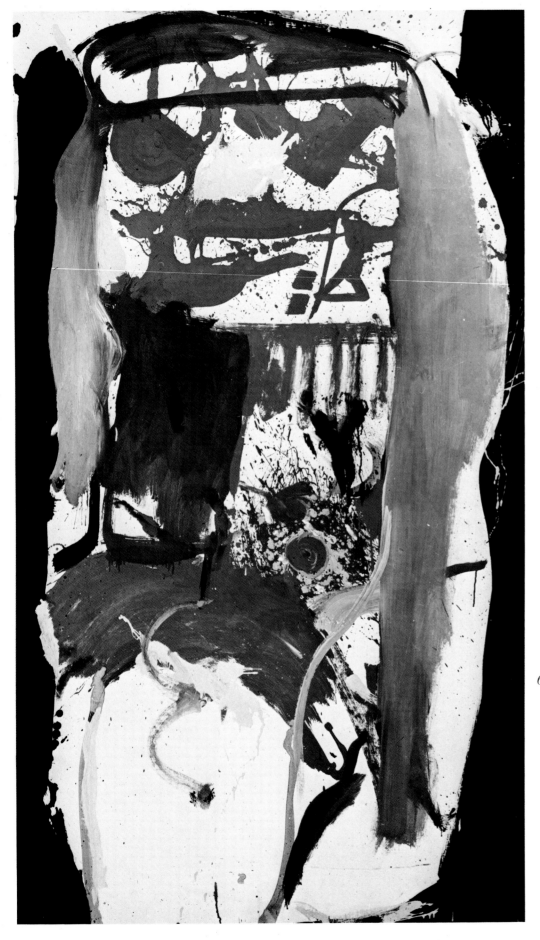

68. WOMAN'S DECISION. *1959*
 Oil on sized, primed canvas, 40 × 70″
 Collection Mr. and Mrs. Lewis C. Merrill, New York City

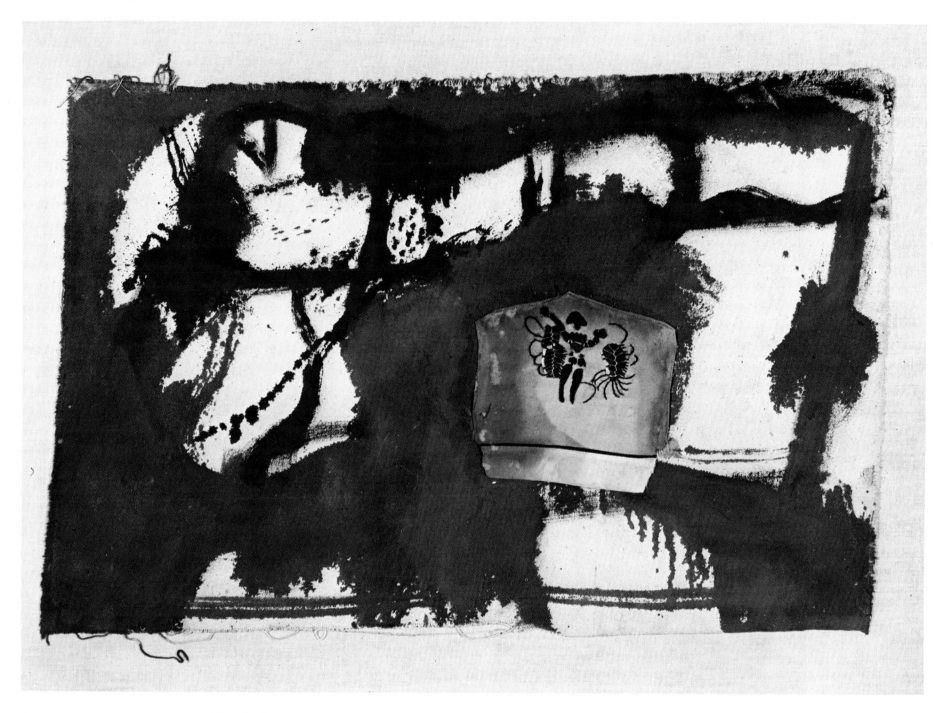

69. THE CHINESE PAJAMAS. *1959. Oil and collage on canvas, 14×22"*

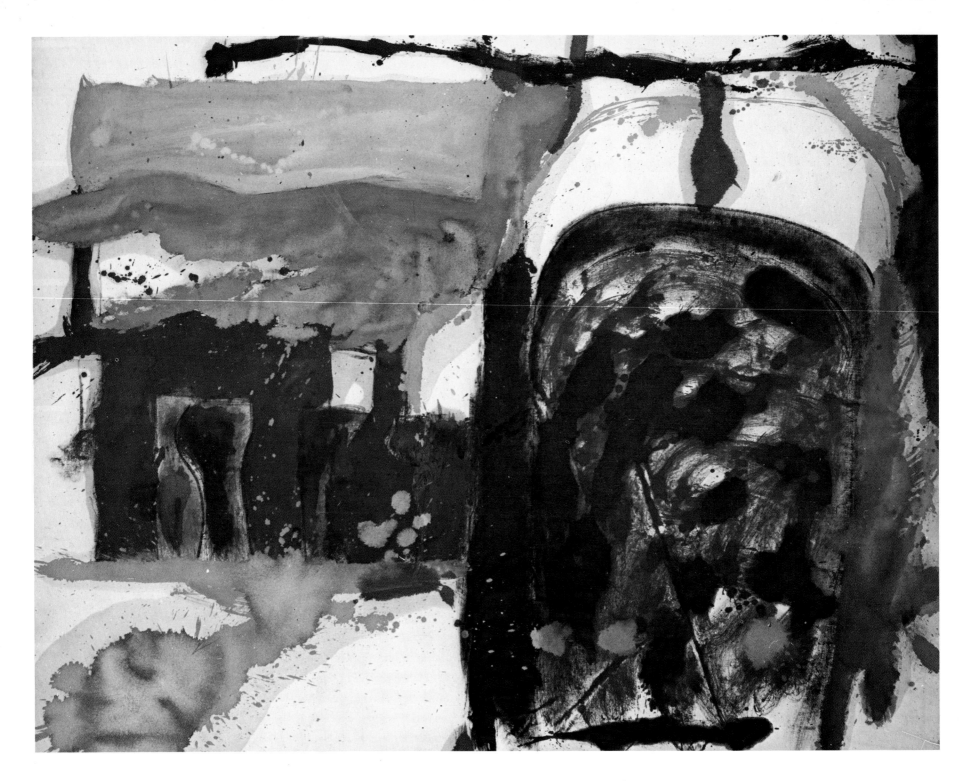

70. THE COURTYARD OF EL GRECO'S HOUSE. *1959. Oil on canvas, 45½×60½". Collection E. C. Goossen, New York City*

71. BROWN BIRD. *1959. Oil on canvas, 48×50". Collection Mr. and Mrs. Robert B. Mayer, Winnetka, Ill.*

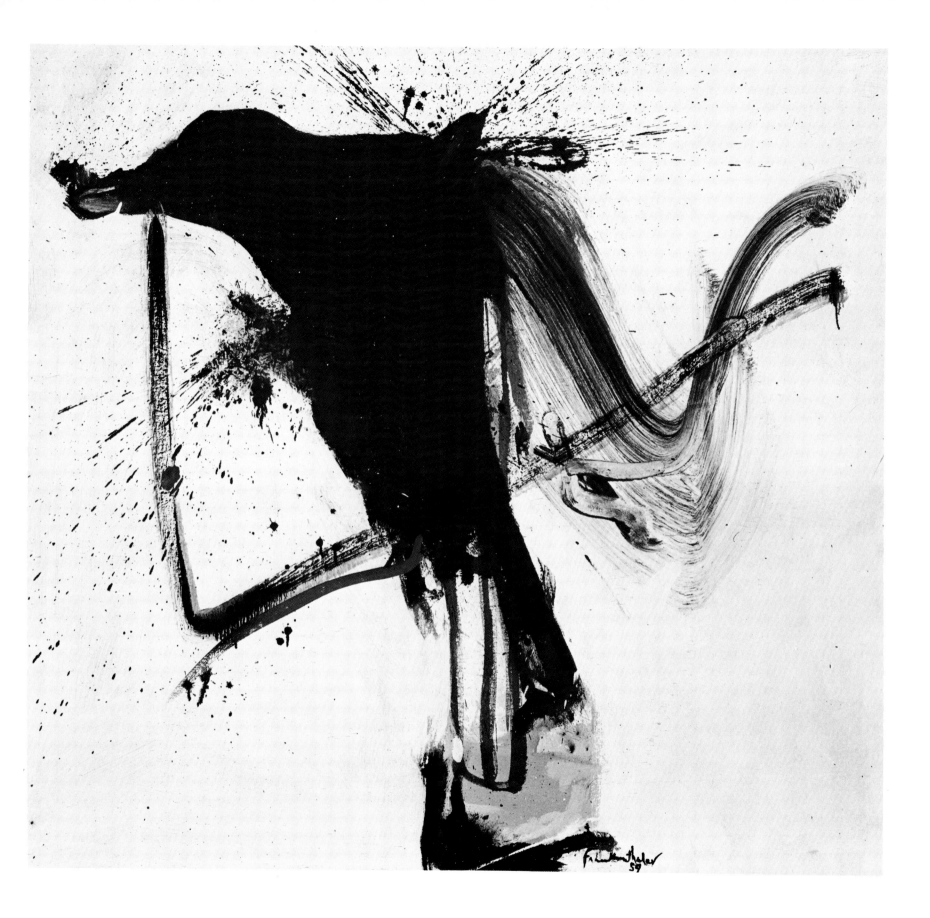

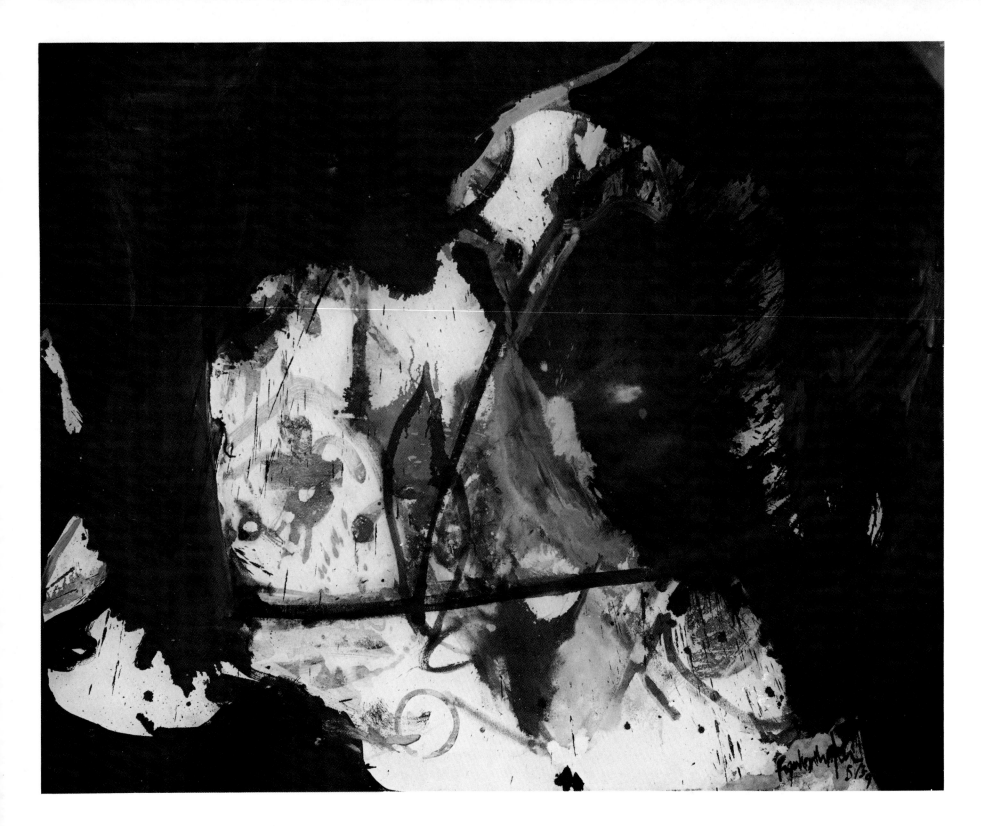

72. FARMER'S ALMANAC. *1959. Oil on canvas, 50×64″*

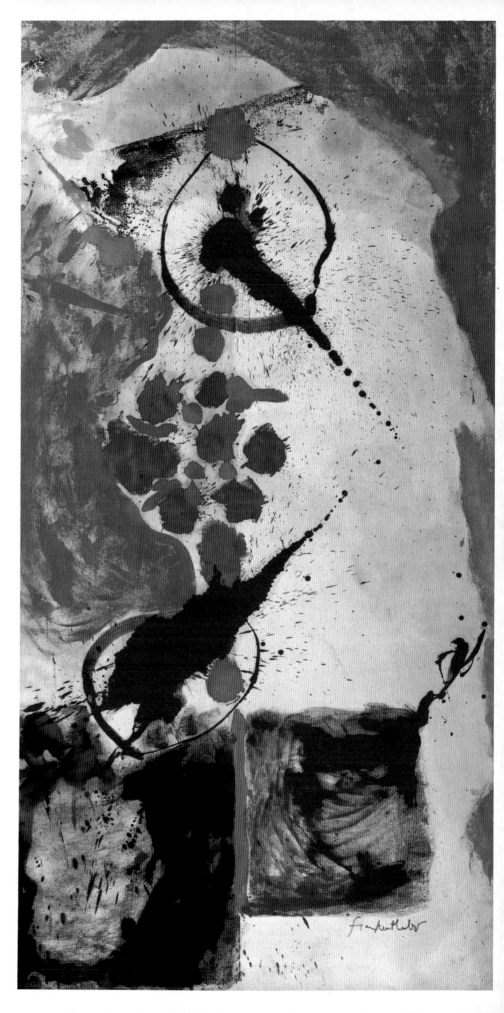

73. LABOR DAY. *1959*
Oil on canvas, sized with gesso, 80¼ × 42″

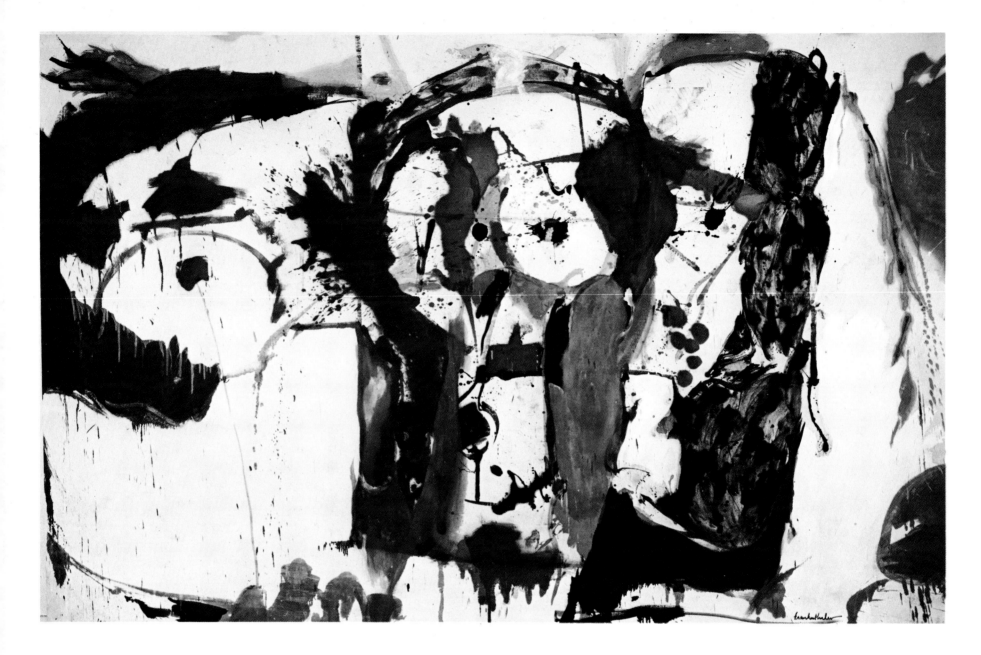

74. MADRIDSCAPE. *1959. Oil on canvas, 8′ 6″ × 13′ 5¼″*

75. FIRST-CLASS MOTEL BEDROOM. *1959. Oil on sized, primed canvas, 55½ × 52″. Collection Mr. and Mrs. Robert Staub, New York City*

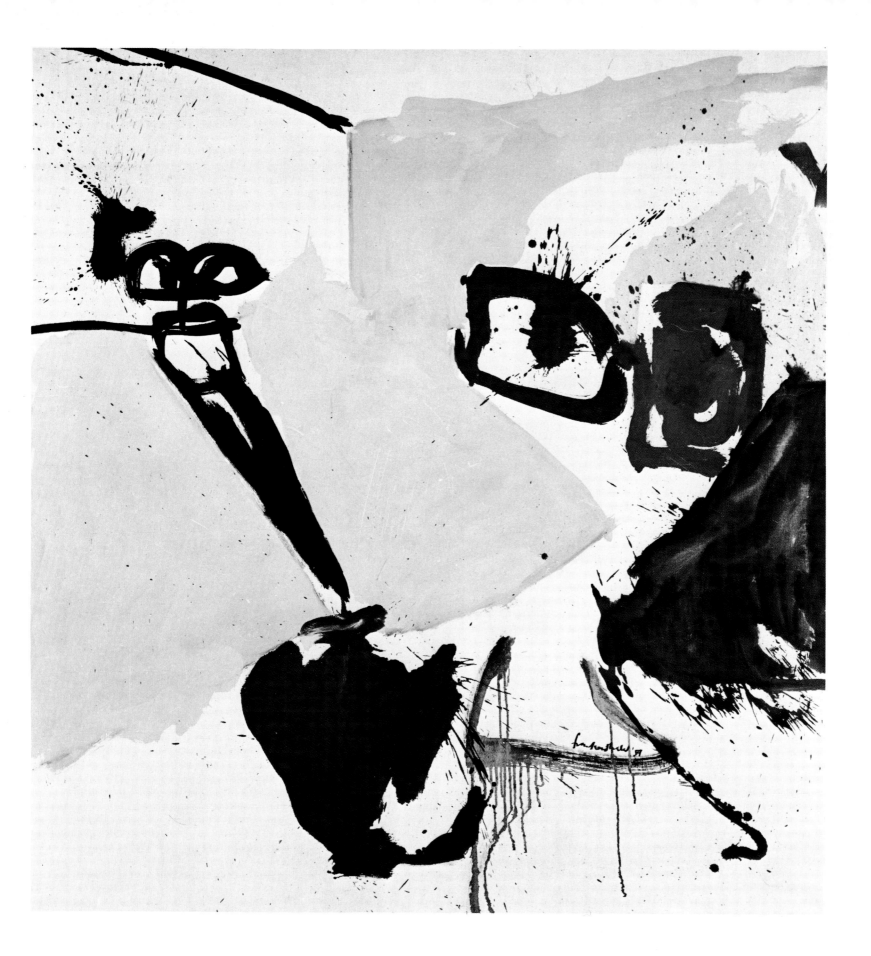

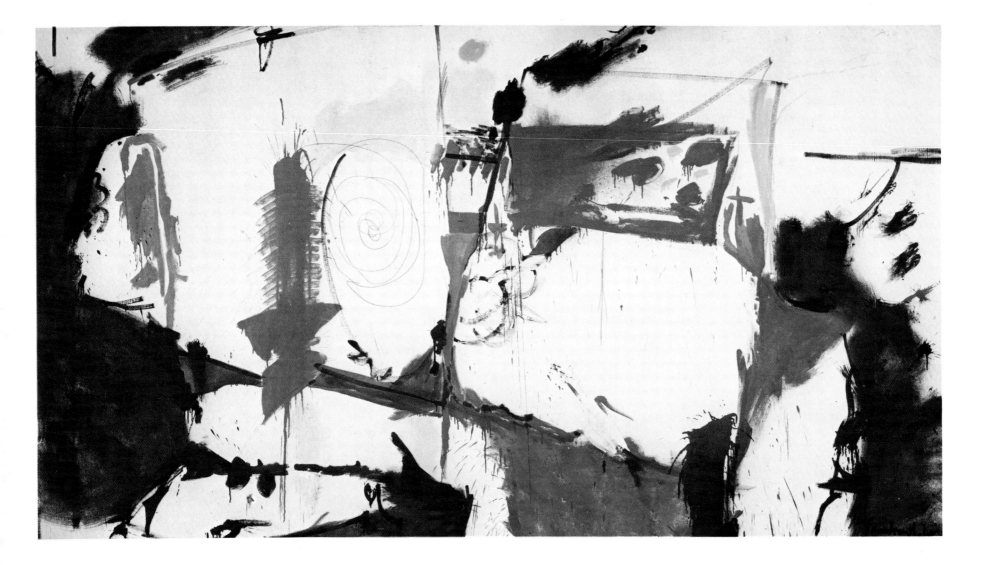

76. RED SQUARE. *1959. Oil on sized, primed canvas, 5′ 8″ × 10′ 6¼″*

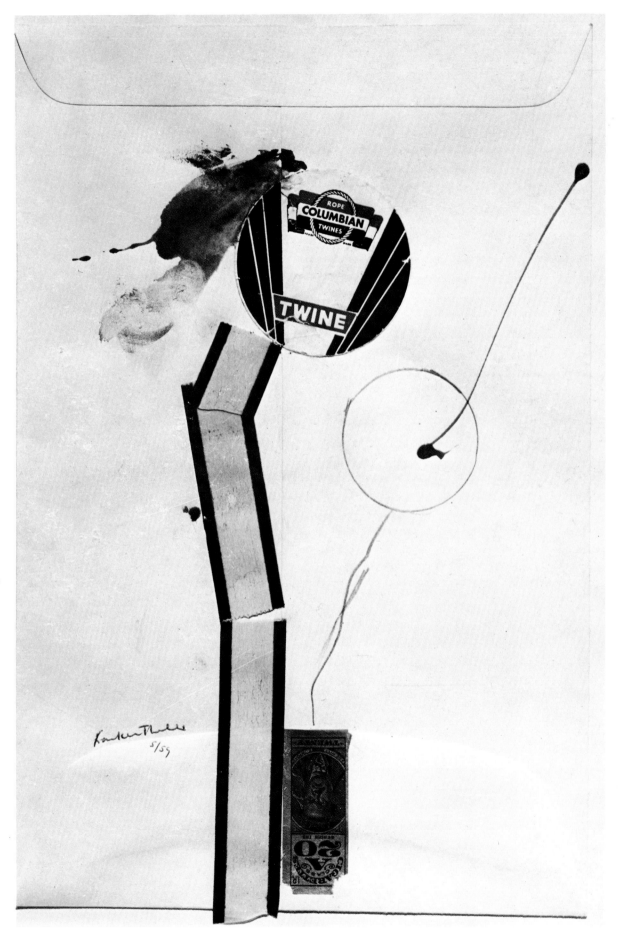

77. TWINE. *1959. Collage, 9⅜×6⅜″*

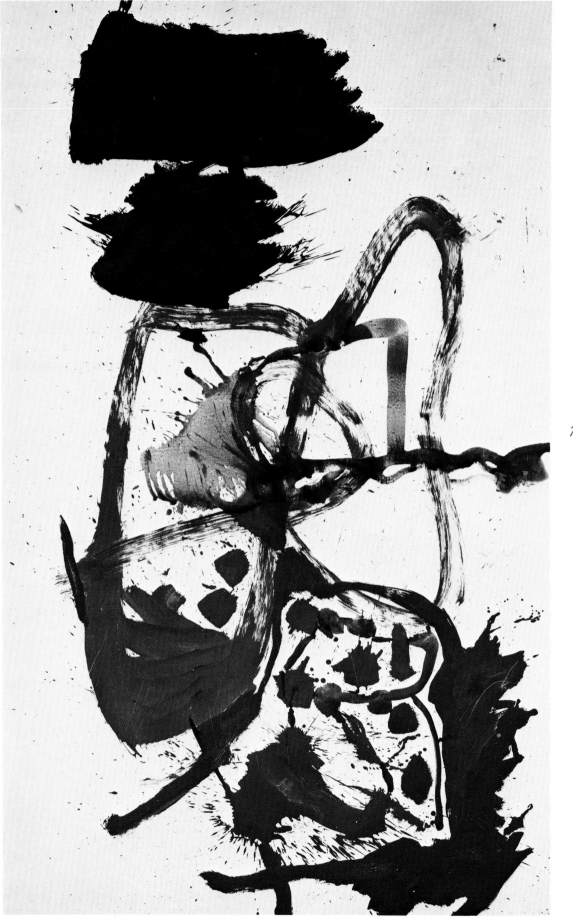

78. WINTER FIGURE WITH BLACK OVERHEAD. *1959*
Oil on sized, primed canvas, 84×53″

79. ITALIAN BEACH. *1960*
Oil on sized, primed canvas, 67×82″

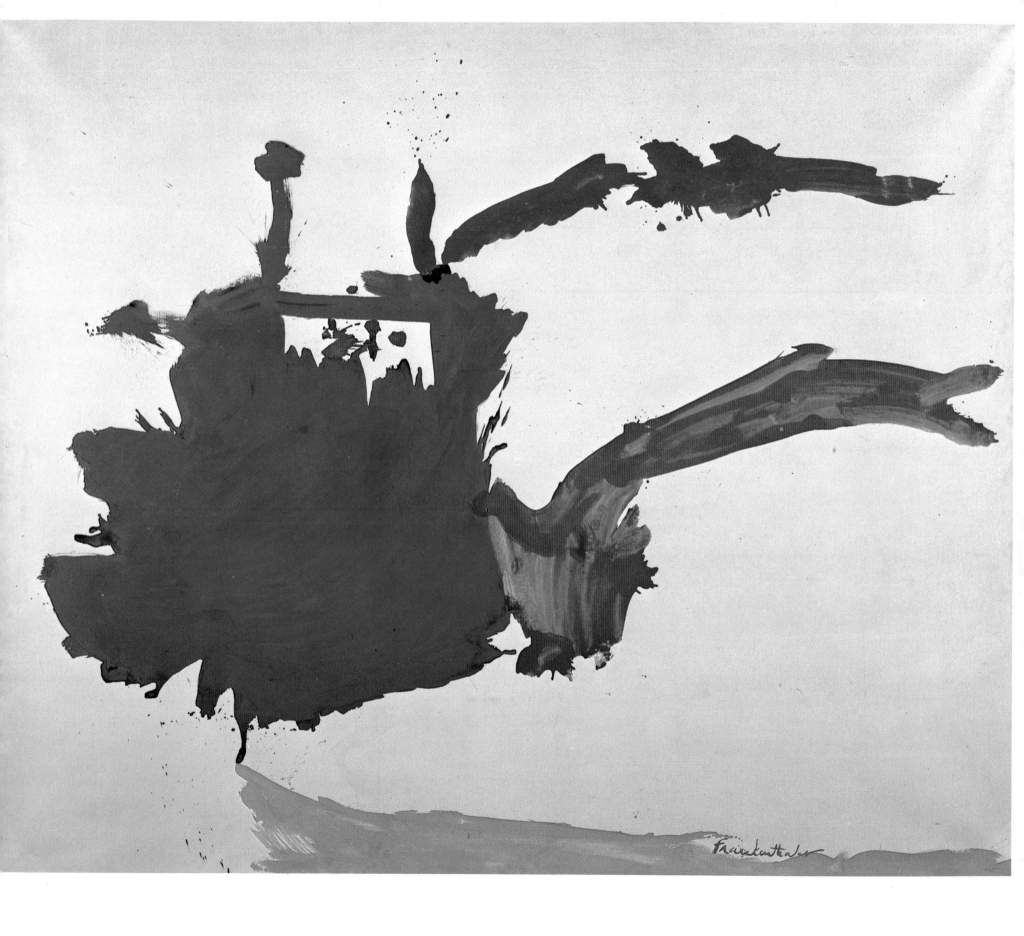

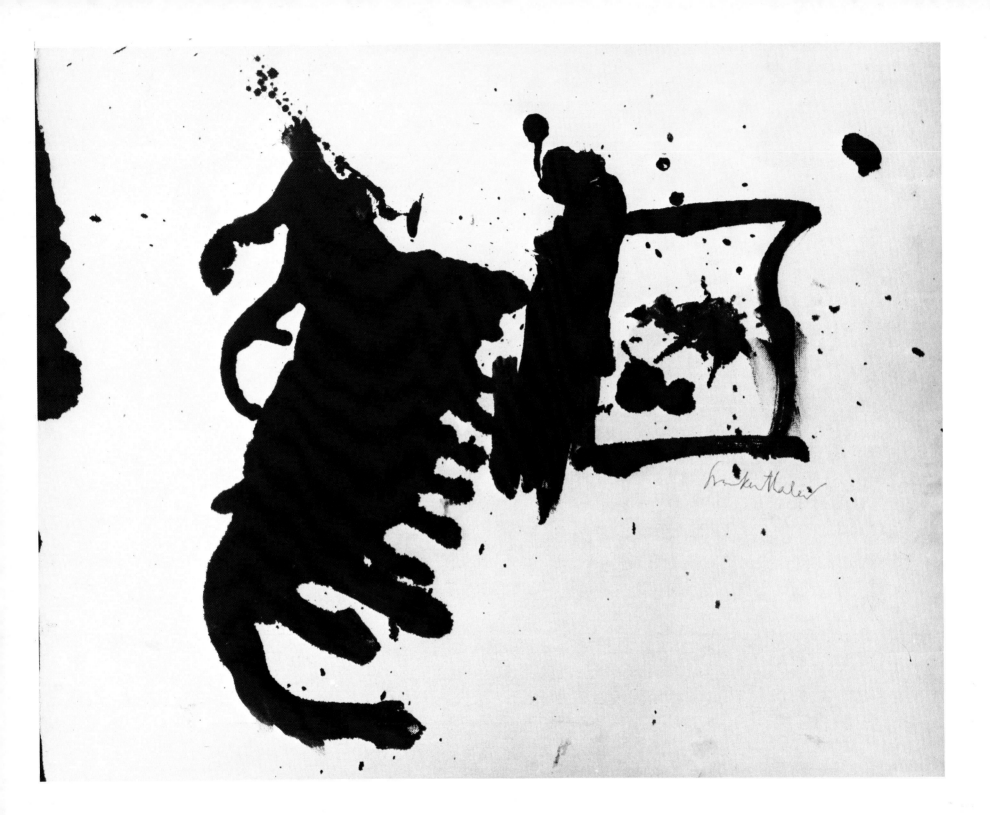

80. ANIMAL SCENE. *1960. Oil on canvas board, 14×17¾". Collection Jay Steffy, Los Angeles*

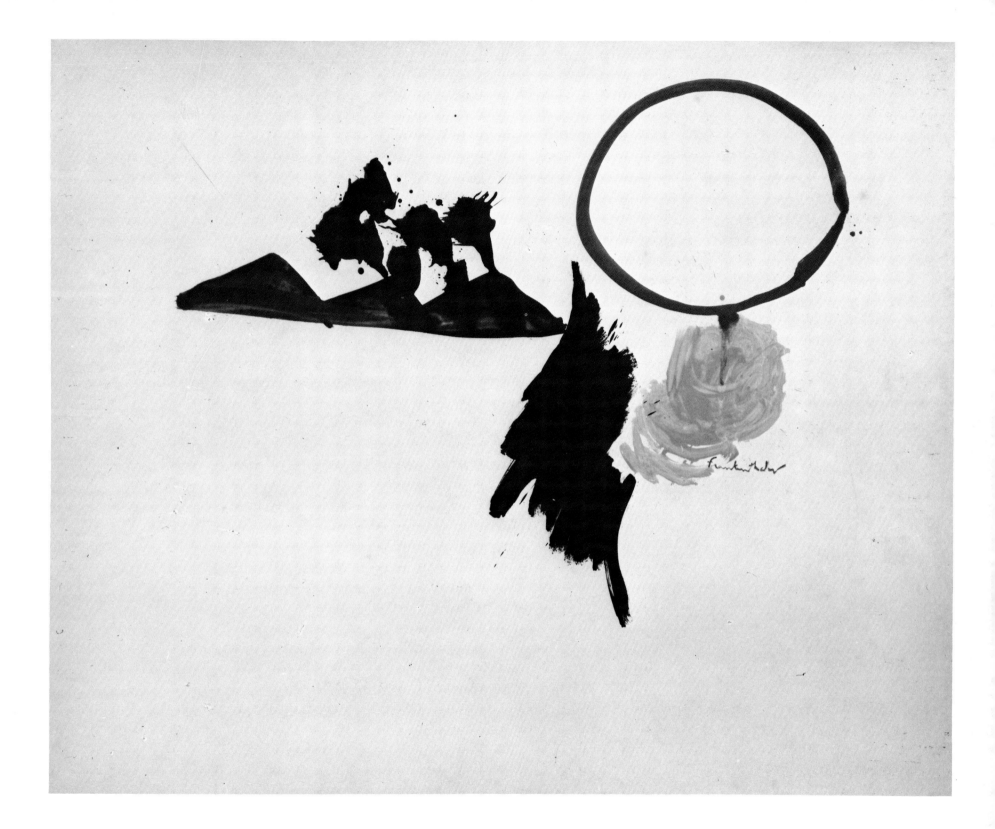

81. FIGURE IN LANDSCAPE. *1960. Oil on sized, primed canvas, 57 × 73″. Collection Mr. and Mrs. John D. Murchison, Dallas*

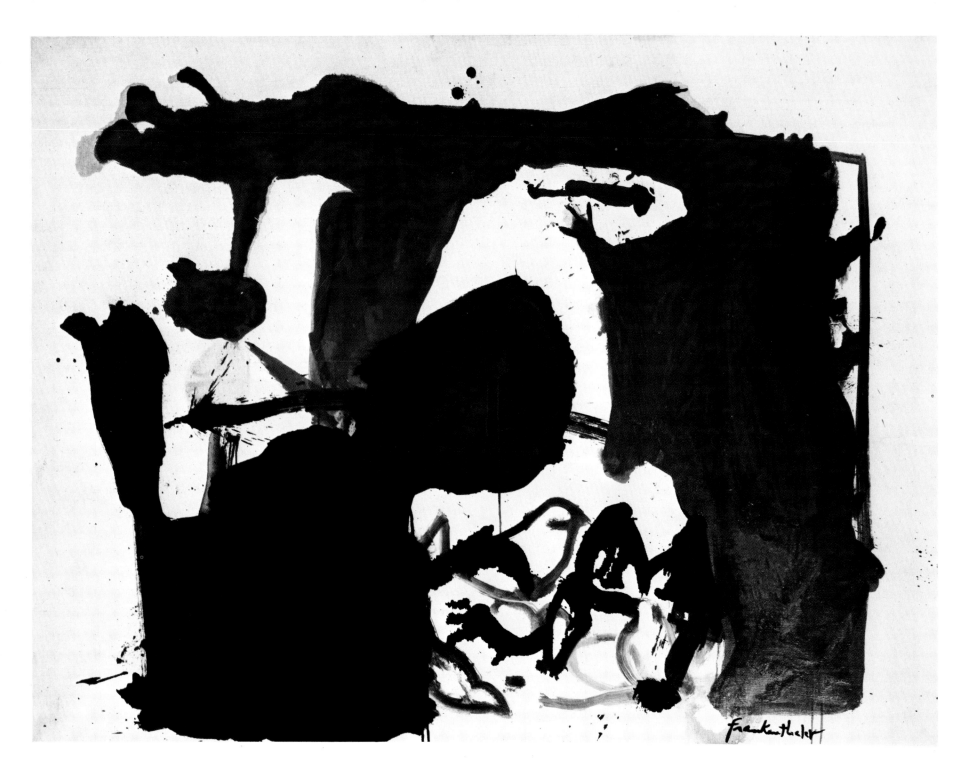

82. COLOMBE. *1960. Oil on sized, primed canvas, 39×52″.*

83. MEDITERRANEAN THOUGHTS. *1960. Oil on sized, primed canvas, 8′ 5″×7′ 10½″*

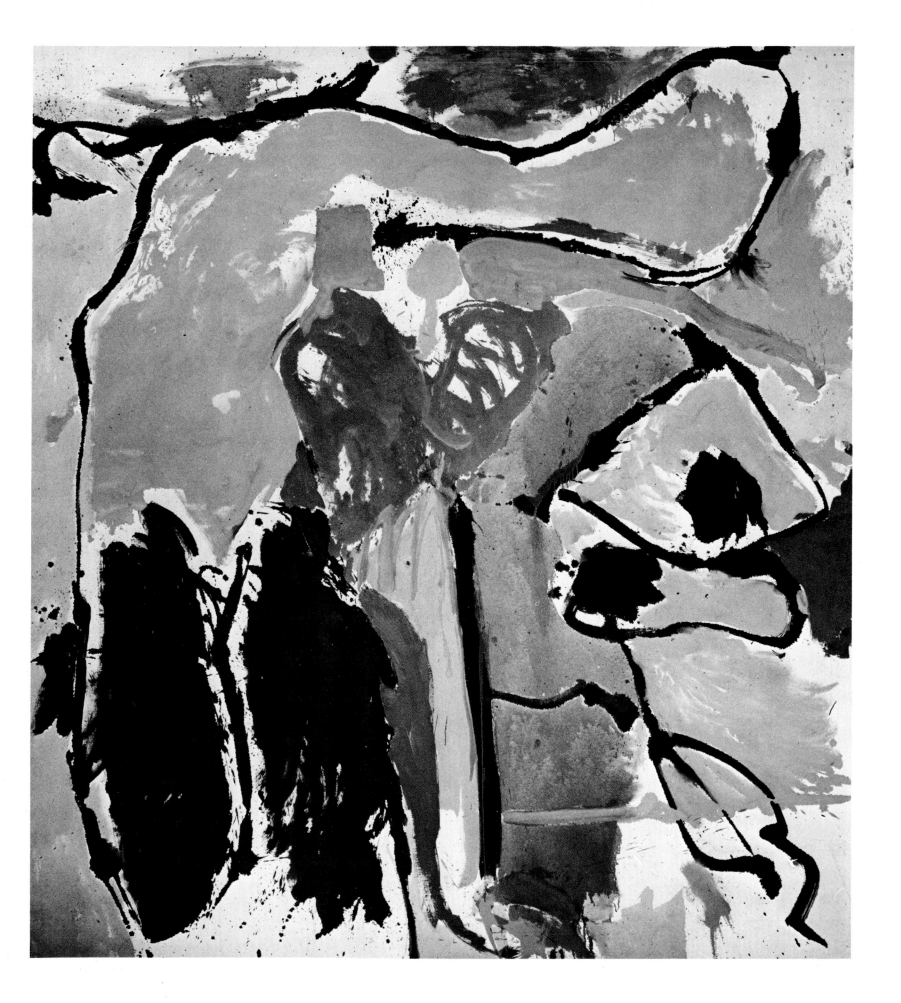

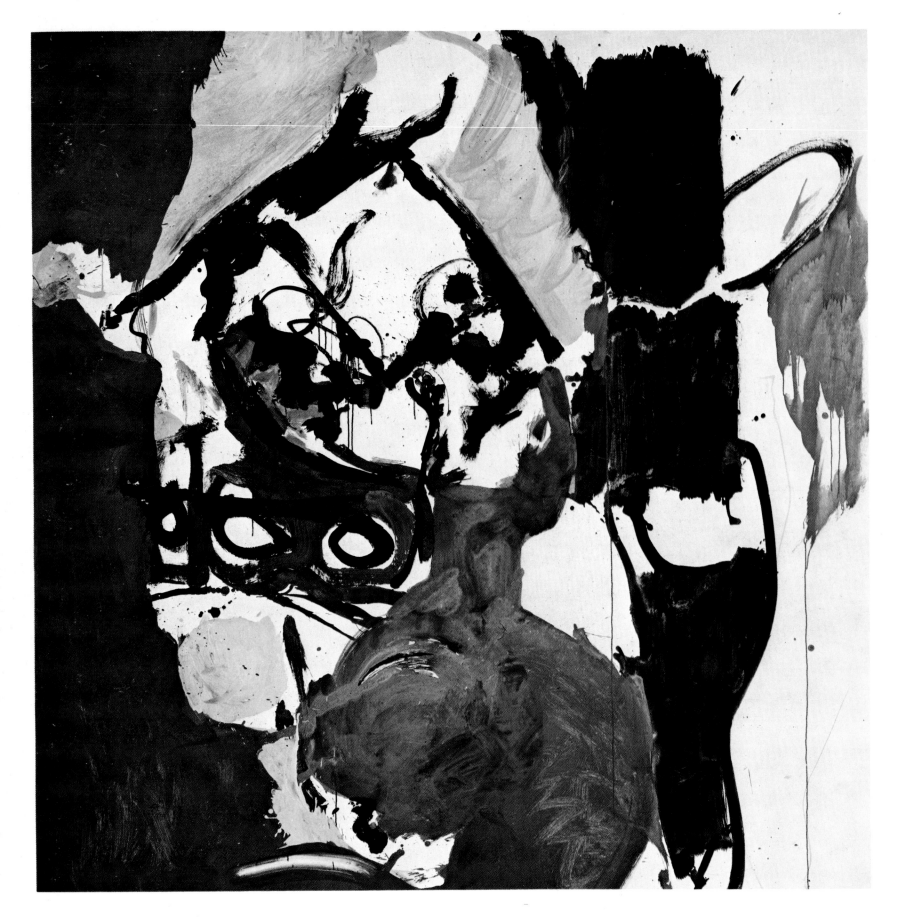

84. FIGURE WITH THOUGHTS. *1960. Oil on sized, primed canvas, 79×77³/₄". Collection Mr. and Mrs. Robert Gutman, Princeton, N.J.*

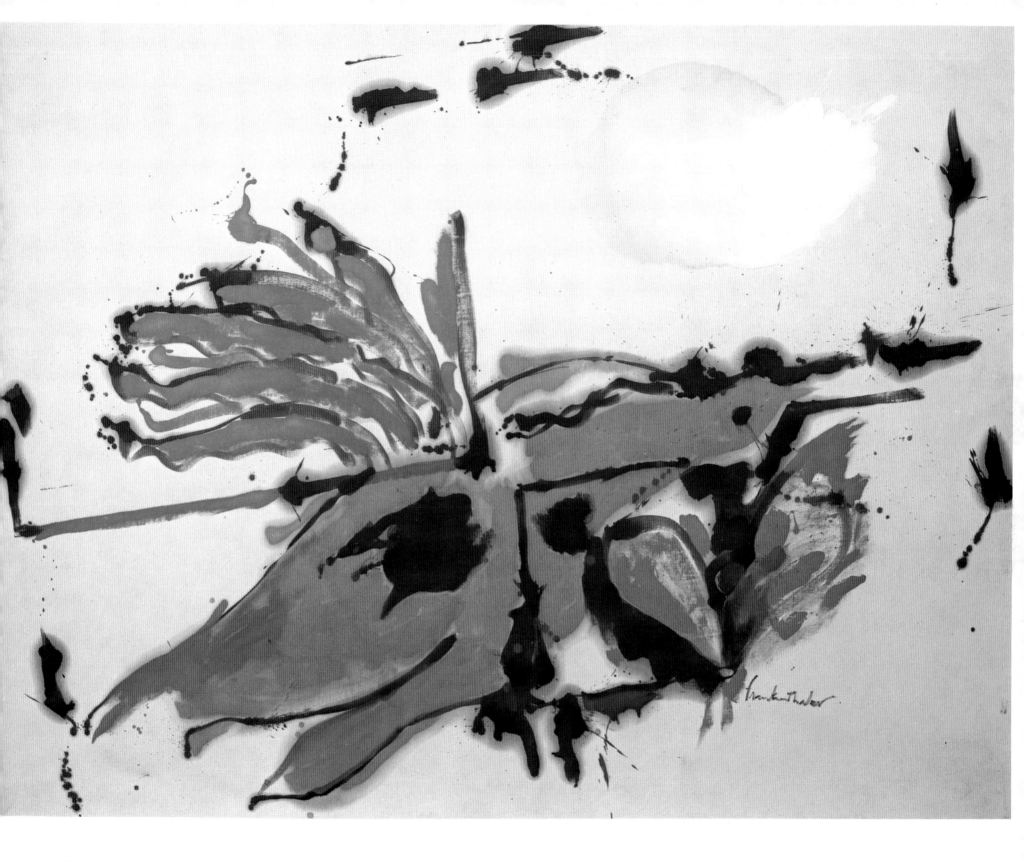

85. PINK BIRD FIGURE. *1961. Oil on canvas, 72×94"*

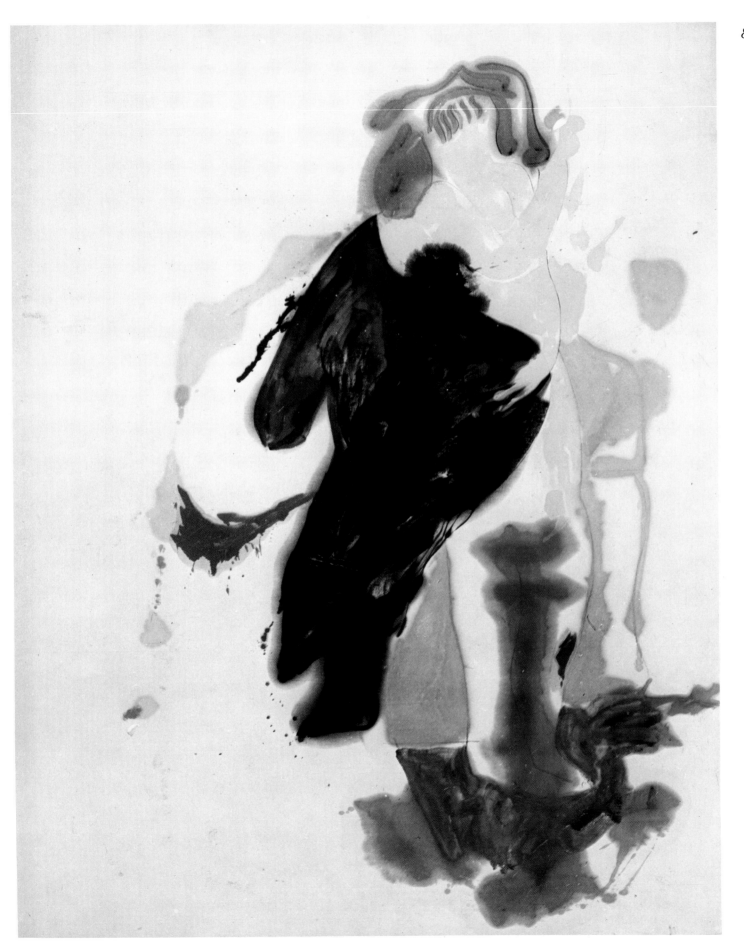

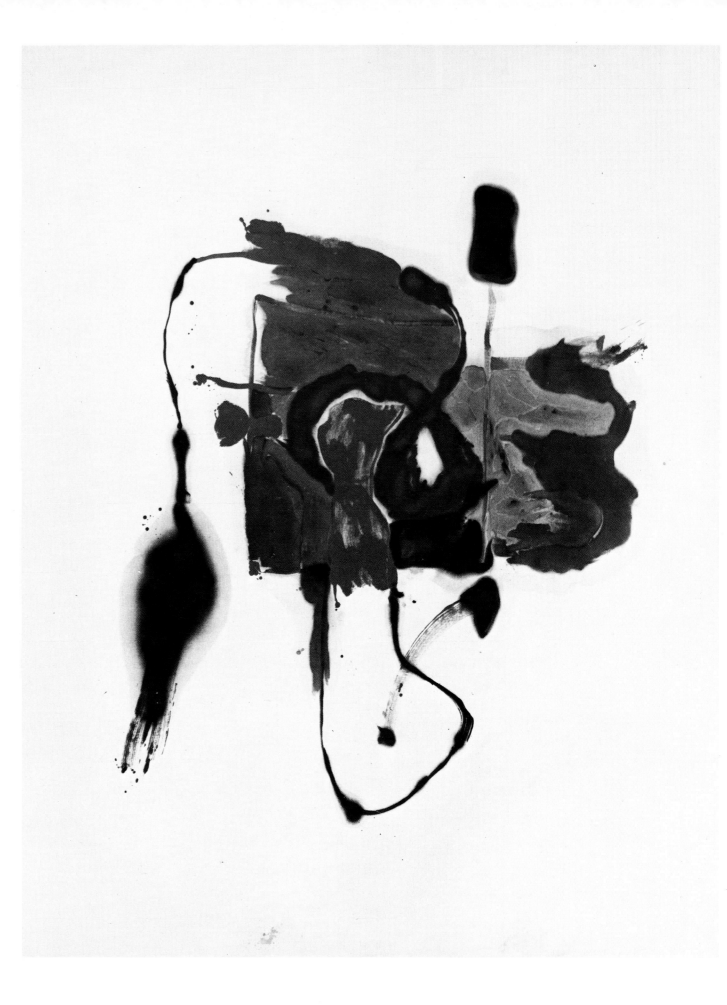

87. BLUE FORM IN A SCENE. *1961*
Oil on canvas, 9′ 9″ × 7′ 9″
Collection Mrs. George Wheelwright, Reno

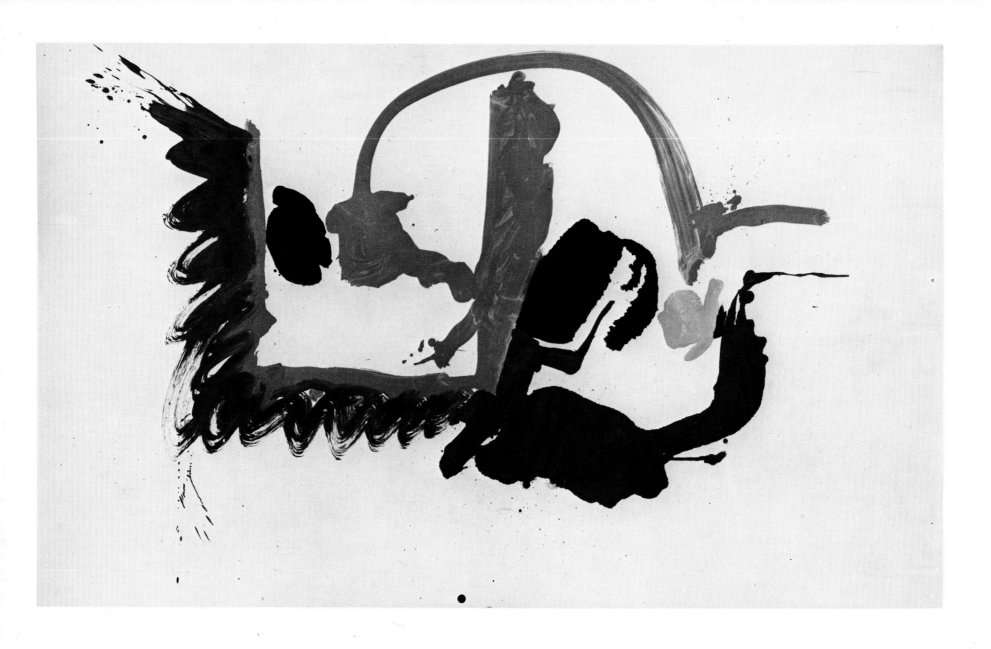

88. MAY SCENE. *1961. Oil on sized, primed canvas, 36×60″*

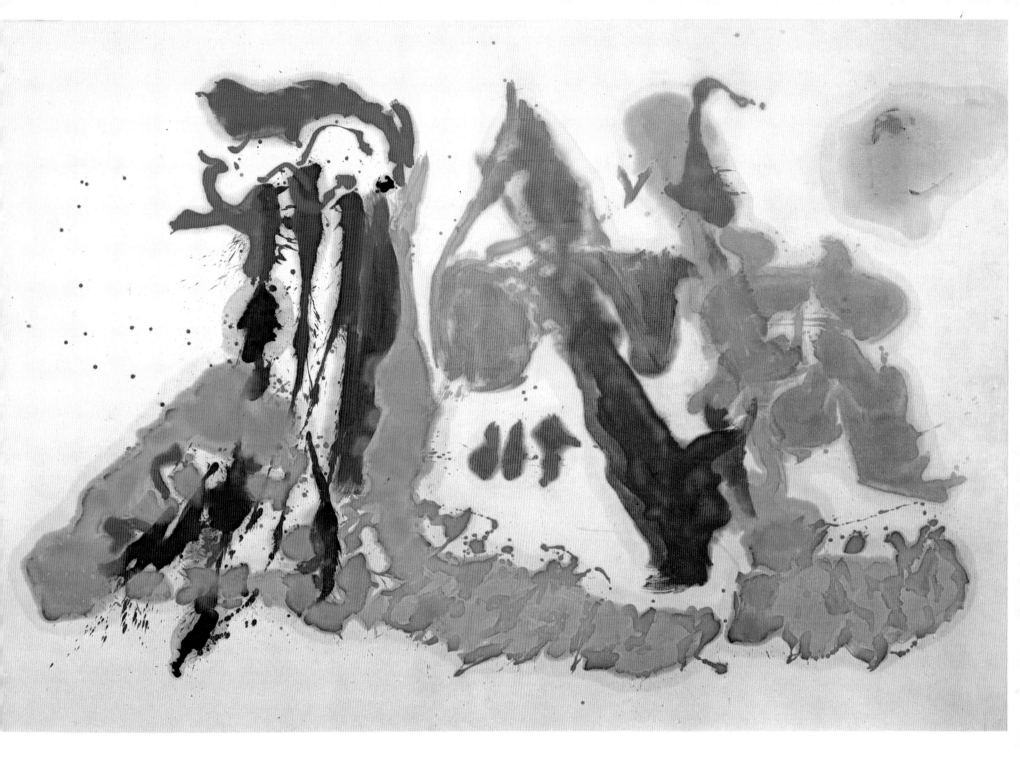

89. ARDEN. *1961. Oil on canvas, 7' 3½" × 10' ¼". Whitney Museum of American Art, New York City*

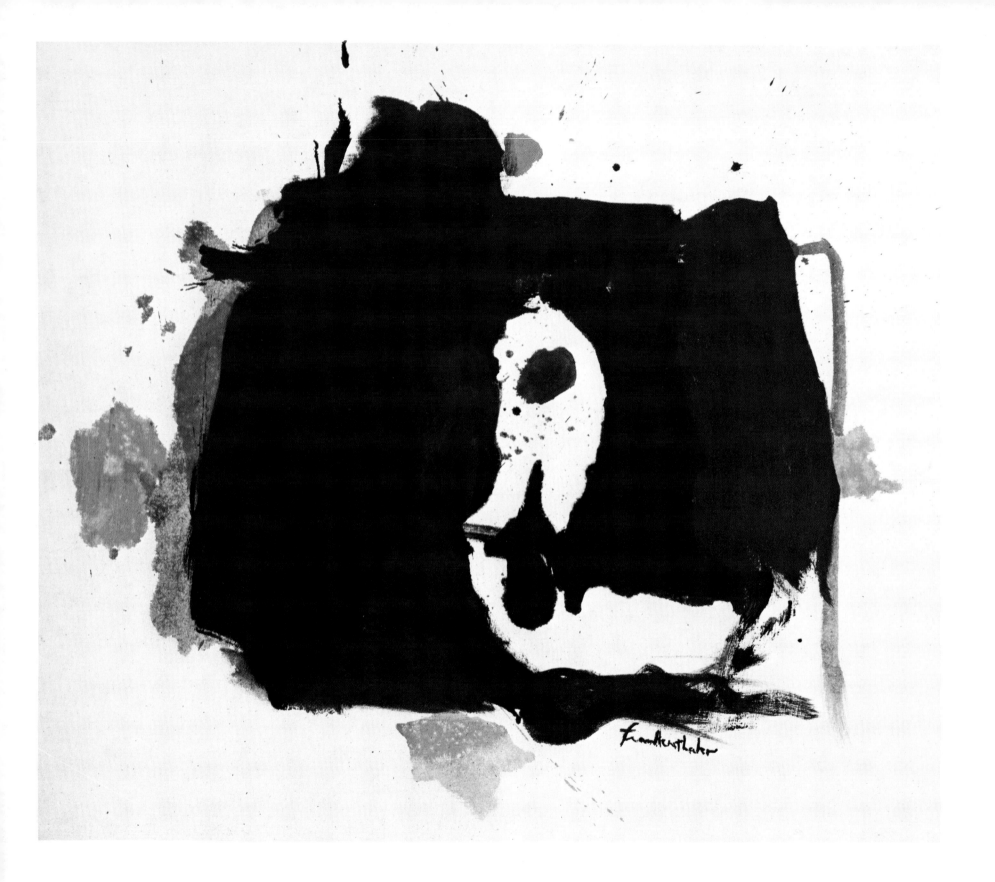

90. NO. 2 ON "TIRE" THEME. *1961. Oil on sized, primed canvas, 46×55″*

91. MOVING DAY. *1961. Oil on sized, primed canvas, 68⅞×59⅞″. Joseph H. Hirshhorn Collection*

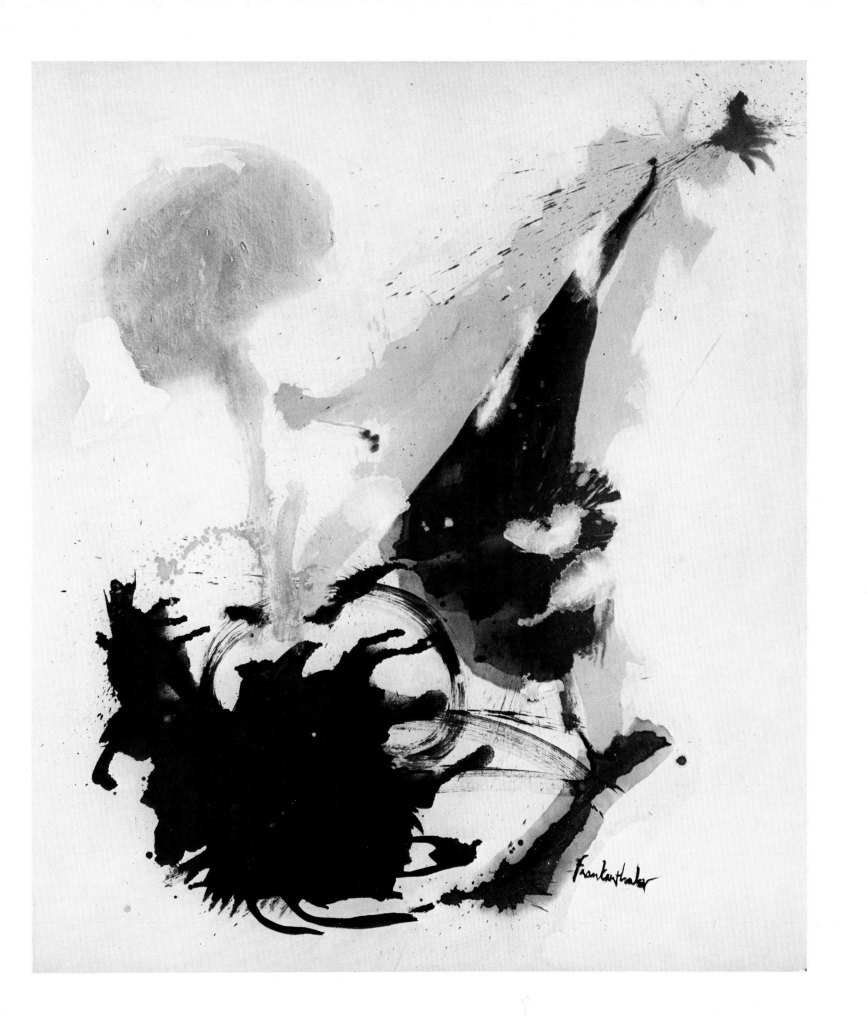

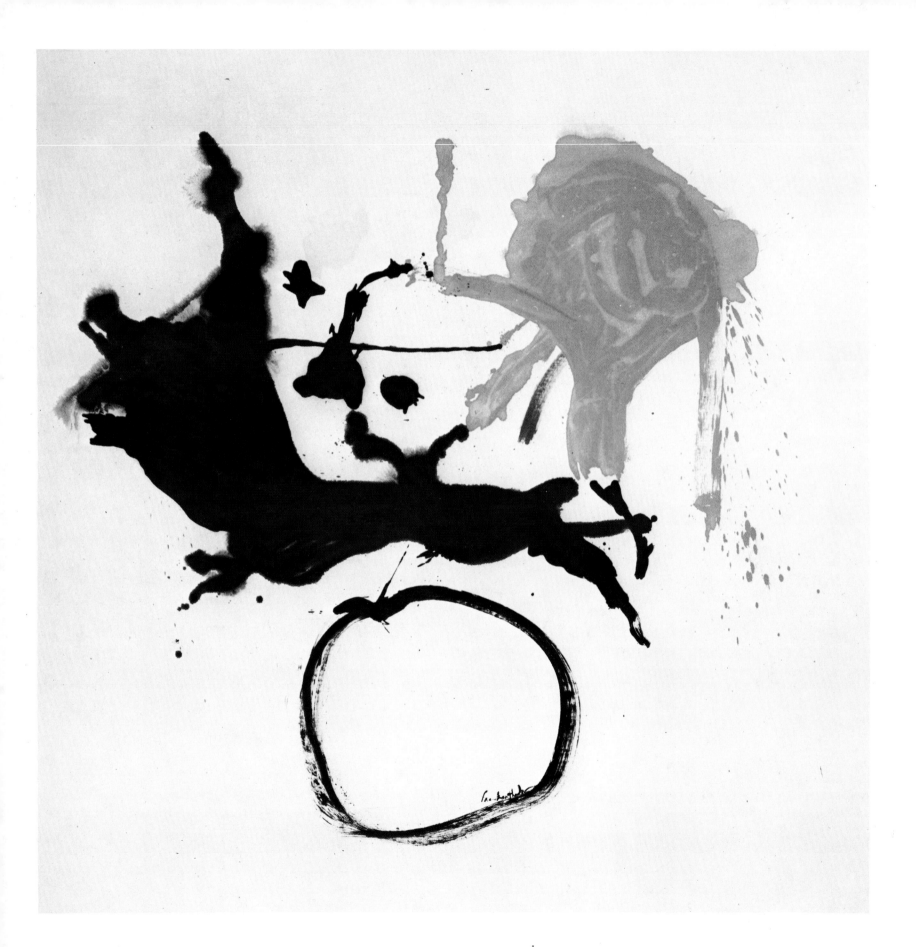

92. OVER THE CIRCLE. *1961. Oil on sized, primed canvas, 84×87". The James Michener Collection, University of Texas Art Museum, Austin*

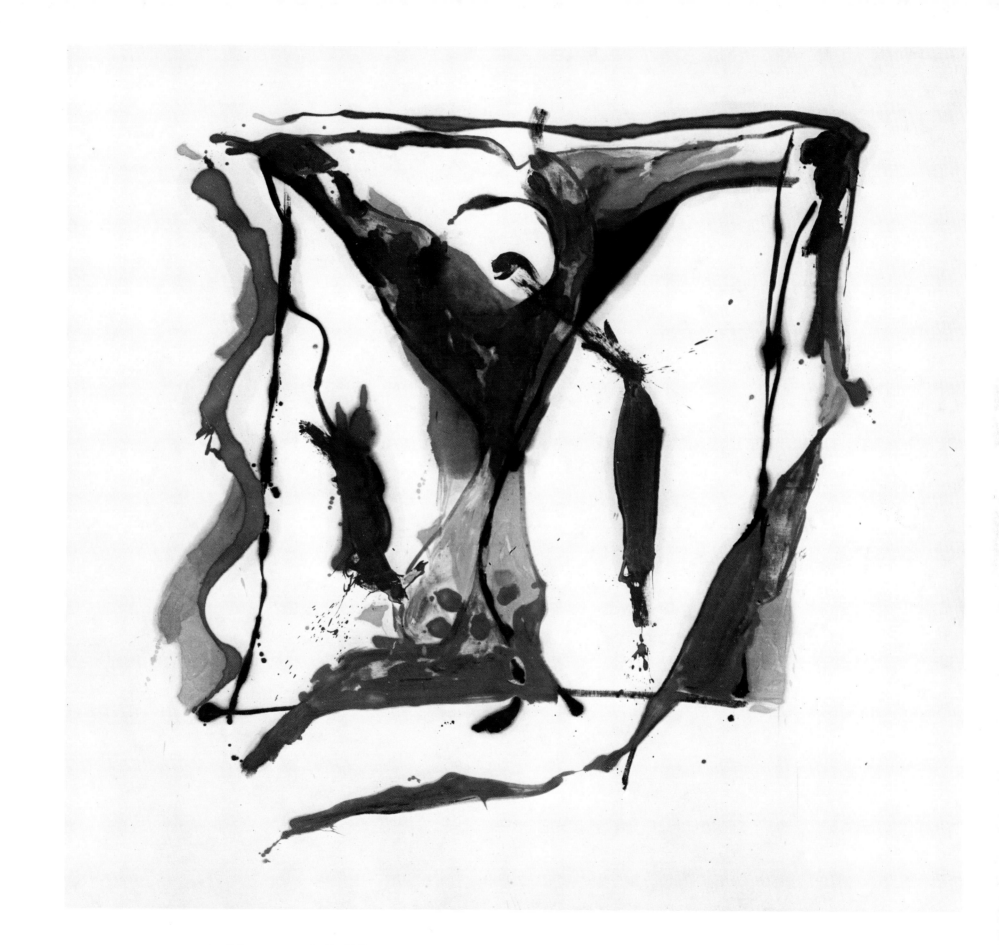

93. PROVINCETOWN I. *1961. Oil on canvas, 7′ 9″ ×8′ 6″*

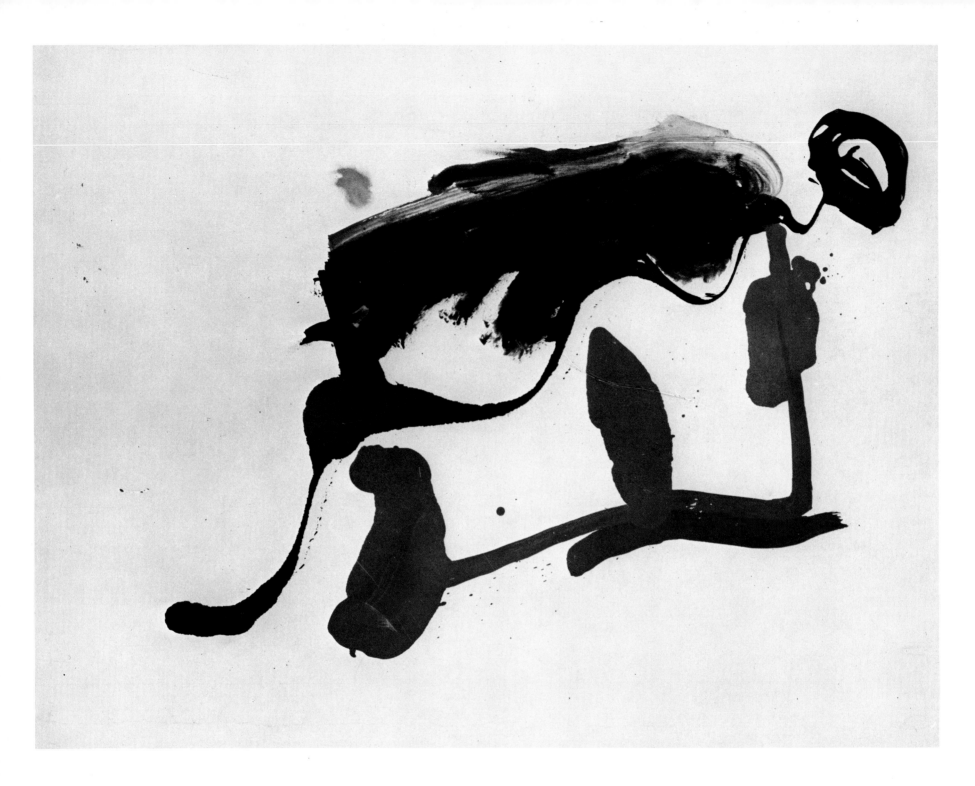

94. RECLINING ON A SQUARE. *1961. Oil on sized, primed canvas, 36×48¼". Collection Jerome R. Zipkin, New York City*

95. BLUE CATERPILLAR. *1961. Oil on canvas, 9′ 9⅛″×5′ 8½″. Private collection, New York City*

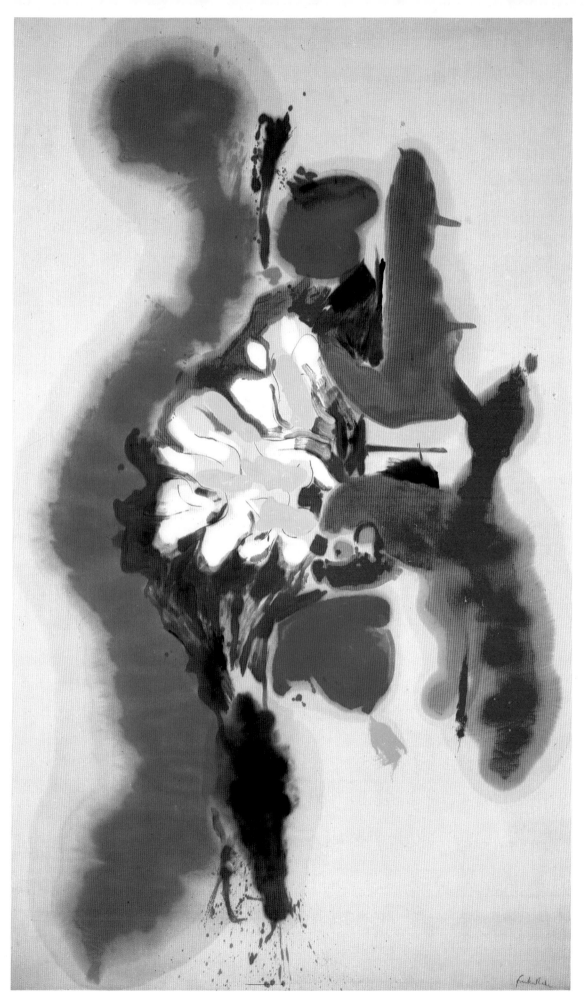

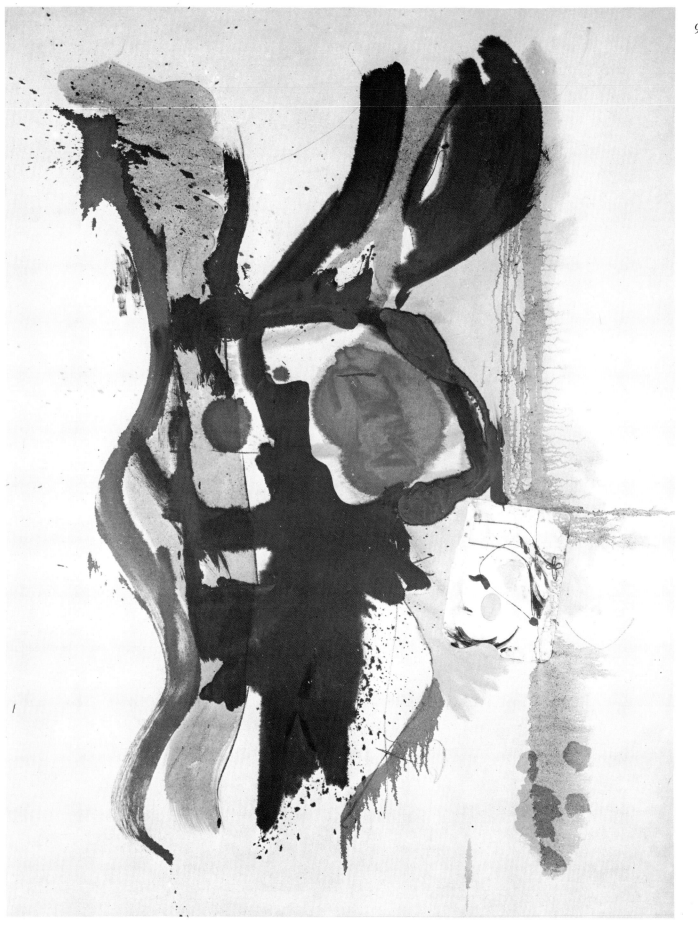

96. SCENE WITH PALETTE. *1961*
Oil on sized, primed canvas with
paper palette, 72×54″

97. ORANGE BREAKING THROUGH. *1961*
Oil on canvas, 93×95″
Collection Mr. and Mrs. David Mirvish, Toronto

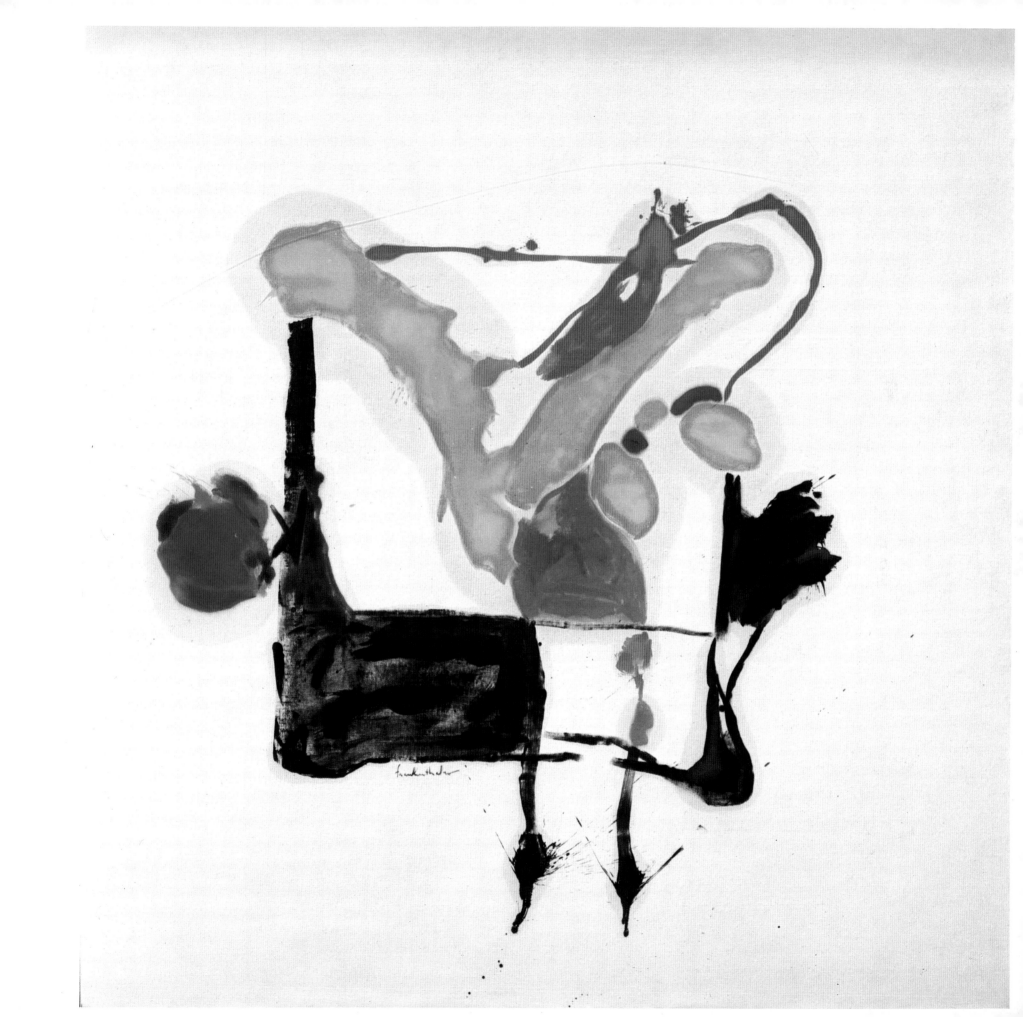

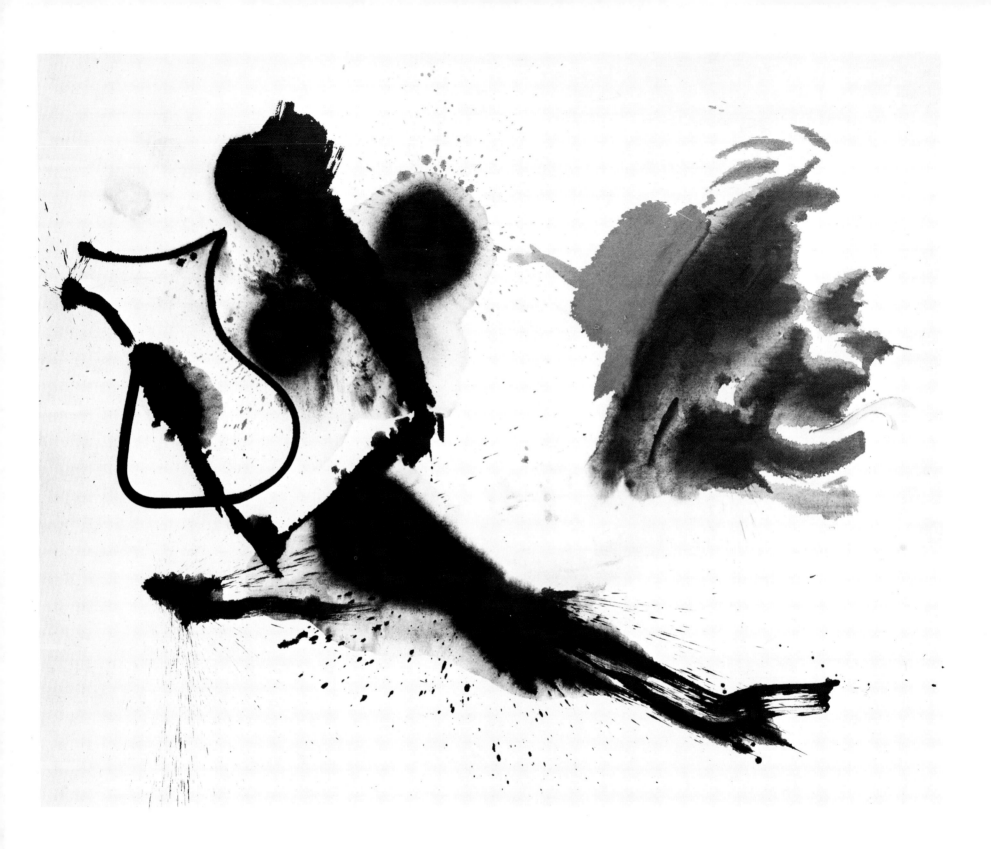

98. SVENGALI. *1961. Oil on sized, primed canvas, 52×64″. Collection Kimiko and John Powers, Aspen, Colo.*

99. SQUARE FIGURE. *1961. Oil on sized, primed canvas, 98×97″*

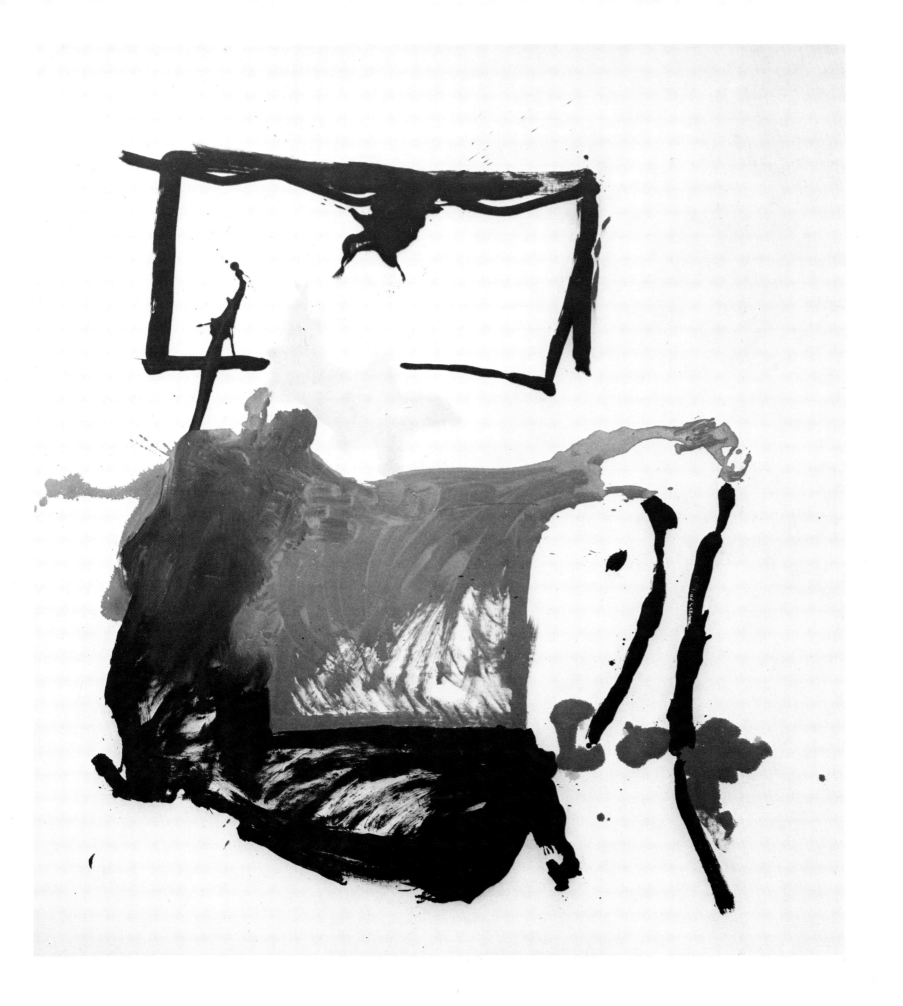

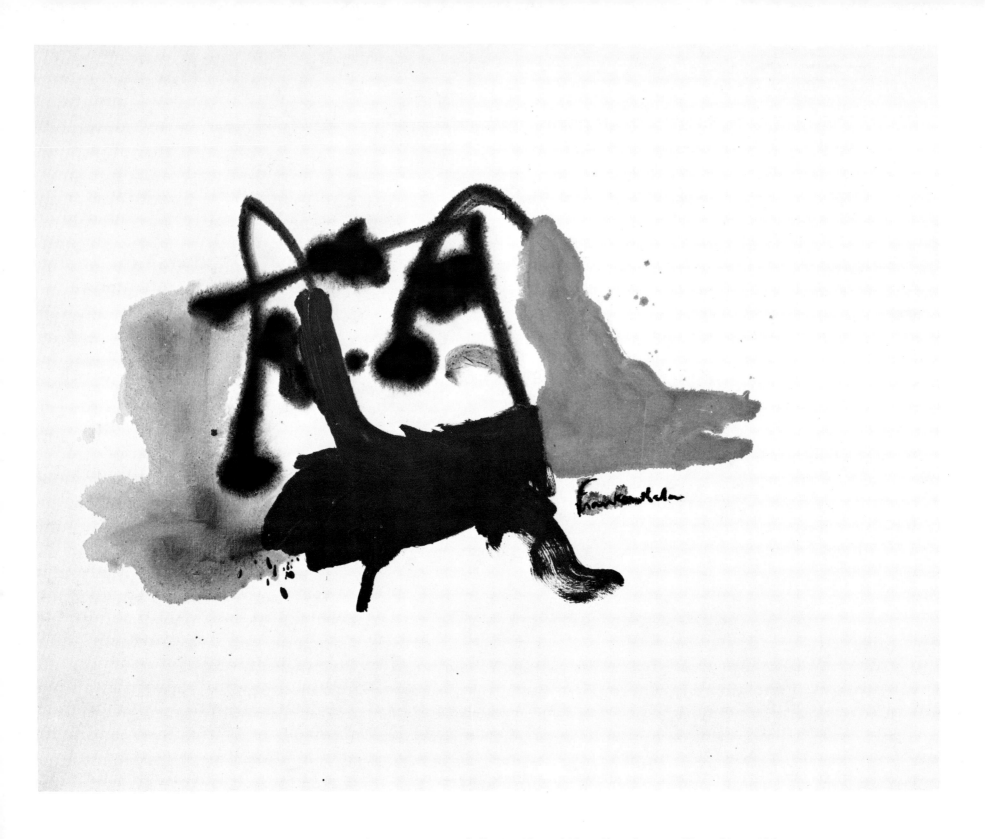

100. THREE–COLOR ANIMAL SCENE. *1961. Oil on sized, primed canvas, 35 × 45". Collection Mr. and Mrs. Abner Brenner, Chevy Chase, Md.*

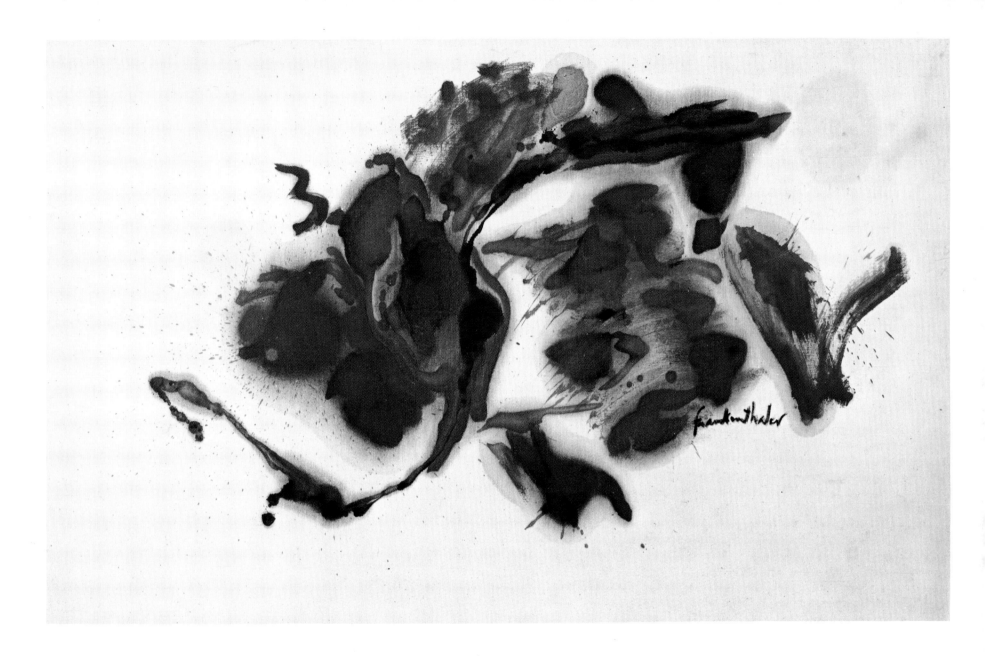

101. TWO MOONS. *1961. Oil on canvas, 32 × 51¾". Collection Lord Dufferin, London*

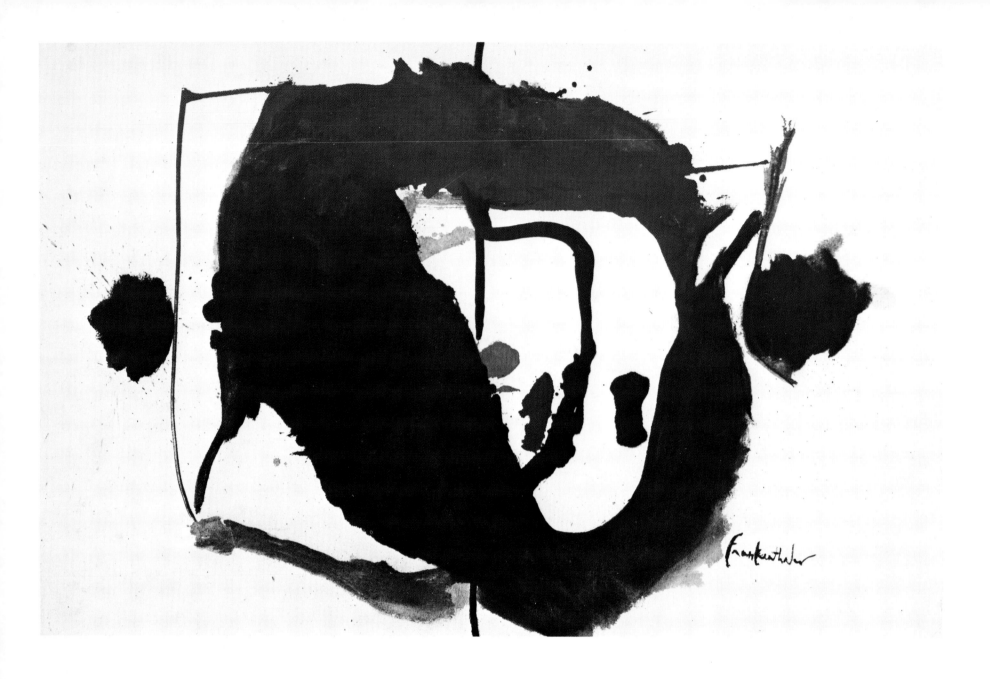

102. TIRE. *1961. Oil on sized, primed canvas, 48×72″*

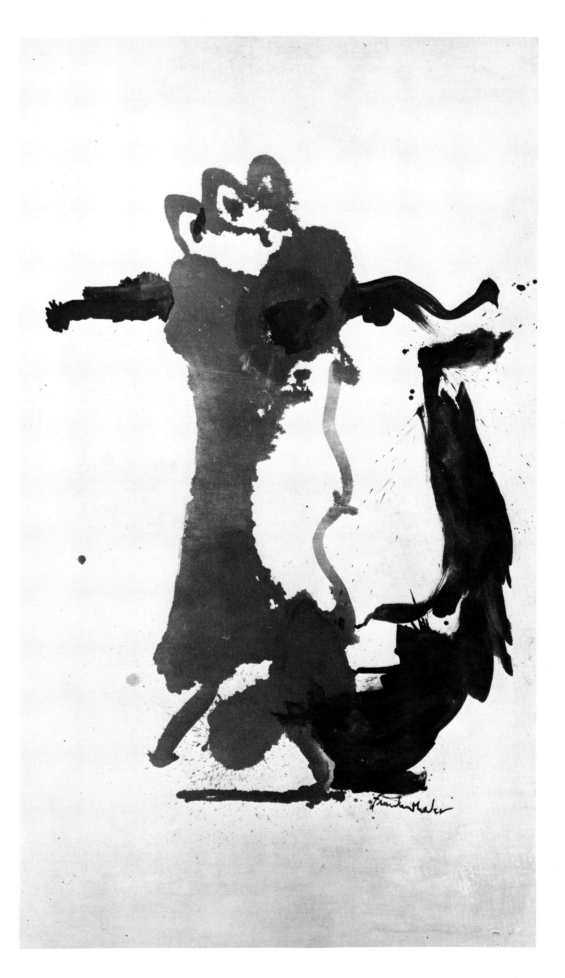

103. TWO-STEP. *1961*
Oil on canvas, primed with gesso, 81¹/₂ × 48¹/₂"

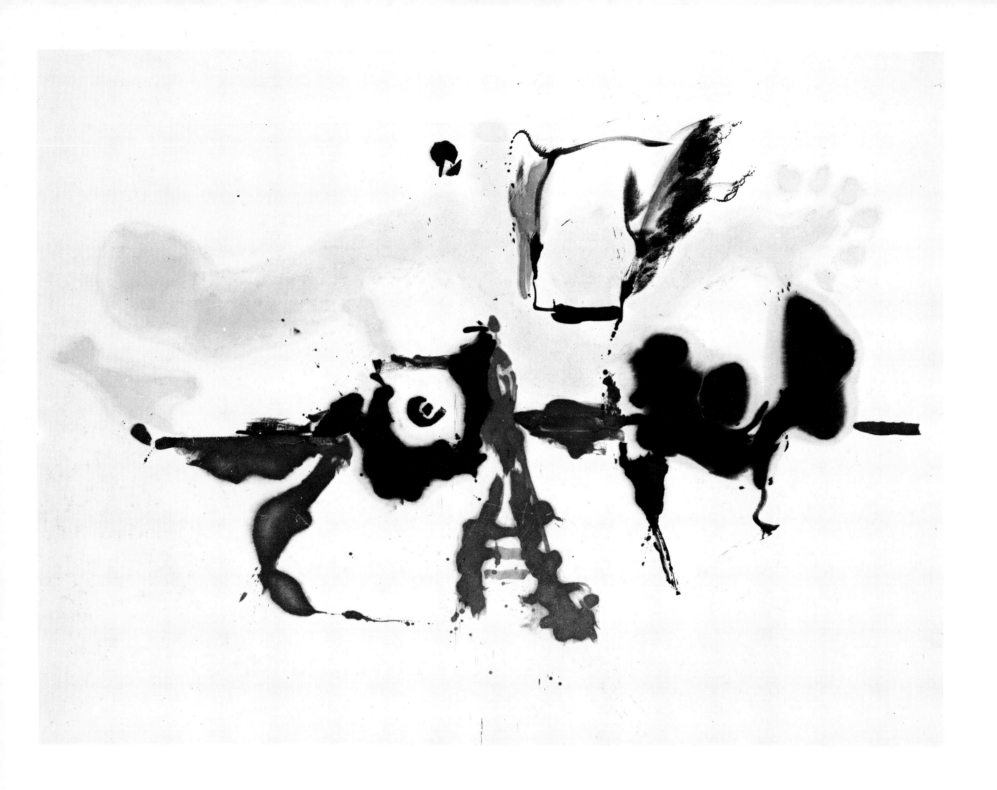

104. YELLOW CATERPILLAR. *1961. Oil on canvas, 7′ 6″ × 10′. Collection Henry Geldzahler, New York City*

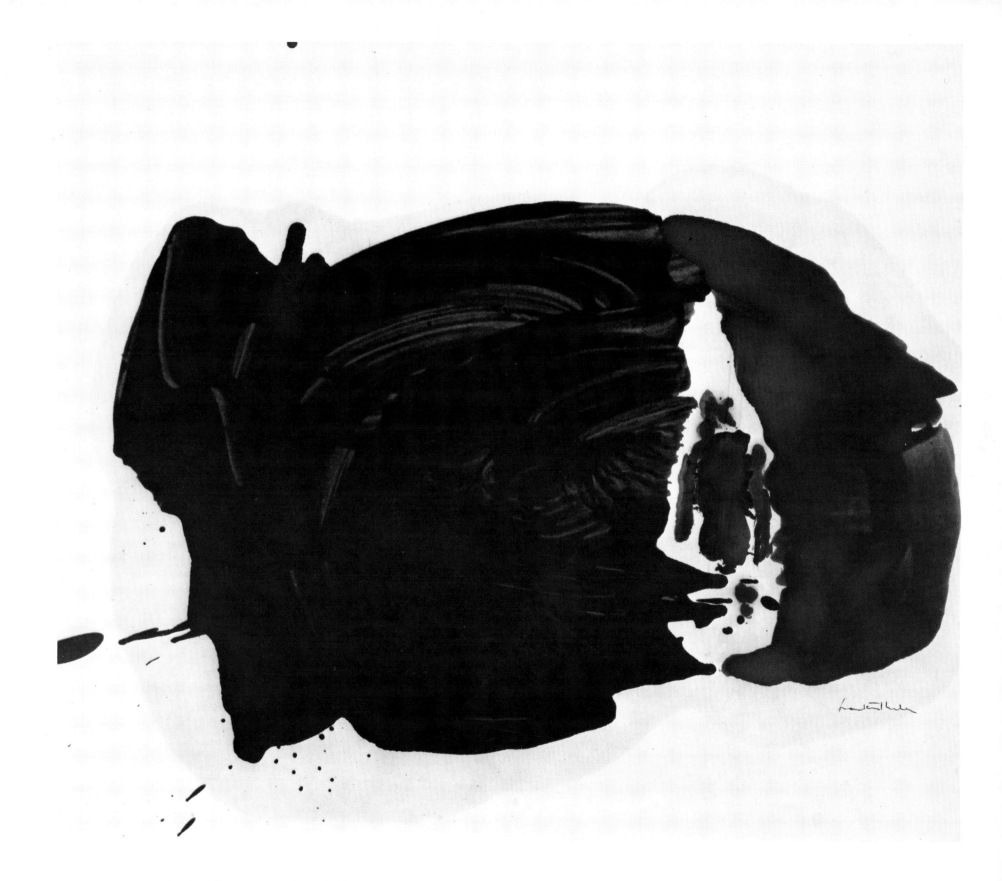

105. UNTITLED. *196 -62. Oil on paper, 13½ × 16¼"*

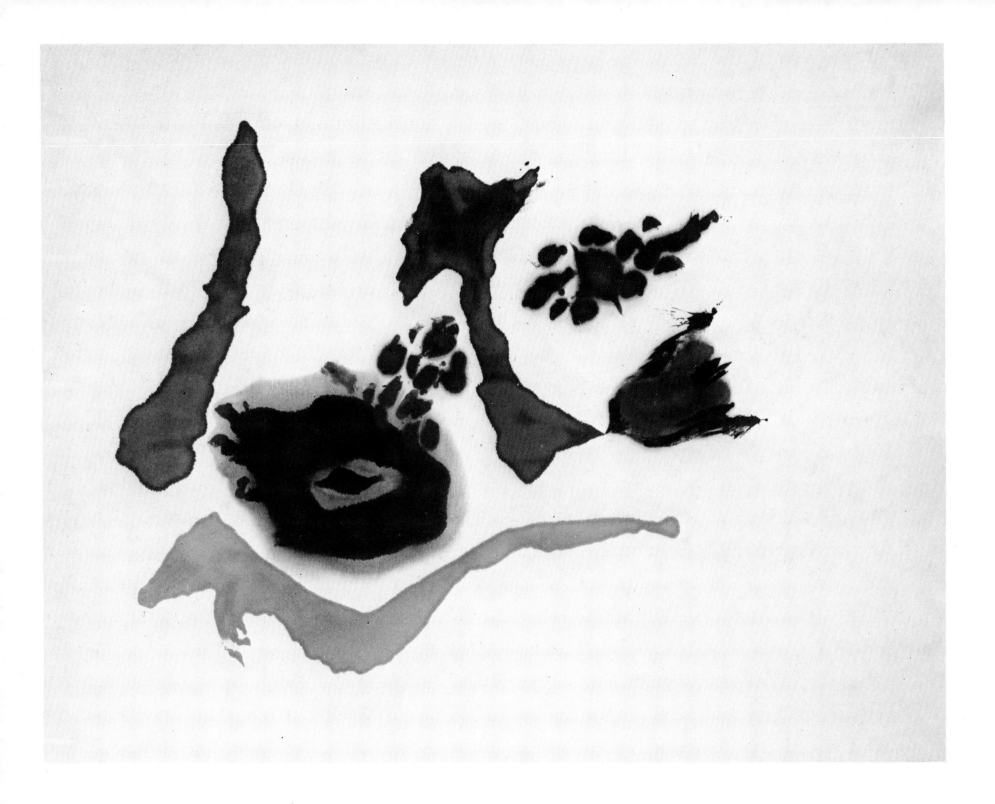

106. THE CAPE. *1962. Oil on canvas, 53×69½". Collection Mrs. Gloria F. Ross, New York City*

107. APPROACH. *1962. Oil on canvas, 82×78". Private collection, New York City*

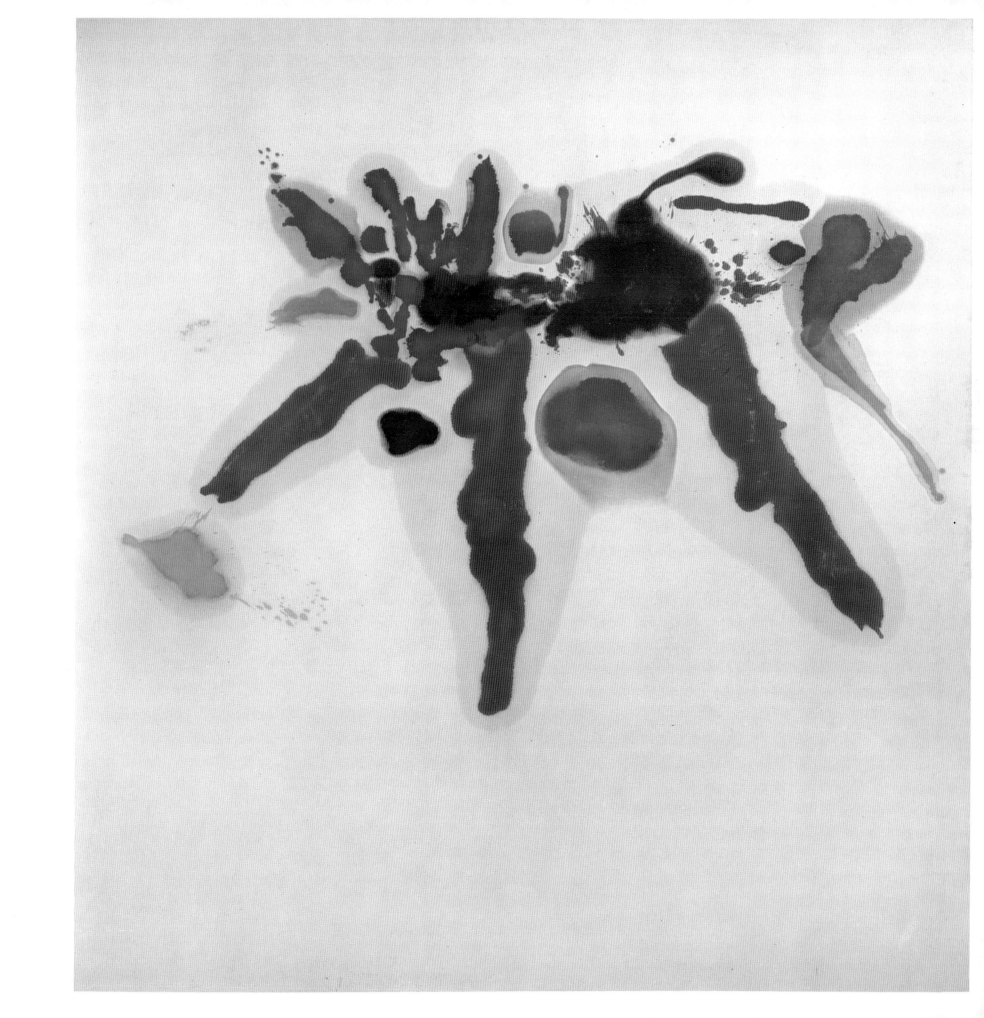

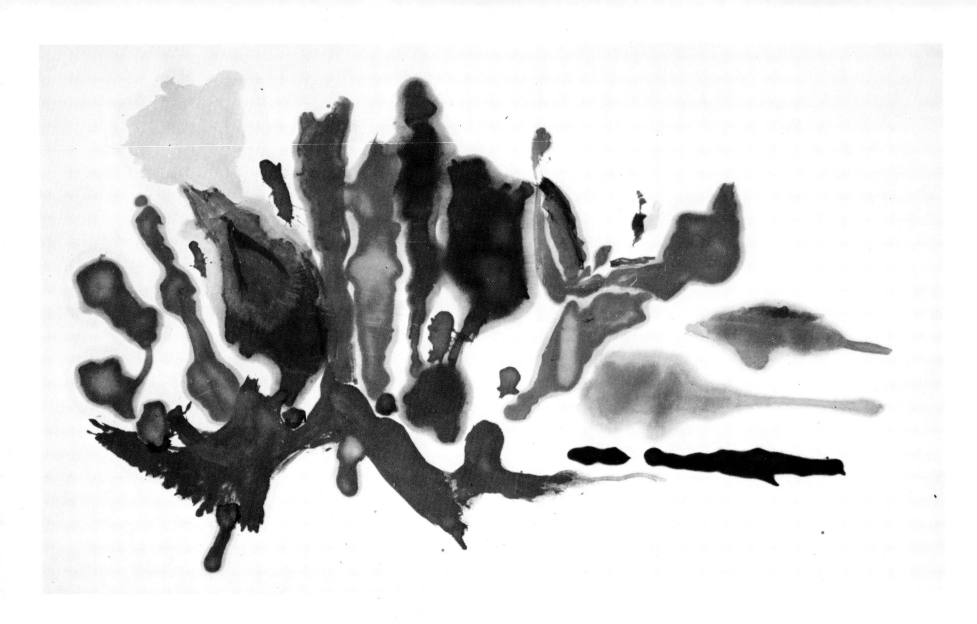

108. COOL SUMMER. *1962. Oil on canvas, 6×10′. Bennington College Collection, Vermont. Gift of the artist*

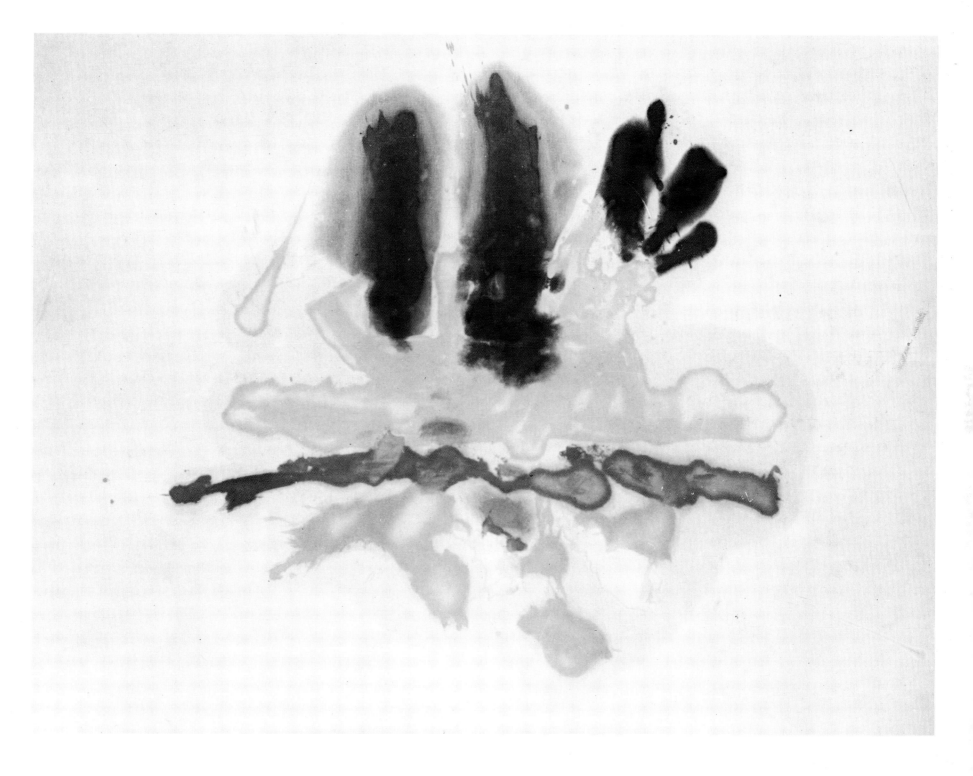

109. HOMMAGE A MARIE LAURENCIN. *1962. Oil on canvas, 60×80"*

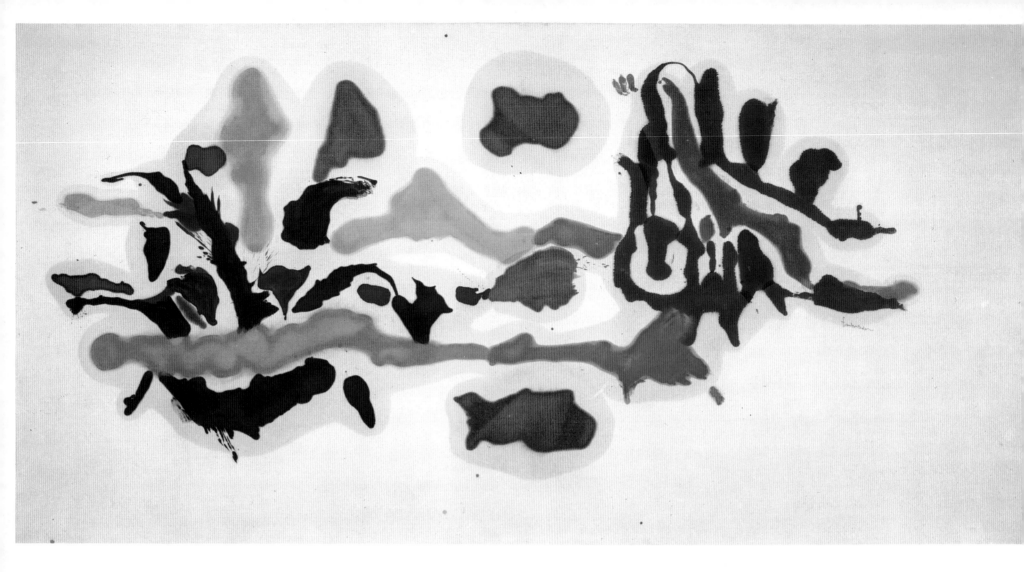

110. SEA SCAPE WITH DUNES. *1962. Oil on canvas, 5′ 10″ × 11′ 8″. New York University Art Collection, New York City*

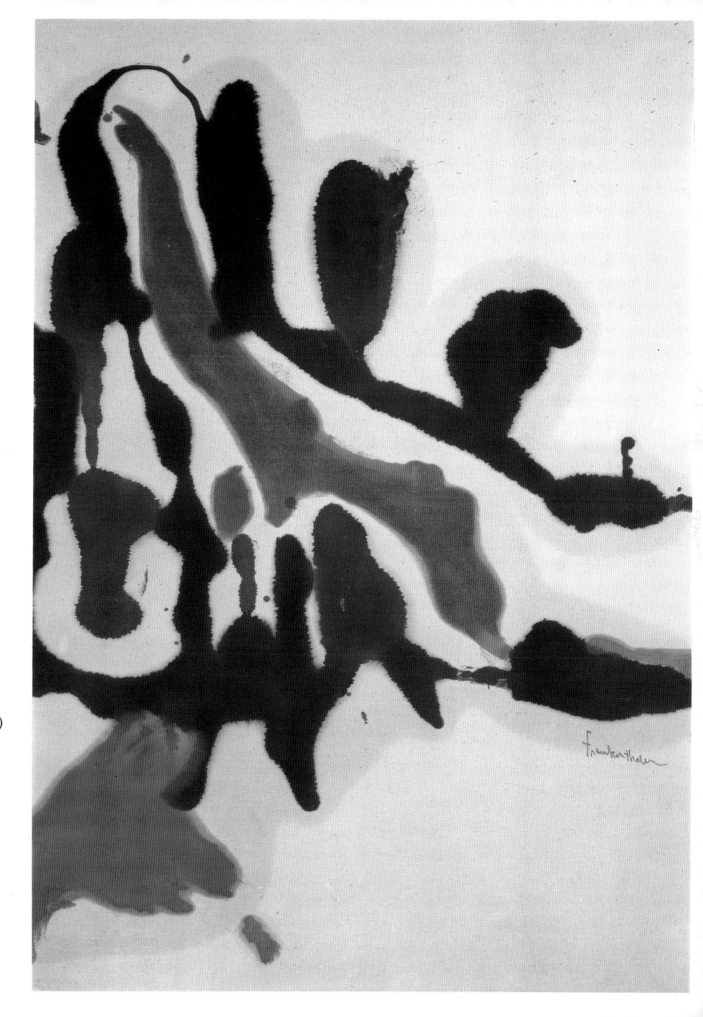

III. SEA SCAPE WITH DUNES (DETAIL)

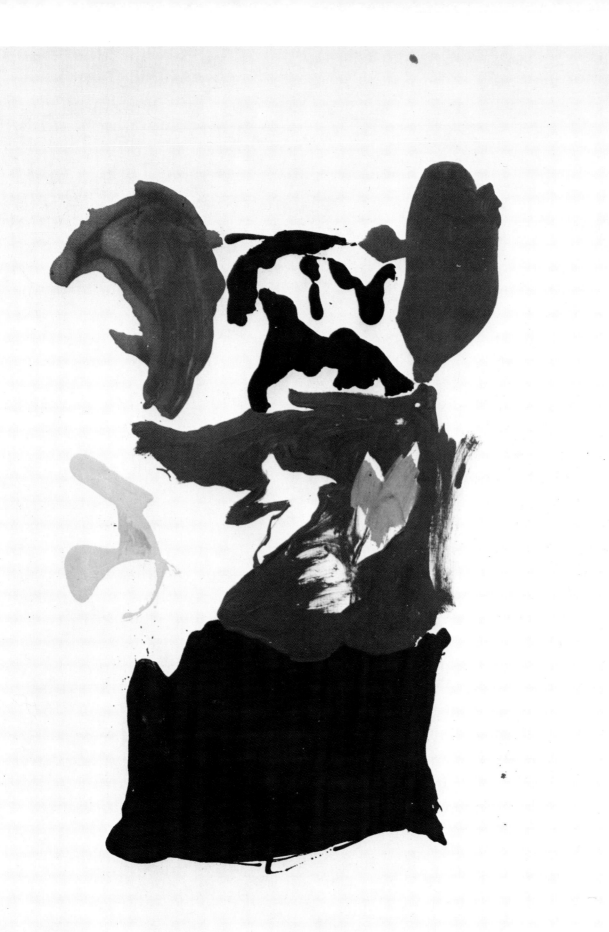

112. THE LAST SWAN LAKE. *1962.*
Oil on sized, primed canvas, 90×79″

113. ARCADIA. *1962*
Oil on canvas, 90×82″
Collection Mr. and Mrs. R. Allen Griffin,
Pebble Beach, Calif.

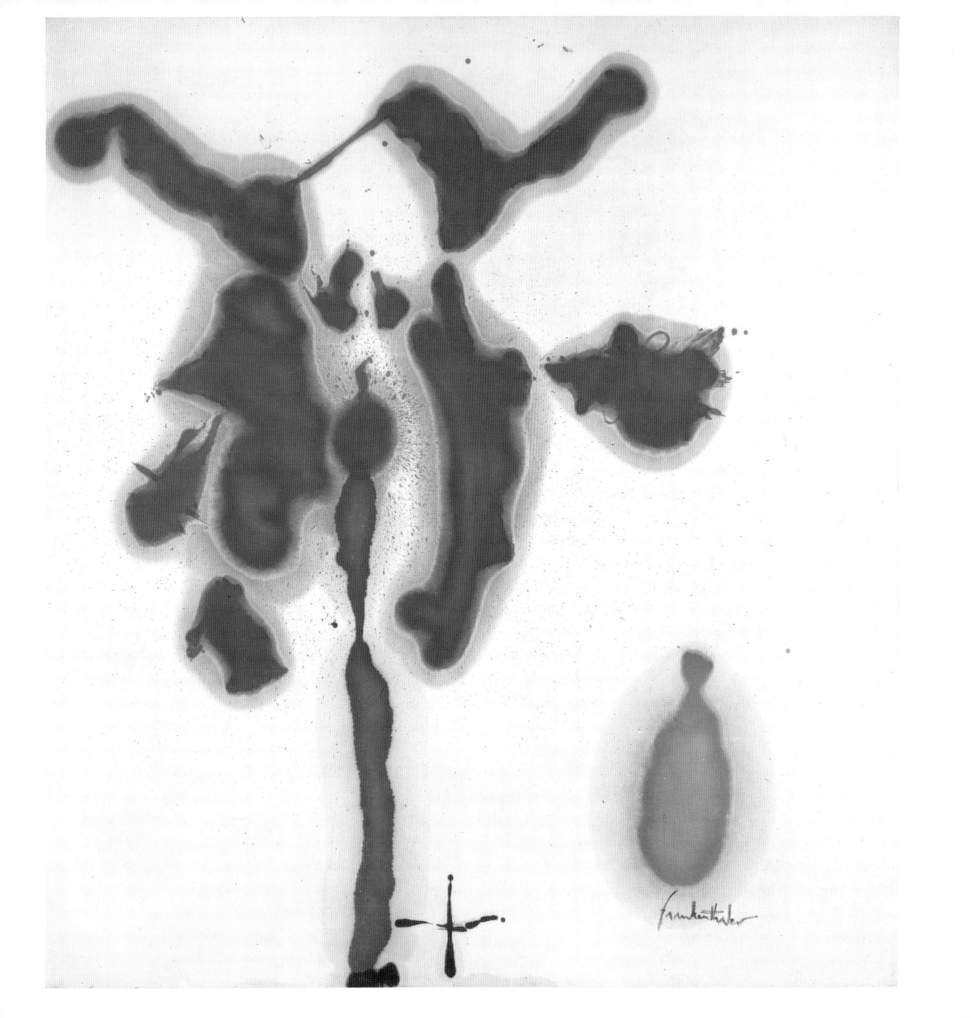

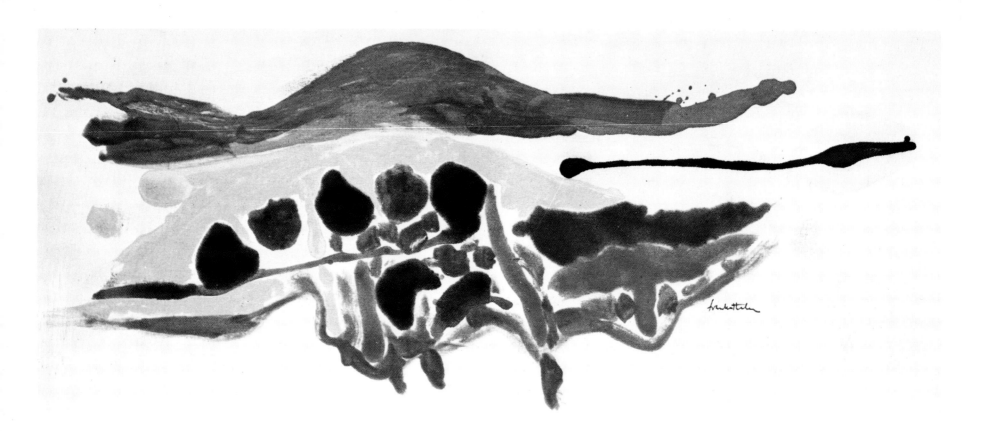

114. PINK FIELD. *1962. Oil on canvas, 24×58″*

115. NORTH WIND. *1962. Oil on canvas, 70½×56″*

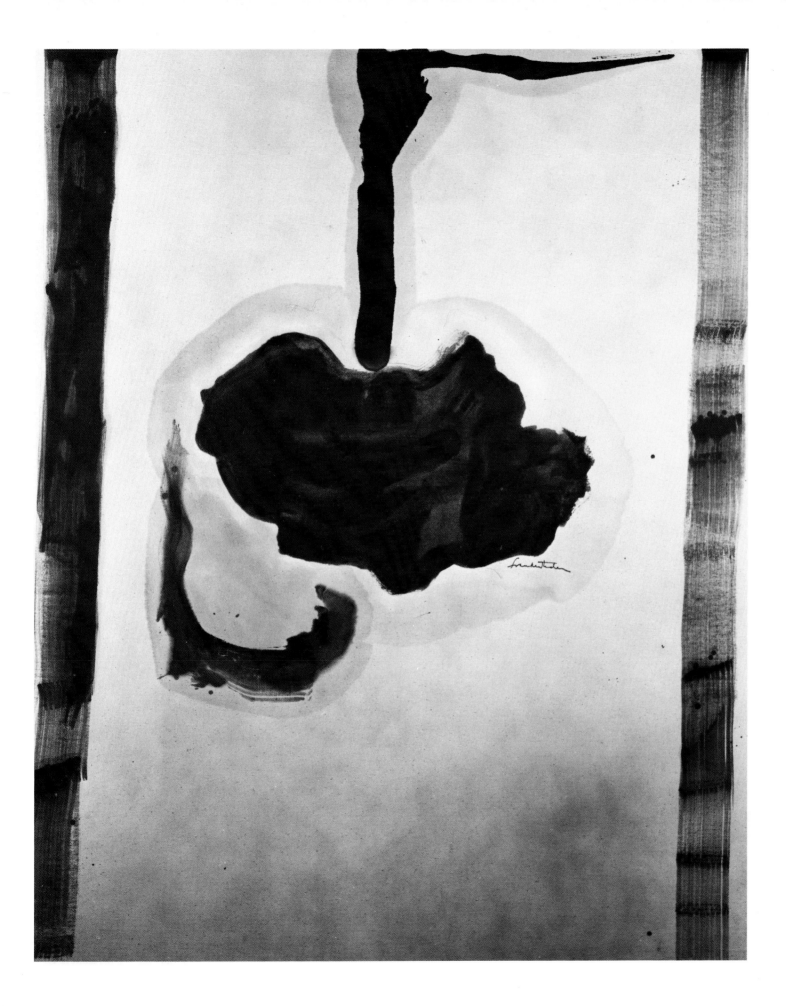

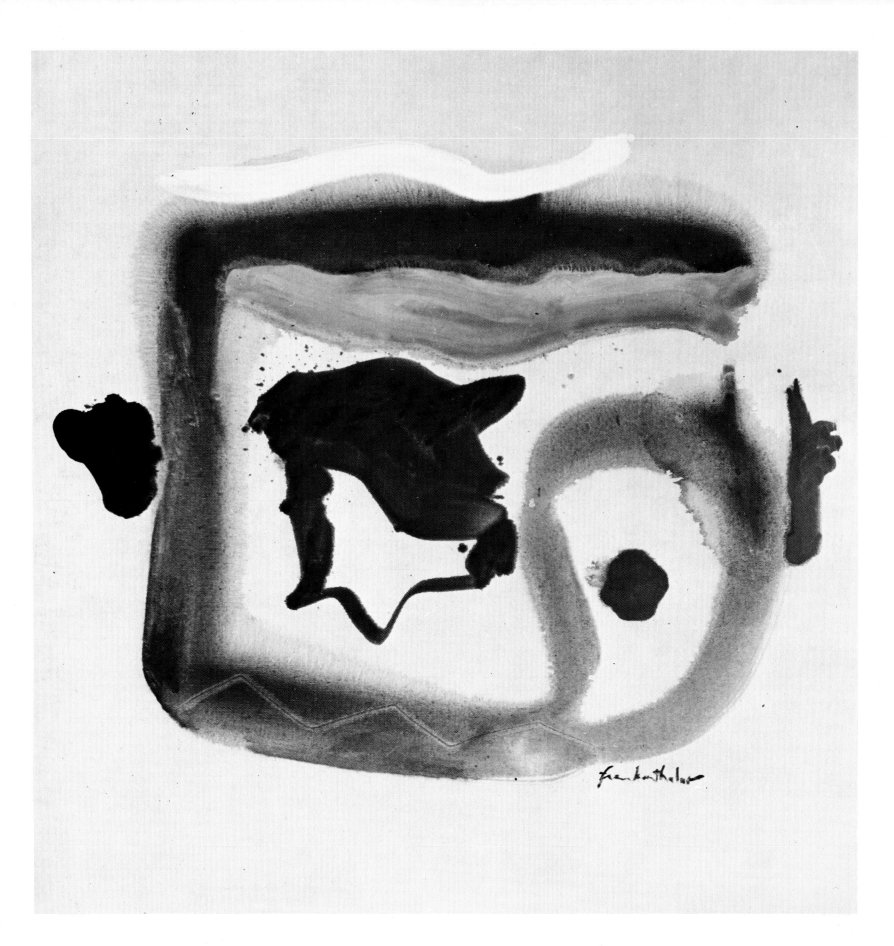

116. SWAN LAKE VARIATION. *1962. Oil on sized, primed canvas, 39⅜×39⅜". Collection Mr. and Mrs. E. B. Lee, Houston*

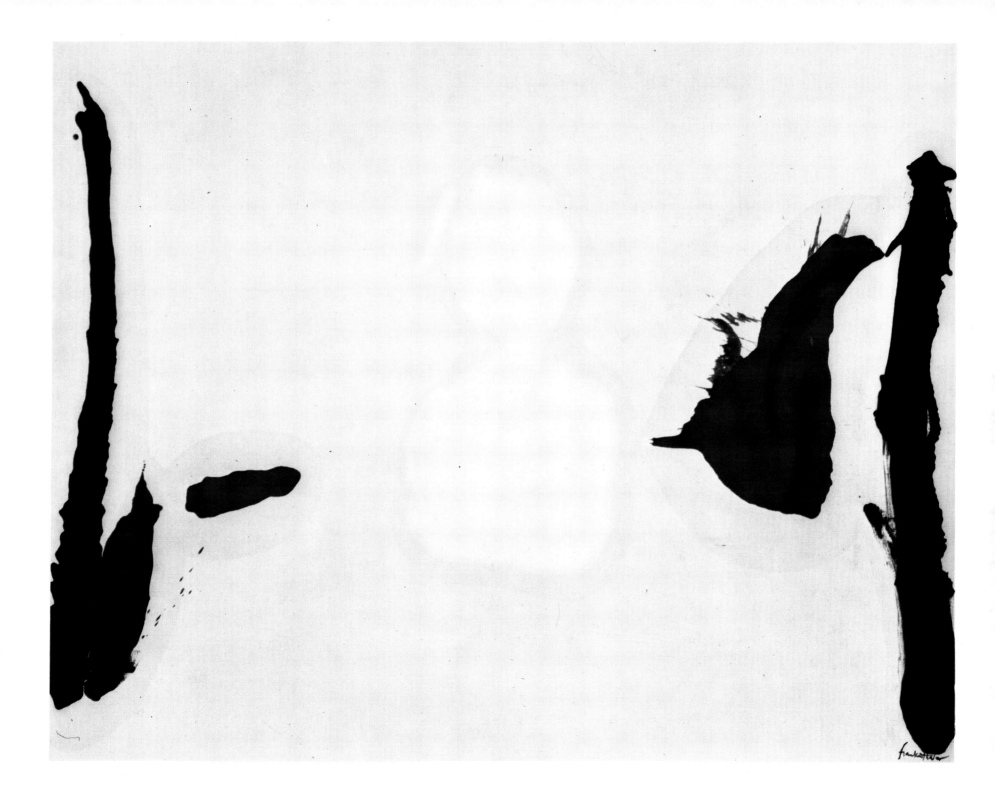

117. WHITE SAGE. *1962. Oil on canvas, 53³/₄ × 70¹/₂″. Woodward Foundation of Washington, D.C.*

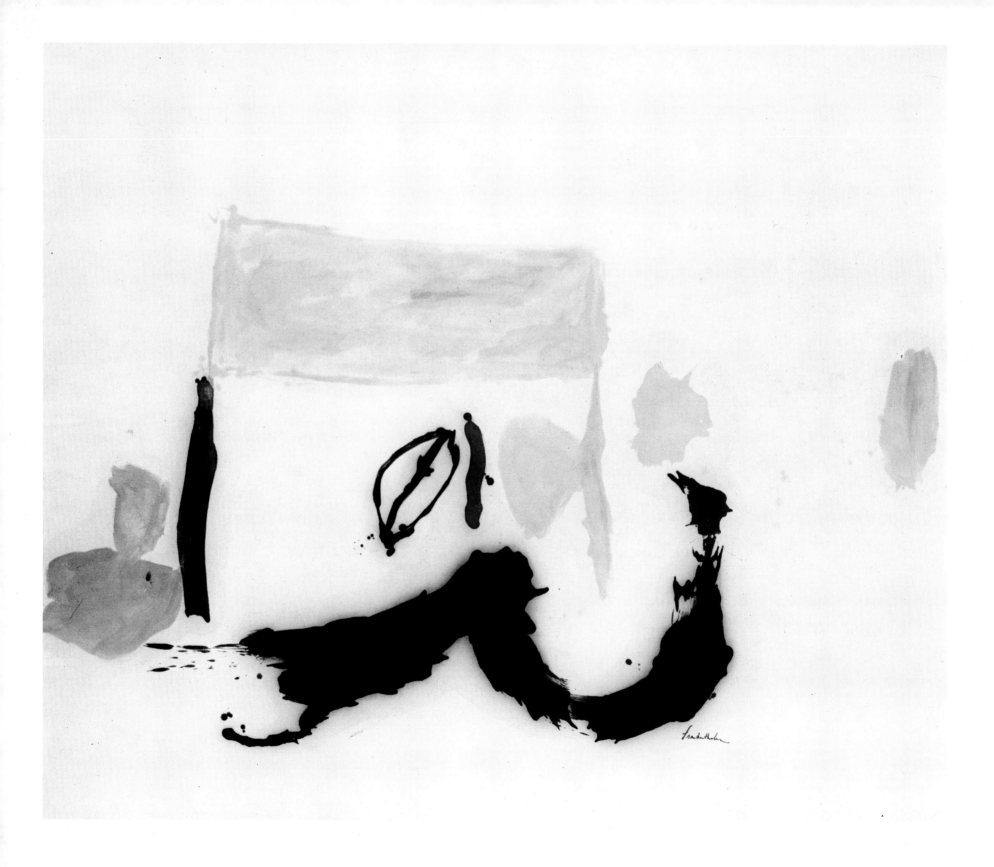

118. YELLOW GAMES. *1962. Oil on canvas, 58×70½"*

119. APRIL 1. *1963. Oil on paper, 17×14". Collection Mr. and Mrs. L. William Teweles, Milwaukee*

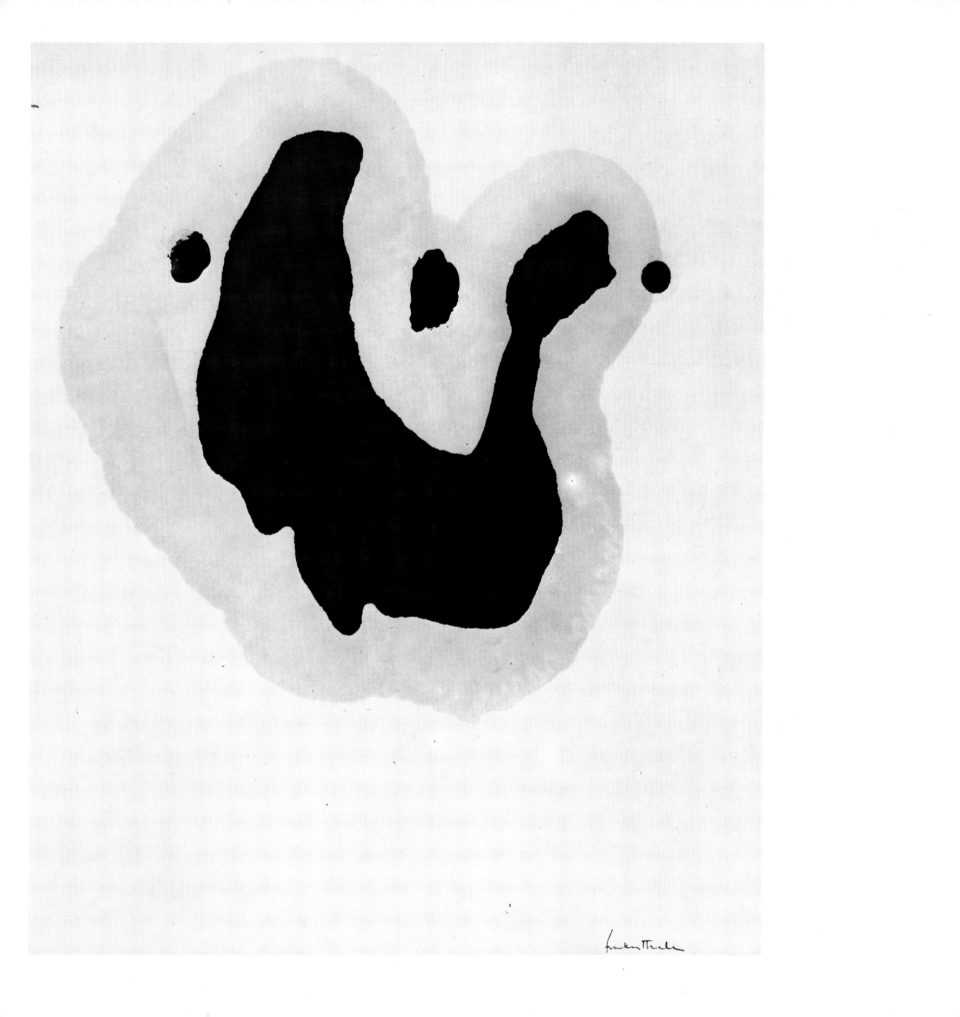

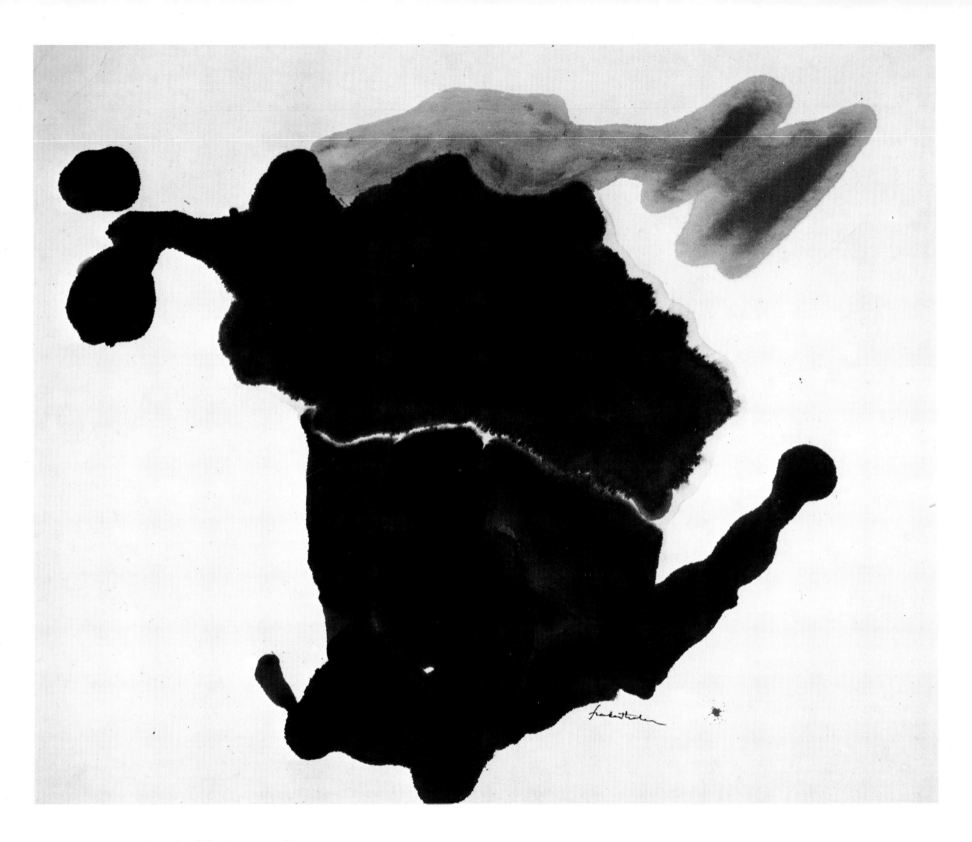

120. BLUE CAUSEWAY. *1963. Oil on canvas, 57*³⁄₄×*72"*

121. FORMATION. *1963. Acrylic on canvas, 76×65". Private collection, New York City*

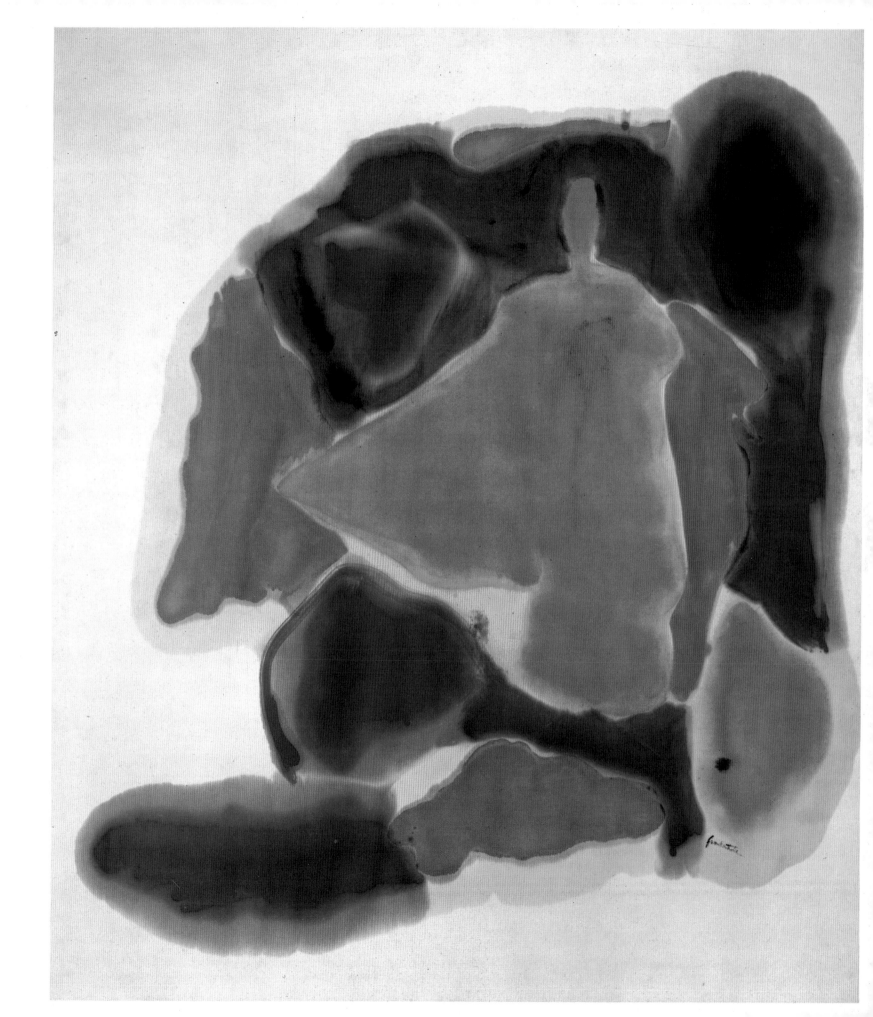

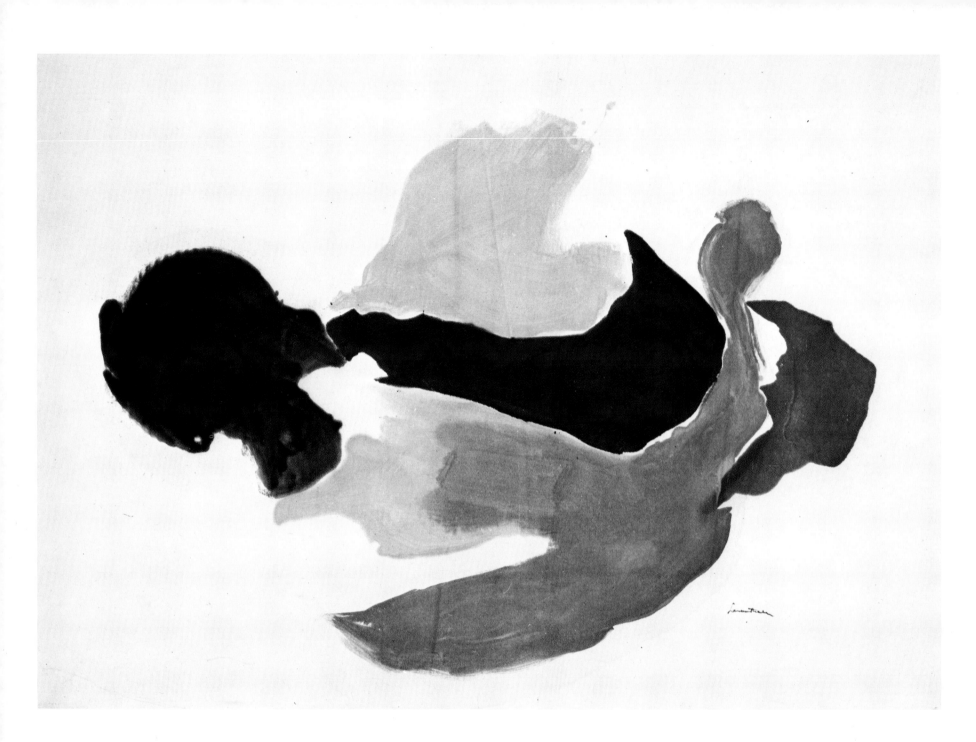

122. BLUE JAY. *1963. Oil on canvas, 64×44". Woodward Foundation of Washington, D.C.*

123. EVIL SPIRIT. *1963. Acrylic on canvas, 82×67"*

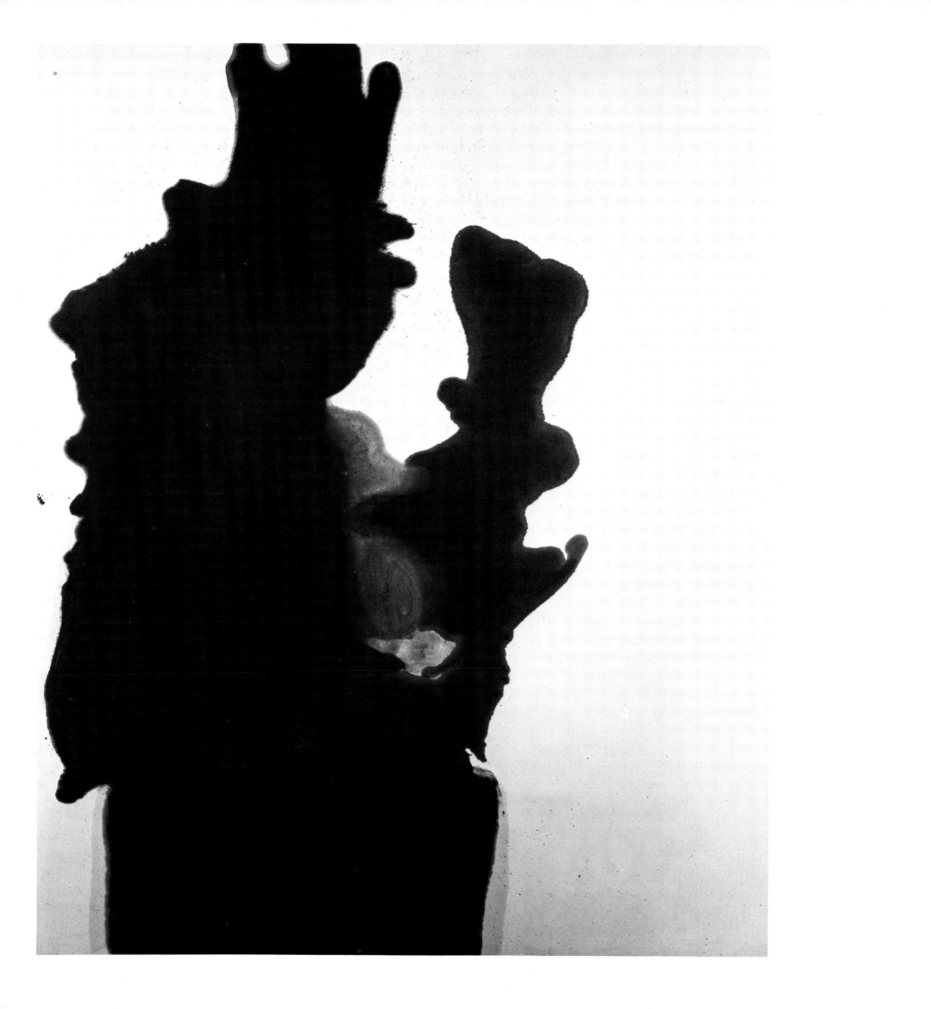

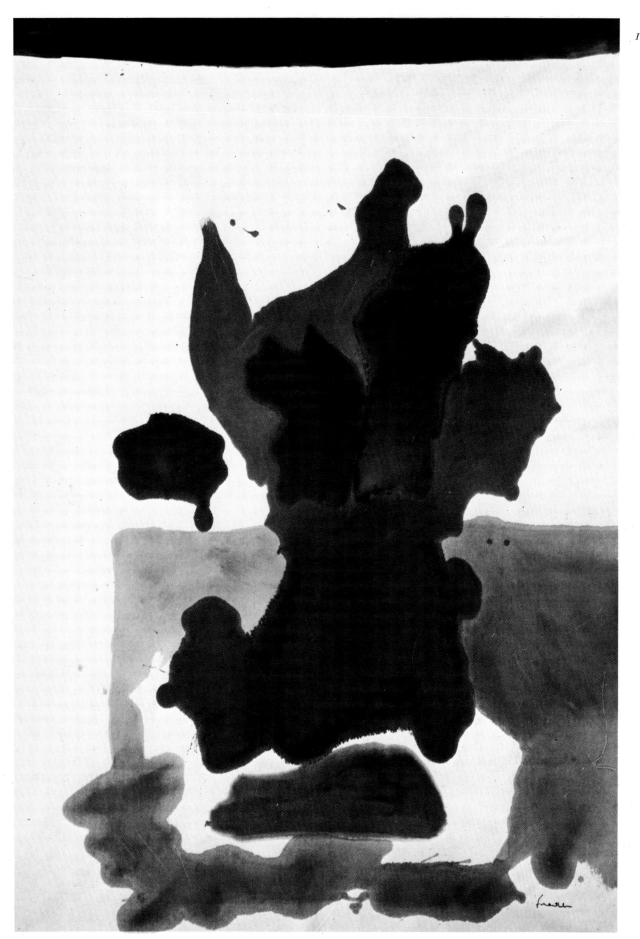

124. CELEBRATION. *1963*
Acrylic on canvas, 84×59"
Collection Mr. and Mrs. Alan J. Freedman,
New York City

125. DAWN SHAPES. *1963*
Oil on canvas, 69¼×58¾"
Collection Mr. and Mrs. Aubrey H. Ettenheimer,
Bloomfield Hills, Mich.

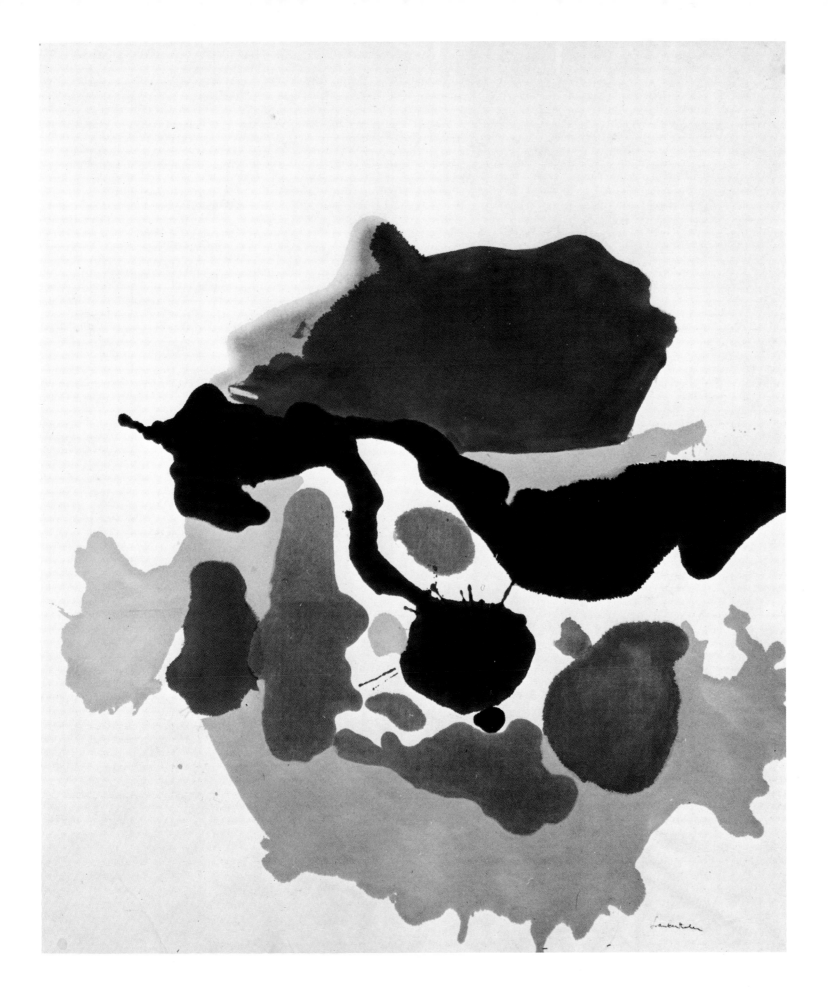

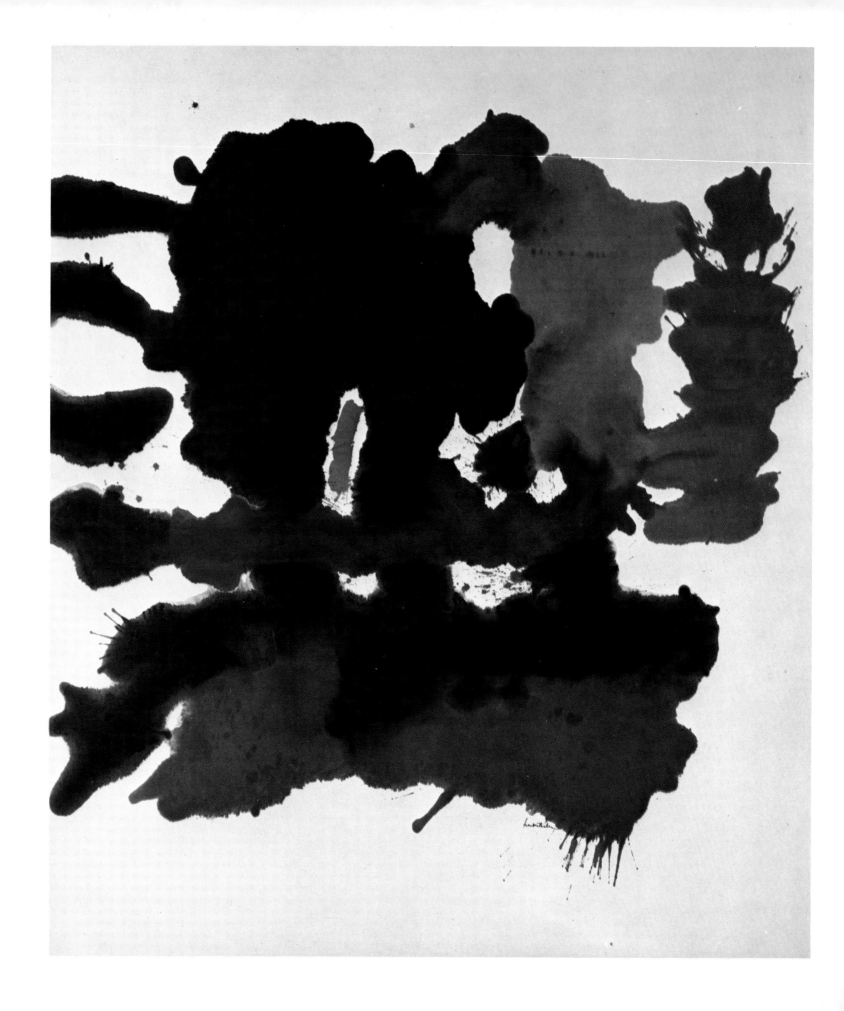

126. BLUE TIDE. *1963*
 Acrylic on canvas, 96×81¾"
 Skidmore, Owings and Merrill, San Francisco

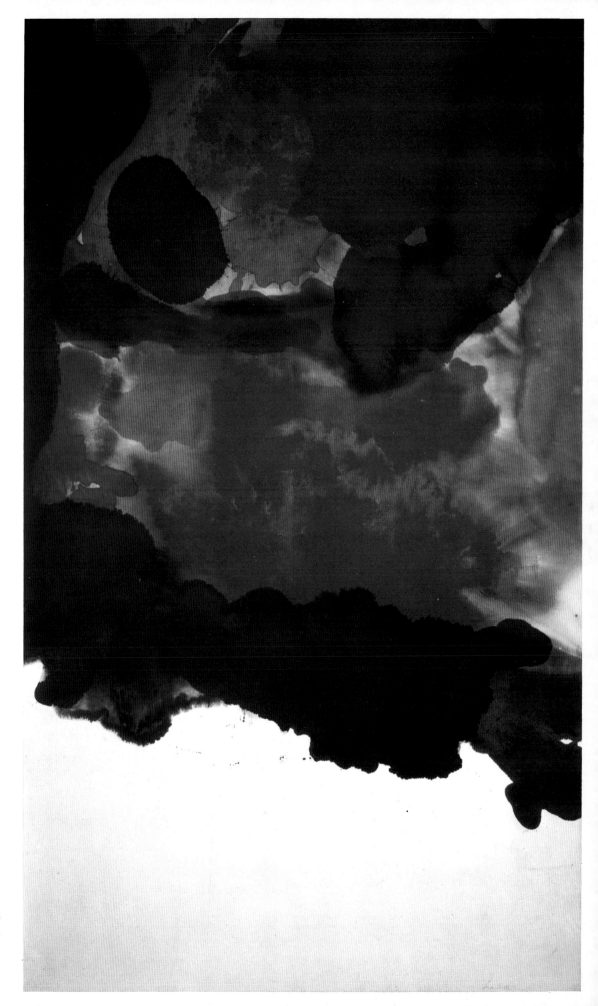

127. BLUE ATMOSPHERE. *1903*
 Acrylic on canvas, 9' 9½"×5' 10"

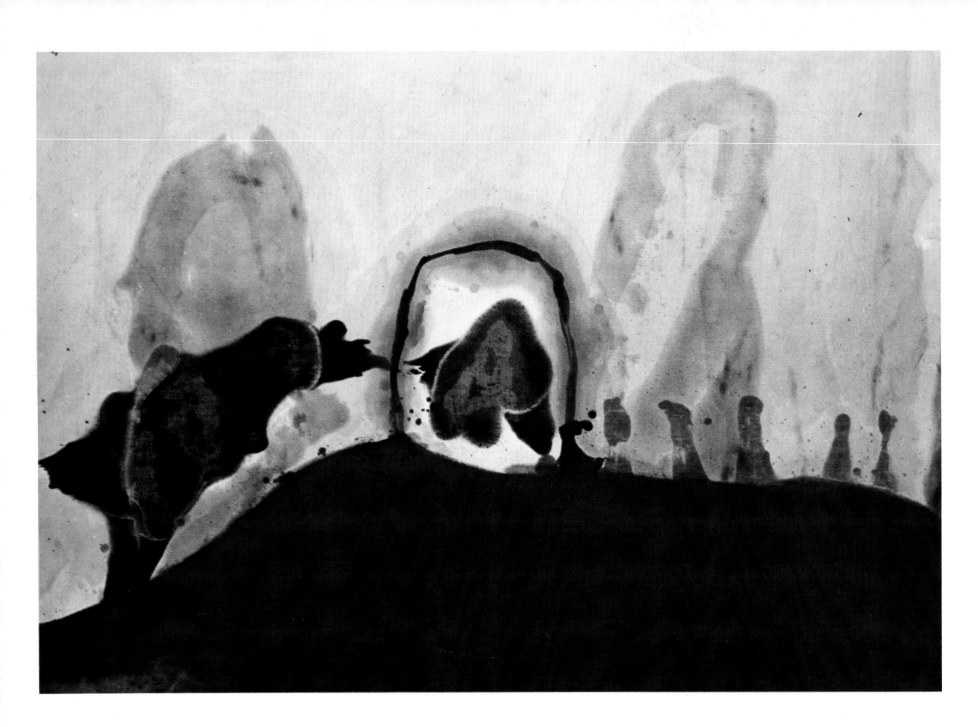

128. CENTER BREAK. *1963. Oil on canvas, 38¼×57". Collection Dr. J. Lawrence Pool, New York City*

129. THE MAUD. *1963. Oil on canvas, 94¼×70⅛". Collection Dr. and Mrs. Robert D. Seely, New York City*

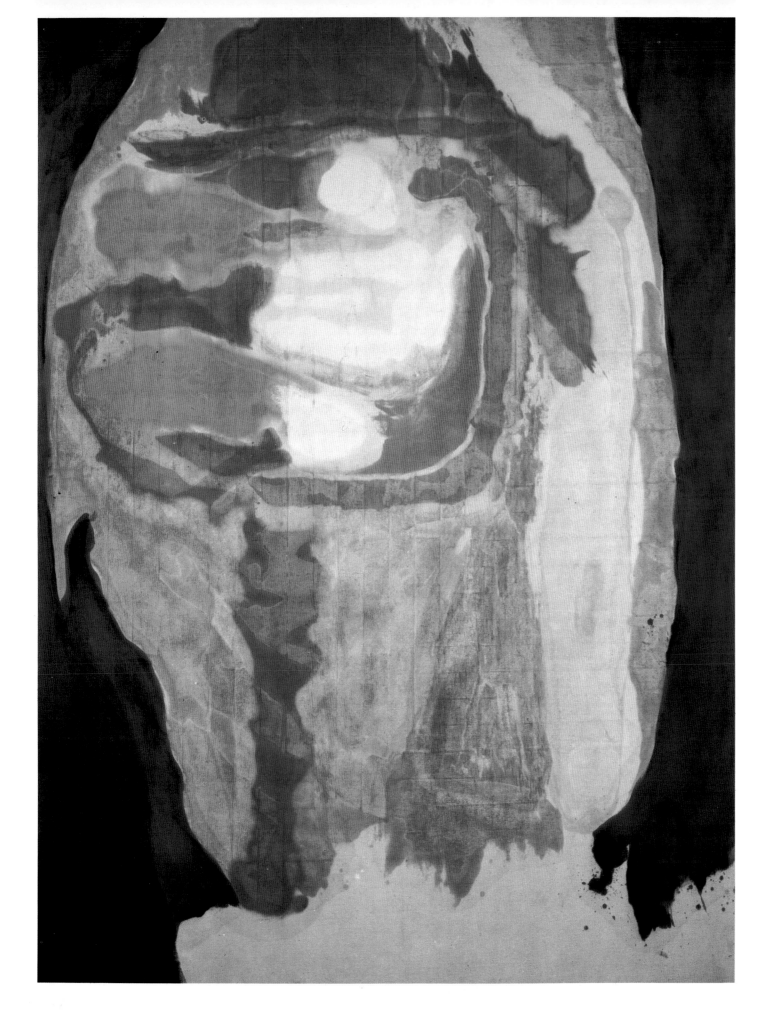

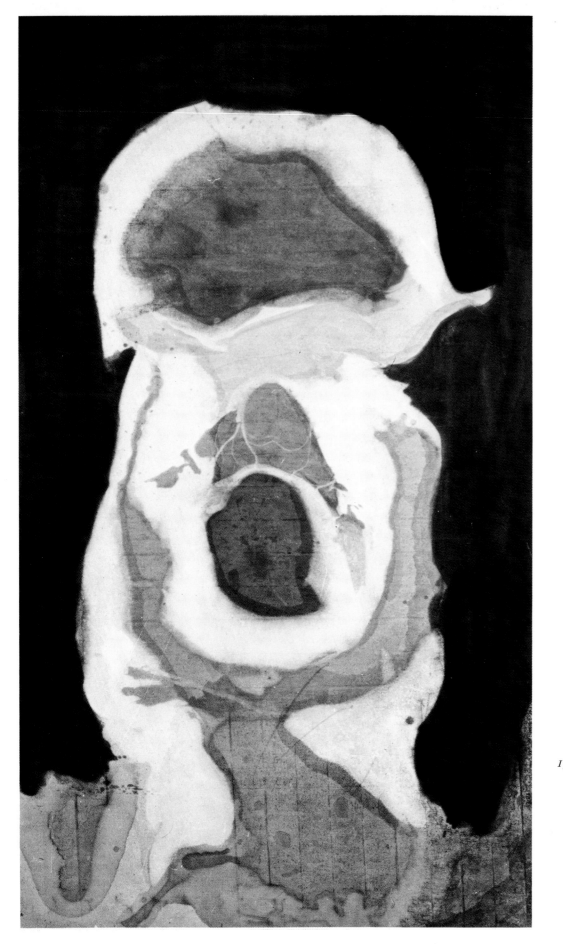

130. WIZARD. *1963*
Oil on canvas, 70×40″
Private collection, New York City

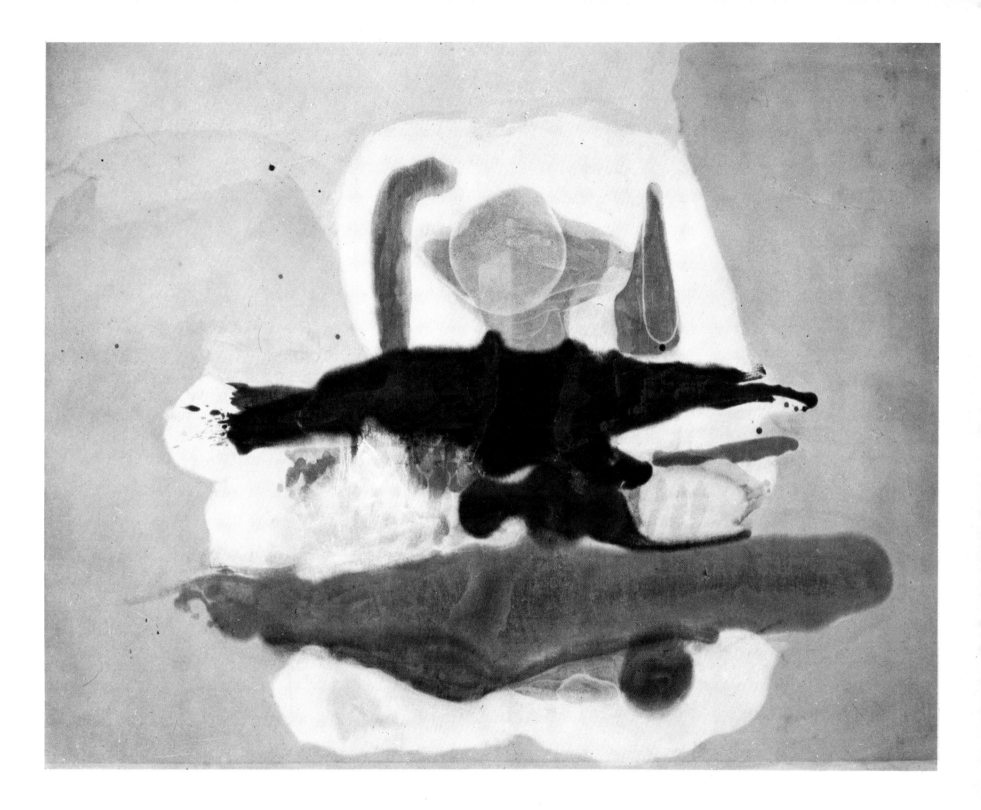

131. YELLOW CLEARING. *1963. Oil on canvas, 53½×69½". Private collection, New York City*

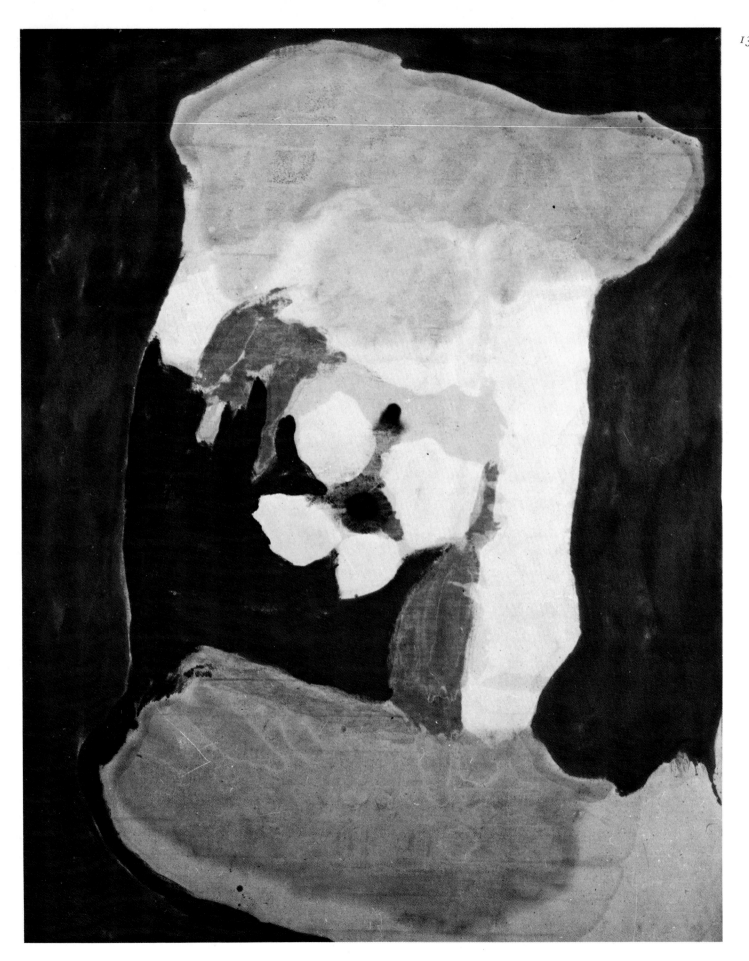

132. FILTER. *1963*
Oil on canvas, 65¾×50½"

133. LONG RANGE. *1963*
Oil on canvas, 82½ × 69½"
Collection Mrs. Samuel G. Rautbord, Chicago

134. LOW TIDE. *1963*
Acrylic on canvas, 84×81¾"
Yale University Art Museum,
New Haven, Conn.
Gift of Mrs. Frederick W. Hilles

135. STORM. *1963*
Oil on canvas, 26½×21¼"
Collection Lawrence Rubin, New York City

136. SUN DIAL. *1963. Oil on canvas, 64½×64″*
Abbot Hall Art Gallery, Kendal, England

137. THAW. *1963. Oil on canvas, 49×33½″*
Hilton Hotel, New York City

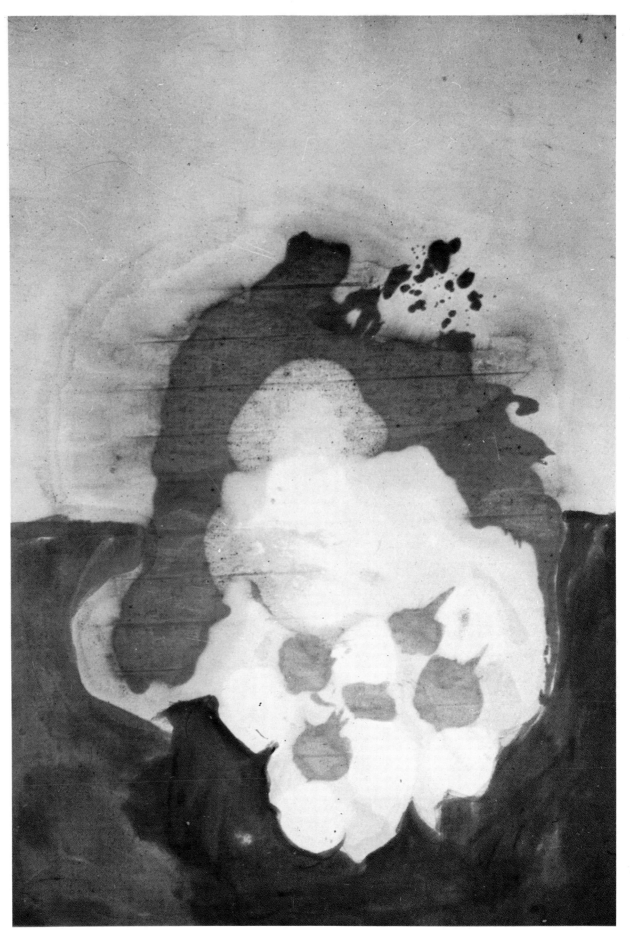

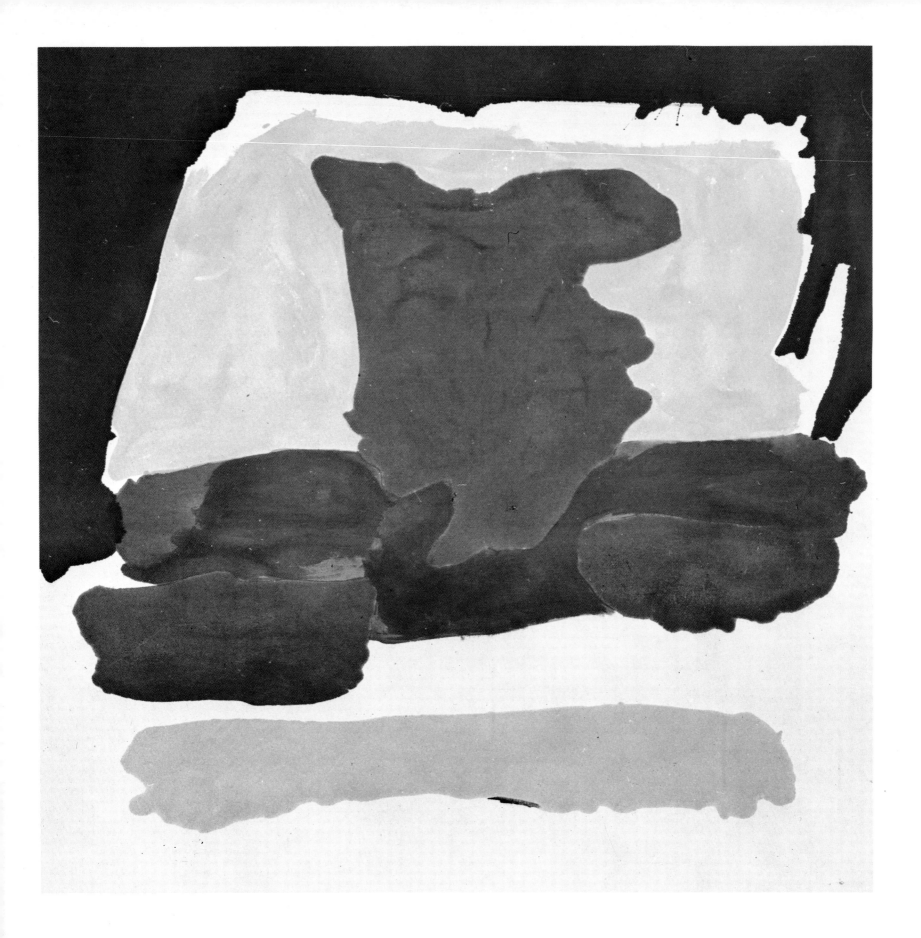

138. SANDS. *1964. Acrylic on canvas, 77×78". Belfast Museum, Ireland*

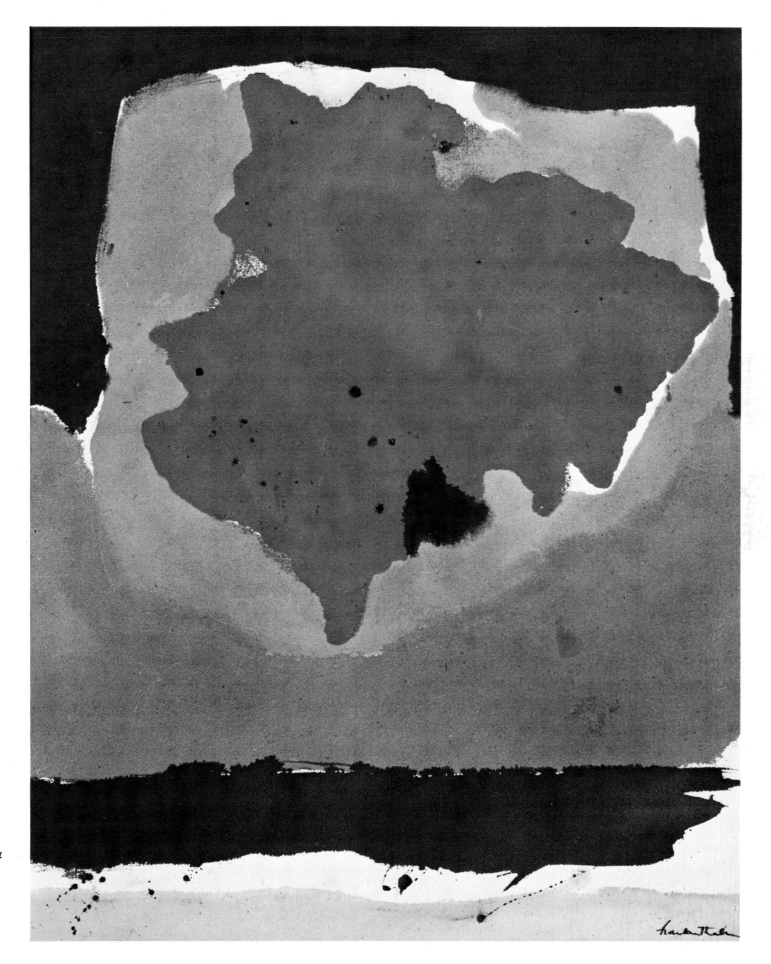

139. DUSK. 1964
Acrylic on canvas, 34×27"
Woodward Foundation of Washington, D.C.

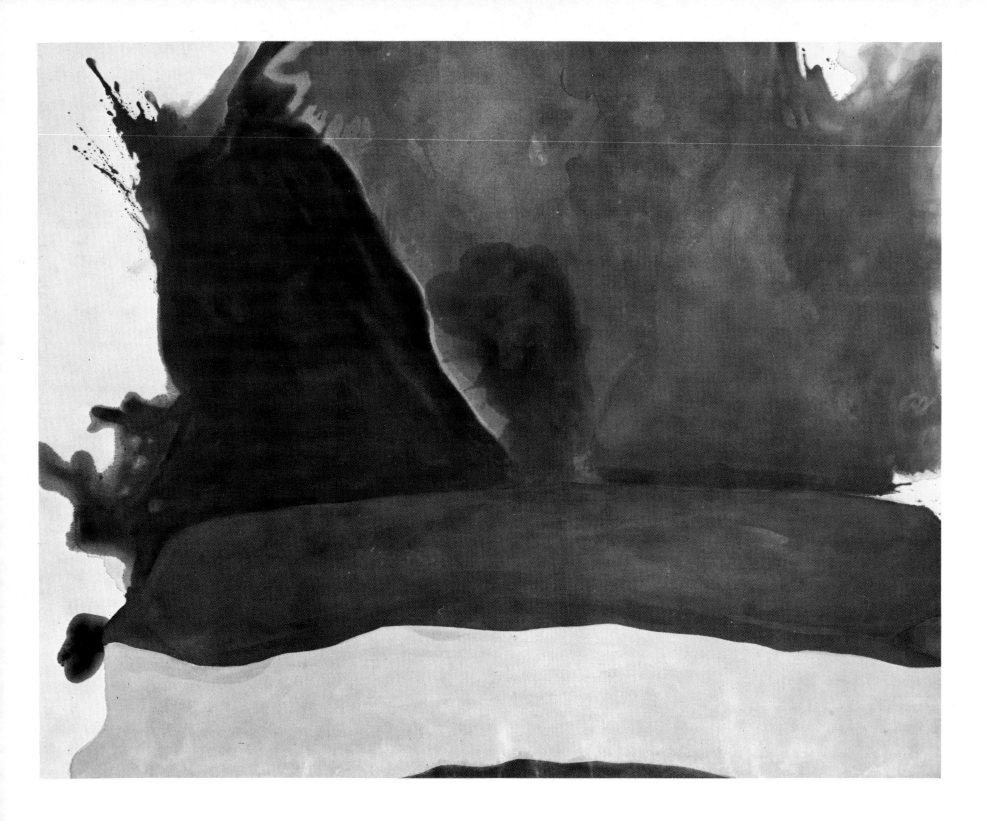

140. TOBACCO LANDSCAPE. *1964. Acrylic on canvas, 69¹⁄₂ × 89¹⁄₄″*

141. INTERIOR LANDSCAPE. *1964. Acrylic on canvas, 8′ 8³⁄₄″ × 7′ 8³⁄₄″. The San Francisco Museum of Art. Gift of the Women's Board*

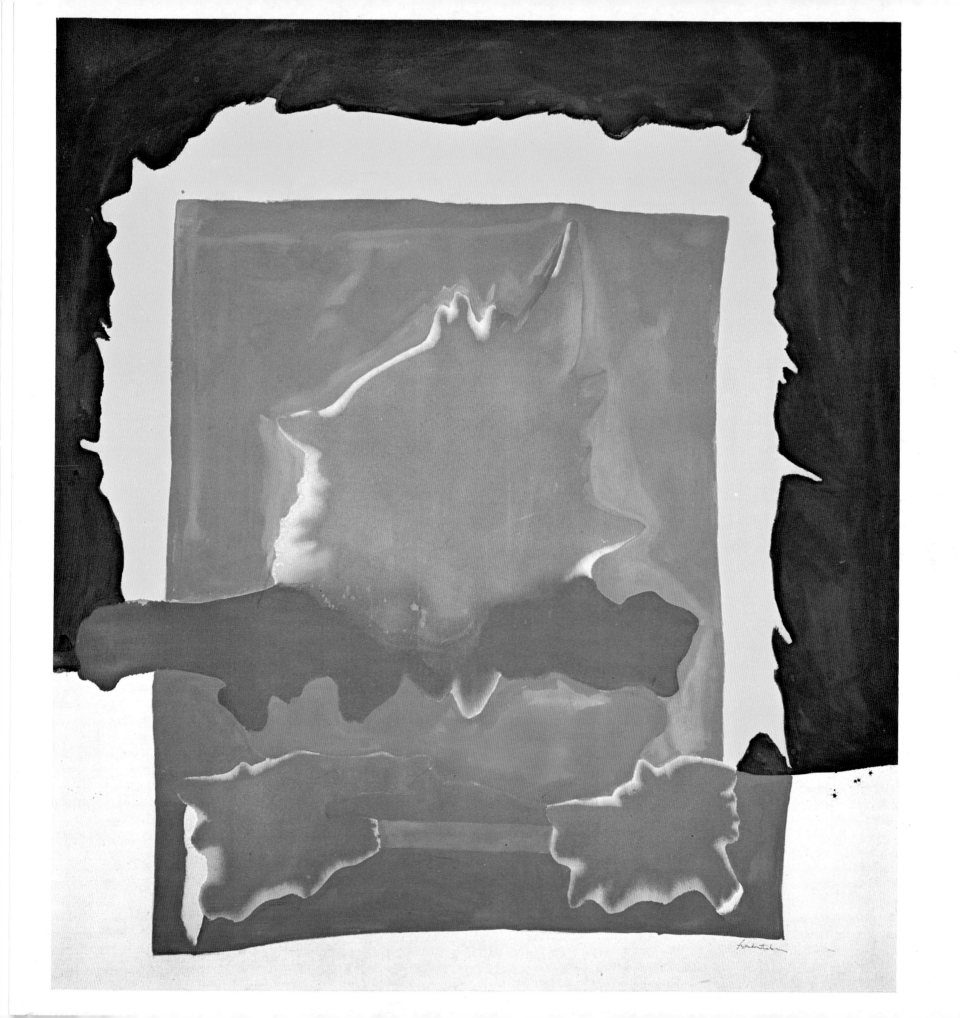

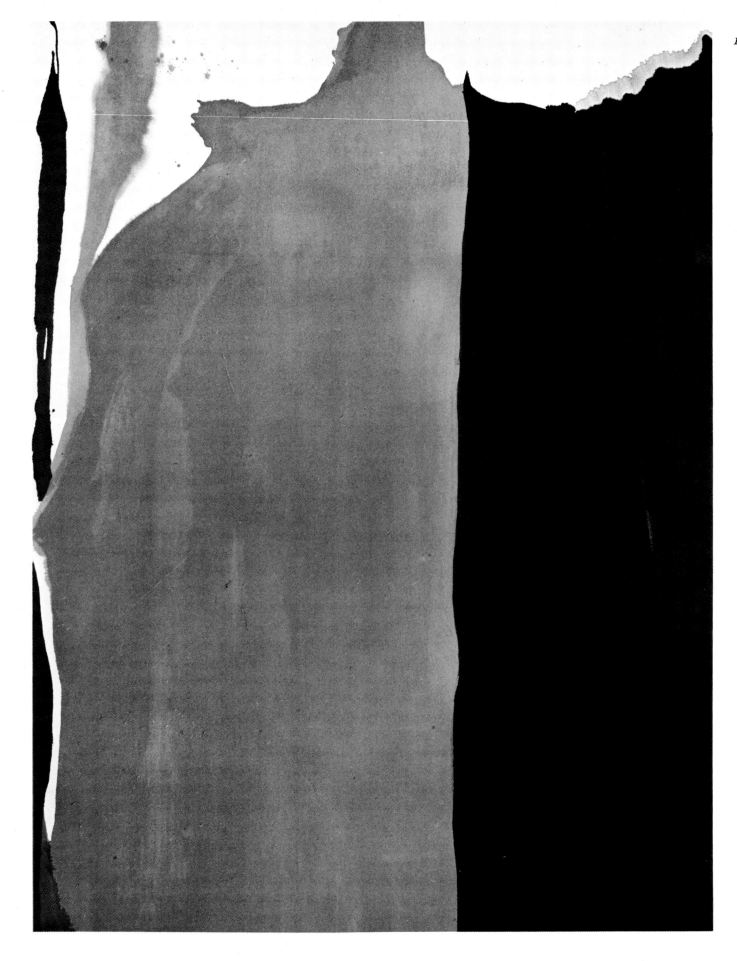

146. PINK LIGHTNING. *1965*
Acrylic on canvas, 72×54"

147. REDSCAPE. *1964–65*
Acrylic on canvas, 81×81¾"
Collection Whitcom Investment Company,
New York City

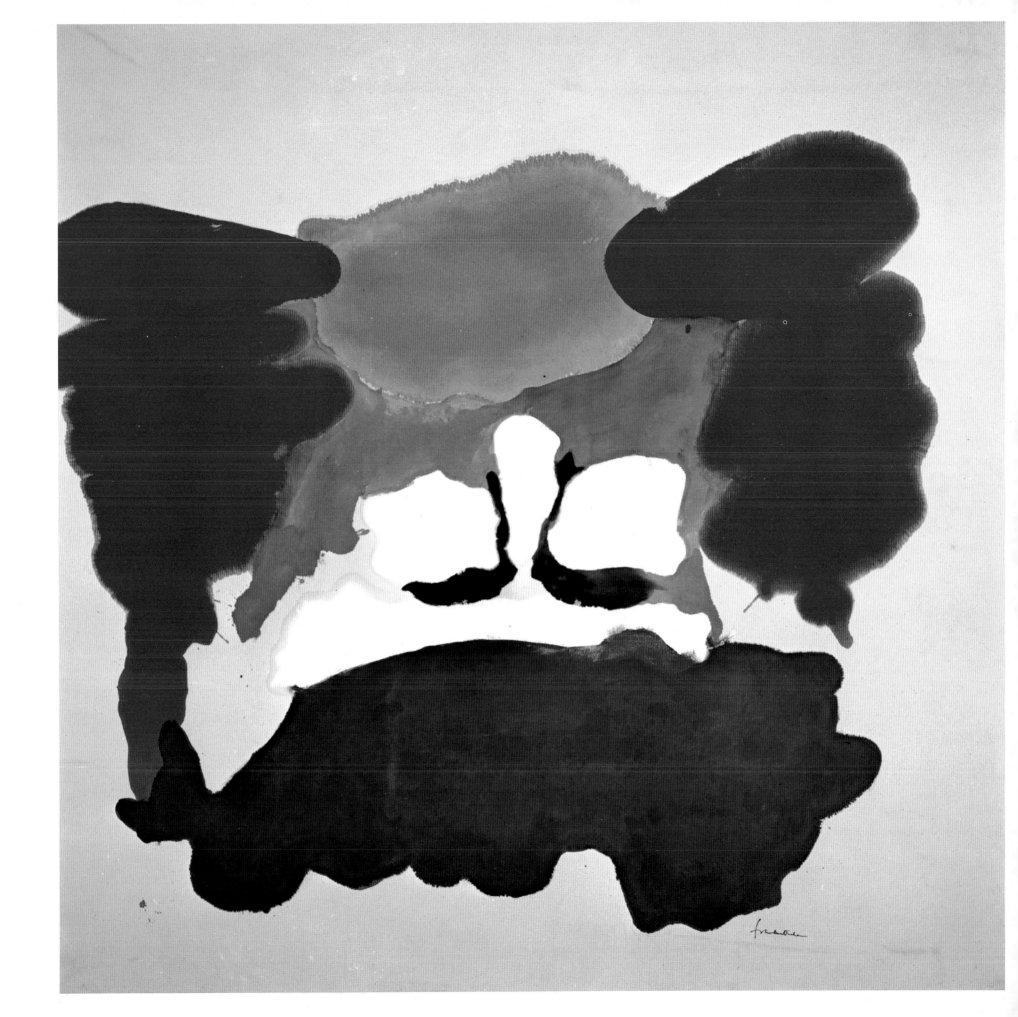

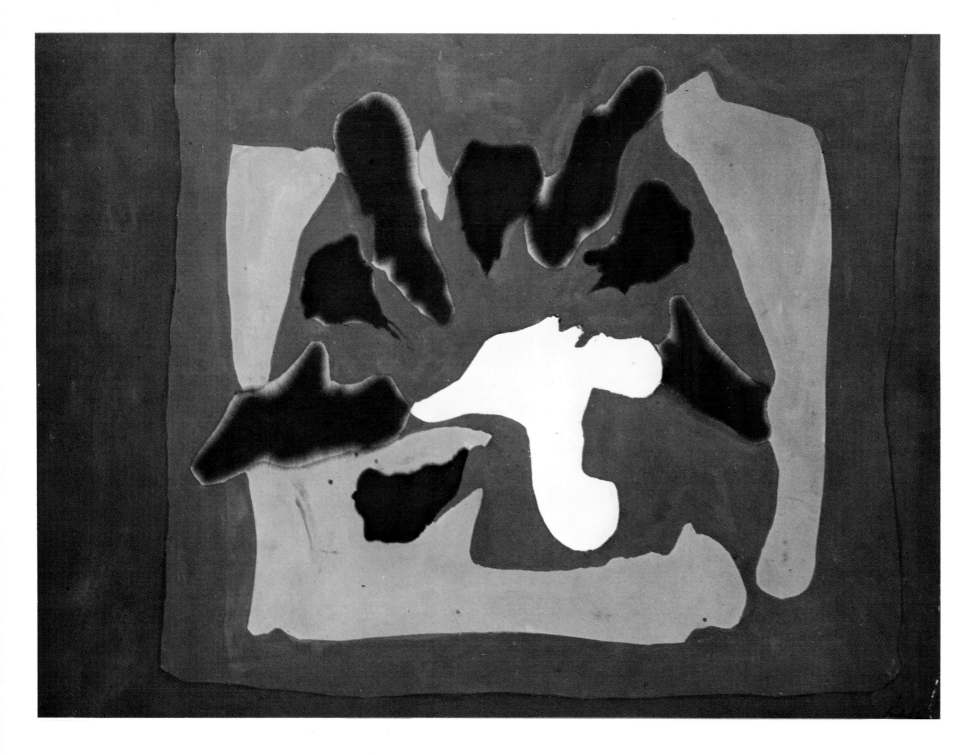

148. POMPEII. *1965. Acrylic on canvas, 80×58″. Collection Jacques Kaplan, New York City*

149. BLUE ARENA. *1965. Acrylic on canvas, 64³/₄×60¹/₂″. The Museum of Contemporary Art, Nagaoka, Japan*

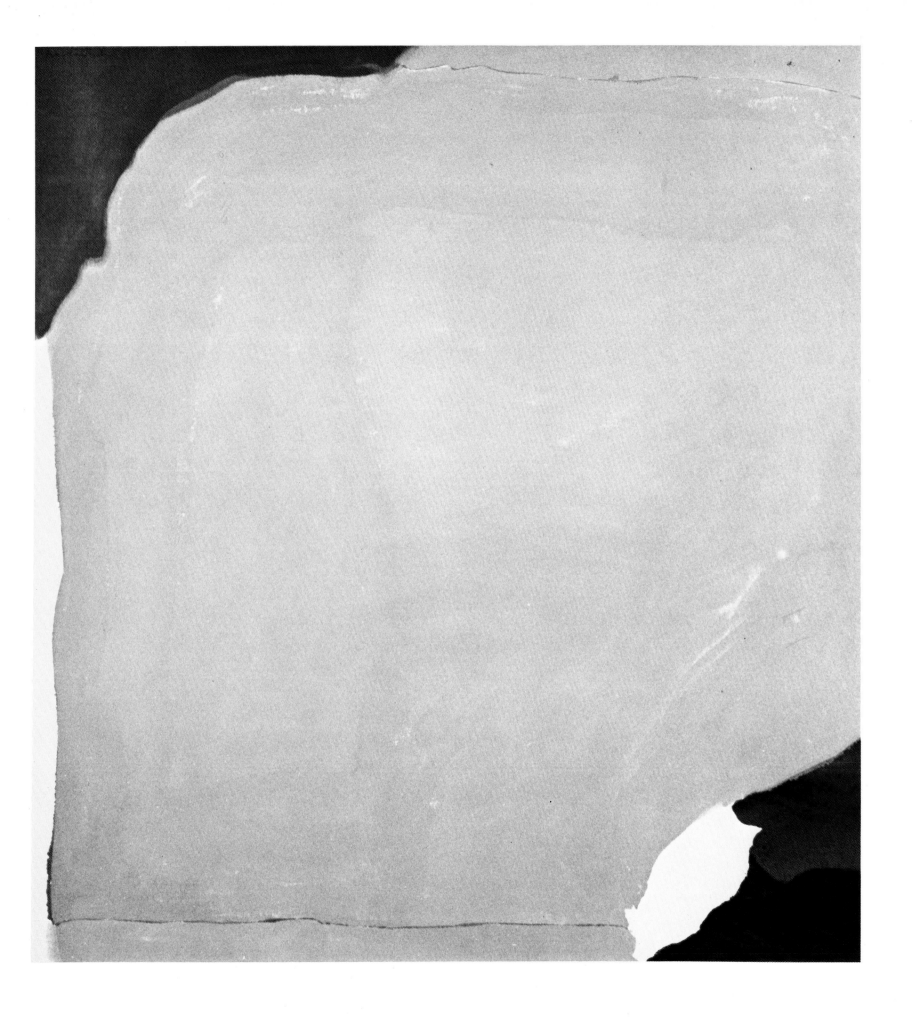

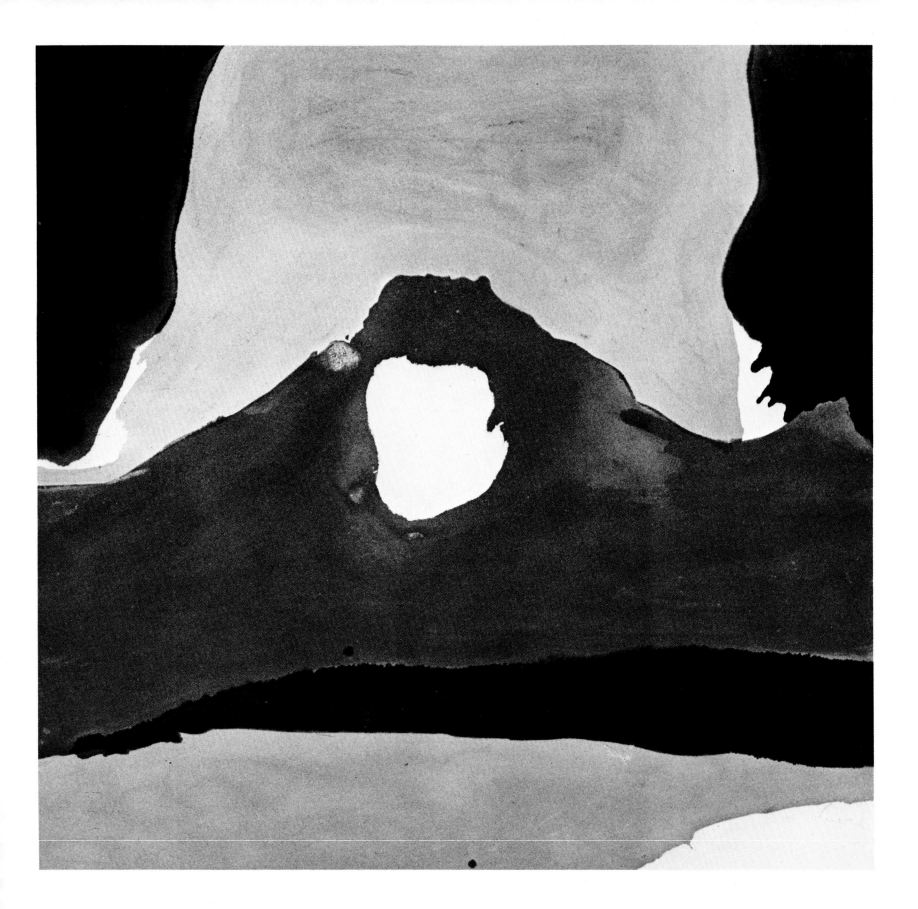

150. FLOE IV. *1965. Acrylic on canvas, 56×59". Collection Mr. and Mrs. David Mirvish, Toronto*

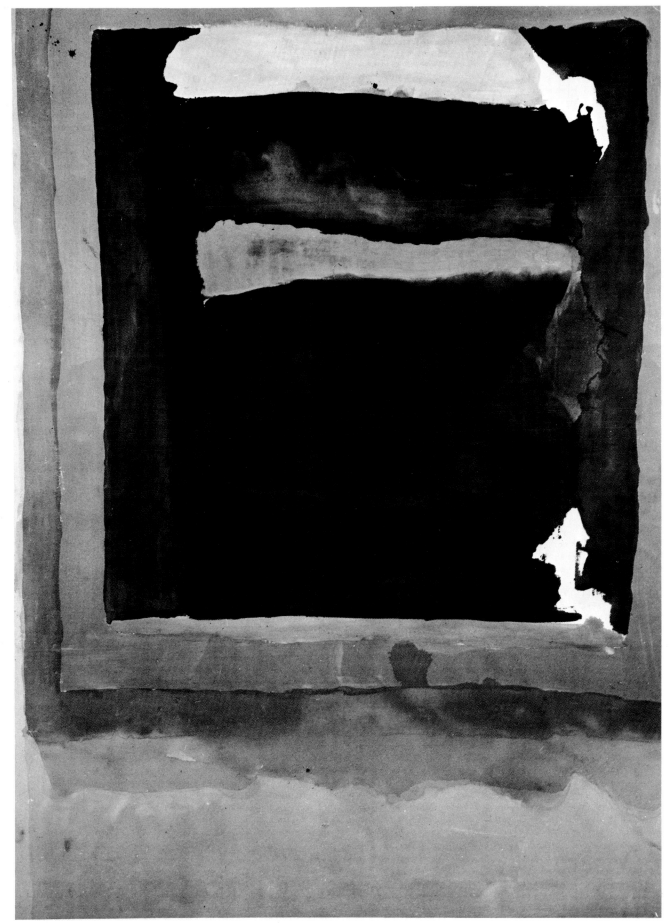

151. BLACK TOUCH. *1965*
Acrylic on canvas, 81×59″
Collection Mr. and Mrs. Robert A. Bernard,
Port Chester, N.Y.

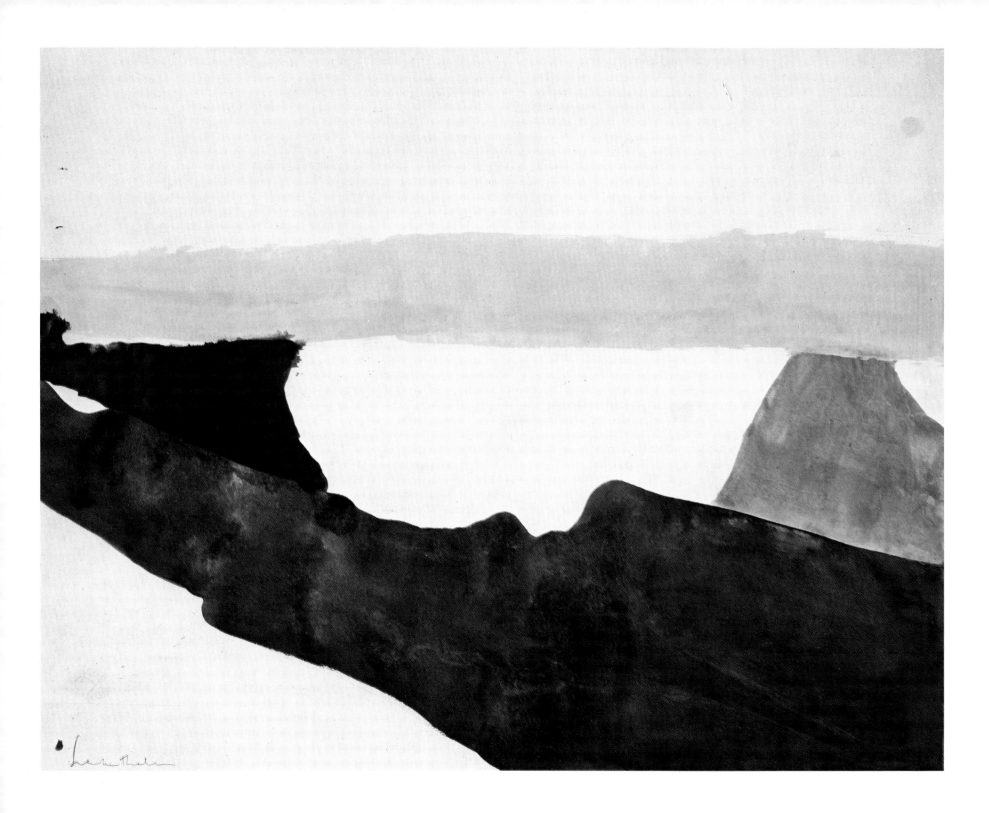

152. YELLOW BRIDGE. 1965. Acrylic on paper, 25×19″

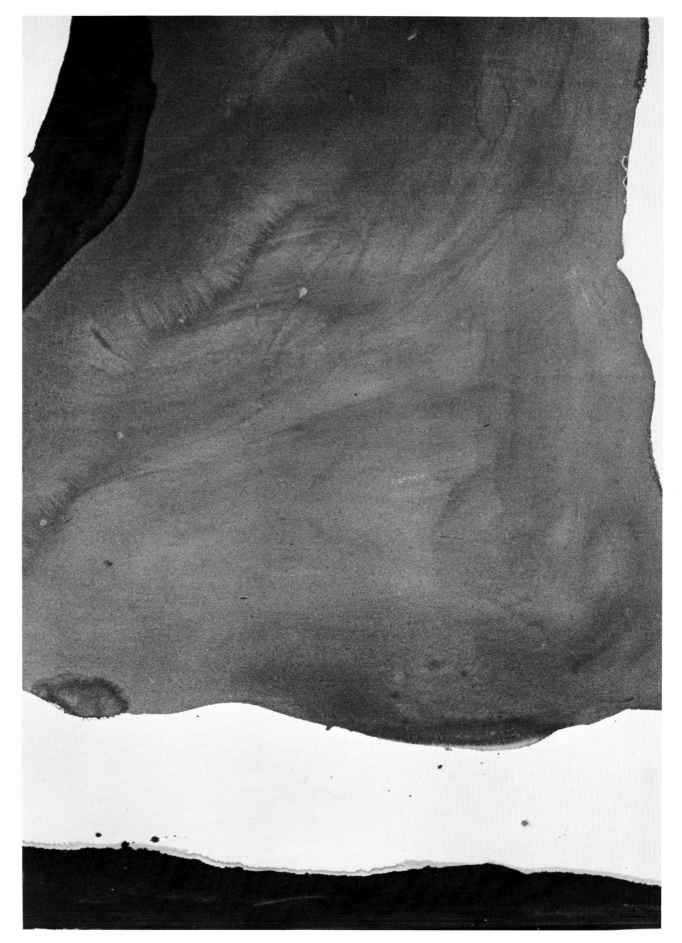

153. SEA STRIP. *1965*
Acrylic on canvas, 53¼ × 40¼"
Collection Mr. and Mrs. M. Goodman, Toronto

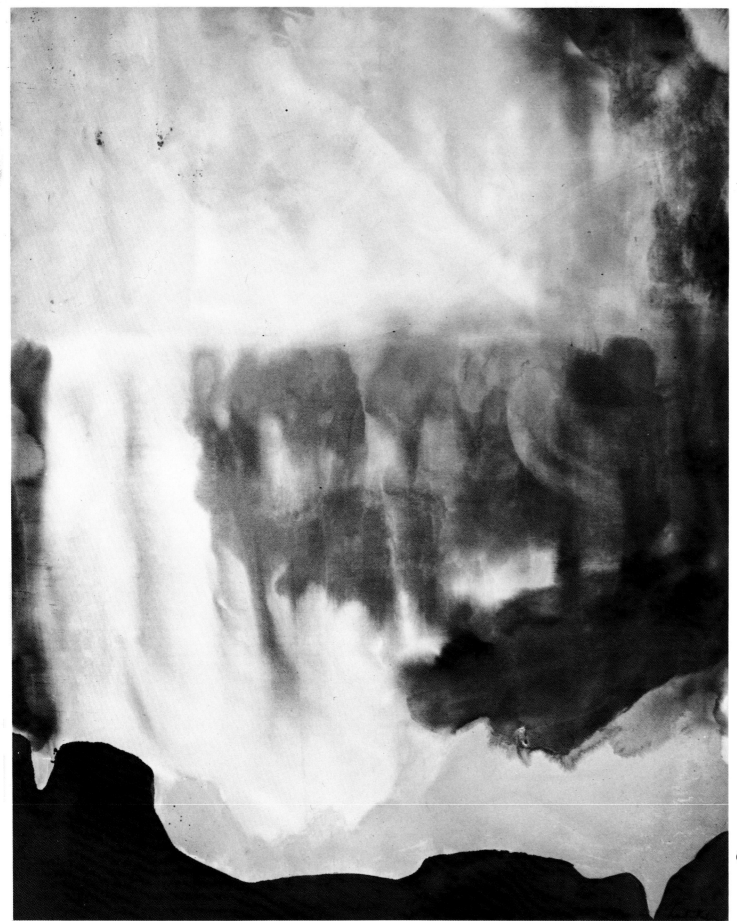

154. CENTRAL PARK. *1965–66*
Acrylic on canvas, 97½×78″

155. ORANGE SHAPES IN FRAME
1964–66. Acrylic on canvas, 93×74″
Collection Mr. and Mrs. Robert B. Mayer,
Winnetka, Ill.

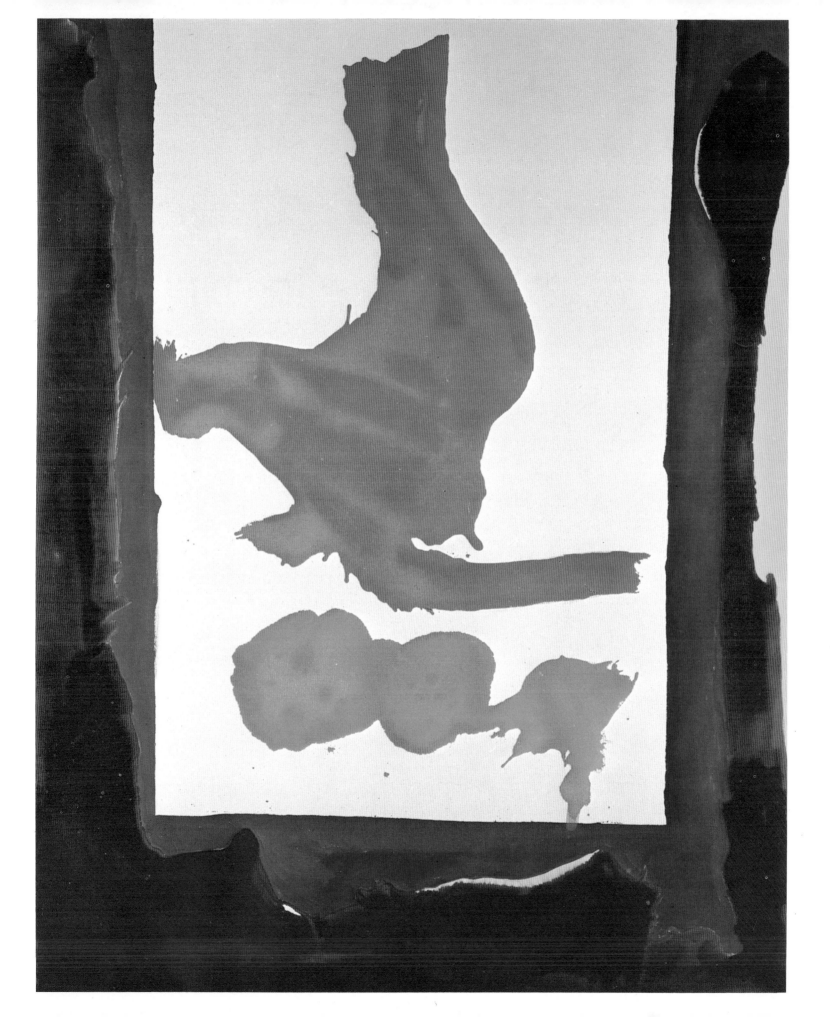

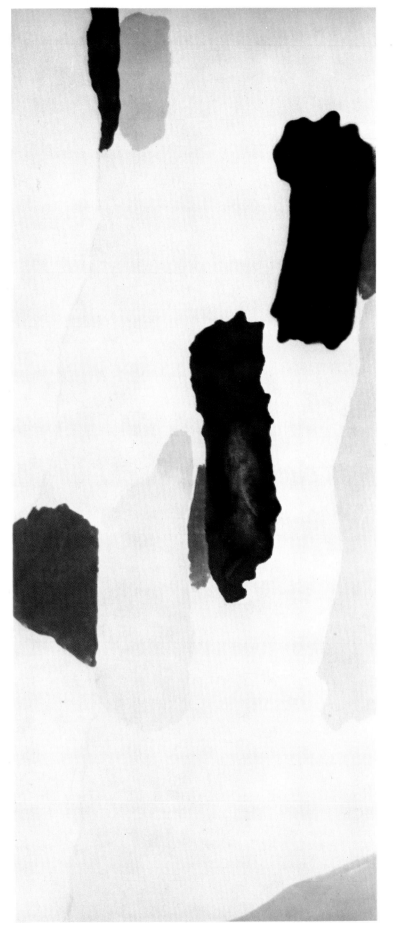

156. BLUE JUMP. *1966. Acrylic on canvas, 9′ 5¾″ × 3′ 11″. Private collection*

157. TUTTI FRUTTI. *1966. Acrylic on canvas, 9′ 8″ × 5′ 9¼″. Collection Gene Baro, London*

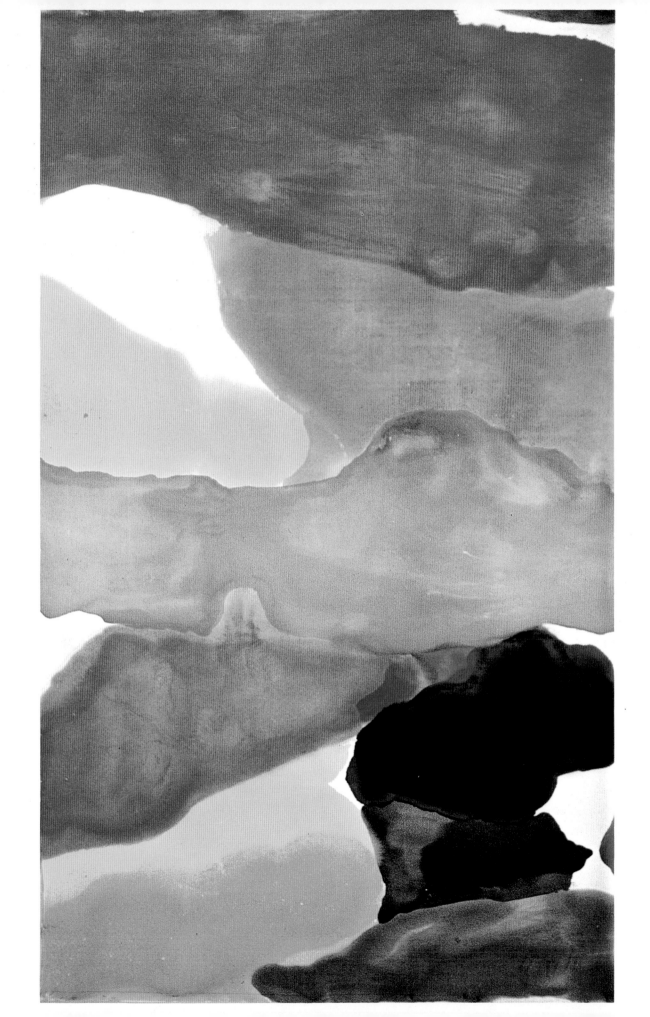

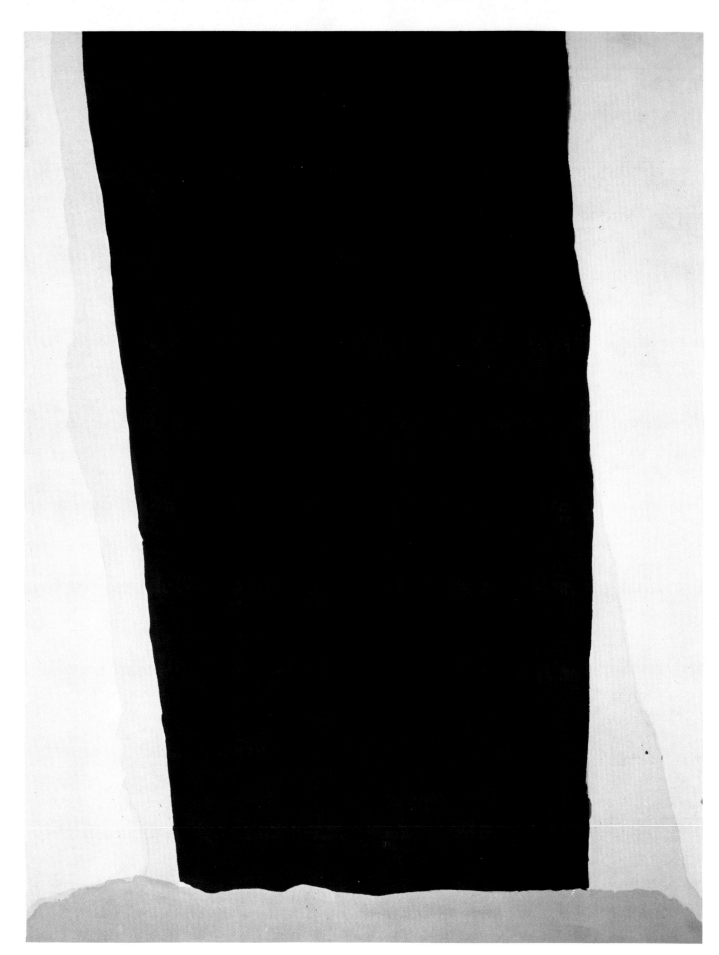

158. BLUE FALL. *1966*
Acrylic on canvas, 90×69"
Courtesy Nicholas Wilder Gallery, Los Angeles

159. RAINBOW ARCH. *1966*
Acryli on canvas, 21×31"
Collection Robert S. Woolf, White Plains, N.Y.

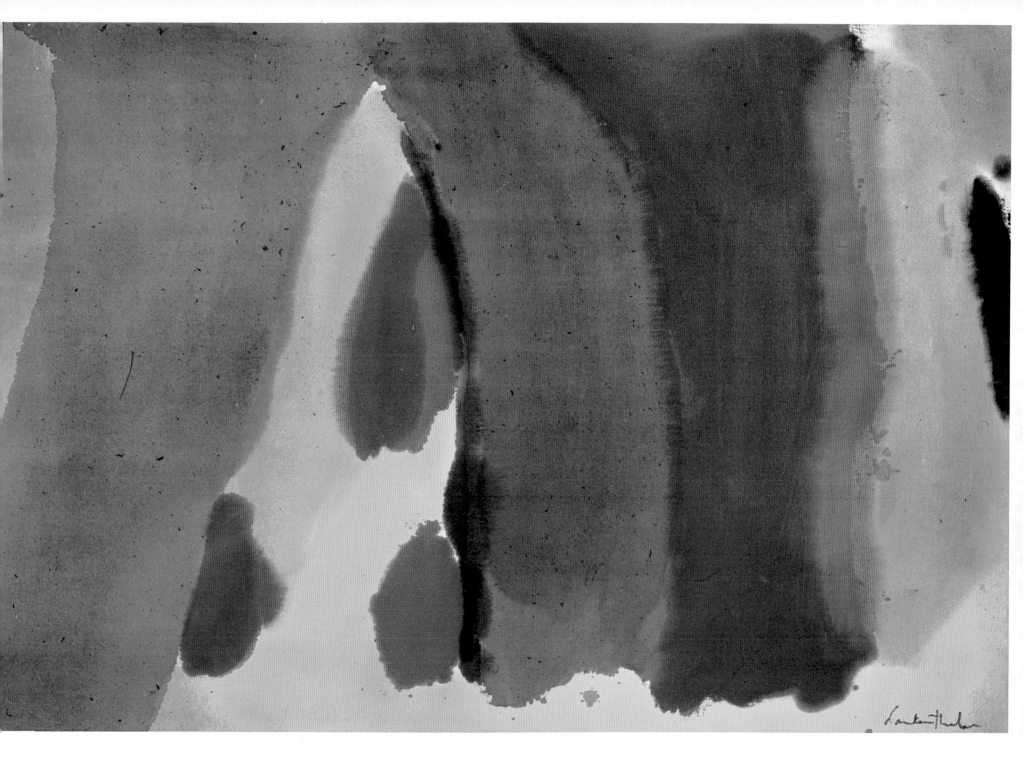

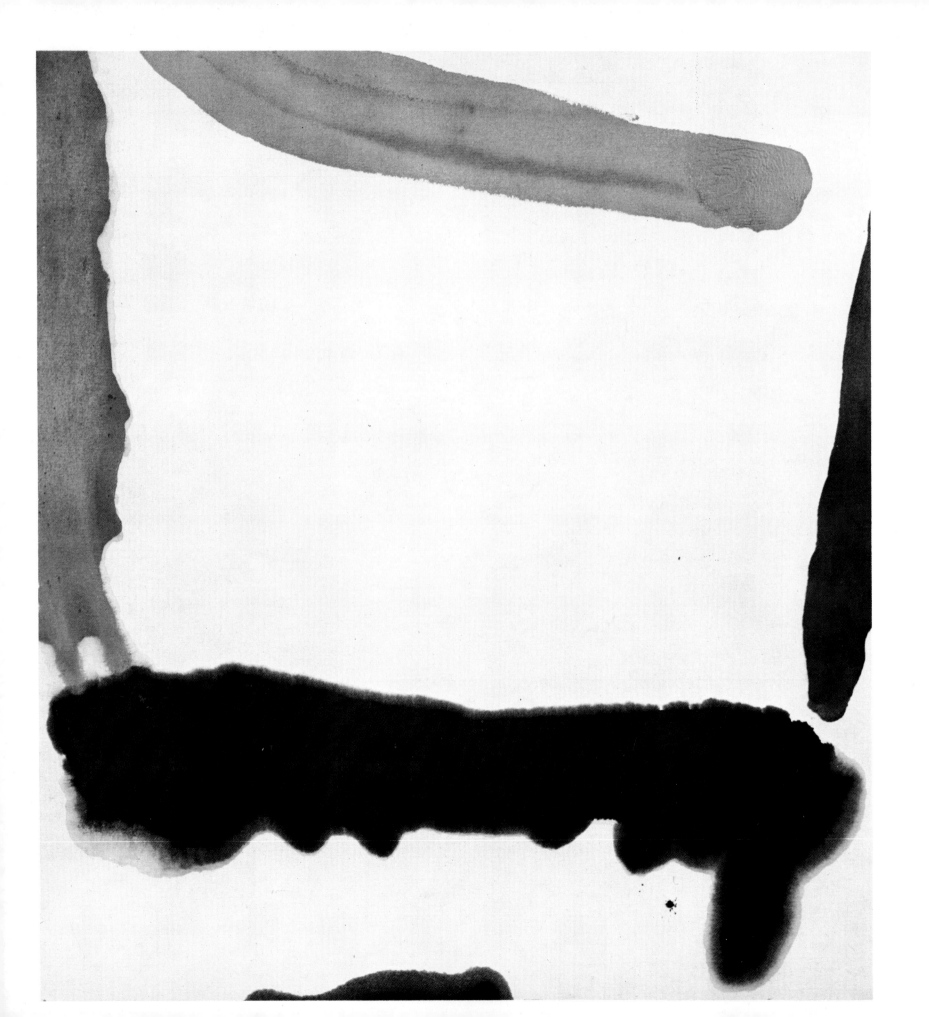

160. INNER EDGE. *1966*
 Acrylic on canvas, 42¾×38½"
 Collection Alexander Liberman, New York City

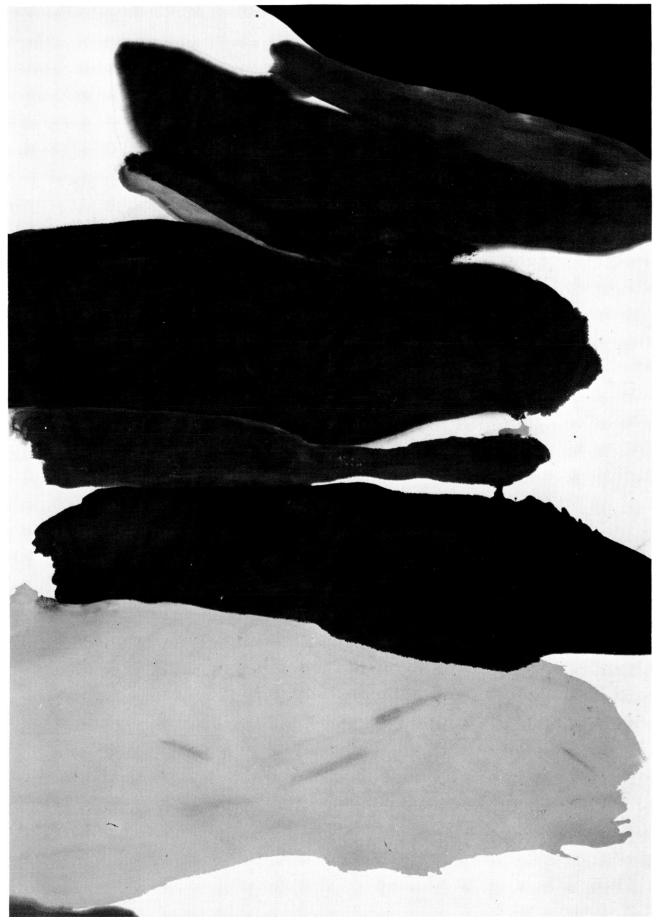

161. EARTH STRATA. *1966*
 Acrylic on canvas, 93×66½"

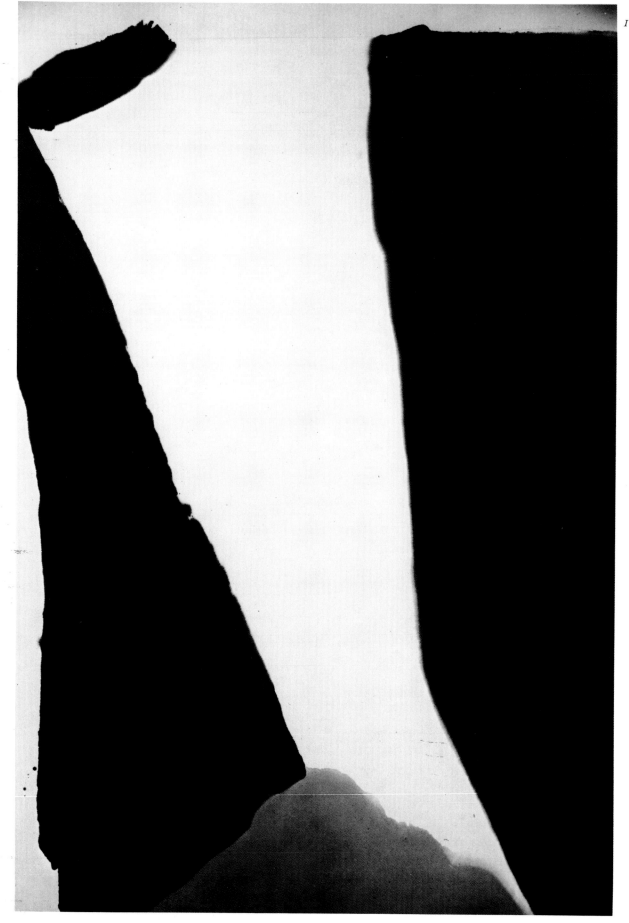

162. FOUR-COLOR SPACE. *1966*
Acrylic on canvas, 8′ 10″ × 6′

163. ONE O'CLOCK. *1966*
Acrylic on canvas, 93³/₄ × 75³/₄″
Collection Albert F. Weis, Savannah, Ga.

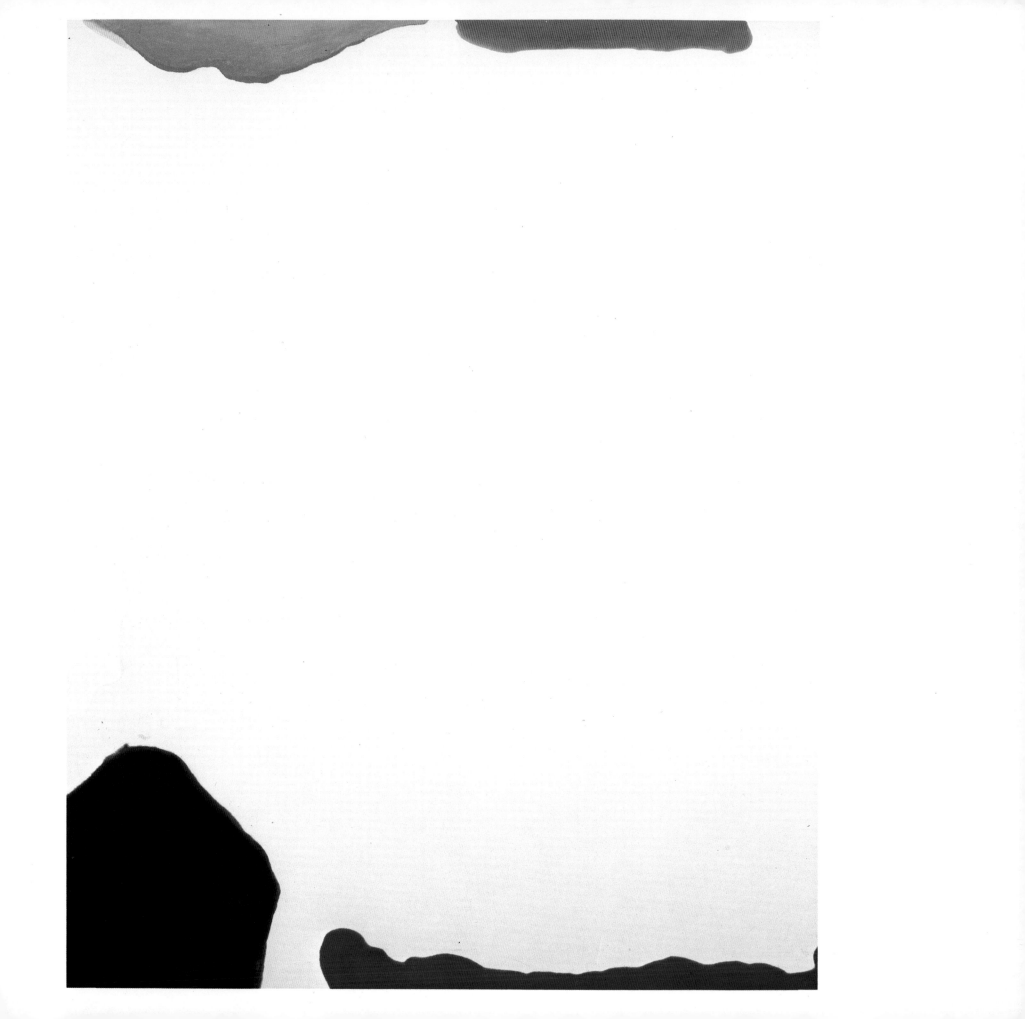

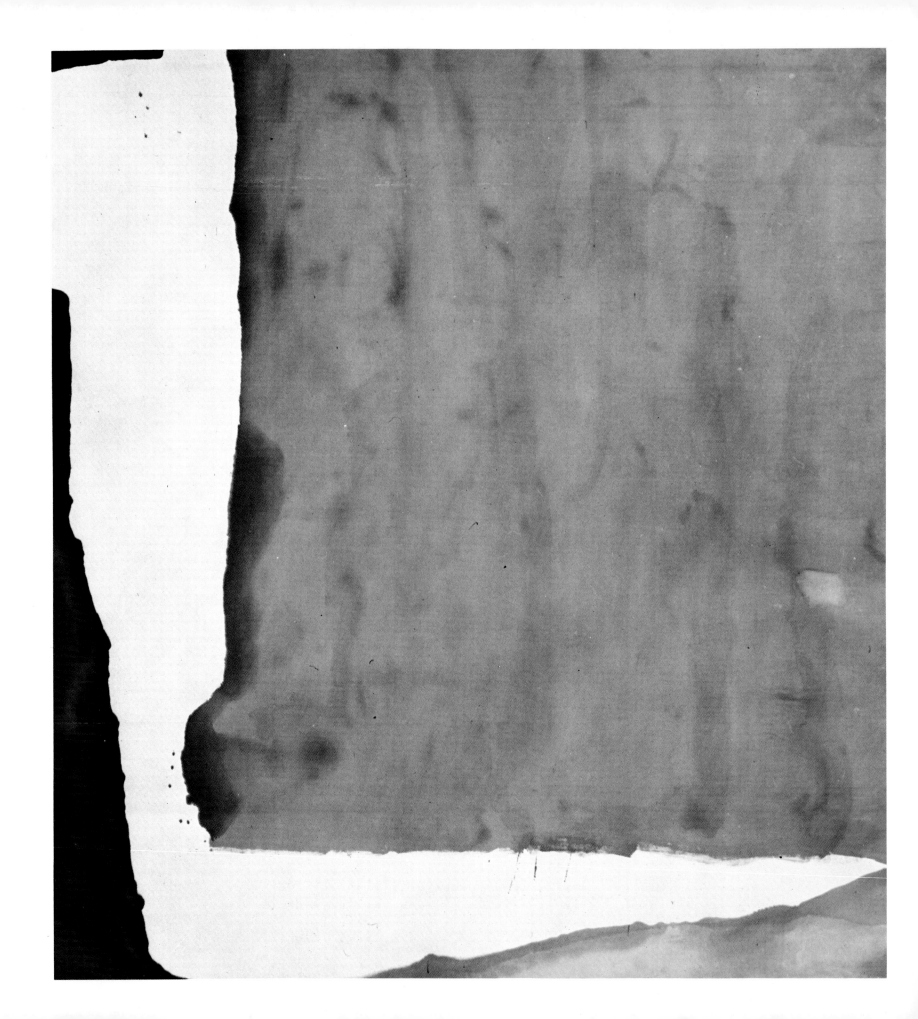

164. MAUVE DISTRICT. *1966. Acrylic on canvas, 8′ 7⅛″×7′ 11″. The Museum of Modern Art, New York City*
Mr. and Mrs. Donald B. Straus Fund, 1967

165. PARKWAY. *1966. Acrylic on canvas, 8′ 5″×2′*

166. ORANGE MEDIAN. *1966. Acrylic on canvas, 35×57". Collection Mr. and Mrs. William P. Scott, Jr., San Francisco*

167. WALES. *1966. Acrylic on canvas, 9' 6"×3' 9"*

168. RED BOOST. *1966. Acrylic on canvas, 84×46″*
Collection Mr. and Mrs. William P. Scott III, New York City

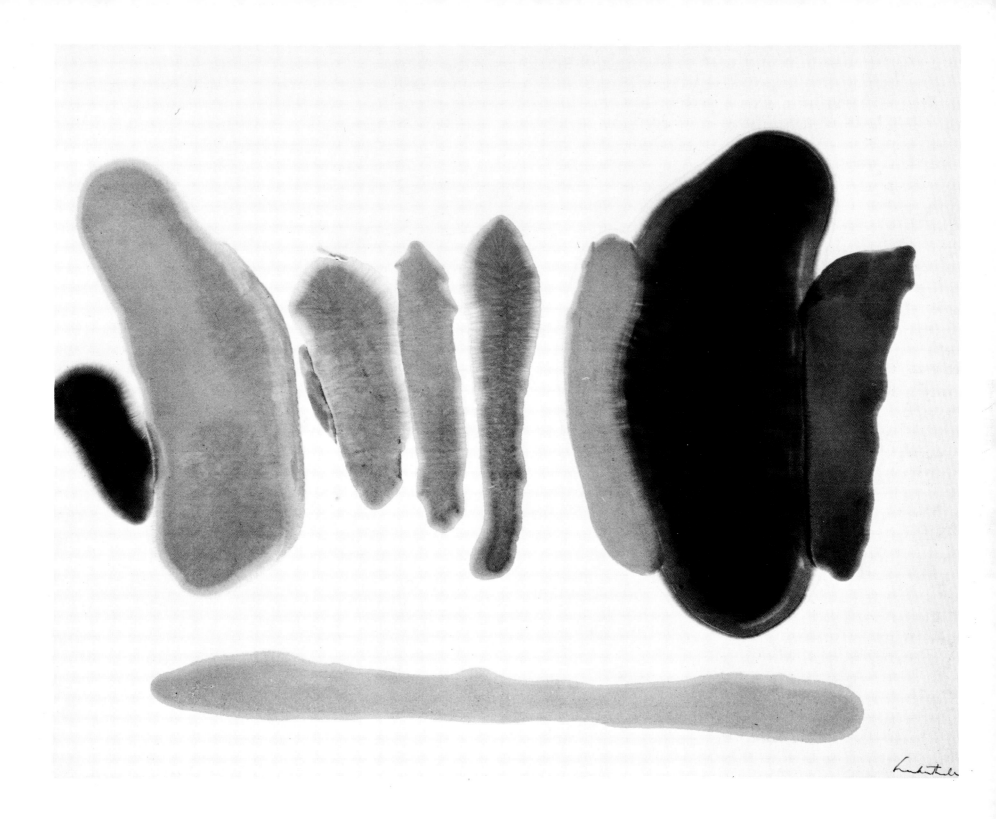

169. SPRING THOUGHTS UNDERSCORED. *1966. Acrylic on canvas, 69½ × 90″*

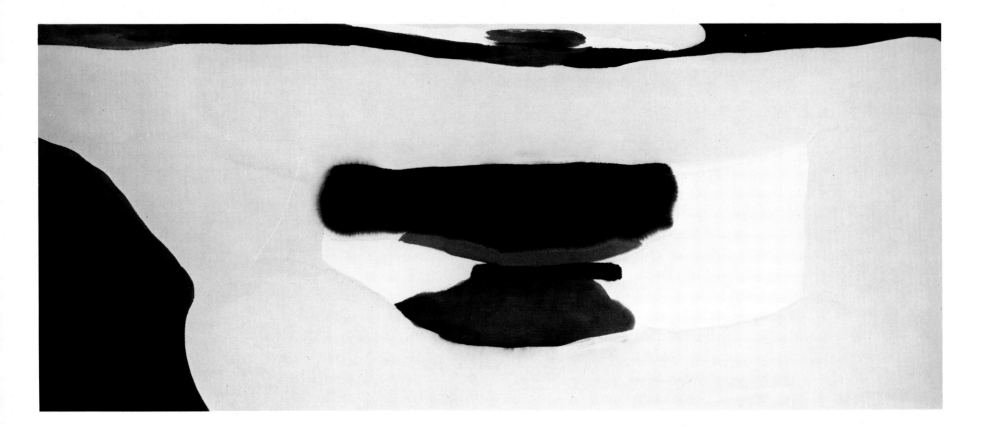

170. SUN FRAME. *1966. Acrylic on canvas, 3' 8" ×8' 8". Honolulu Academy of Arts, Hawaii*

171. THE HUMAN EDGE. *1967. Acrylic on canvas, 10' 4⅝" ×7' 9¼". Everson Museum of Art, Syracuse*

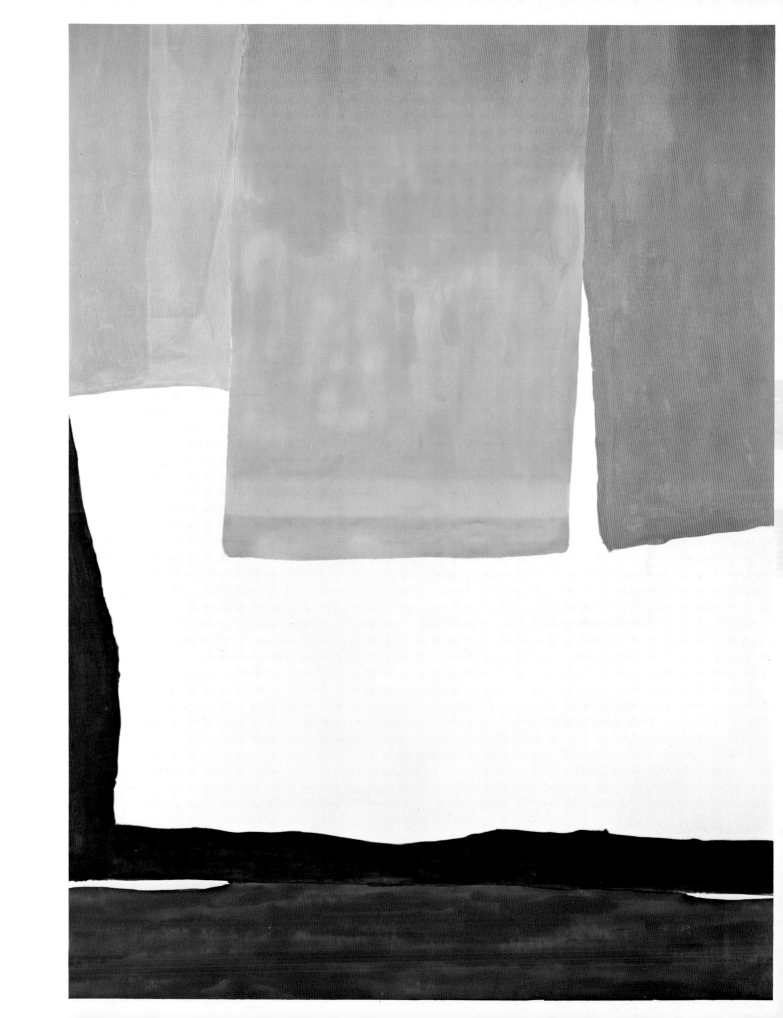

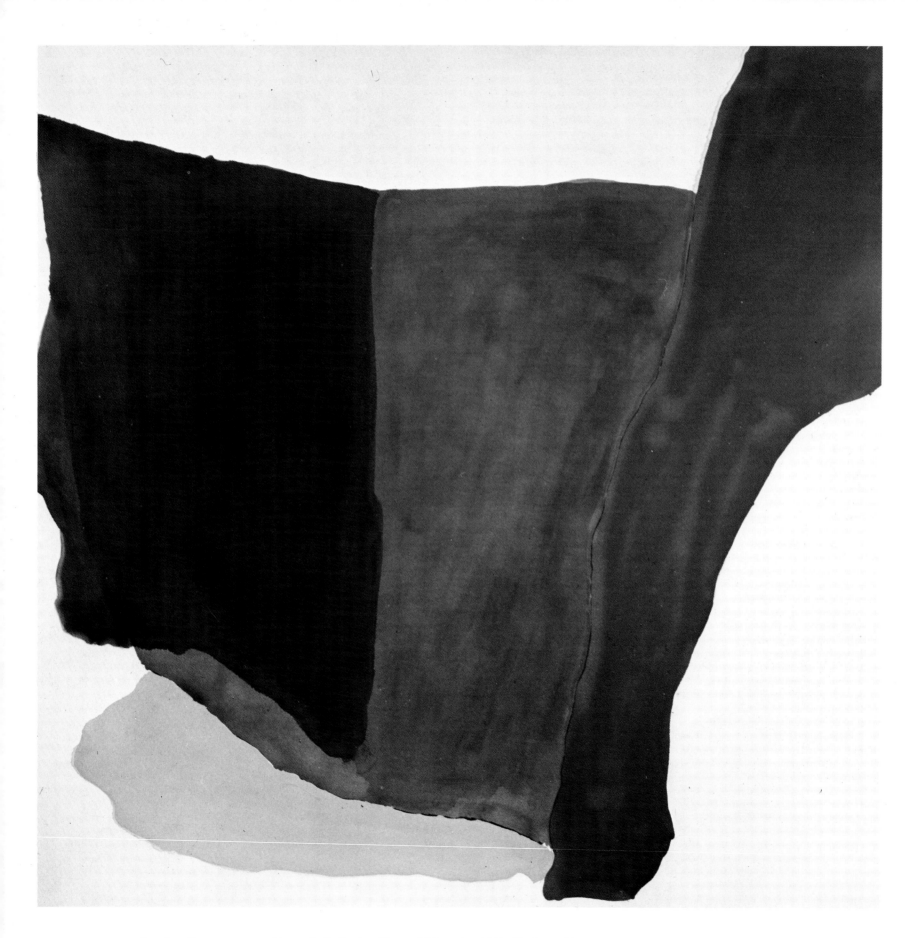

172. LOGGING. *1967. Acrylic on canvas, 93¾×97″. Collection Mr. and Mrs. Arnold L. Ginsburg, Harrison, N.Y.*

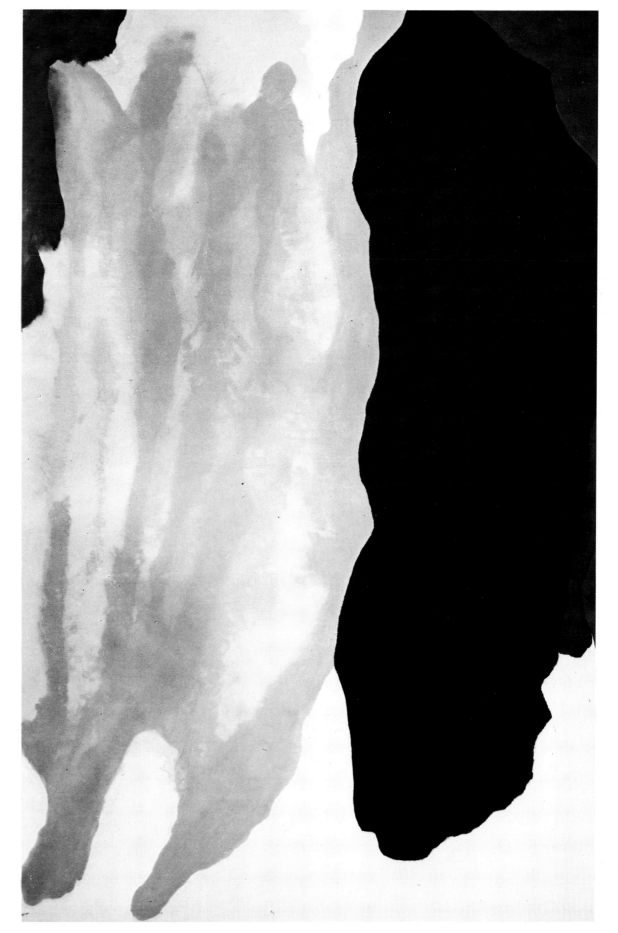

173. HARVEST. 1967
Acrylic on canvas, 11′ 8″ × 7′ 6″
Collection Jaime C. del Amo, Los Angeles

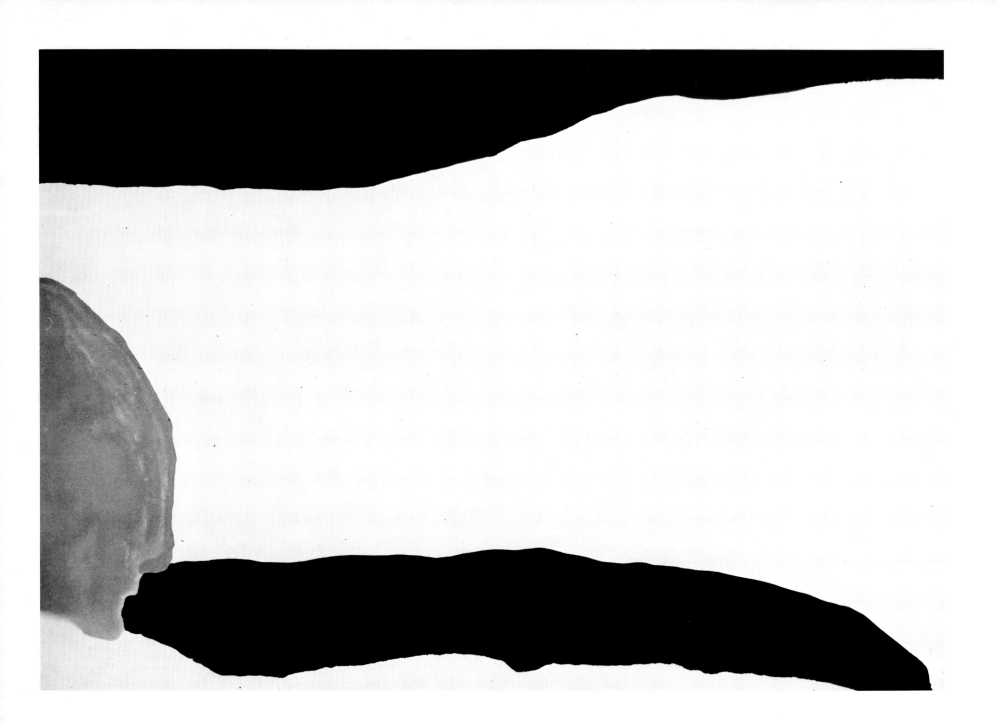

174. GOLDEN AXIS. *1967. Acrylic on canvas, 5′ 9″×8′ 7″. Collection Sydney Wragge, New York City*

175. GOLDEN DAY. *1967. Acrylic on canvas, 82×93¼″*

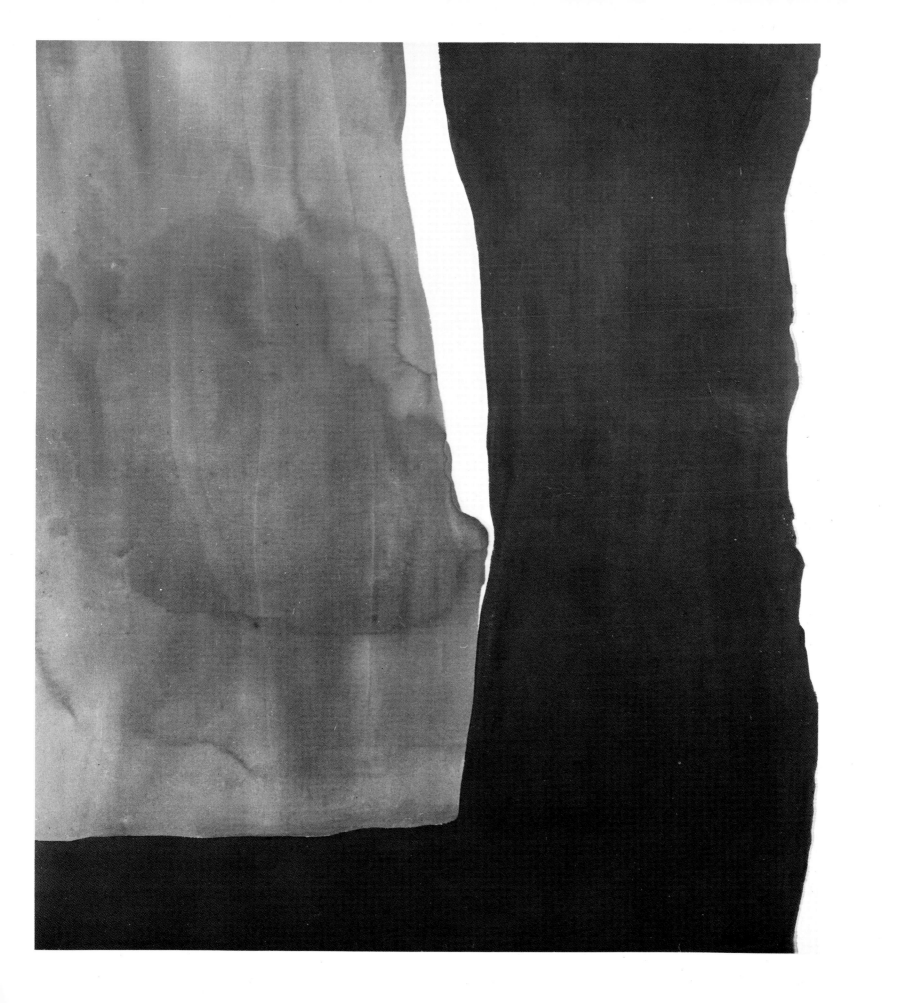

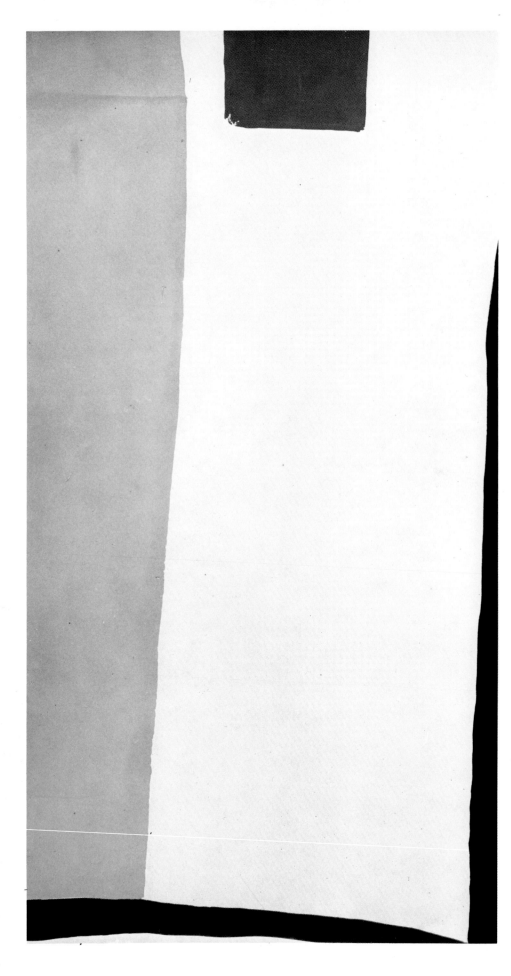

176. EDEN REVISITED. *1967. Acrylic on canvas, 10' 10" ×5' 9½"*

177. ADRIATIC. *1968*
Acrylic on canvas, 7' 9" × 11'
Pasadena Art Museum. Gift of the artist

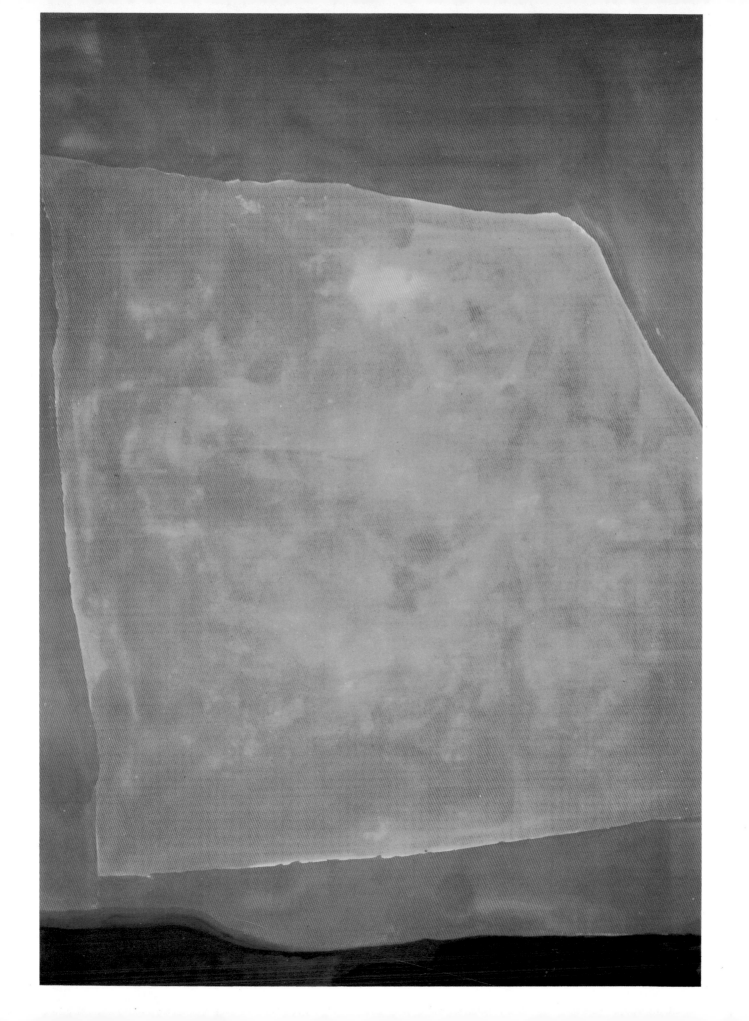

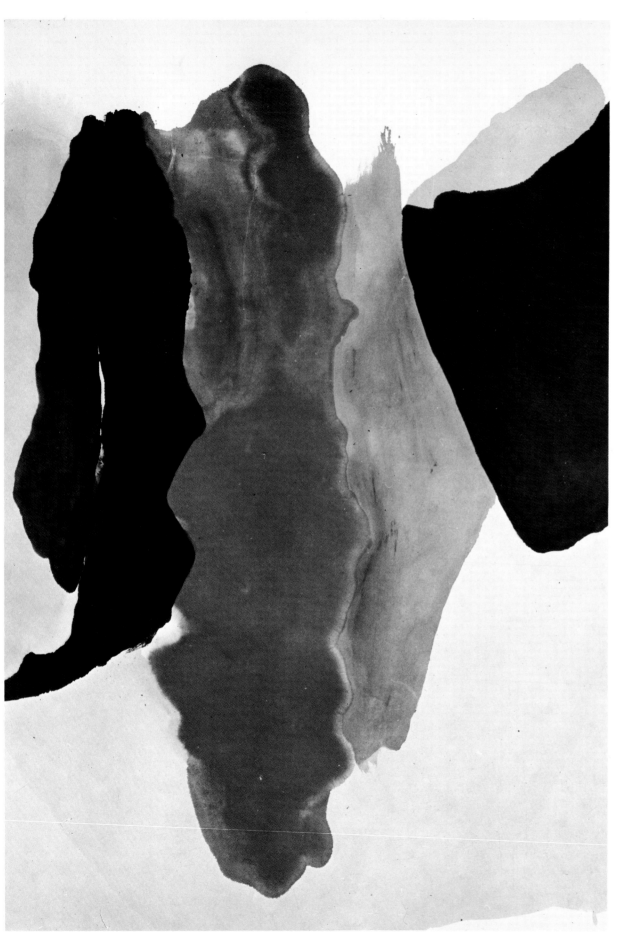

178. CINNAMON BURN. *1968*
Acrylic on canvas, 10' × 6' 10"

179. COALITION. 1968. Acrylic on canvas, 83 × 75½"
Collection Mr. and Mrs. Edwin Thorne, New York City

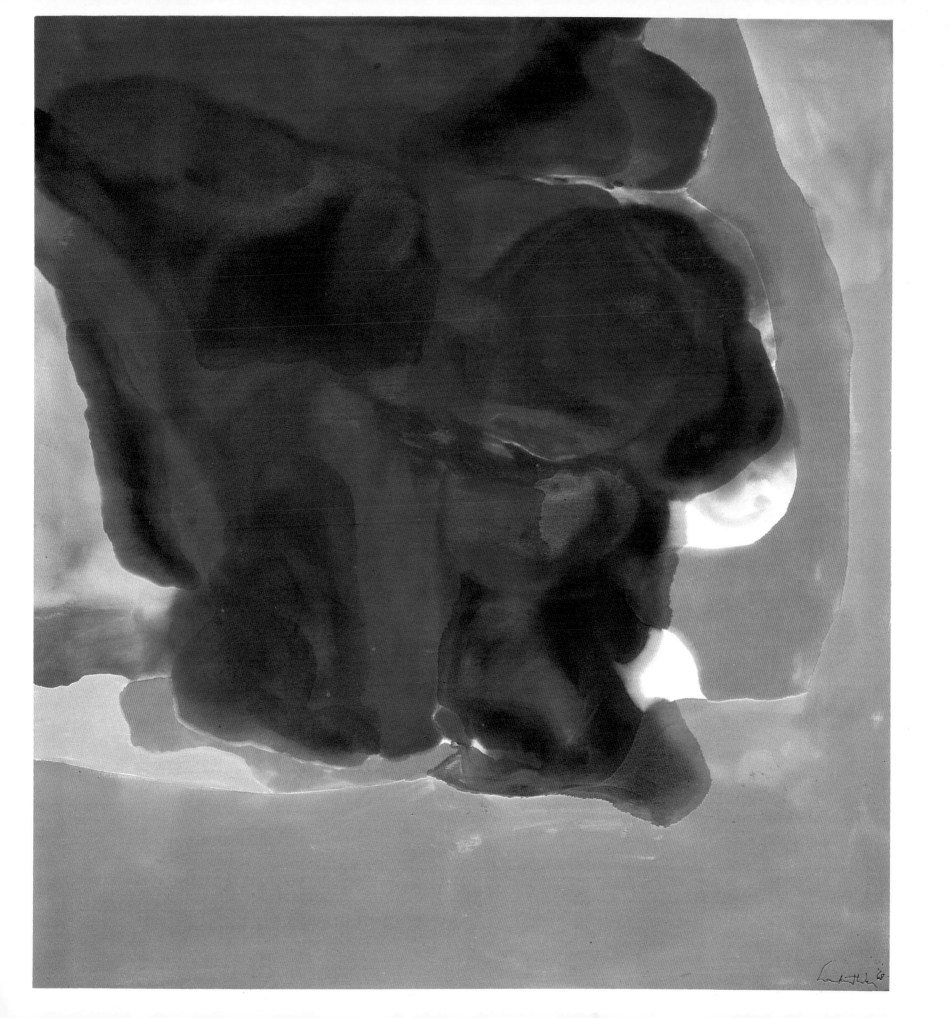

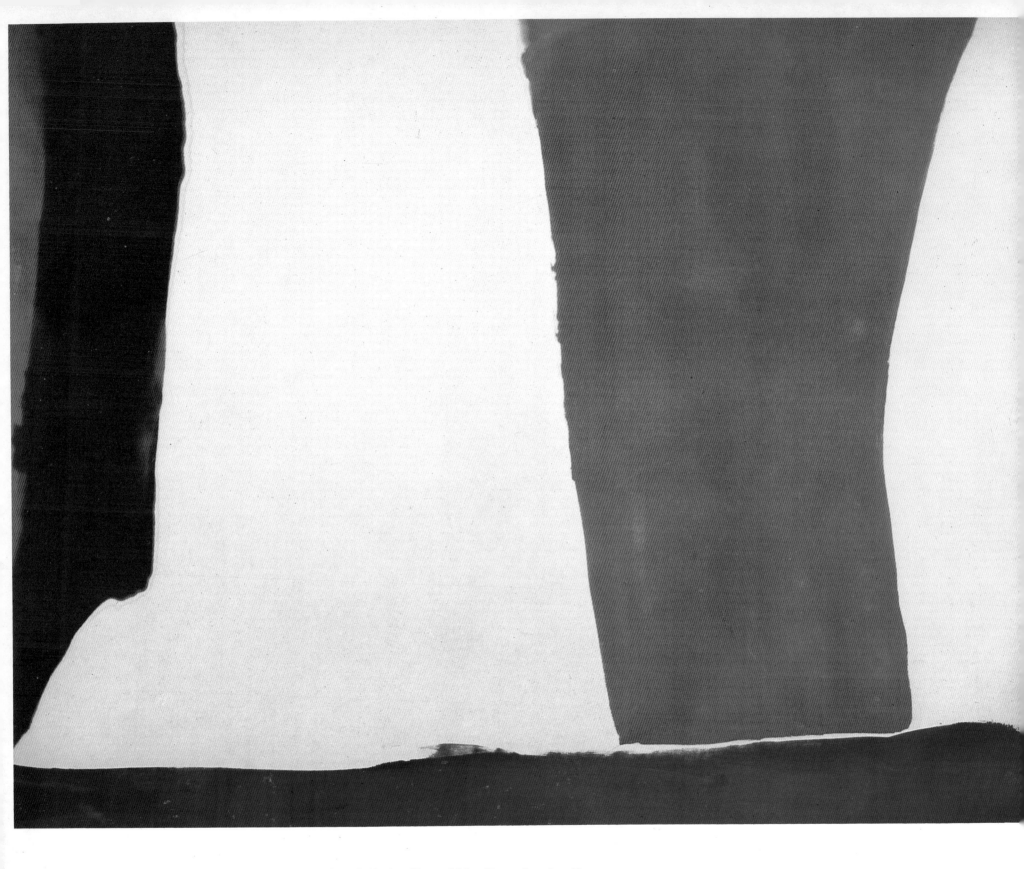

180. SUMMER BANNER. *1968. Acrylic on canvas, 72¼ × 93⅝". Collection Mr. and Mrs. Fayez Sarofim, Houston*

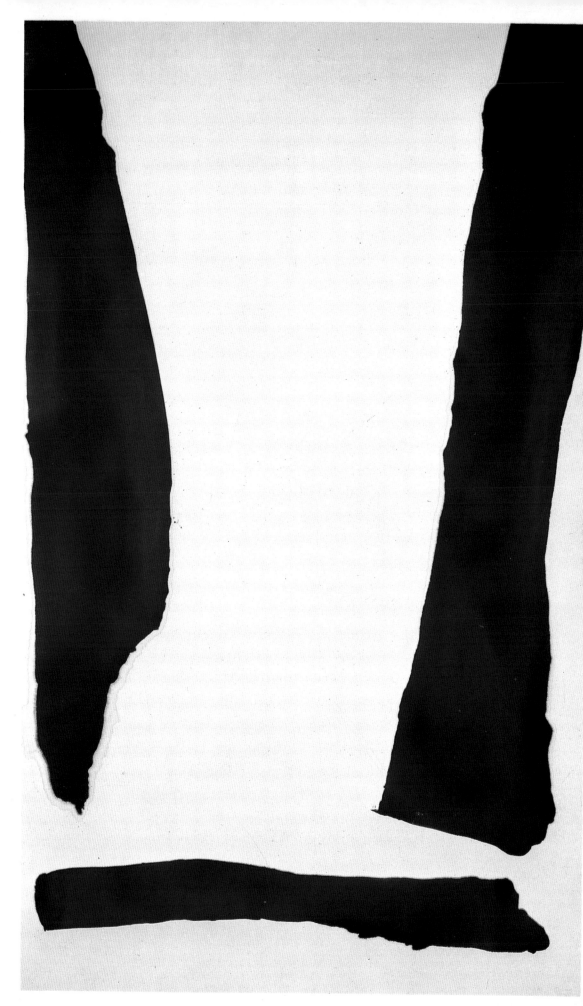

181. BLUE NORTH. *1968*
Acrylic on canvas, 12′ 10⅛″ × 7′ 9″
Private collection

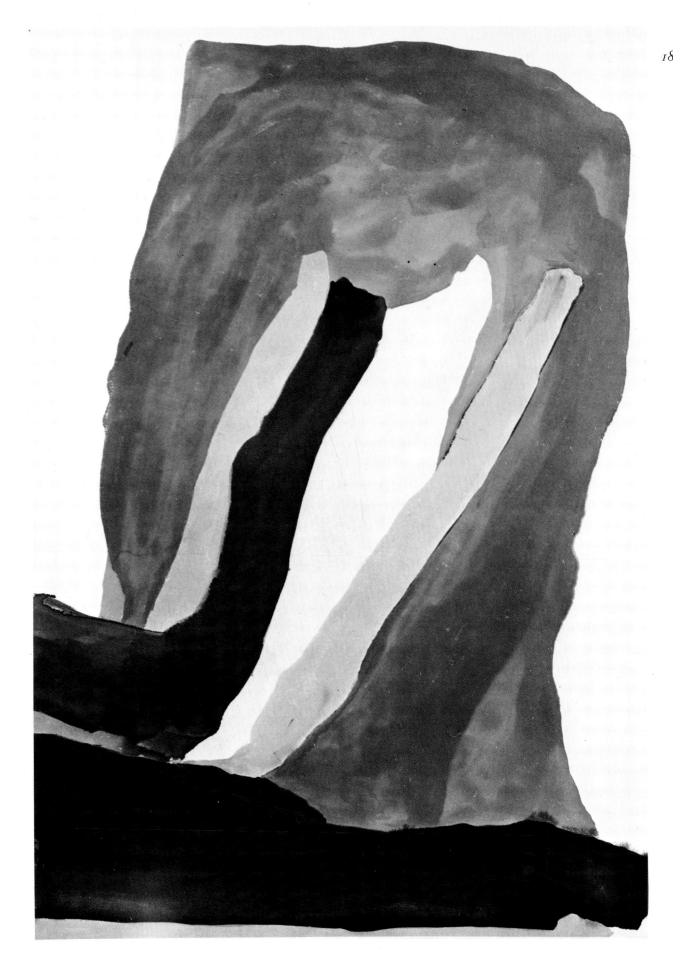

182. SUMMER CORE. *1968*
 Acrylic on canvas, 93×65½"
 Collection Mr. and Mrs. Harry Macklowe,
 New York City

183. ORANGE PROSCENIUM. *1968*
 Acrylic on canvas, 8′ 9½″×5′ 8″
 Collection the artist. Courtesy Kasmin Ltd., London

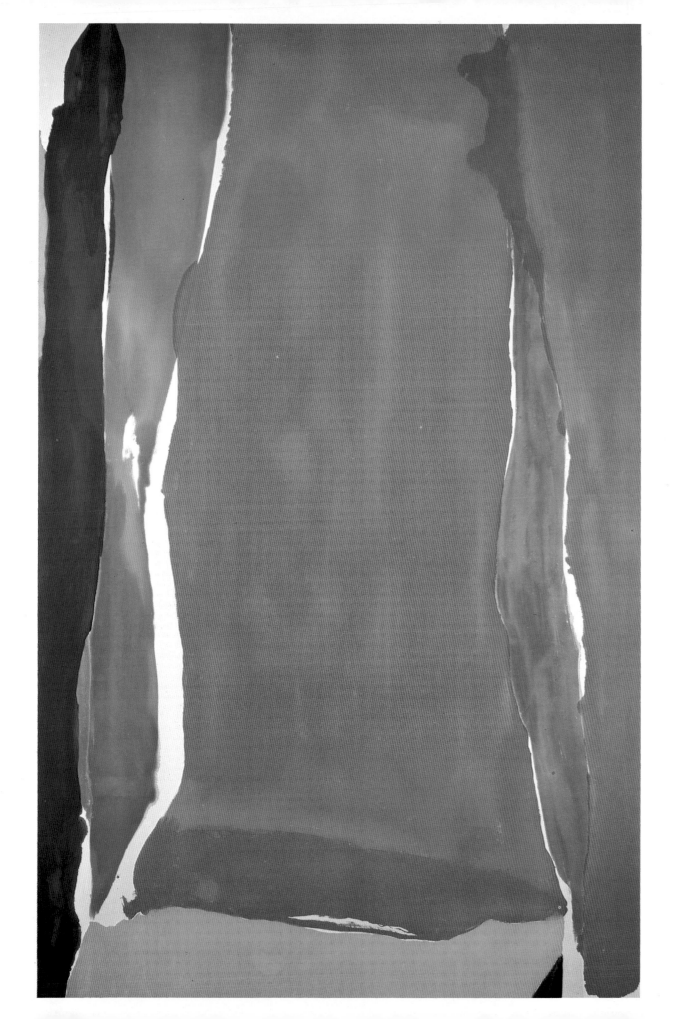

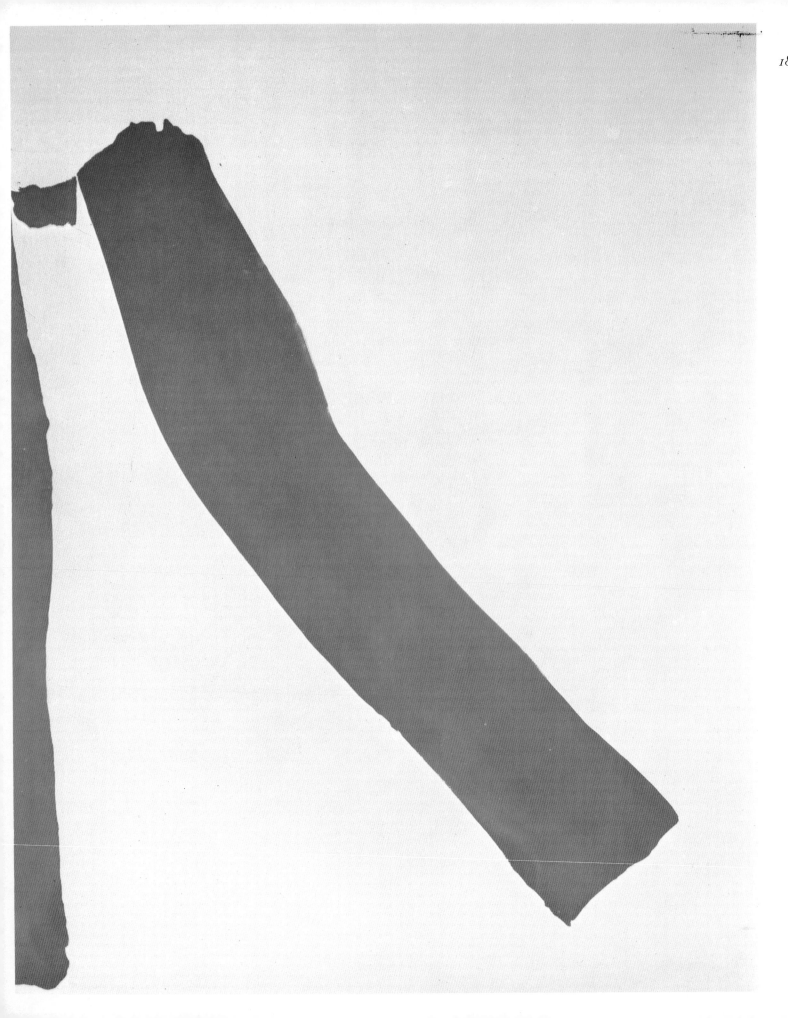

184. STRIDE. *1969*
Acrylic on canvas, 9′ 9¼″×7′ 10″
The Metropolitan Museum of Art,
New York City

185. HURRICANE FLAG. *1969*
Acrylic on canvas, 9′ 11″×8′ 9½″
Courtesy André Emmerich Gallery,
New York City

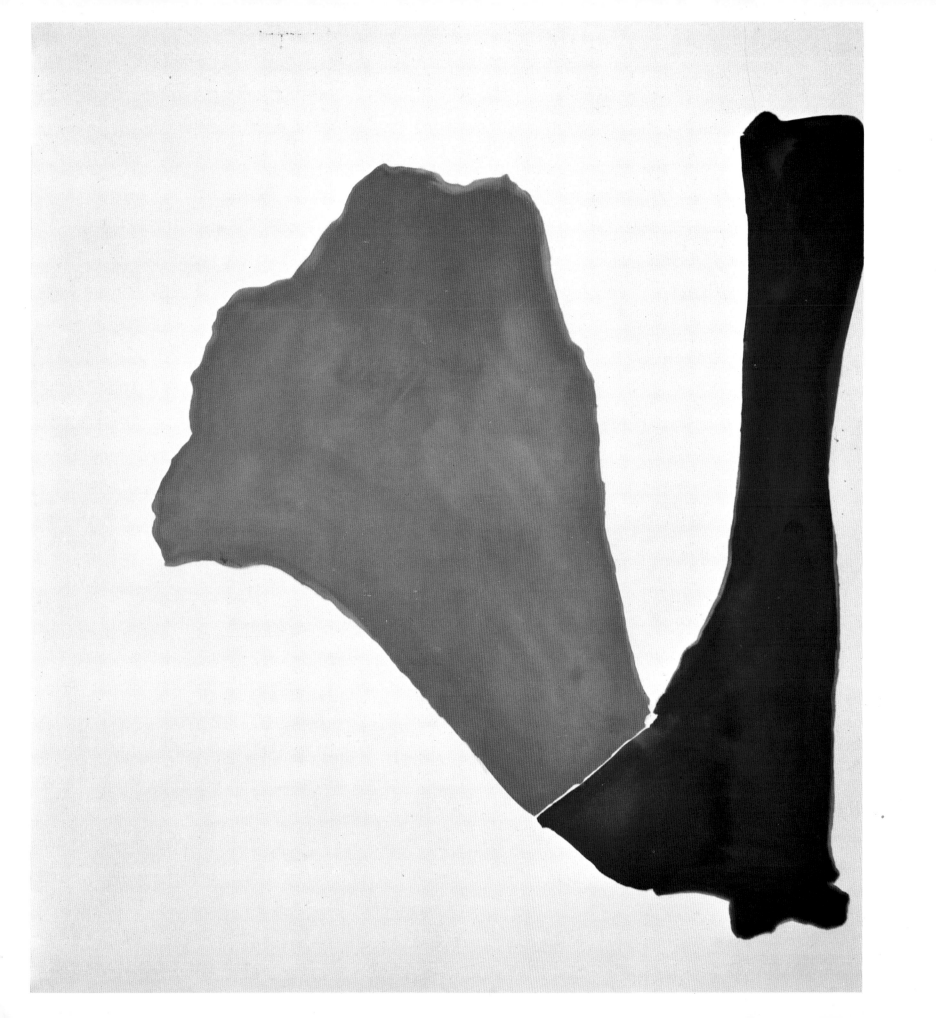

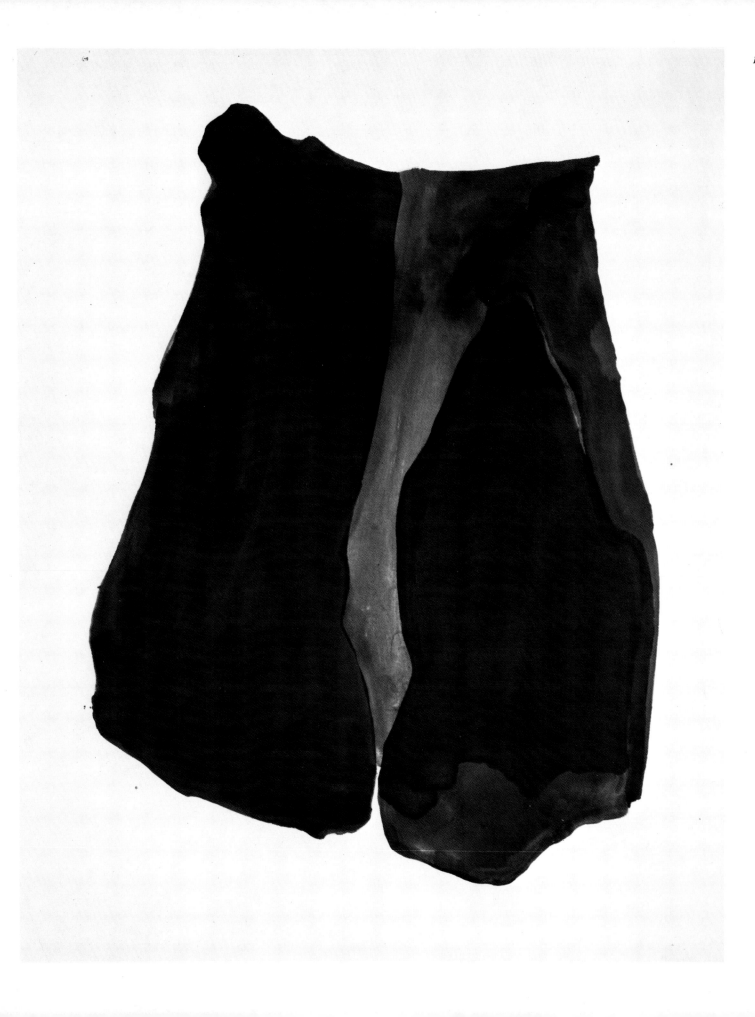

186. LOZENGE. *1969*
Acrylic on canvas, 8' 7" × 7' 9½"
Courtesy Nicholas Wilder Gallery,
Los Angeles

BIOGRAPHICAL OUTLINE

 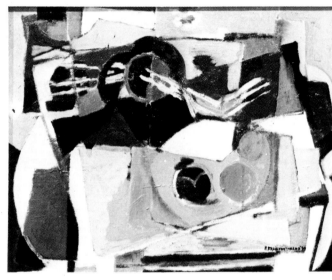

187. 188. 189.

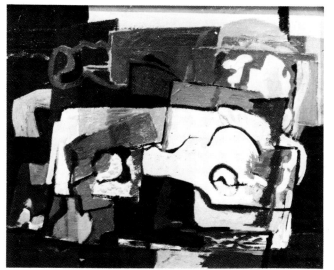

190.

191.

187. Paul Feeley seminar, Bennington College, 1949

188. ABSTRACT STILL LIFE *(1949)*

189. ABSTRACT STILL LIFE *(1949)*

190. ABSTRACT STILL LIFE *(1949)*

191. ABSTRACT STILL LIFE *(1949)*

1928 Born December 12, New York City, to Martha (née Lowenstein) and Alfred Frankenthaler. Two older sisters, now Mrs. Marjorie Iseman and Mrs. Gloria Ross.

1940 Father, a New York State Supreme Court Justice, dies on January 7.

1945 Graduates from the Dalton School; previously attended Horace Mann and Brearley schools. During autumn, continues to study painting with Rufino Tamayo, her art instructor at Dalton.

1946 Enters Bennington College, spring term. Studies art with Paul Feeley. Part of literary milieu that includes Kenneth Burke, Erich Fromm, W. H. Auden, Stanley Edgar Hyman, Ralph Ellison, and her schoolmate Sonya Rudikoff.

1947 Spends nonresident term working for *Art Outlook,* a magazine review, and studying at Art Students League with Vaclav Vytlacil.

1948 Travels, summer, to Amsterdam, London, Zurich, Brussels, Paris.

1949 Studies with painter Wallace Harrison at his school on Fourteenth Street. Graduates, B. A., from Bennington. Enters Graduate School of Fine Arts, Columbia University, autumn. Particularly interested in Meyer Schapiro's course. Shares studio on Twenty-first Street with Sonya Rudikoff.

1950 Organizes "Bennington Alumnae," May, for Seligmann Gallery. Meets critic Clement Greenberg. Also that spring meets David Smith, Lee and Jackson Pollock, Elaine and Willem de Kooning, Franz

260

Kline, Charles Egan, Adolph Gottlieb, Friedel Dzubas, Piero Dorazio. Studies for three weeks with Hans Hofmann at his Provincetown School. Exhibition: "Twelve Unknowns," Kootz Gallery (Frankenthaler selected by Adolph Gottlieb). Visits Black Mountain College, August. Rents David Hare's studio on East Tenth Street, spring, for a year.

1951 Frank O'Hara, John Ashbery, Barbara Guest among friends; also Harry Jackson, Larry Rivers, Grace Hartigan, Alfred Leslie who, like herself, are associated with Tibor de Nagy Gallery, run by John Myers. Begins to visit Smith in Bolton Landing, New York, and the Pollocks in Springs, Long Island. Exhibitions: "New Generation," group show at recently started Tibor de Nagy Gallery; "Ninth Street Show," rented store space. First one-man show: Tibor de Nagy Gallery.

1952 Paints *Mountains and Sea*. Exhibition: First Annual, Stable Gallery. Travels through Nova Scotia and Cape Breton, painting watercolors, summer. Shares a studio on Twenty-third Street with Friedel Dzubas.

1953 Painters Kenneth Noland and Morris Louis visit her studio and are impressed by work they see there. Begins exchange of studio visits with them between Washington, D.C., and New York City. One-man show: Tibor de Nagy. Group show: Tibor de Nagy. Studies art of museums and churches, Spain and Paris, summer.

1954 One-man show: Tibor de Nagy. On summer visit to Spain, hill towns of Italy, Florence, Rome, London continues to study Quattrocento and Old Master art.

1955 Mother dies in April. Exhibition: "U.S. Painting: Some Recent Directions," Stable (based on *Art News* essay by T. B. Hess). Moves studio/apartment to Ninety-fourth Street, West End Avenue. Rents Marca-

192.

193.

194.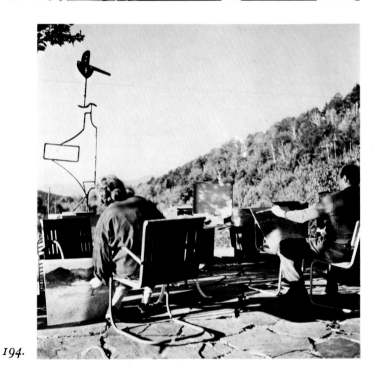

195.

192. *Lee Krasner, Clement Greenberg, Helen Frankenthaler, and Jackson Pollock at Eddie Condon's, January, 1951*

193. *With Hans Hofmann in his Provincetown studio, summer, 1950*

194. *Clement Greenberg and Helen Frankenthaler landscape painting at David Smith's Terminal Ironworks, Bolton Landing, New York, 1952*

195. *John Myers, Alfred Leslie, Grace Hartigan, and Helen Frankenthaler making kites at Leslie and Hartigan's Essex Street loft, spring, 1951*

196. *Joan Mitchell, Helen Frankenthaler, and Grace Hartigan at the opening of Frankenthaler's exhibition at the Tibor de Nagy Gallery, 1957. Above: PLANETARIUM. 1956*

197. *With David Smith in front of MOUNTAINS AND SEA (see plate 18) at Helen Frankenthaler's apartment at 94th Street and West End Avenue, 1957*

198. *With Robert Motherwell at their wedding lunch, April 6, 1958, at L'Armorique Restaurant, New York City*

196.

197.

198.

Relli's Springs, Long Island, studio for one summer month.

1956 Designs ark tapestry curtains for Temple of Aaron, St. Paul, Minnesota. One-man show: Tibor de Nagy. Goes to Germany, Austria, Paris, Netherlands, summer.

1957 Teaches painting, adult education program, Great Neck, Long Island, with other members of the Tibor de Nagy Gallery. One-man show: Tibor de Nagy. Exhibitions: "Artists of the New York School: Second Generation," Jewish Museum; "Young America 1957: 30 American Painters and Sculptors Under 35," Whitney Museum of American Art.

1958 Marries Robert Motherwell on April 6. Teaches drawing and painting, School of Education, New York University, part-time through 1961. One-man show: Tibor de Nagy. Exhibition: "Nature in Abstraction," Whitney Museum. Travels extensively throughout France and Spain for several months during honeymoon. Paints in France, rented villa in St. Jean-de-Luz. Moves New York studio to vacant store on Ninety-fourth Street, Third Avenue.

1959 *School of New York: Some Younger Artists,* ed. B. H. Friedman, includes Frankenthaler essay by Sonya Rudikoff. One-man show: André Emmerich Gallery. Exhibitions: Documenta II ("Kunst nach 1945"), Kassel, V Biennial, São Paulo; First Prize, I Biennale de Paris (for *Jacob's Ladder*). Works in Falmouth, Massachusetts, summer studio.

1960 Executes first of fifteen different lithographic prints at Universal Limited Art Editions. Retrospective show, directed by Frank O'Hara, Jewish Museum. One-man show: André Emmerich. Exhibition: "Sixty American Painters 1960," Minneapolis, Walker Art Center. Moves New York studio to Eighty-third Street, Third Avenue.

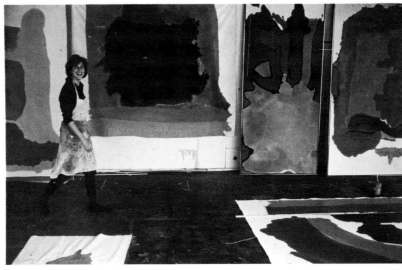

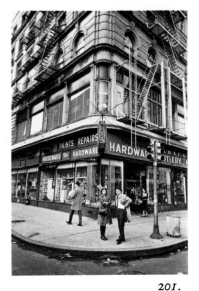

199. *200.* *201.*

1961 Appears on BBC, London, with interviewer David Sylvester. E. C. Goossen essay appears in *Art International*. One-man shows: André Emmerich; Los Angeles, Everett Ellin; Paris, Galerie Lawrence. Exhibition: "American Abstract Expressionists and Imagists," Guggenheim Museum. Frequently visits Paris and London during forthcoming years. Establishes first Provincetown studio in a barn. Continues to paint summers in Provincetown through 1969.

1962 Teaches class for ailing William Baziotes, Hunter College. Begins to use synthetic polymer (acrylic) paints. Retrospective show: Bennington College Carriage Barn (one in New York School series). One-man show: Milan, Galleria Dell'Ariete.

1963 Serves on Fulbright Selection Committee through 1965. Executes gouaches for *Art in America* anniversary album. One-man shows: André Emmerich; Galerie Lawrence.

1964 Makes ceramic earthenware plates at Bennington pottery with David Smith, Alexander Liberman, and Cleve Grey. One-man show: London, Kasmin Ltd. Exhibitions: "Post-Painterly Abstraction," Los Angeles County Museum of Art; "Prints by Painters and Sculptors," Museum of Modern Art circulating show. Moves Provincetown studio to residence, overlooking the sea.

1965 Interview with Henry Geldzahler appears in *Artforum*. Designs poster for *Paris Review*. One-man shows: André Emmerich; Toronto, David Mirvish Gallery. Visits Paris, London, Venice, Dubrovnik, Athens, Greek islands, summer.

1966 With three other painters, represents United States in Venice. Interviewed on NBC, "New York: The New Left Bank." One-man show: André Emmerich. Exhibitions: 33rd Biennial, U.S. Pavilion, Venice; "Two Decades of American Painting," Museum of Modern Art circulating show.

1967 Teaches at School of Art and Architecture, Yale University, and School of Visual Arts, New York. Elected trustee, Bennington College. One-man shows: Los Angeles, Nicholas Wilder Gallery; Detroit, Gertrude Kasle Gallery. Exhibition: "American Painting Now," Montreal, Expo '67 (shows 30' x 16' painting). Moves Provincetown studio to wooded park area.

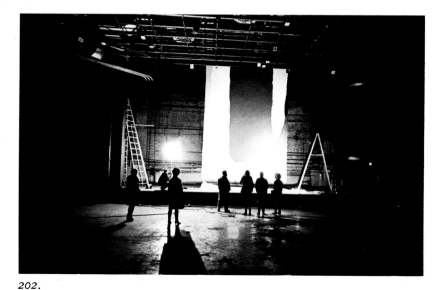

202.

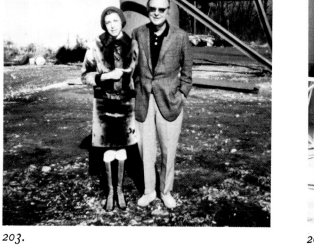

203.

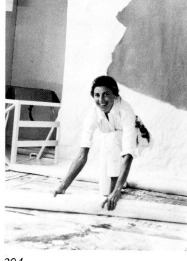

204.

199. *With Robert Motherwell at his studio at 86th Street and Third Avenue, 1964*

200. *Helen Frankenthaler in her studio at 83rd Street and Third Avenue, 1964*

201. *With Eugene Goossen on the corner of 83rd Street and Third Avenue; above is her studio. 1967*

202. *With Henry Geldzahler at a vacated RKO-Broadway movie theater,*
rented for the viewing of Helen Frankenthaler's painting for Expo '67. 1967

203. *With Robert Motherwell at the Connecticut*
home of the Alexander Libermans, 1969; behind is a Liberman sculpture

204. *Working in her Provincetown studio, summer, 1969*

1968 Appointed fellow, Calhoun College, Yale University. Executes first of three different aquatints at Universal Limited Art Editions. One-man show: André Emmerich. Given Joseph E. Temple Gold Medal Award, Philadelphia Academy of Fine Arts.

1969 Retrospective show, directed by E. C. Goossen, organized by the Whitney Museum and the International Council of the Museum of Modern Art. Opens at Whitney and also shown in London, Hanover, Berlin. One-man show: André Emmerich. Exhibitions: "New York Painting and Sculpture: 1940–1970" and "Prints by Four New York Painters," Metropolitan Museum. Visits Ireland and Berlin. Made Doctor of Humane Letters, Skidmore College.

1970 Teaches Yale seminar, spring term. Exhibition: "American Artists of the 1960s," Boston University. Visits Morocco and in Provence does watercolors again. Moves New York studio to two-floor former carriage house on East Eighty-third Street. Given Spirit of Achievement Award, Albert Einstein School of Medicine; Eighth Lively Arts Award.

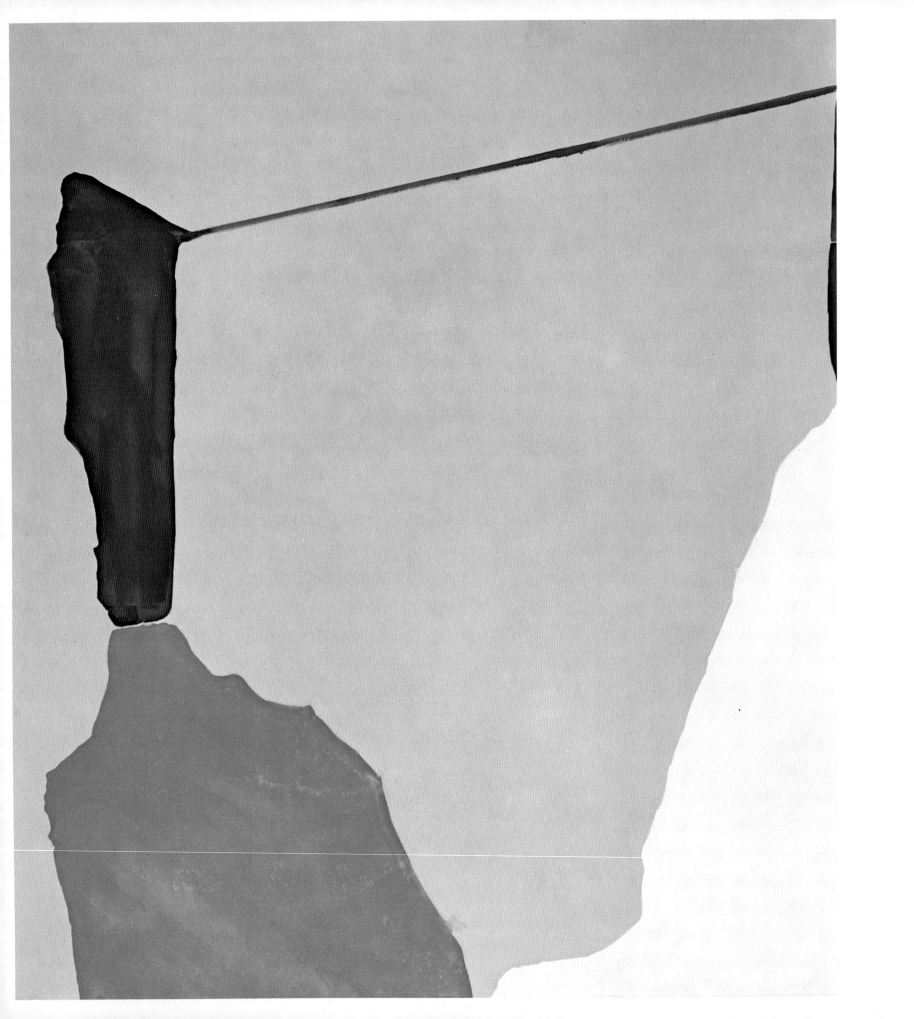

SELECTED BIBLIOGRAPHY

205. BLUE RAIL. *1969*
Acrylic on canvas, 8' 11" × 7' 9"
Courtesy David Mirvish Gallery, Toronto

STATEMENTS BY THE ARTIST

1 In exhibition catalogue *Young America 1957: Thirty American Painters and Sculptors Under Thirty-Five*. New York: Whitney Museum of American Art, 1957, p. 18.

2 "New Talent Annual, 1957." *Art in America,* vol. 45, no. 1 (March, 1957), p. 29.

3 In exhibition catalogue *Nature in Abstraction*. New York: Whitney Museum of American Art, 1958, p. 12 (softcover edition). New York: Macmillan, 1958, p. 12; p. 66 (hardcover edition only). See Bibl. 74.

4 In exhibition catalogue *Contemporary American Painting and Sculpture*. Urbana: University of Illinois Press, 1959, p. 215.

5 "Is There a New Academy?" *Art News,* vol. 58, no. 4 (Summer, 1959), pp. 34, 59.

6 Quotations from an interview with Helen Frankenthaler conducted by David Sylvester for the BBC, London, 1961, in exhibition brochure *Helen Frankenthaler*. Bennington, Vt.: Bennington College, May, 1962, n.p.

7 GELDZAHER, HENREY. "An Interview with Helen Frankenthaler." *Artforum,* vol. 4, no. 2 (October, 1965), pp. 36–38.

8 *New York: The New Left Bank*. New York: NBC telecast, June 22, 1966.

Tape of this program may be seen in the Television Archive at the Museum of Modern Art, New York.

9 Quotations from a letter to the author. In BARO, GENE: "The Achievement of Helen Frankenthaler." *Art International,* vol. 11, no. 7 (September, 1967), pp. 33–38.

10 Typescript of a tape-recorded interview with Helen Frankenthaler, conducted by Barbara Rose in Provincetown and New York, August and November, 1968 (Oral History Program, Archives of American Art). Restricted use, Archives of American Art, New York (Smithsonian Institution).

11 "Helen Frankenthaler . . . Cloud Slant." *Art Now: New York,* vol. 1, no. 3 (March, 1969), n.p.

12 "Heiress to a New Tradition." *Time,* vol. 93, no. 13 (March 28, 1969), pp. 64–69. Unsigned article on the occasion of her Whitney Museum retrospective.

13 "We Talk to . . . Helen Frankenthaler," *Mademoiselle,* vol. 69, no. 4 (August, 1969), pp. 343–44.

BOOKS

14 RUDIKOFF, SONYA. "Helen Frankenthaler's Painting." In B. H. Friedman, ed., *School of New York: Some Younger Artists*. New York: Grove, 1959, pp. 11–17.

15 PELLEGRINI, ALDO. *New Tendencies in Art.* New York: Crown, 1966, pp. 134, 138, 146.

16 ROSE, BARBARA. *American Art Since 1900.* New York: Praeger, 1967, pp. 224–26.

17 ARNASON, H. H. *History of Modern Art: Painting, Sculpture, Architecture.* New York: Abrams, 1968, pp. 593, 621–23.

18 ROSE, BARBARA. *American Painting: The Twentieth Century*, vol. 2. Geneva: Skira, 1969, pp. 90, 96, 100–105.

ARTICLES AND CRITIQUES

19 HESS, THOMAS B. "U.S. Painting: Some Recent Directions." *Art News Annual*, vol. 54, no. 7, pt. 2 (November, 1955), pp. 73–98, 174.

20 ——— "Younger Artists and the Unforgivable Crime." *Art News*, vol. 56, no. 2 (April, 1957), pp. 46–49, 64–65.

21 RUDIKOFF, SONYA. "Tangible Abstract Art." *Partisan Review*, vol. 24, no. 2 (Spring, 1957), p. 274.

22 "Women Artists in Ascendence: Young Group Reflects Lively Virtues of U.S. Painting." *Life*, vol. 42, no. 19 (May 13, 1957), pp. 74–77.

23 RUBIN, WILLIAM S. "The New York School—Then and Now: Part II." *Art International*, vol. 2 (May–June, 1958), pp. 19–22.

24 EMMERICH, ANDRE. "The Artist as Collector." *Art in America*, vol. 46, no. 2 (Summer, 1958), pp. 23–28.

25 RUBIN, WILLIAM S. "Younger American Painters." *Art International*, vol. 4, no. 1 (1960), pp. 24–31.

26 "The Vocal Girls." *Time*, vol. 75 (May 2, 1960), pp. 74–76.

27 GOOSSEN, E. C. "Helen Frankenthaler." *Art International*, vol. 5, no. 8 (October, 1961), pp. 76–79.

28 BERKSON, WILLIAM. "Poet of the Surface." *Arts*, vol. 39, no. 9 (May-June, 1965), pp. 44–50.

29 ASHTON, DORE. "Helen Frankenthaler." *Studio International*, vol. 170, no. 868 (August, 1965), pp. 52–55.

30 ROSE, BARBARA. "The Second Generation: Academy and Breakthrough." *Artforum*, vol. 4, no. 1 (September, 1965), pp. 53–63.

31 FRIEDMAN, B. H. "Towards the Total Color Image." *Art News*, vol. 65, no. 4 (Summer, 1966), pp. 31–33, 67–68.

32 RUBIN, WILLIAM S. "New Acquisitions: Painting and Sculpture—1967–68. "*Museum of Modern Art Members Newsletter*, October, 1968, n.p.

33 SMITH, GABRIELLE. "Helen Has a Show." *New York*, vol. 2, no. 7 (February 17, 1969), pp. 46–49.

34 KRAMER, HILTON. "Abstraction and 'The Landscape Paradigm.' " *New York Times*, March 2, 1969.

35 ROSENSTEIN, HARRIS. "The Colorful Gesture." *Art News*, vol. 68, no. 1 (March, 1969), pp. 29–31, 68.

36 SHIREY, DAVID L. "Gestalts of Color." *Newsweek*, March 24, 1969, pp. 101–2B.

37 ROSE, BARBARA. "Helen Frankenthaler." *Artforum,* vol. 7, no. 8 (April, 1969), pp. 28–33.

38 KRAMER, HILTON. "Thirty Years of the New York School." *New York Times Magazine,* October 12, 1969.

39 BANNARD, WALTER DARBY. "Notes On American Painting of the Sixties." *Artforum,* vol. 8, no. 5 (January, 1970), pp. 40–45.

ONE-MAN EXHIBITIONS AND REVIEWS

40 NEW YORK. TIBOR DE NAGY GALLERY. November 12–December 1, 1951. Checklist.
 B[etty] H[olliday], *Art News,* vol. 50, no. 7, pt. 1 (November, 1951), p. 48.
 P[aul] B[rach], *Art Digest,* vol. 26, no. 5 (December, 1951), pp. 18–19.

41 NEW YORK. TIBOR DE NAGY GALLERY. January 27–February 14, 1953.
 S[am] F[einstein], *Art Digest,* vol. 27, no. 10 (February, 1953), p. 20.
 F[airfield] P[orter], *Art News,* vol. 51, no. 10 (February, 1953), p. 55.
 Stuart Preston, *New York Times,* March 9, 1953.

42 NEW YORK. TIBOR DE NAGY GALLERY. November 16–December 4, 1954. Announcement card.
 S[tuart] P[reston], *New York Times,* November 19, 1954.
 F[rank] O'H[ara], *Art News,* vol. 53, no. 8 (December, 1954), p. 53.
 M[artica] S[awin], *Art Digest,* vol. 29, no. 6 (December, 1954), pp. 24–25.

43 NEW YORK. TIBOR DE NAGY GALLERY. February 18–March 8, 1956.

 P[arker] T[yler], *Art News,* vol. 54, no. 10 (February, 1956), p. 49.
 Stuart Preston, *New York Times,* February 5, 1956.
 L[averne] G[eorge], *Arts,* vol. 30, no. 6 (March, 1956), p. 59.

44 NEW YORK. TIBOR DE NAGY GALLERY. February 12–March 2, 1957. Color announcement.
 D[ore] A[shton], *New York Times,* February 9, 1957.
 J[ames] S[chuyler], *Art News,* vol. 55, no. 10 (February, 1957), p. 10.
 E[lizabeth] P[ollet], *Arts,* vol. 31, no. 6 (March, 1957), p. 54.

45 NEW YORK. TIBOR DE NAGY GALLERY. January 6–25, 1958. Color poster announcement.
 E[laine] G[ottlieb], *Arts,* vol. 32, no. 4 (January, 1958), p. 55.
 P[arker] T[yler], *Art News,* vol. 56, no. 9 (January, 1958), p. 20.
 Howard Devree, *New York Times,* January 12, 1958.

46 NEW YORK. ANDRE EMMERICH GALLERY. March 30–April 25, 1959.
 Lawrence Campbell, *Art News,* vol. 58, no. 3 (May, 1959), p. 14.
 S[idney] T[illim], *Arts,* vol. 33, no. 8 (May, 1959), p. 56.

47 NEW YORK. THE JEWISH MUSEUM. *Helen Frankenthaler Paintings.* January 26–March 2, 1960. Catalogue essay by Frank O'Hara; b & w ill; chronology; por; bio.
 John Canaday, *New York Times,* February 7, 1960.
 Barbara Butler, *Art International,* vol. 4, nos. 2–3 (1960), p. 55.
 D[onald] J[udd], *Arts,* vol. 34, no. 6 (March, 1960), p. 55.
 A[nne] S[eelye], *Art News,* vol. 59, no. 1 (March, 1960), pp. 39, 57–58; letters in

response to this review, *Art News*, vol. 59, no. 3 (May, 1960), p. 6.

48 NEW YORK. ANDRE EMMERICH GALLERY. March 28–April 23, 1960. Color poster announcement.
Stuart Preston, *New York Times*, April 2, 1960.
J[ames] S[chuyler], *Art News*, vol. 59, no. 3 (May, 1960), p. 13.
S[idney] T[illim], *Arts*, vol. 34, no. 8 (May, 1960), p. 57.

49 LOS ANGELES. EVERETT ELLIN GALLERY. March 20–April 15, 1961. Announcement: b&w ill; por.

50 PARIS. GALERIE LAWRENCE. October 15–November 7, 1961. Catalogue: col and b&w ill; por; bio.
John Ashbery, *Art International*, vol. 5, no. 9 (November, 1961), p. 50.

51 NEW YORK. ANDRE EMMERICH GALLERY. November 14–December 2, 1961. Announcement: ill; por; bio; bibl.
Brian O'Doherty, *New York Times*, November 17, 1961.
D[onald] J[udd], *Arts*, vol. 36, no. 4 (January, 1962), pp. 38–39.
J[ack] K[roll], *Art News*, vol. 60, no. 9 (January, 1962), p. 10.

52 MILAN. GALLERIA DELL'ARIETE. March 8–18, 1962. Catalogue: reprinted Goossen essay (Bibl. 27); col and b&w ill; bio.
Gualtiero Schoenberger, *Art International*, vol. 6, no. 3 (April, 1962), p. 58.

53 BENNINGTON (VT.). BENNINGTON COLLEGE. *Helen Frankenthaler*. May, 1962. Brochure catalogue: introduction by Lawrence Alloway; quotations from Sylvester interview (Bibl. 6); comment by Paul Feeley; ill.

54 NEW YORK. ANDRE EMMERICH GALLERY. March 5–30, 1963.
I[rving] S[andler], *Art News*, vol. 62, no. 1 (March, 1963), p. 11.
Dore Ashton, *Arts and Architecture*, vol. 80, no. 4 (April, 1963), pp. 4–5.
Michael Fried, *Art International*, vol. 7, no. 3 (April, 1963), pp. 54–56.
D[onald] J[udd], *Arts*, vol. 37, no. 7 (April, 1963), p. 54.
Dore Ashton, *Studio International*, vol. 165, no. 842 (June, 1963), pp. 253–54.

55 PARIS. GALERIE LAWRENCE. Fall, 1963.
Annette Michelson, *Art International*, vol. 7, no. 9 (December, 1963), p. 57.

56 LONDON. KASMIN LIMITED. May–June, 1964. Catalogue: col and b&w ill; por; bio.
Denis Bowen, *The Arts Review*, vol. 16, no. 10 (May 30–June 13, 1964), pp. 2, 25.
Jasia Reichardt, *Aujourd'hui*, vol. 8, no. 470 (October, 1964), p. 56.

57 NEW YORK. ANDRE EMMERICH GALLERY. March 16–April 3, 1965. Color poster announcement.
Max Kozloff, *The Nation*, vol. 200, no. 14 (April 5, 1965), pp. 374–76.
L[awrence] C[ampbell], *Art News*, vol. 64, no. 3 (May, 1965), p. 10.

58 TORONTO. DAVID MIRVISH GALLERY. December 8–29, 1965. Announcement card.

59 NEW YORK. ANDRE EMMERICH GALLERY. October 8–27, 1966. Brochure: col and b&w ill; por.
John Gruen, *World Journal Tribune*, October 12, 1966.
Hilton Kramer, *New York Times*, October 22, 1966.
S[cott] B[urton], *Art News*, vol. 65, no. 7 (November, 1966), pp. 11–12.
Michael Benedikt, *Art International*, vol.

10, no. 10 (December, 1966), pp. 64–65.

60 LOS ANGELES. NICHOLAS WILDER GALLERY. March 14–April 1, 1967. Announcement card: col ill.
Jules Langsner, *Art News,* vol. 66, no. 3 (May, 1967), pp. 22, 24.

61 PUTNEY (VT.). WINDHAM COLLEGE. *Helen Frankenthaler: A Selection of Work on Paper, 1958–1966.* May 8–21, 1967. Announcement card.

62 NEW YORK. ANDRE EMMERICH GALLERY. April 6–25, 1968. Color poster announcement.
Hilton Kramer, *New York Times,* April 13, 1968.
Christopher Andrae, *Christian Science Monitor,* April 17, 1968.
S[cott] B[urton], *Art News,* vol. 67, no. 3 (May, 1968), pp. 13–14.
James R. Mellow, *Art International,* vol. 12, no. 5 (May, 1968), pp. 67–68.
Max Kozloff, *Artforum,* vol. 6, no. 10 (Summer, 1968), pp. 48–49.

63 NEW YORK. WHITNEY MUSEUM OF AMERICAN ART. *Helen Frankenthaler.* February 20–April 6, 1969. Catalogue: essay by E. C. Goossen; col and b&w ill; por; exhibition lists; bibl. Exhibition organized by the Whitney Museum of American Art and the International Council of the Museum of Modern Art, New York. Variant catalogues issued by participating museums (see Bibl. 64–66).
See Bibl. 12, 33–37 for critiques.

64 LONDON. WHITECHAPEL GALLERY. *Helen Frankenthaler.* May 7–June 8, 1969. Combined Whitney Catalogue (Bibl. 63) with separately issued insert containing introductory essay by Bryan Robertson; chronology.

Gregory Battcock, *Art and Artists,* vol. 4, no. 2 (May, 1969), pp. 52–55.
Bernard Denvir, *Art International,* vol. 13, no. 7 (September, 1969), p. 66.

65 HANOVER. ORANGERIE HERRENHAUSEN. *Helen Frankenthaler.* August 21–September 21, 1969. Catalogue: reprinted Goossen essay (Bibl. 63) in German; col and b&w ill; installation views of the Whitney exhibition; por; bio.

66 BERLIN. KONGRESSHALLE. *Helen Frankenthaler: Bilder 1952–1968.* October 2–21, 1969. Catalogue in German: col and b&w ill; por; bio.

67 NEW YORK. ANDRE EMMERICH GALLERY. November 18–December 4, 1969. Catalogue: col and b&w ill.
Jean-Louis Bourgeois, *Artforum,* vol. 8, no. 5 (January, 1970), pp. 70–71.
H[arris] R[osenstein], *Art News,* vol. 68, no. 9 (January, 1970), p. 16.

GROUP EXHIBITIONS AND REVIEWS

68 NEW YORK. JACQUES SELIGMANN AND COMPANY GALLERY. *Bennington College Alumnae Paintings.* May 15–27, 1950. Brochure checklist. Exhibition organized by Helen Frankenthaler.

69 NEW YORK. KOOTZ GALLERY. *Fifteen Unknowns.* December 5–30, 1950. Brochure checklist. Frankenthaler selected by Adolph Gottlieb.
Henry McBride, *Art News,* vol. 49, no. 8 (December, 1950), p. 51.

70 NEW YORK. 60 EAST 9TH STREET. *Ninth St.: Exhibition of Paintings and Sculpture.* May 21–June 10, 1951. Poster announcement.

T[homas] B. H[ess], *Art News,* vol. 50, no. 4 (Summer, 1951), pp. 46–47.

71 PITTSBURGH. CARNEGIE INSTITUTE. [Annuals] *The 1955 Pittsburgh International Exhibition of Contemporary Painting.* October 13–December 18, 1955. Catalogue issued.

Thomas B. Hess, *Art News,* vol. 54, no. 7 (November, 1955), pp. 40–42, 56–57. Also included in: December 5, 1958–February 8, 1959; October 27, 1961–January 7, 1962.

72 NEW YORK. WHITNEY MUSEUM OF AMERICAN ART. *Young America 1957: Thirty American Painters and Sculptors Under Thirty-Five.* February 27–April 14, 1957. Catalogue: bio; statements.

Hess, Bibl. 20.

73 NEW YORK. THE JEWISH MUSEUM. *Artists of the New York School: Second Generation.* March 10–April 28, 1957. Catalogue introduction by Leo Steinberg. Selected by Meyer Schapiro.

Hess, Bibl. 20.

74 NEW YORK. WHITNEY MUSEUM OF AMERICAN ART. *Nature in Abstraction.* January 14–March 16, 1958. Variant soft- nad hardcover catalogues issued: text by John I. H. Baur; bio by Rosalind Irvine. (See Bibl. 3.)

75 NEW YORK. WHITNEY MUSEUM OF AMERICAN ART. [Annuals] *Annual Exhibition of Contemporary American Painting.* November 19, 1958–January 4, 1959. Catalogue issued.
Also included in: December 31, 1961–February 4, 1962; December 11, 1963–February 2, 1964; December 8, 1965–January 30, 1966; December 13, 1967–February 4, 1968; December 16, 1969–February 1, 1970.

76 SAO PAULO. MUSEU DE ARTE MODERNA. *V Bienal.* 1959. Catalogue introduction in Portuguese and English for American section. Selected by Sam Hunter.
Also shown in: MINNEAPOLIS. INSTITUTE OF ARTS. 1959.

77 URBANA. UNIVERSITY OF ILLINOIS. [Annuals] *Contemporary American Painting and Sculpture.* March 1–April 5, 1959. Catalogue issued.
Also included in: March 3–April 7, 1963; March 7–April 11, 1965; March 5–April 9, 1967. Location moved to Champaign, Krannert Art Museum.

78 KASSEL, MUSEUM FRIDERICIANUM. *Documenta II: Kunst nach 1945.* July 11–October 11, 1959. Catalogue essay by Werner Haftmann, vol. I, *Malerei.*

79 CHICAGO. ART INSTITUTE. [Annuals] *Sixty-fourth American Exhibition.* January 6-February 5, 1961. Catalogue issued.
Also included in: January 11–February 10, 1963.

80 PARIS. MUSEE D'ART MODERNE DE LA VILLE DE PARIS. *Première Biennale de Paris.* October 2–25, 1959. Catalogue preface by Raymond Cogniat; U.S. note by Peter Selz.
New York Times, October 7, 1959.
Jean Grenier, *Art International,* vol. 3, no. 9 (1959), pp. 6–7.

81 MINNEAPOLIS. WALKER ART CENTER. *Sixty American Painters 1960: Abstract Expressionist Painting of the Fifties.* April 3–May 8, 1960. Catalogue foreword and text by H. H. Arnason; extensive bio; individual and group bibl.
Sir Herbert Read and H. H. Arnason, *Art News,* vol. 59, no. 3 (May, 1960), pp. 32–36.

82 NEW YORK. SOLOMON R. GUGGENHEIM MUSEUM. *American Abstract Expressionists and Imagists.* October–December, 1961. Catalogue text by H. H. Arnason; bio; individual and group bibl.

83 SEATTLE. SEATTLE WORLD'S FAIR. *Art Since 1950: American.* April 21–October 21, 1962. Catalogue foreword by Norman Davis; introduction by Sam Hunter.
Also shown in: WALTHAM (MASS.). BRANDEIS UNIVERSITY, ROSE ART MUSEUM. November 21–December 23, 1962.

84 PHILADELPHIA. ACADEMY OF FINE ART. [Annuals] *Annual Exhibition of American Painting and Sculpture.* January 15–March 1, 1964. Catalogue issued.
Also included in: January 21–March 6, 1966; January 19–March 3, 1968.

85 LONDON. THE TATE GALLERY. *Painting and Sculpture of a Decade: 1954–1964.* April 22–June 28, 1964. Catalogue notes by Alan Bowness, Lawrence Gowing, Philip James. Exhibition selections from the Calouste Gulbenkian Foundation.
Roger Coleman, *Art International,* vol. 8, no. 5–6 (Summer, 1964), p. 96.
Alan Bowness, *Studio International,* vol. 167, no. 853 (May, 1964), p. 190–95.

86 LOS ANGELES. COUNTY MUSEUM OF ART. *Post-Painterly Abstraction.* April 23–June 7, 1964. Catalogue essay by Clement Greenberg, organizer of the exhibition.
Also shown in: MINNEAPOLIS. WALKER ART CENTER. July 13–August 16, 1964; TORONTO. ART GALLERY OF TORONTO. November 20–December 20, 1964.

87 NEW YORK. THE SOLOMON R. GUGGENHEIM MUSEUM. *Word and Image.* December, 1965. Brochure introduction by Lawrence Alloway.

A[my] G[oldin], *Arts,* vol. 40, no. 4 (February, 1966), p. 54.

88 ST. JOHN. NEW BRUNSWICK [CANADA] MUSEUM. *Frankenthaler. Noland. Olitski.* 1966. Catalogue introduction by J. Barry Lord.
Also shown: REGINA. THE NORMAN MACKENZIE ART GALLERY; SASKATOON. MENDEL ART GALLERY; CHARLOTTETOWN. CONFEDERATION ART GALLERY AND MUSEUM.

89 NEW YORK. PUBLIC EDUCATION ASSOCIATION. *Seven Decades: 1895–1965: Crosscurrents in Modern Art.* April 26–May 21, 1966. Catalogue text by Peter Selz. Frankenthaler shown at Cordier-Ekstrom, Inc.

90 VENICE. UNITED STATES PAVILION. *XXXIII International Biennial Exhibition of Art.* June 18–October 16, 1966. Catalogue foreword by David W. Scott; introduction by Henry Geldzahler, organizer of the American section; essay on Frankenthaler by William S. Rubin; bio; por; selected bibl.
Norbert Lynton, *Art International,* vol. 10, no. 7 (September, 1966), p. 89.
Rolf-Gunter Dienst, *Das Kunstwerk,* vol. 21, no. 11–12 (August-September, 1966), pp. 36–55.
Hilton Kramer, *New York Times,* June 16, 1966.

91 NEW YORK. THE JEWISH MUSEUM. *The Harry N. Abrams Family Collection.* June 29–September 5, 1966. Catalogue introduction by Sam Hunter; interview with Abrams.

92 NEW YORK. THE WHITNEY MUSEUM OF AMERICAN ART. *Art of the United States: 1670–1966.* September 28–November 27, 1966. Catalogue foreword and text by Lloyd Goodrich.

93 New York. Museum of Modern Art, International Council. *Two Decades of American Painting.* 1966–67. Catalogue essays by Irving Sandler, Lucy Lippard, G. R. Swenson. Variant catalogues issued. Also shown in: Tokyo, October 15–November 27, 1966; Kyoto, December 12–30, 1966; New Delhi, March 25–April 15, 1967; Melbourne, June 6–July 8, 1967; Sydney July 17–August 20, 1967.

94 Washington, D.C. Corcoran Gallery of Art. [Biennials] *Thirtieth Biennial Exhibition of Contemporary American Painting.* Spring, 1967. Catalogue issued.
 Gene Baro, *Studio International,* vol. 174, no. 891 (July–August, 1967), pp. 49–51.

95 Montreal. United States Pavilion. *Expo '67.* April 28–October 29, 1967.
Also shown in: Boston. Institute of Contemporary Art. *American Painting Now.* December 15, 1967–January 10, 1968. Catalogue essay by Alan R. Solomon; por.

96 New York. Museum of Modern Art. *The 1960s: Painting and Sculpture from the Museum Collections.* June 28–September 24, 1967. Brochure introduction by Dorothy Miller.
 Hilton Kramer, *New York Times,* July 2, 1967.
 F[rederick] T[uten], *Arts,* vol. 42, no. 1 (September–October, 1967), pp. 51–52.

97 San Francisco. San Francisco Museum of Art. *Untitled, 1968.* November 9–December 19, 1968. Catalogue foreword by Gerald Nordland; introduction by Wesley Chamberlin.
 Knute Stiles, *Artforum,* vol. 7, no. 5 (January, 1969), pp. 50–52.

98 New York. Museum of Modern Art. *Twentieth-Century Art from the Nelson Aldrich Rockefeller Collection.* May 26–September 1, 1969. Catalogue foreword by Monroe Wheeler; preface by Nelson A. Rockefeller; essay by William S. Lieberman.

99 New York. Metropolitan Museum of Art. *New York Painting and Sculpture: 1940–1970.* October 18, 1969–February 8, 1970. Catalogue foreword by Thomas P. F. Hoving; introduction by Henry Geldzahler; reprints of essays by Michael Fried, Clement Greenberg, Harold Rosenberg, Robert Rosenblum, William S. Rubin; bio; individual and group bibl.
 Hilton Kramer, *New York Times,* October 18, 1969.
 Hilton Kramer, *New York Times,* October 19, 1969.
 Philip Leider, *Artforum,* vol. 8, no. 4 (December, 1969), pp. 62–65.

100 Boston. Boston University School of Fine and Applied arts Gallery. *American Artists of the Nineteen Sixties.* February 6–March 14, 1970. Catalogue text by H. H. Arnason, organizer of the exhibition.